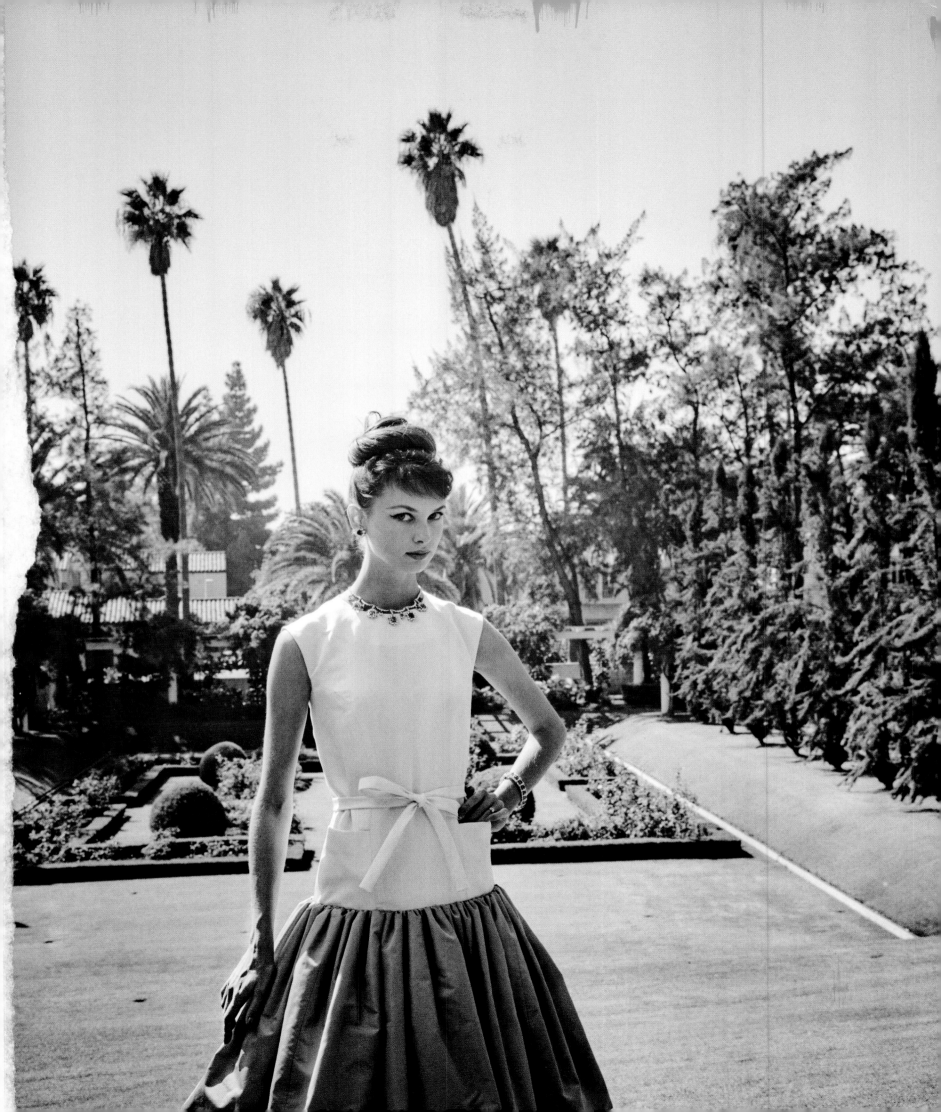

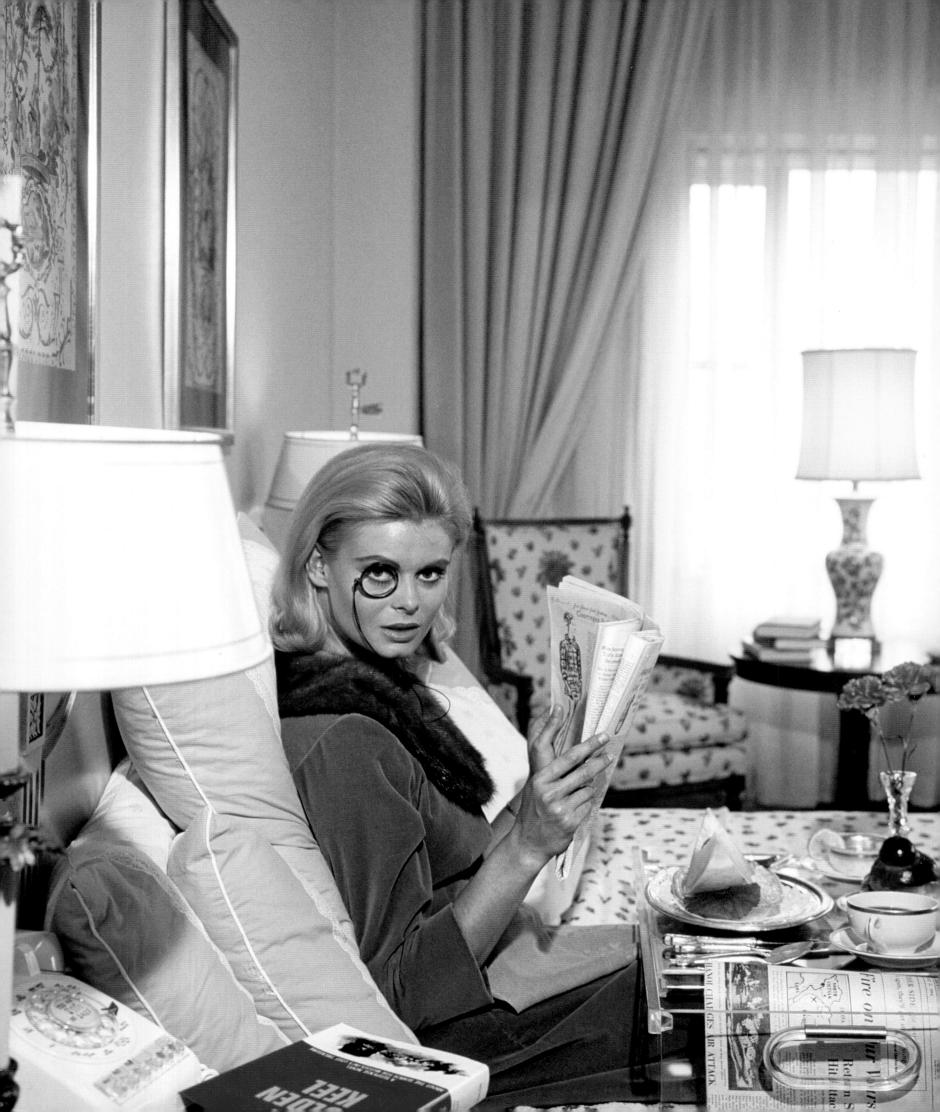

SLIM AARONS
Style

PHOTOGRAPHS BY SLIM AARONS

TEXT BY SHAWN WALDRON & KATE BETTS
Foreword by Jonathan Adler

GETTY IMAGES ABRAMS, NEW YORK

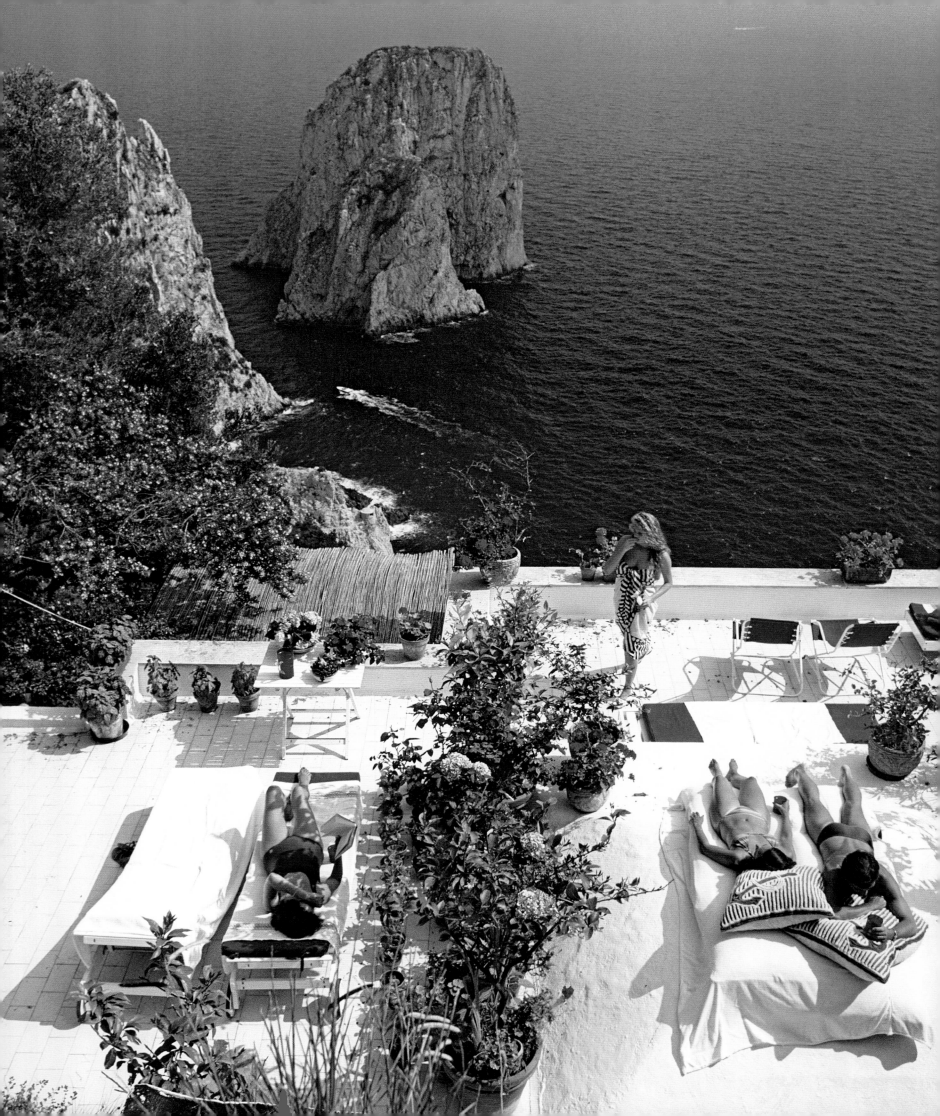

CONTENTS

FOREWORD:
ATTRACTIVE THINGS

BY JONATHAN ADLER

"BIRTH, SCHOOL, WORK, DEATH"—that bleak and iconic 1988 song by the Godfathers terrified my younger self. Like every Gen X-er, I was born with a Kafka-esque outlook. Birth, School, Work, Death—was that the story of Life? Oy vey! Birth had occurred twenty years earlier and school was about to end, so work and death were all I had to look forward to. There was no way around it. Or was there?

Enter Slim Aarons. It was 1993, and I had recently quit my office job and was embarking on a career as a potter (mishugana career choice, btw). For kicks I would haunt the Strand bookstore in NYC looking for design inspiration. One day I was flipping through the photography section and there IT was: a Slim Aarons monograph. Instantly I felt a surge of dopamine. Here was Babe Paley lolling at Round Hill villa. Socialites in lemon and white resort clothing lounging poolside at the Kaufmann House. A *roué* and a beauty playing backgammon *in* the pool at a groovy Acapulco resort. A family outing in a streamlined sixties amphibious car? Um, yes please! Here was a world that combined design with fun, optimism, color, and spontaneous glamour. These people were all going to die too. But before they did, they were going to have F-U-N, probably in a gorgeous Caprese palazzo.

The pictures were blowing my mind. But Slim Aarons's hilarious motto was changing my life. Slim summed up his oeuvre perfectly: attractive people doing attractive things in attractive places. Attractive people doing attractive things in attractive places. Attractive people doing attractive things in attractive places. I repeated the phrase three times, and suddenly my bleak worldview

was washed away like a Thetan from a Scientologist's body. I had a new guru.

In Slim Aarons's world, the dramatis personae are never to be found staring at the horizon with existential terror. They are, in sharp contrast, frozen during moments of heavenly becaftaned unapologetic self-indulgence. Slim Aarons's glamorous jet-set snaps were the big bang of FOMO that made Instagram possible. Everybody on earth faces challenges, but when Slim hits the pause button, the world takes a momentary break and the relentless cycle of Birth, School, Work, Death takes a back seat to color, style, Regency pool pavilions, sun-soaked ski slopes, bougainvillea-covered colonnades, and suntanned arms clanking with statement jewelry. In Slim's world, birth happens at New York Presbyterian. School? Brearley. And then the nasty bits of life—work and death—evaporate into a cloud of Palm Beach, Capri, Southampton, Acapulco, Gstaad. Rinse and repeat. Life is so . . . attractive. It's always time for another boozy and sun-soaked luncheon.

By some miracle—I'm sure Slim Aarons's optimism had a hand in it—I managed to turn my little pottery concern into a viable business. I work, I pay my taxes, and I'm lucky to live a creative life. But on the bad hair days, the days I'm trapped in Topeka because of a missed flight, when rainy days or Mondays have got me down, I conjure the jet-set glamour of guru Slim. Suddenly the Topeka airport fades away and I find myself sitting poolside with that lady in the lace crop top with the blonde flip, and an important question pops into my head: *Can I please have another Harvey Wallbanger?*

Guests mingle by the pool at the Kaufmann House, architect Richard Neutra's Palm Springs modernist masterpiece, 1970.

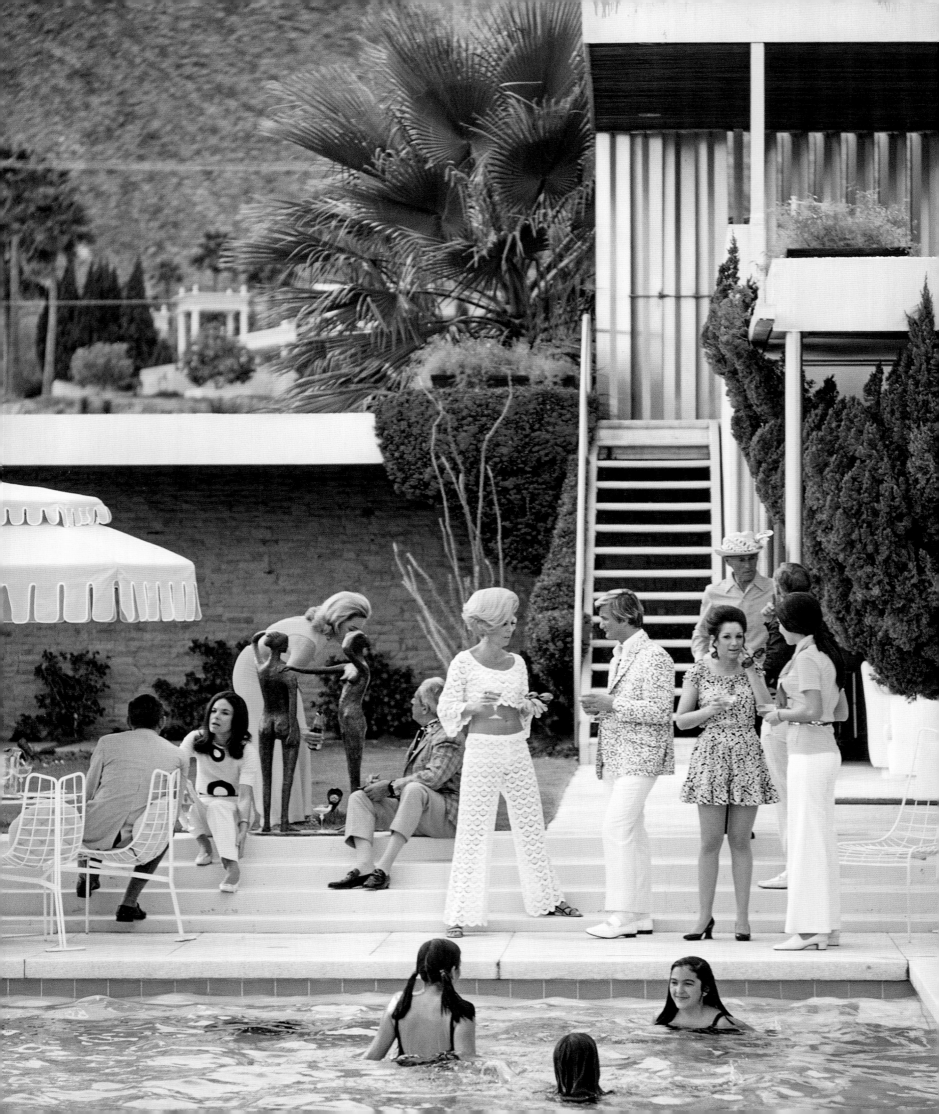

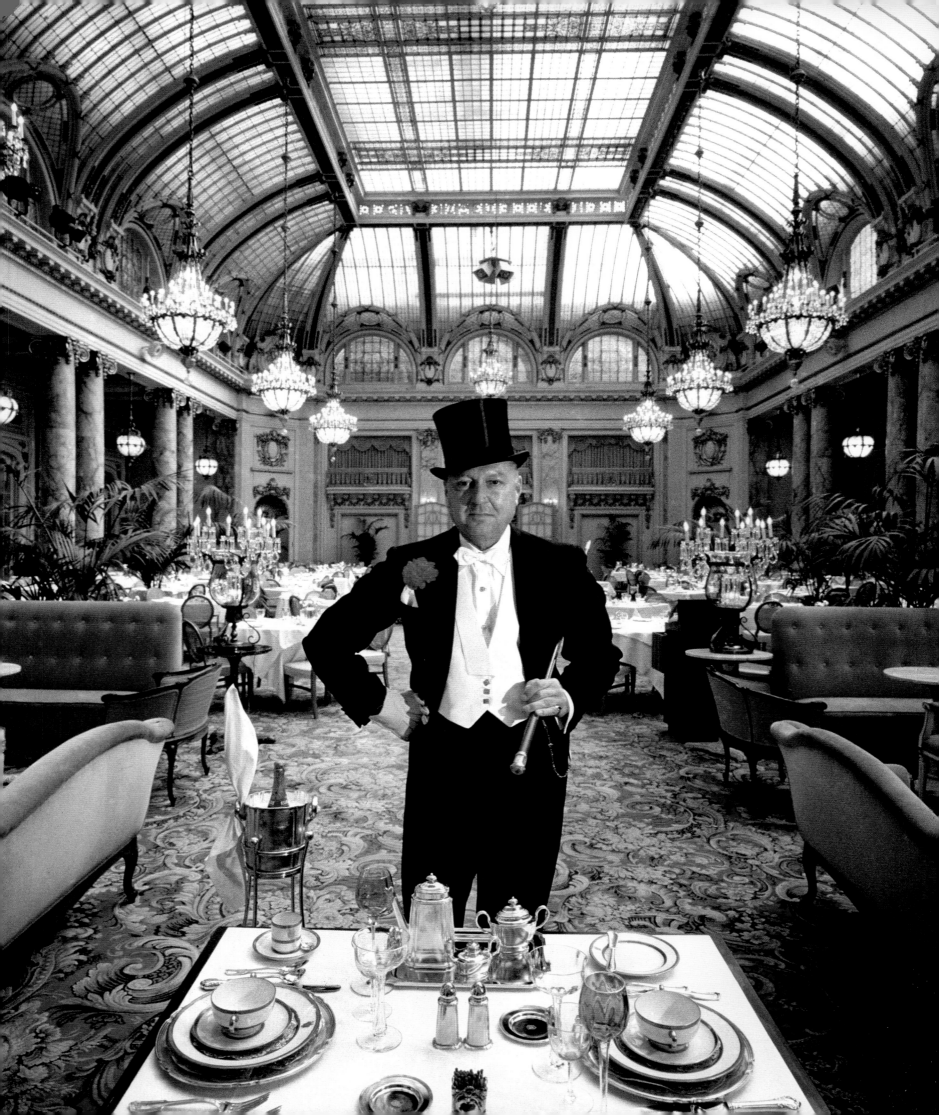

INTRODUCTION

BY SHAWN WALDRON

WHEN GIVEN THE CHANCE, Slim Aarons would be the first to proudly and enthusiastically admit that he was not a fashion photographer. His own words were, "I don't do fashion. I take photos of people in their own clothes and that becomes fashion." It's a simple premise: These are the Beautiful People, this is how they dress, and soon, this is how you will dress, too.

Fashion photography first appeared on the printed page in the early twentieth century in magazines such as *Art et Décoration* and *Vogue*. Baron de Meyer and Edward Steichen, two pioneers of the genre, overcame photography's technical limitations by introducing dramatic lighting and custom-built sets to infuse pictures with elements of distinction and chic. Their photographs showed the latest fashions, naturally, but also incorporated avant-garde art and design. Society women, already the main subject and readers of the fashion press, were among the earliest sitters,[1] often wearing garments from their own wardrobe. The practice was not without controversy—*Vogue* caused a minor scandal in upper-class circles after publishing a particularly haughty portrait of Gertrude Vanderbilt Whitney taken by de Meyer in 1913—but within a few short years the mutually beneficial relationship between fashion photographers and the elite was firmly established.

Fashion pictures evolved aesthetically throughout the first half of the twentieth century, but never drifted far from their raison d'être: the promotion of fantasy first and clothes second. At their core, the best fashion pictures are a conspiracy involving the photographer—who envisions a role, character, or situation—and the sitter, who plays along (or not). In the early days of his career, Slim shot straight fashion pictures for magazines and catalogs, generally outdoors, using both professional models and civilians, examples of which are being revealed to the public for the first time in this volume. They aren't half bad as far as fashion pictures go, but ultimately, Slim took his work in a different direction. Considering the gruesome scenes he witnessed in Europe as a World War II army

photographer, it is not surprising the concept of creative artifice held little appeal. Instead, he went straight to the source, documenting the real-life grandeur and luxury other photographers turned to for inspiration. Slim was innately curious about the people of privilege who populated this private world: how they lived, what they ate, where they vacationed, and what they wore.

Garments are the ultimate public signifiers—the designer Miuccia Prada has described them as instant language—but style is more than just clothes, of course. Style is comportment and carriage. It is the objects that surround us and how they are arranged, how one entertains and passes time, and both how and where we travel. It is not what we wear, but how we wear it. Slim may not have formally studied fashion, but he innately understood style; he had it himself. Even today, more than twenty years since he stopped making pictures, his name is regularly invoked by writers and journalists as shorthand for the Good Life: *like straight out of a Slim Aarons photo . . .*

It's easy to see why. Slim's photographs are portals to another place where the sun is shining, the grass resplendent, the pool temperate, and money, well, we don't talk about that. I spoke with Jack Carlson, former member of the US rowing team and now founder and CEO of the Rowing Blazers fashion brand, about Slim and his enduring influence. Carlson is fascinated with Slim's life and his work and recently incorporated Slim photographs into Rowing Blazers pieces. Asked what makes Slim special, Carlson said, "Slim captured privileged spaces and the sort of environments people dream of inhabiting, but the scenes—the people, the places—are idealized. He knew, the subjects knew—and ultimately the viewer knows—this is not *exactly* real life." He continued, "Slim was not complicit. He was an interloper that relied on charm and amazing photographic talent to get into the places he needed to be. There's a sense of remove in his pictures, and that's what makes them simultaneously charming and exciting." To the modern viewer, Slim's pictures are chimeras, or, to put it another way, lightning in a bottle.

In terms of sheer output, Slim's archive is mind-boggling; the neatly stacked and shelved boxes of negatives and slides stand ten feet high and occupy two long rows and dozens of file cabinets in the Getty Images archive. After spending countless hours looking

[1] Modeling as a profession was not common before the late 1920s. For practical reasons, the earliest fashion photographs featured stage actresses: There was ample supply in New York and Paris, and they were generally available during the day, tended to be physically attractive, knew how to hold a pose, and understood the value of free publicity.

through the files, it becomes clear that Slim was at his best when photographing people. During his forty years behind the lens, he exposed hundreds of thousands of portraits in B&W and color. Making generalizations about an archive of that scale may be considered an act of folly, but here's one anyway: Slim gradually refined his approach to portraiture into two camps divided along age lines. The under-thirties tend to be toned and tanned, classic beauties (or traditionally handsome), and appear delighted to have found themselves situated in front of this tall, agreeable man with dangling cigarette and handheld cameras. They smile, flirt, preen, and pose. For his more mature subjects, Slim favored a wider lens to bring in the surrounding environment and help gloss over the more detrimental effects of sun, age, booze, and tobacco. His formal sitters' expressions range from tickled pink to slightly embarrassed, while a handful feign outright annoyance (except for the Brits, who consistently come across as comfortable, patient, and self-assured).

Regardless of age, rank, and position, however, Slim's subjects are unconditionally themselves and entirely present. Yes, Slim was engaging, gregarious, polite, and popular, but his greatest skill, and the reason his photography remains so enchanting, was his ability to capture the privileged in unguarded moments without judgment or prejudice. He was neither sycophant nor critic. Designers, stylists, and the fashion world at large have embraced his photography for more than three decades because the people and places in Slim's pictures appear, in the immortal words of Diana Vreeland, simply *divine*. Beyond that, however, they embody a highly marketable form of idealized realism. How can anyone look at Slim's photograph of sixties supermodel Veruschka in Acapulco wearing a purple Pucci jumpsuit while doing the limbo at an after-dark beach party and not want to be next in line? Is it possible to see Slim's snap of Peter Pulitzer casually smiling in khaki pants with jacket tossed over one shoulder and not imagine the publishing heir/citrus farmer working alongside his wife, Lilly, in their Palm Beach fruit stand that also happens to sell brightly patterned frocks of her own design? These pictures are life first, fashion second, which is one of Slim's specialties. As we see in this volume, however, the fashion is a close second and ready inspiration for designers aiming to build a global brand around a particular vision of high-American style. To them, Slim did it first and he did it best. His archive is the Holy Grail.

The value of presenting clothes in context, which Slim did effortlessly, cannot be overstated. In *The Times of Bill Cunningham*, a 2018 documentary created using footage from a rediscovered 1994 interview, the beloved street photographer relates a story from the time Vreeland was organizing exhibitions at the Metropolitan Museum of Art's Costume Institute. According to Cunningham, who considered himself a fashion historian, the Costume Institute staff followed a strict academic and research-based doctrine when it came to dressing mannequins; garments and accessories were paired following visual guidance lent by period advertisements or catalogs. Vreeland, however, preferred to mix and match; decade, designer, or fit be damned. She saw no issue with wrapping an Hermès scarf around the head of a mannequin draped in a Jacques Fath dress, because this is how women actually dressed. Cunningham, clearly in agreement with the grande dame's approach, earnestly says, "Women of style wouldn't be caught dead copying the showroom!" In 1960, Slim photographed Nan Kempner unwinding in the lodge with cocktail in hand and a knowing smile following a day of skiing at Sugarbush, Vermont. Her puff-sleeve polka-dotted blouse is unbuttoned down to her black pencil skirt, revealing a black lace bra and turquoise necklace. She looks happy, relaxed, and chic; you can almost be certain they did not show that top like that in the showroom.

Jack Carlson is one of the latest designers to be inspired by Slim, but he was certainly not the first. Ralph Lauren, Tory Burch, Sid Mashburn, Tom Ford, Diane von Furstenberg, Michael Kors, Paul Smith, Anna Sui, and Jonathan Adler (along with hordes of contemporary social media influencers) cite Slim as an inspiration. For Kors, the appeal is multifaceted. The designer told me, "The focus for Slim always seemed, to me, to be about style, not fashion. The people he photographed were inherently stylish. I try to make my designs about directing the eye towards the wearer first, and also thinking in terms of what will look timeless for years to come. The images Slim shot look timeless today because the focus is on the person and their style—and ultimately that is what endures."

A snapshot of Slim on board a yacht off the coast of Capri in September 1968 hangs in clothier Sid Mashburn's influential menswear shop. Slim, tan after a long summer spent hopscotching

preceding spread Journalist Lucius Beebe in the Garden Court restaurant in San Francisco's Palace Hotel, 1960. A noted historian and sartorialist, he holds a walking stick that previously belonged to a Wells Fargo stage driver.

opposite above Stephen "Laddie" Sanford, heir of a great carpet fortune and one of America's foremost polo players, relaxes at the Gulfstream Polo Club, Lake Worth, Florida, 1955. Ralph Lauren was so taken with this photo he personally asked Slim to shoot a campaign around it, which Slim politely declined.

opposite below left Peter Pulitzer, scion of the Pulitzer publishing family and husband to Lilly, on the patio of his Palm Beach, Florida, home, 1968. The high-waisted, full cut of his khaki pants was first made popular during World War II by American troops in the Pacific Theater. According to Slim, Pulitzer was one of three regular subjects with a perpetual tan—the other two being Willy Hutton of Palm Beach and the actor George Hamilton.

opposite below right American socialite and fashion writer Nan Kempner after a day on the slopes at Vermont's Sugarbush Mountain ski resort, 1960.

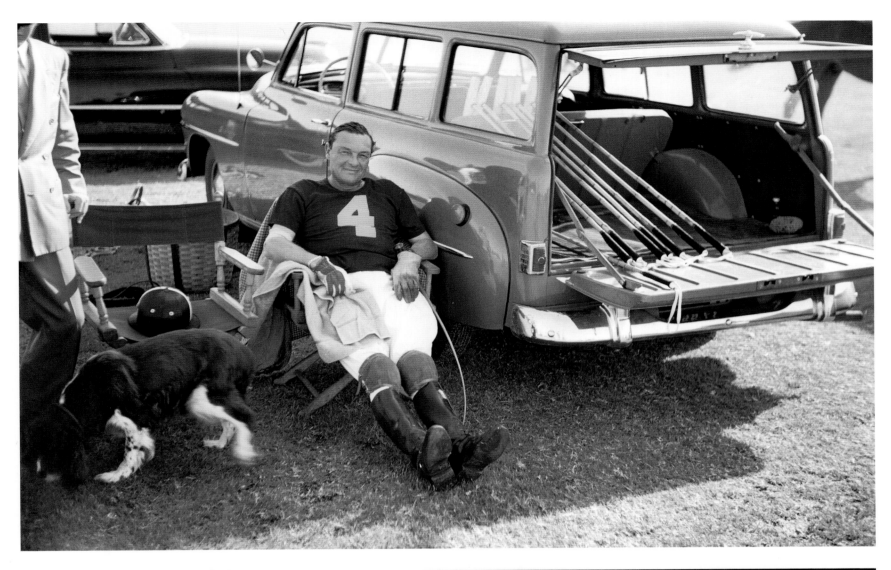

from one vacation spot to the next, smirks at the camera while standing arms akimbo. An unlit cigarette dangles from his mouth, and mirrored sunglasses sit atop his windblown hair. When asked about what Slim means to him, Mashburn said to me, "His pictures are this super immersive experience. The people look cool, the places are fantastic, and the vibe is beckoning: 'You're here! You're welcome! Make yourself at home!' That may be one of the reasons the photo of him has been on our Atlanta moodboard since we first opened in 2007, because he created the same exact feeling—inspiring but also inviting—that we were going for with the store."

The inhabitants of Slim's world, or, more accurately, the world that Slim inhabited, represent the very characters designers like Kors, Mashburn, and Burch have been drawing upon for decades as they present their vision of prototypical American style—louche, monied, preppy, and WASPy, but also earnest, classic, and, as Kors says, timeless. Depending on the season, critics may wring their hands over a sprinkling of garishness or a dose of corporate banality, but isn't that American too? *Holiday*, *Harper's Bazaar*, and *Town & Country* originally published Slim's pictures as reportage and surrounded them with serious articles about upper-class life and rituals. The images were given a second life as designers, photographers, and creatives turned to Slim's collective output as a form of visual inspiration in the 1990s and 2000s. Today, his work has found a new audience among the Instagram generation; his color work in particular aligns with their obsession over surface, saturated color, and exotic locales. This new gaggle of devotees is not as overtly concerned with the who, when, and where of the photographs as they are with the broader lifestyle. No one has shown us the conceptual Good Life from the inside out better, and for longer, than Slim.

To an outsider, the rarefied world of postwar society and celebrity Slim accessed through editorial assignments and his own personal charisma appears to have been ruled by established families, traditions, and dictates predicated on the concentration and maintenance of power and wealth. The reality was that society, American society in particular, had been around for less than a century and existed in a constant state of renewal and expansion. In 1923, Frank Crowninshield, editor of *Vanity Fair* and one of the most beloved literary men in New York, published a history of New York society for the thirtieth-anniversary issue of *Vogue* at the insistence of his Condé Nast colleague and *Vogue* editor in chief Edna Woolman Chase. Paris-born with Boston Brahmin[2] roots, Crownie, as he was affectionately known, was a true bon vivant: highly cultured,

unerringly polite, and always properly dressed. A lifelong bachelor with an unerring eye for modernist painting and sculpture, Crowninshield was at home in the finer clubs, restaurants, and drawing rooms of New York, Newport, and the cultural capitals of Europe.

His essay, titled "Ten Thousand Nights in a Dinner Coat," which is worth reading for the brilliantly sardonic opening paragraphs alone, collates the formative history of American society into four distinct but rapidly evolving periods with their own set of rules, personalities, and core institutions. Crowninshield charts the progression from a small and informal group of New Yorkers with strong Dutch colonial roots through the turbulent period following the Great War, when a youth-driven embrace of liberated nihilism rewrote the standards of acceptability. Between those two extremes, society had been formalized, cataloged, codified, and, to the disdain of those already in its opulent embrace, expanded in an explosion of Roaring Twenties capital. These critical years engrained and entrenched upper-class hallmarks such as the country estate and outdoor sporting life, private resorts and cosmopolitan clubs, the Four Hundred[3] and social registers, cotillion and charity balls, newly minted millionaires decamping for New York, and, most consequentially, the emergence of a draconian list of ever-changing and unspoken conventions designed as a de facto barrier to entry.

In the years before mass entertainment created the modern celebrity, the main targets of newspaper gossip columns were the trials and tribulations of the social elites. Publications such as *Town Topics: The Journal of Society* (1887–1923) were essential reading for members of established society, arrivistes, and social climbers alike, but also helped foster the broader public's fascination with blue-blooded scandals, the more outrageous the better. *Town Topics* editor Colonel William d'Alton Mann populated his popular gossip column, "Saunterings," with salacious blind items obtained by bribing household staff, eavesdropping at parties and clubs, or through his network of willing informants.

As the public's fascination with entertainers and athletes waxed throughout the 1920s, their interest in the coming and goings of traditional society waned. In the postwar years, the very definition of society expanded, at least in the public's consciousness and their level of interest—fame and physical attractiveness became qualifiers as much as wealth and breeding. By the time Slim began documenting the elite in earnest, the hyperbolic refrain heard in both popular media and private conversation was, "Society is dead." In 1960, the social historian Cleveland Amory, like Crowninshield

[2] Boston Brahmins are the original American aristocracy. Slim discovered them after moving in with his grandparents in New Hampshire as a child. Slim held Boston in the highest regard throughout his life; it's no coincidence his wife was born and raised there.

[3] The Four Hundred was a list of the official members of New York Society. It was created by Ward McAllister at the invitation of Mrs. Astor, the original society doyenne, and first published in the *New York Times* on February 16, 1892. There is open debate as to the reason why the list was capped at four hundred; the most popular explanation is that was the maximum number of guests able to comfortably fit in the ballroom of Mrs. Astor's Fifth Avenue mansion.

a Boston Brahmin and well-regarded man of letters, looked back at the postwar period in *Who Killed Society*, the third and final installment in his popular series of society satire.[4] The following year, Amory laid out the book's thesis in a series of twelve nationally syndicated newspaper articles, beginning with "Who Killed Society? 'It Wasn't Much of a Funeral.'" The article is sprinkled with first-person testimony from a collection of Old Guard grande dames, about half of whom posed for Slim at one time or another. Mrs. William Woodward Sr. of New York reminisces about "dear old Harry Case telling me he'd run a block to see a girl's ankle—but just the same there was style." According to Amory, privacy, once cherished among the elite, was all but forsaken, a remnant of "the days when photographers were not sought after and fawned over but, instead, occasionally 'permitted' to take a picture." Mrs. G. Alexander McKinlock of Chicago said, "In the old days everything was private. There were private houses and private parties and private balls and private yachts and private railroad cars and private everything. Now everything is public—even one's private life."

While every generation loves to complain about the next, Amory was on to something. Though it was far from revolutionary, change was in the air, at least in terms of who would lead society into the future and their relationship with the press. The editors of *Holiday* also recognized the shifting sands and in 1958 sent Slim around the US to photograph the current state of society. Articles, such as "The Effete East," written by Roger Angell, "The Glittering Socialites," and "Who Are Real Society" by Stephen Birmingham, featured a mix of the old guard and next generation but also proved that the foundational roots and structures of society Crowninshield had outlined decades earlier remained firmly in place. Angell argued the best schools, clubs, and families still resided on the East Coast, also the centers of finance and culture, while Birmingham cautioned that Modern Society could be found in many cities, but it should never be confused with Real Society—aka Amory's Old Guard. Such artificial demarcations were of no interest to Slim. He followed his instincts and trusted his gut when shooting—chances were if you were in the proverbial room, you were somebody. His images reflected and further solidified the faces that were acknowledged to be among society's evolving in-crowd.

The *Holiday* assignments were critical in Slim's evolution as a photographer and the development of his artistic voice and vision. The thousands of photographs Slim shot in the second half of the 1950s provided the framework for what became his trademark: charity galas and debutante balls, assemblies and civic councils, royals, women shopping or wearing couture gowns posed in stately homes, outdoor sport and hunting, private homes, clubs and

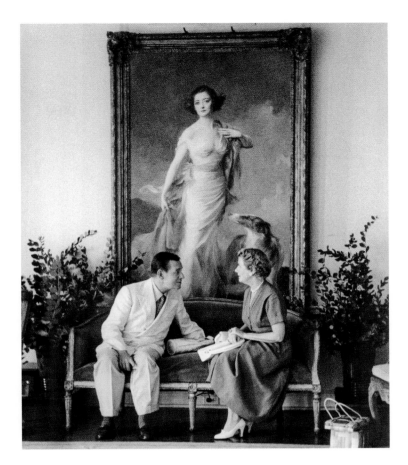

Mr. and Mrs. Harvery Firestone, Jr. in Newport, 1950s, around the time they purchased Ocean Lawn, their sprawling waterfront mansion. Mrs. Firestone, a noted collector of art and antiques, also had one of Newport's best wardrobes. At her insistence, garments were cleaned in Paris but pressed in Newport. Her impeccable two-story closet was so large Ocean Lawn's next owners were able to convert it into three bedrooms and a library.

resorts, and a stream of patroon and old-world families, businessmen, artists, writers, and intellectuals.

Though the rules of the social world evolved from fin de siècle to mid-century, the seasonal calendar held steady across the decades and served to steer society from point to point. Cotillion and ski holidays were followed by spring galas and equestrian events, which led to European holidays, yachting, and leisurely days around the pool or at the tennis club. Fall, of course, was marked by hunting and shooting and the return to school and city life. The particulars, manner of dress, and destinations evolved, but the rituals remained and for four decades were the guiding force in Slim's roving life. The seasonal calendar is also the principal form around which this volume, the first to focus on the elements of style and rhythms of society that course through Slim's work, is arranged. Along with the obvious nod to the cycles of fashion, organizing this selection of two hundred plus pictures shot over four decades in this manner highlights the common threads of time and catalogs the evolution of society from the late 1940s to the early '90s. Viewed as a year in the life, these connected moments become mirrors reflecting both past and present.

[4] The two earlier titles are *The Proper Bostonians* (1947) and *The Last Resorts* (1952).

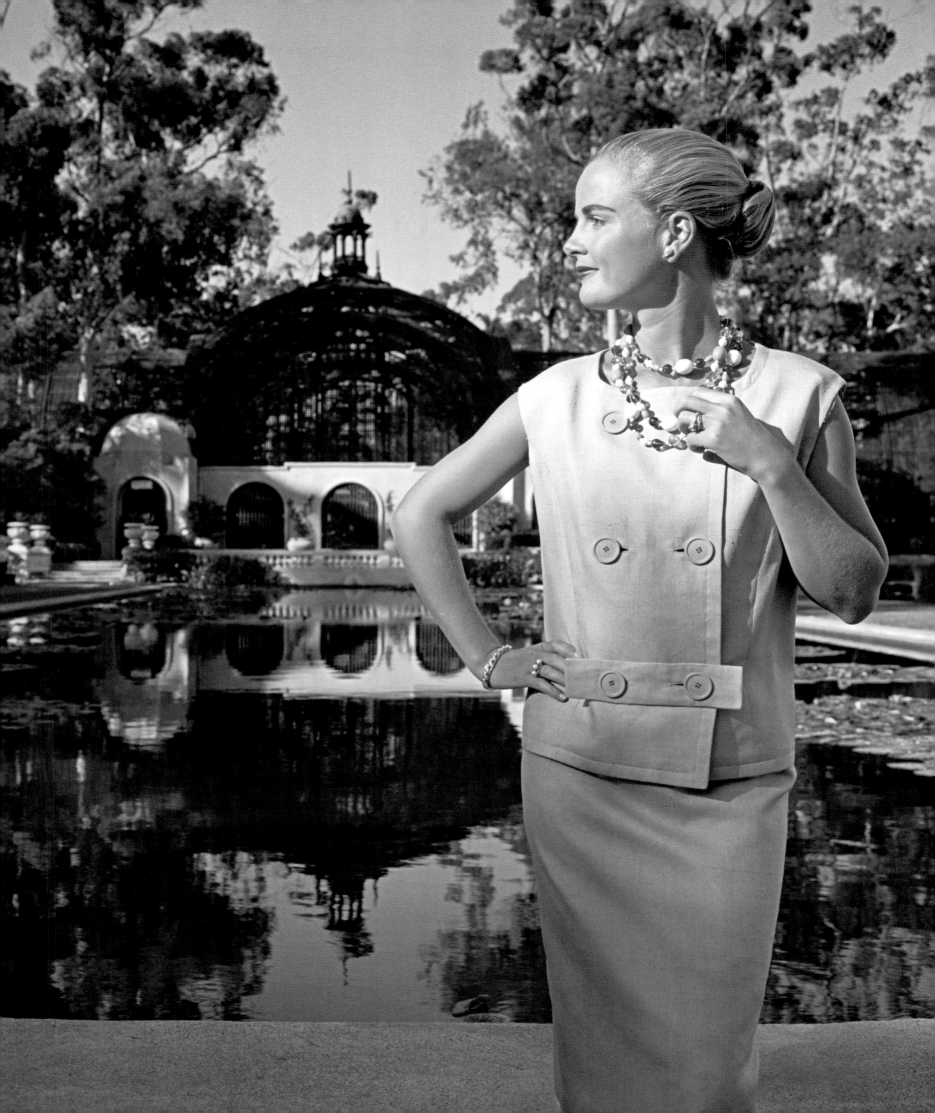

SEASONS OF STYLE

BY KATE BETTS

DAPPLED LIGHT DANCES on the water's surface behind the model as she poses in a stiff pink suit, one hand clutching her beaded necklace, another hand planted firmly on her hip, her hair tucked into a low chignon. The year is 1960 and the photographer, Slim Aarons, has traveled the world, shooting celebrities and travel stories for *Life* and *Holiday* magazines. Now, in the Southern California sunshine, he was following fashion's age-old structure, the changing seasons, and trying his hand at a very different kind of image. The models he chose were not just standard industry mannequins; they had titles and husbands with Ivy League degrees and stationery embossed with the names of their palatial homes; they belonged to exclusive country clubs; they were perfectly at ease in the rarefied atmosphere of inherited wealth. In print their names included an "of" that incorporated their preferred geography: Mrs. Anne Ryan of La Jolla; Mrs. Sydney Brodie of Beverly Hills, Mrs. Jessie Woolworth Donahue of Palm Beach.

An unpublished photo from that same year features a young woman perched on the sandy steps of her family's oceanfront compound in Palm Beach. Her white gloves and heels offer a startling contrast with the crashing waves and cement sea wall behind her, but it hardly matters. There, in a single image framing the sophisticated posture of a young Mrs. Winston Guest of Palm Beach, better known as C.Z., we see the whole world of wealth and privilege in the 1950s. Guest, the ash-blonde debutante who will dominate New York society for decades, will become one of Aarons's greatest models, appearing again and again in shots taken at her family home—C.Z. in crisp white shorts or a bright orange skirt, clasping her young son's hand or holding the collar of her enormous Great Dane as the vivid cobalt sky and turquoise blue of the pool play against the whitewashed Greek columns of Villa Artemis.

The collection of images Aarons produced as he moved through the social circles of Palm Beach and New York—Guest, again in his viewfinder, caught mid-conversation with *Vogue* photographer Cecil Beaton at a jewel-encrusted gala at the Plaza Hotel—were as noteworthy as his impact on the world of style was indelible. Through Aarons's work you can read the evolution of style across four decades, a statement about how to live, not just what to wear.

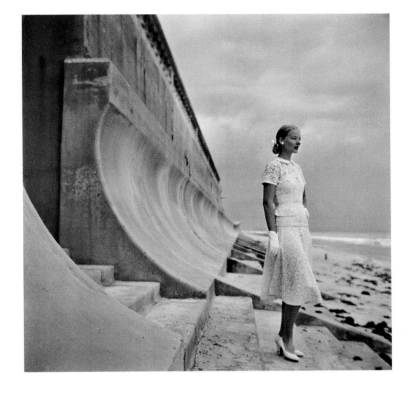

opposite Mrs. Anne Ryan, née Evenson, wearing a sleeveless two-piece combination tailored from a Bill Blass design outside the Botanical Building in Balboa Park, San Diego, 1960.

above Lucy Douglas Cochrane Guest, better known as C.Z., on the beach at Villa Artemis, the Guest family Palm Beach estate, 1954. She was named to the International Best Dressed List Hall of Fame in 1959.

Aarons received his photography education in the army during World War II; an early assignment was photographing West Point military maneuvers. Later he covered the siege at Monte Cassino, Italy, for *Yank*, the horrors of which nearly broke him. But it was the years after the war, in Italy, when he documented *La Dolce Vita* in Rome that piqued his interest in "attractive people in attractive places"—an experience that made it inevitable he would be drawn to style. He brought his particular aesthetic to his work and approached assignments with what proved to be unusual advantages. With his charm and his journalistic training, Aarons gained access to the private domains of the wealthy and socially

well-connected, slipping into country clubs, onto yachts, and behind the gates of vast villas. He shot socialites in front of their dreamy swimming pools and manicured French gardens. He photographed fashion designers themselves, catching Gianni Versace on Lake Como, Oscar de la Renta in the Dominican Republic, and Nino Cerruti in Capri. Not steeped in the conventions of fashion photography, he brought an outsider's freshness to the job. He disliked artifice. He wasn't interested in the labels inside a jacket or the shape of a dress. He saw style in a broader context, as an expression of a place, a window on a culture, a way of capturing not just a designer's or a model's personal glamour but the spirit of a time, a social zeitgeist.

Aarons traveled light, carrying little more than a Leica and a tripod, and in a way he anticipated the spontaneous—not to say compulsive—picture-taking of the iPhone-toting Instagram generation that defines so much of contemporary style. Taking hundreds of thousands of images over the course of his career, he found his signature in the environmental shot, pulling back the lens and framing subjects in their settings. Aarons understood that what surrounded his subjects revealed as much about their style as what they were wearing, or how they were standing, or the expression they'd composed for the camera. He looked beyond wardrobes to see what he might discern of his subject's personal style in the accoutrements of their room or the location of their houses. Signifiers were everywhere: the arrangement of a garden, the uniforms of servants, or the gleam of Bain de Soleil on a sunbathing ingenue. You could not really feel the indolent flush of luxury blanketing an Italian contessa lounging on the deck of a yacht without the additional detail of a bronzed boy-toy preening nearby. And similarly, how could the collection of Sévres porcelain lining the shelves in the background of a portrait not reveal as much about the aristocratic pretensions of a French Count as his silk ascot? Porcelain, pools, horses, polo mallets, Porsches, Greek ruins, tufted velvet sofas, and the polished teak of Riva powerboats were among the many accessories appearing in Aarons's photographs, purposefully staged to convey the essence of a subject's style as carefully as a fashion stylist accessorizes a model with a Gucci handbag or an Hermès scarf.

The fact that Aarons's sparkling photos of C. Z. Guest at Villa Artemis remain some of the most iconic and influential pictures of their time is not surprising. If today we accept as axiomatic that style

above Patsy Pulitzer Bartlett at Palm Beach, 1954. Slim photographed Pulitzer, a Florida native who had left the sunny confines for a New York modeling career, for a *Holiday* fashion feature titled "The Palm Beach Look."

left The dashing and ever-affable Slim with passport in one hand and camera equipment in the other, ca 1955.

opposite A young woman laces her heeled espadrille in Portofino marina, 1977.

is inextricably linked to image-making, it's difficult to grasp how confined and circumscribed the sources of style were before Slim Aarons's photographs showed us the private realms of high society and Hollywood, offering glimpses of life where people were less concerned with managing their images, and unapologetic about their fortune and privilege. Aarons showed us style that was fashionable and compelling because the subjects seemed to exude a calculated nonchalance even as they strictly observed every nuance of style.

Aarons documented and helped to shape a changing aesthetic over half a century in which style gradually—and then radically—freed itself from social conventions. In the late 1950s, when he photographed a wide-eyed Jackie Kennedy off-guard in her duchess satin evening dress at a charity ball, or a young Italian woman lacing up her espadrilles by the side of the road in Portofino, Aarons was announcing that style could be expressed naturally, in natural light, with natural gestures, as opposed to the frozen studio images so popular in fashion magazines of that era. Perhaps it truly was a matter of seeming effortless, the artifice of no artifice. When Aarons first ventured to Palm Beach and Capri in the 1950s, the multibillion-dollar image-making machinery we know today had not yet turned style into a commodity, a brand name you could just purchase at any Madison Avenue boutique. Style was a full education in manners and gestures: which club to join, where to attend dancing school, whom to invite to dinner, what to serve, and how to behave at the table. If you bought a suit or a tie at Brooks Brothers, for example, you were also offered a book of manners. Style was instruction for each season: what to wear to a summer dinner in Newport, a winter cotillion in Boston, or an autumn tailgate at Princeton. Style today is often about exhibitionism, showing off what you have in terms of possessions and wealth. But back in those simpler times style was still rife with the romance of aspiration—in the misty words of one 1954 *Holiday* magazine article, it was "a way of living, a time of year, the shape of a season."

Indeed, style in Aarons's definition still often seems paradoxically as concrete and elusive as "the shape of a season," something easier to recognize than to define. Looking back, we glimpse it in gestures that caught Aarons's eye—the smile of a woman waving from the back of a Riva in Monte Carlo, sundress ruffled by a breeze. Or the way Mrs. Guilford Dudley Jr. of Palm Beach holds her dog's leash in her white-gloved hands as they stroll down Worth Avenue. Or the telling detail of Princess Margaret's "royal" blue luggage tags. More than those of any photographer of his generation, Aarons's images are proof that style is ubiquitous, expressed everywhere in everything we do.

Perhaps what is most valuable about the body of Aarons's work for magazines—initially for *Life* and then *Holiday* and in later years for *Town & Country*—is the sheer half-century sweep of it. In the early images his eye is strictly journalistic, but as he began to

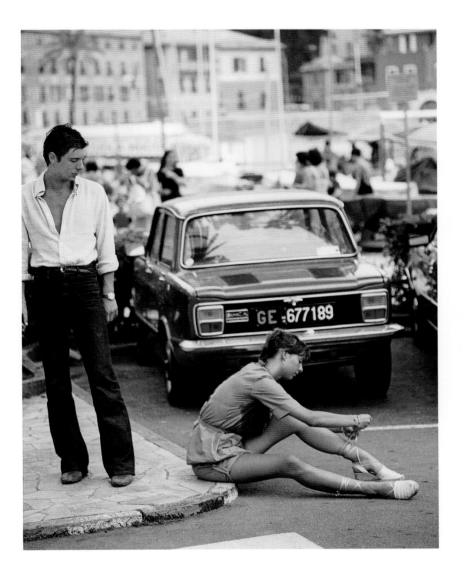

appreciate the vibrancy of color photography his work became all the richer, and his style, subjects, and locations ever more opulent.

In 1948 Aarons was still based in Europe and credited by his family name, "George." His assignments for *Holiday* were black-and-white photographs of influential people such as the mid-century costume designer Irene Lentz, who dressed Lana Turner in *The Postman Always Rings Twice*, and Marlene Dietrich in *Seven Sinners*. Living in Rome at the Hotel Excelsior, and working on movie sets, he met celebrities like Joan Fontaine and Louis Armstrong.

Eventually Aarons followed his connections to Los Angeles. He photographed the actress Ann Miller in her costume for MGM's *Easter Parade* and then captured a gaggle of elegant women attending a hat show on Rodeo Drive. His work of that time suggests the beginnings of a more celebratory approach to life, a recognition of a general readiness to move beyond the dour practicality of wartime rationing and restriction. Women were tired of sensible, broad-shouldered suits and seemed to be yearning for something more feminine and frivolous, ready to embrace peacetime leisure. They took their cues both from the cultivated glamour of stars on the silver screen—seventy-five million Americans attended a movie at least once a week—and from the haute couture revival

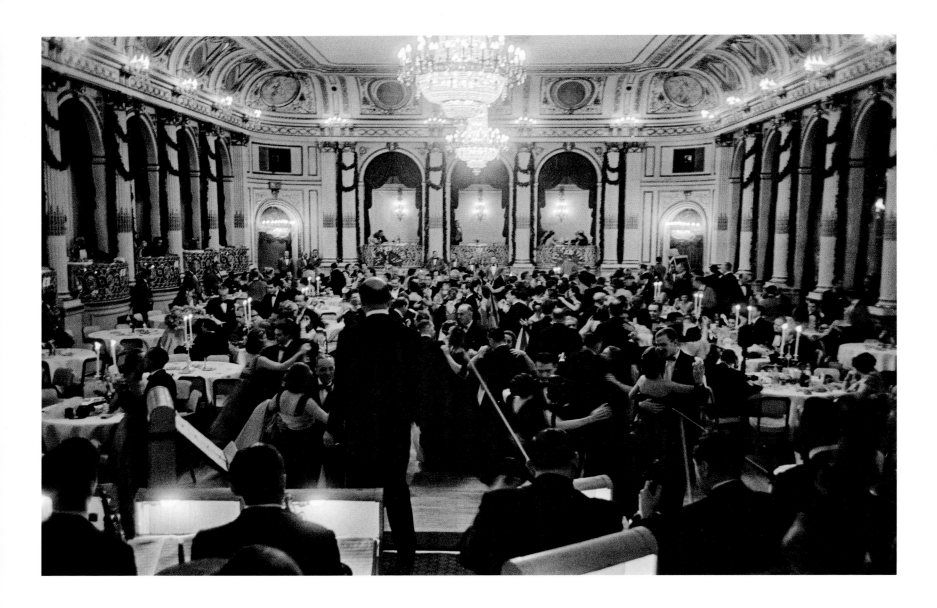

in Paris, where designers like Christian Dior had brought a new optimism to postwar fashion with his ultra-feminine New Look of extravagant evening gowns in delicate pastel colors.

Aarons really came into his own in the 1950s, when he adopted his nickname professionally and coined his visual style in places like Los Angeles and Palm Beach, where it was easy to mythologize the sunstruck postwar allure of the Good Life beside sparkling swimming pools. Shooting for *Holiday*, which was billed as the new jet-set bible, Aarons understood the yearning in American hearts and tapped into the mood of the 1950s as Rosie the Riveter gave way to Doris Day. Affluence was in. Debutante balls became the rage as female careerism was ditched for marriage and family life. In America more than 50 percent of female university students

dropped out to marry. "Career woman" became a pejorative term. Women who had built tanks and aircraft were ushered back to the kitchen and encouraged to feminize. They retreated from cities to keep house in the suburbs and hew to a more traditional "normative" vision of feminine glamour.

By the late 1950s Aarons's career was in full swing, iconizing the rich and the beautiful in color-saturated Kodachrome. He captured the opulent atmosphere of the bougainvillea-laced patios of Beverly Hills or what *Holiday* editors called the "razzle-dazzle" of Miami and the "rich tranquility" of Hobe Sound. Unlike most photographers, Aarons sometimes wrote his own copy for *Holiday*, describing parties at the St. Regis rooftop and tennis week at Newport's Casino, where he learned the difference between old guard Newporters and the young casual set who sipped champagne on the rocks and preferred "comfortable" clothes to formal wear. It was in Newport where he discovered the phenomenon of "the season" and began to trail his sun-seeking subjects from resorts to clubs to ski slopes. Through his lens we see how style shifts with the weather: Fall brought tweed Norfolk blazers and poodle skirts to Ivy League tailgate parties; winter required fox-trimmed parkas

above The view from the bandstand during the Fan Ball, a highlight of the 1950s New York society calendar. The annual charity gala was held on a Friday in November in the Plaza's grand ballroom. The dress code called for a fan, but coquetry was optional.

opposite Color and whimsy atop Snowmass Village, Colorado, 1968.

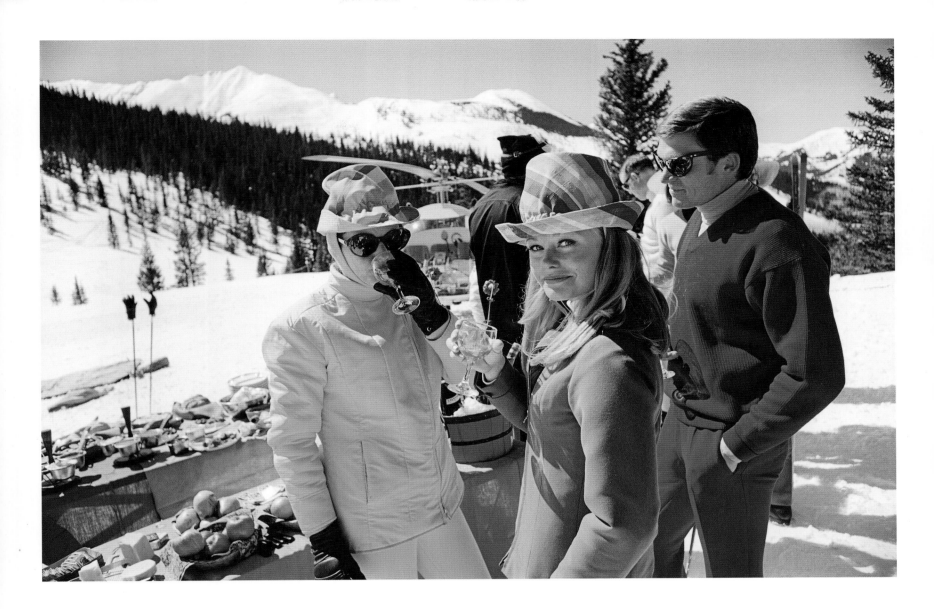

and monkey fur boots at "stand-up" fondue picnics on the slopes of Snowmass. In the spring, spectators flocked to the Henley Royal Regatta on the River Thames, where the trim of jaunty rowing jackets identified the members of each team. In the summer, arguably Aarons's favorite time of the year, his subjects clustered around lake-sized pools in Tahoe or hopped a boat called a "pickerel chaser" around the Thousand Islands archipelago in the upper St. Lawrence River.

Aarons's images brought the contrasts in these exclusive enclaves into focus: the tribal differences between the urban sophistication of Manhattan's Park Avenue and the idyllic country life of Manchester, New Hampshire. Sports, and of course parties, shaped the images of each place: Boston's white-gloved cotillions; Middleburg, Virginia's red-coated fox hunt. In the pieces Aarons wrote to accompany many of his *Holiday* photos, his voice was perfectly matched to his visual style. Of Palm Beach, which he called "the gathering place for families of fashion and fortune," he observed: "the party is the principal indoor and outdoor sport." Among a certain set in Jamaica's Montego Bay, where he returned again and again, he noted "cocktailing" is a verb.

Aarons was keenly aware of the evolution of style from the constraints of the late 1940s through the self-conscious formality of the 1950s to the rebelliousness of the 1960s, arguably the most socially convulsive decade of the century. Seemingly overnight, he witnessed the ascent of youth fashion and the influence of sexual freedom. One of the many effects of the crusade for women's rights, notably announced in Betty Friedan's 1963 book *The Feminine Mystique*, was a loosening of sartorial codes that had corseted women for much of the postwar years. The bourgeois fantasies formerly peddled in fashion magazines gave way to pictures of liberated society girls like Penelope Tree posing in Mary Quant's microminiskirts. Yves Saint Laurent introduced the braless look to the haute couture in 1967, three years after Rudi Gernreich's topless "monokini" had been banned in France. String bikinis replaced modest one-piece tanks, and young women who once frequented the Newport Casino in straw hats and white gloves now arrived barefoot in Lilly Pulitzer's minidresses, which had been designed to wear without undergarments. Air travel made European vacations more common. Pan Am meals were catered by Maxim's of Paris. Slim followed his flock to Sardinia, Porto Ercole, and Capri,

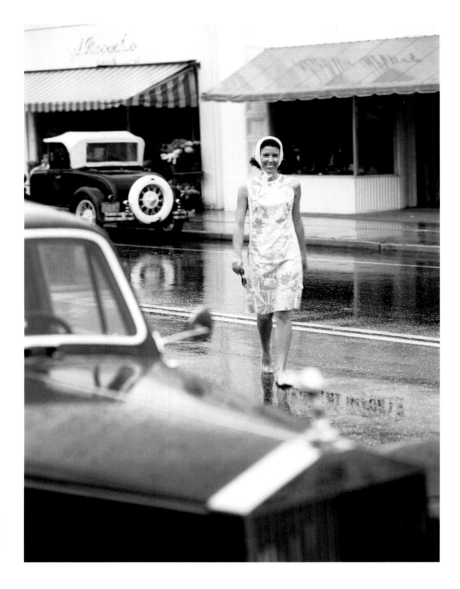

changes. They continued to frequent the same clubs and casinos and polo fields, draped in the glittering gowns and jewels and jaunty equestrian habits and polo mallets they had always favored. Nonetheless, Aarons adapted to the times, posing socialites on motorcycles in Saint Tropez instead of polo ponies in Palm Beach. As Kennedy Fraser wrote in *The New Yorker* in 1974, recklessness is the necessary electricity of style. Suddenly American resorts like Newport felt a bit blah, especially in the summer when jet-set sun-seekers hightailed it to the Marbella Club, or the Hotel du Cap, doffing their bikini tops by day and dancing all night at the Whiskey à Go Go.

That recklessness was still brewing into the late 1970s, when the cheery strains of Beach Boys classics segued into Donna Summer's hedonistic disco beat. The oil crisis and resulting recession depressed most fashion-conscious women's budgets, but didn't dampen the spirits of Aarons's aristocratic debutantes. They still played backgammon poolside and lingered over luncheons on the Riviera, where "play clothes" were a thing—silk rompers and loosely tied Hermès scarves. Fashion was less formal and emphasized the body. In America, Halston swathed his clients in cashmere sweaters and shirtwaist dresses, liberating them from the conventions of couture. Some called it feminist fashion, and maybe it was, with women entering the workforce and embracing simpler silhouettes. Suddenly, Jackie Onassis in a trench coat and a headscarf was the chicest thing on earth.

Style ultimately reflects the surrounding society, so by the time Ronald Reagan and Margaret Thatcher took over in the 1980s, most fashionable women had tossed their boho frocks for stricter stuff, including tailored suits and floppy bow ties. For the first time in American history, more women would be working outside the home than in it. Suddenly, the country club look of 1980s Washington gave way to the "power" look of sharp shoulder pads and cone-heeled pumps to convey an aura of confidence and sexuality and competence. But these executive women, dressed in their soulless uniforms, were uninteresting to Aarons. He much preferred the women who still wore Lillie Langtry–style ball gowns and ladies-who-lunch tweed suits. His idea of female empowerment was more unexpected—socialites and bankers' wives posing in their rococo castles in gaudy, merengue poufs of taffeta or sunbathing topless on the decks of yachts parked in Monaco's glitzy marina.

By the early 1990s, Aarons had retired from shooting for magazines, following his great friend and editor Frank Zachary out the door at *Town & Country*. The timing was prescient, as the 1990s and 2000s proved challenging when it came to finding interesting subject matter in the private enclaves of Palm Beach. Aarons was no longer the only photographer with entrée. The rise in digital technology meant anyone could and would access the private worlds of Hollywood and high society. So what happens when capturing that perfect view of the Amalfi Coast from a perch in

where beguiling European socialites like Pilar Crespi and Marisa Berenson reveled in the footloose look, layering ropes of beads over slinky mesh dresses. They called it "throw-away chic."

By the early 1970s, as the near-revolution of 1968 still reverberated in Paris and on college campuses in America, student protesters embraced the denim and T-shirt look of hippie chic. The color palette softened, from psychedelic pink, purple, and green to muted tranquil mauves and browns. Women traded in their Lilly Pulitzer shifts for long layers of crepe de chine dragging on the ground in defiance of bourgeois taste. London's East End punk scene inspired more individualistic style. Aarons might have noticed looser mores even among his social register subjects, but the world he photographed was largely undisturbed by the decade's radical social

above Mrs. A. Atwater Kent, formerly Hope Hewlett Parkhurst, crosses Worth Avenue following a rainstorm, 1964. Going barefoot was de rigueur among the new Palm Beach generation and emblematic of the looser sensibility and style they brought to the buttoned-up resort town.

opposite Donna Stefanella Vanni Calvello di San Vicenzo in the Hall of Mirrors at her family's Sicilian belle époque palazzo, 1984.

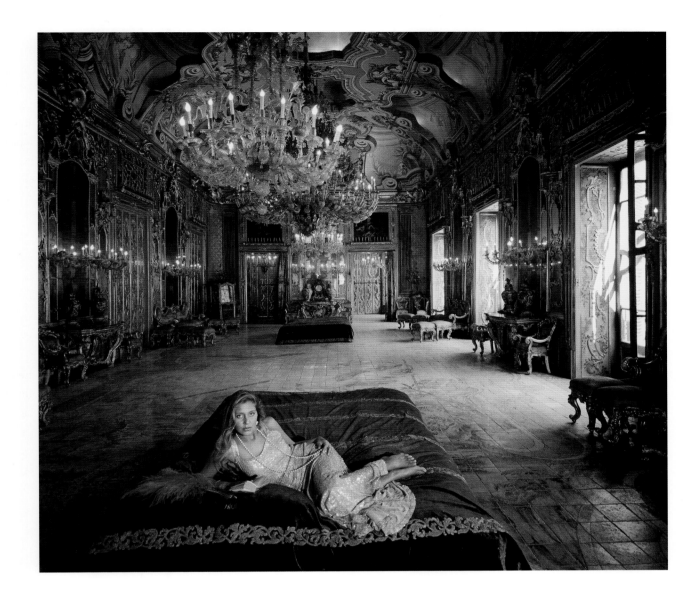

Positano becomes something so democratic that almost anybody could immortalize the moment on their iPhone with the help of filters and digital editing apps?

In a way, Slim Aarons was a man of his time, a shaper of what he observed and observer of what he shaped. In every photograph he took, Aarons arranged the view—his view—with careful consideration, instructing a subject to change his jacket, or hold a drink, pulling back the camera so an entire mid-century house and Palm Desert landscape would come into view behind a pool where two women gossiped, or simply framing a Newport tennis match in a round trellis window. It is hard to imagine anyone today having the influence he had in his heyday.

Just as image-making has become more democratic, so, too, has style. Brands like Lilly Pulitzer are no longer uniquely associated with Palm Beach, thanks to the facsimiles churned out by global fast-fashion brands. Fashion and style have lost some of their imagination and creative power. The uniforms of each decade resurface on runways with dull regularity. The flower power prints of the 1970s were last summer's must-haves, and the sharp shoulders of 1980s boardrooms have become a fashion fetish of the millennial generation. As often as these retro styles are revived, as the present imitates the past, so, too, return the iconic images of Aarons's Palm Springs patios and Riviera luncheons. Open any fashion magazine or Instagram feed and contemporary photos inspired by iconic images like "Poolside Gossip" or "Kings of Hollywood" abound. But even the best Instagram influencer cannot fully reconstruct the moments Aarons captured on those bougainvillea-laced patios in Beverly Hills, or against the whitewashed Greek columns of Villa Artemis in Palm Beach. Even Aarons's outtakes are windows onto a time and a place and tribes of people—a world whose intoxicating blend of glamour and recklessness is impossible to re-create. As the photographer himself wrote, his subjects were "sophisticates who roam the world hunting the sun," and he knew, as they did, that style is not something you whip up with a filter or an app or, worse, way too much money. Porto Ercole, Cannes, Corsica, Marbella—all of these glamorous locales still exist, but without Mrs. Winston Guest of Palm Beach or Mrs. Spellman Prentice of Hobe Sound, or the seasons of cricket and polo matches and debutante balls, that wonderful world of unapologetic privilege and effortless glamour is accessible to us only through Aarons's brilliant images.

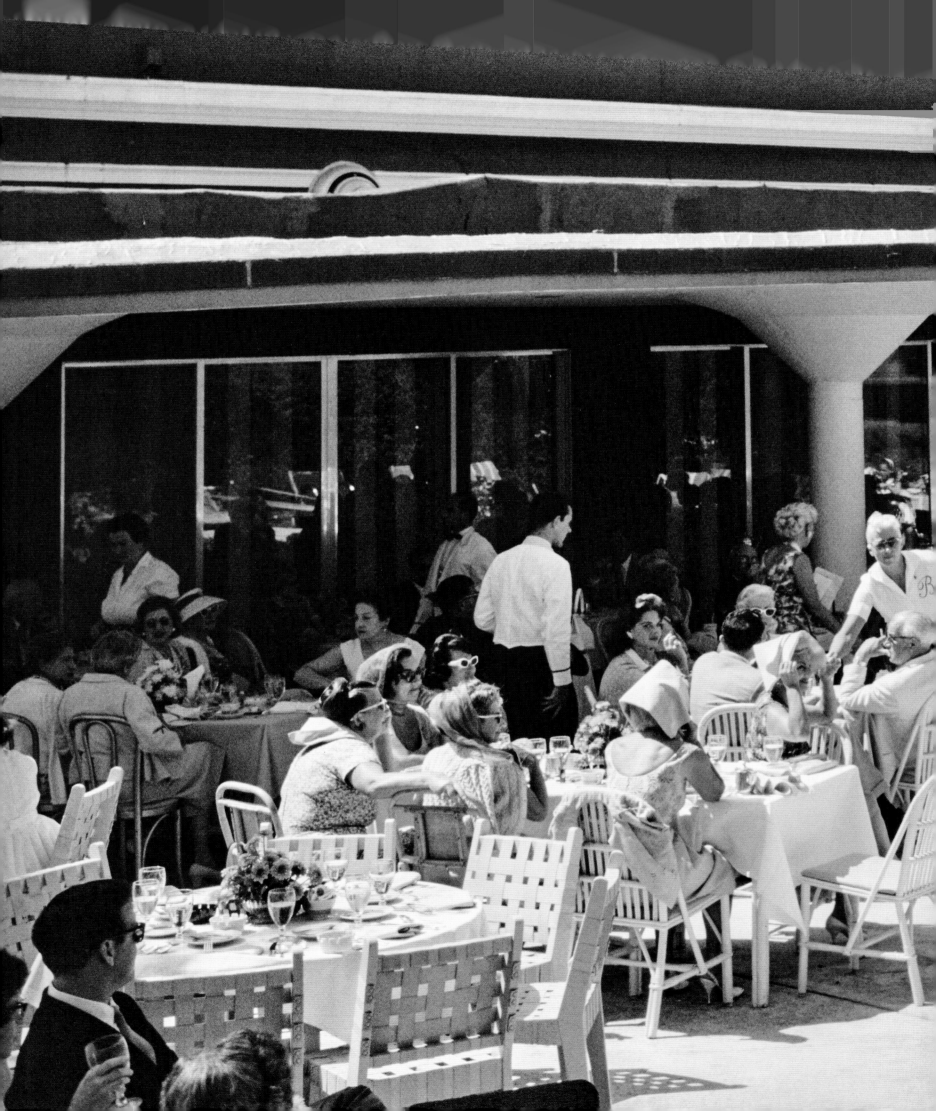

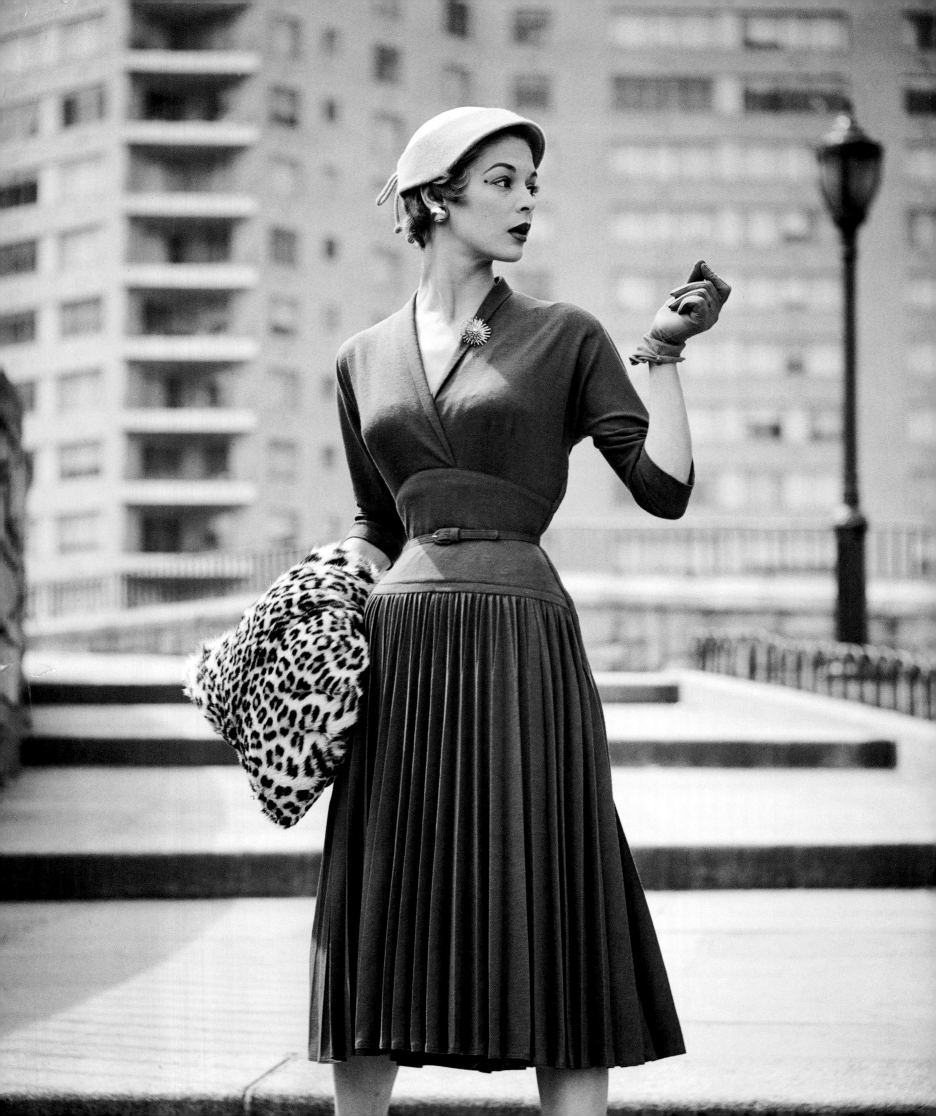

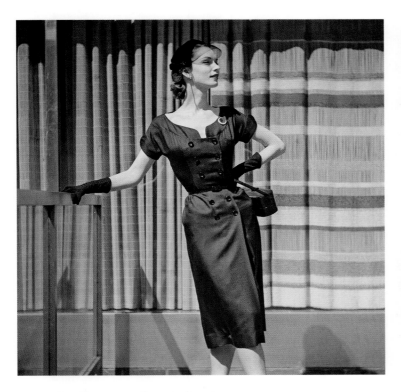
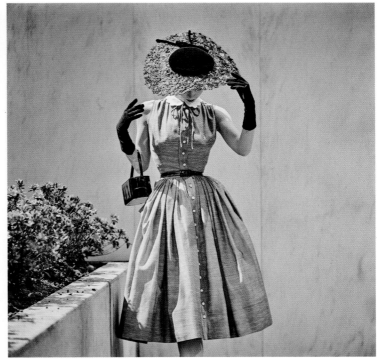
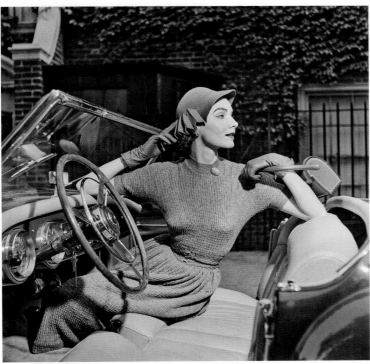
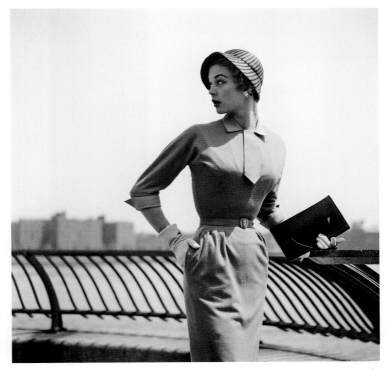

preceding spread Poolside fashion show at the Colony Hotel, Palm Beach, 1961.

opposite American model Jean Patchett for Saks Fifth Avenue, 1950s. Patchett was one of the first to join Eileen Ford's groundbreaking model agency in the late 1940s and became the face of fashion in the 1950s. Over a fifteen-year period, she appeared on more than forty magazine covers and in hundreds of editorial spreads, catalog shoots, and advertisements. She was responsible for launching two of the trends that defined the 1950s: the doe-eyed look and a well-placed beauty mark.

above Saks Fifth Avenue catalog shoot, 1950s.

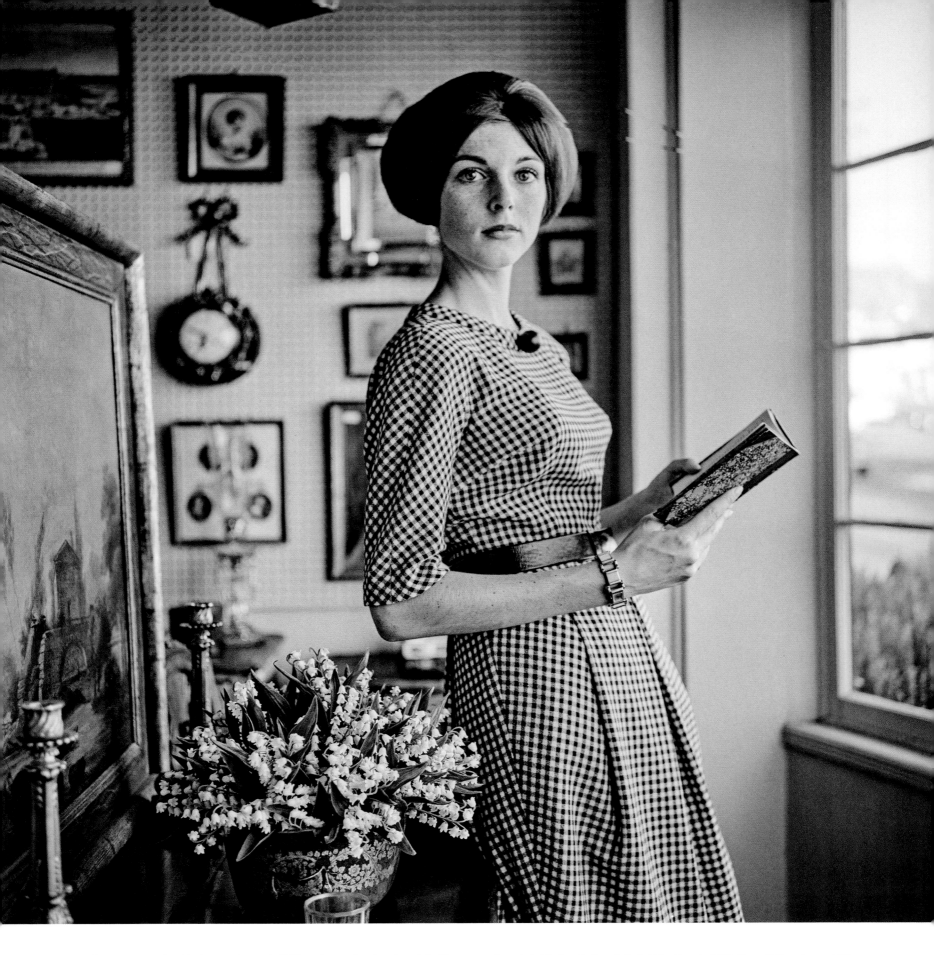

Slim photographed fashion in the early 1950s using professional models. The artifice did not appeal, however, and in the second half of the decade he transitioned to photographing the latest fashions on society women for *Harper's Bazaar* and *Town & Country*. He excelled at the setup which was his own unique hybrid of portrait and straight fashion. In 1960, *Town & Country* sent Slim to California for a fashion story featuring the next generation of Beverly Hills society, including Gwendolyn Warner, née Rowan, seen here in an antiques shop wearing a dress of lightweight black and white wool from Bellaine.

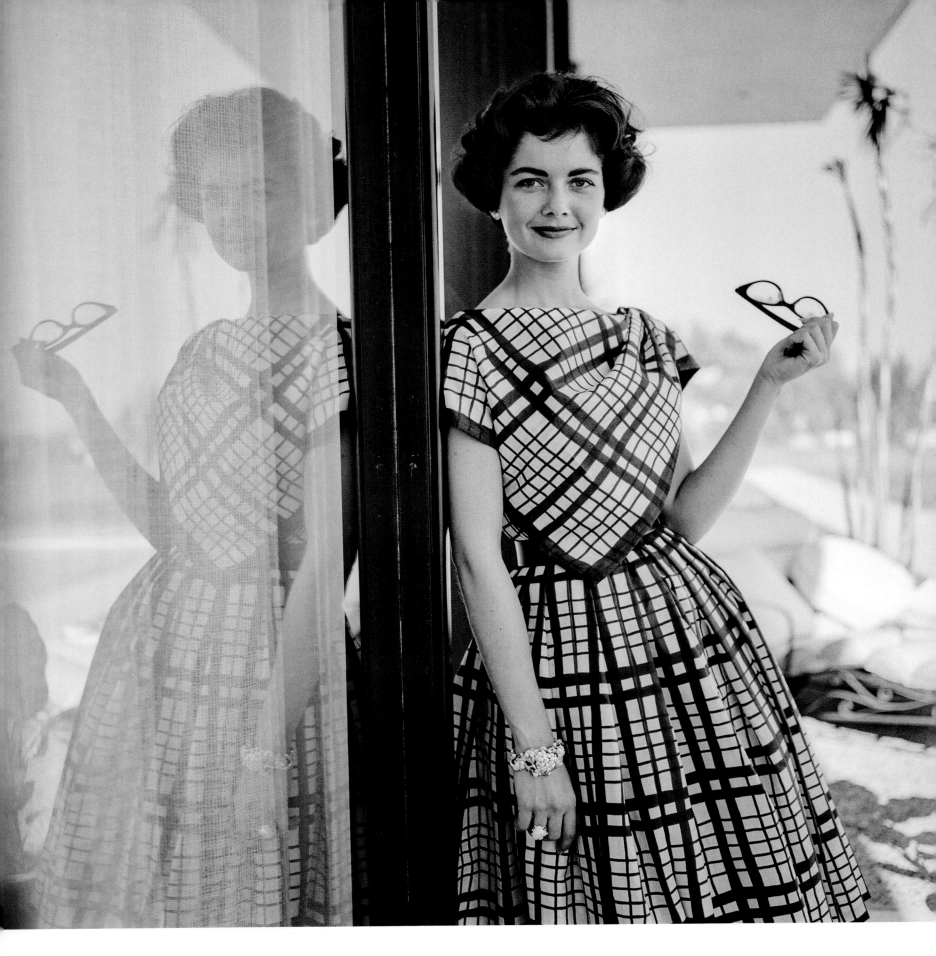

Pamela Johansing, later Pitts, posing at the Bel Air home of director Henry Hathaway wearing an afternoon dress by Paul Whitney made of silk plaid with scarf-draped bodice and soft-pleated skirt.

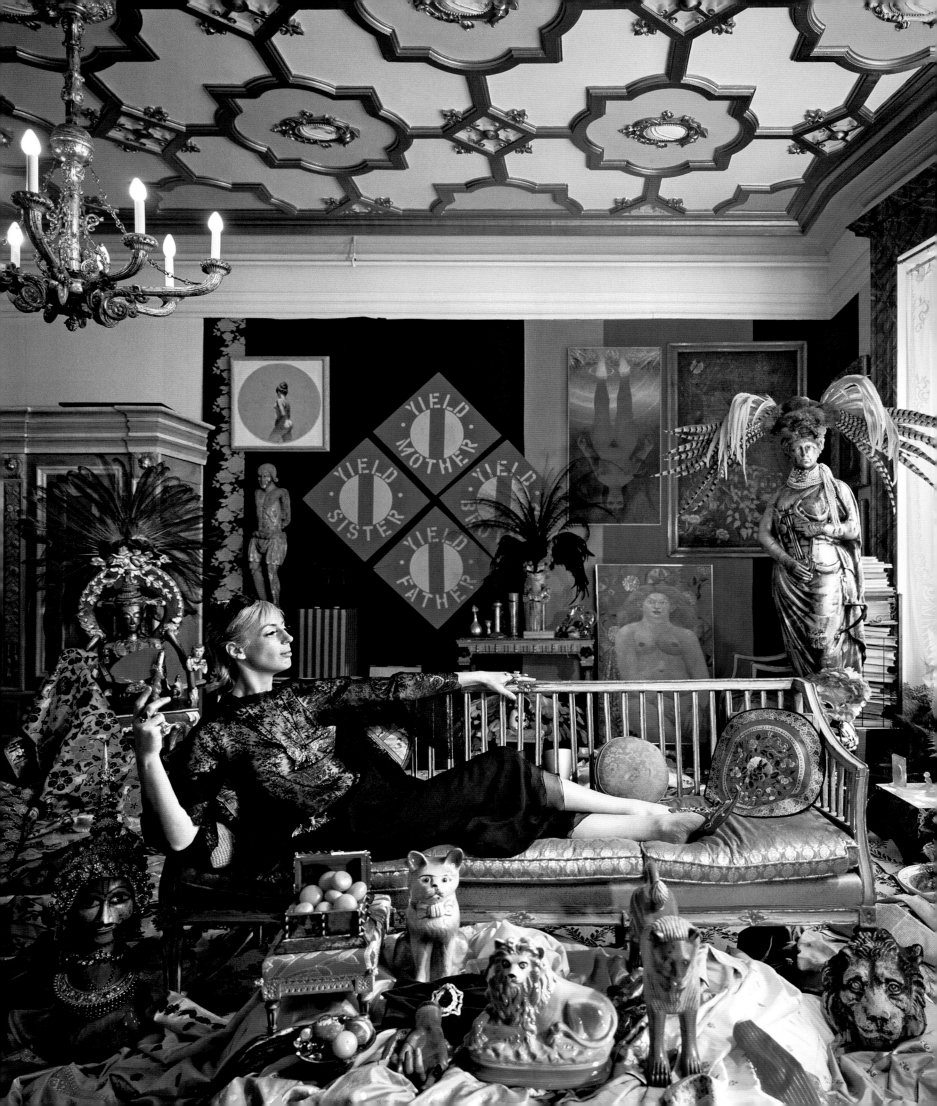

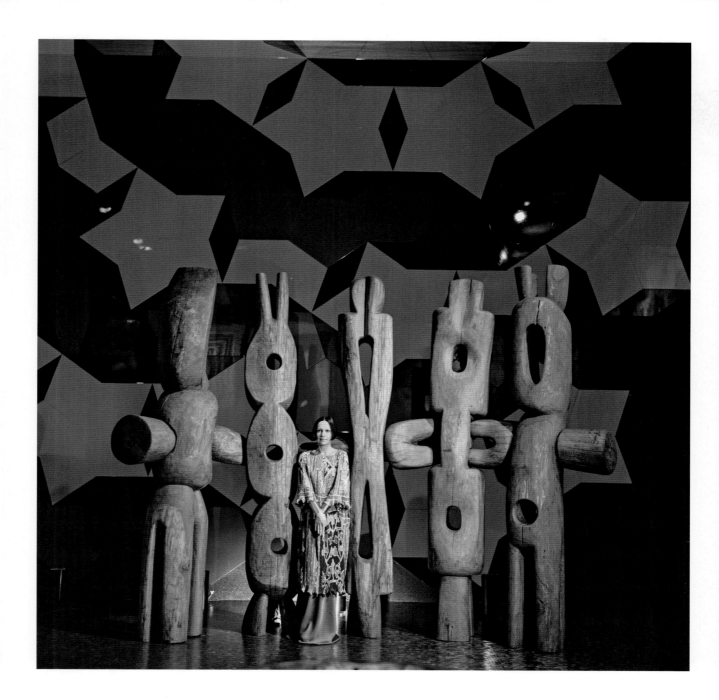

left Socialite and mod fashion designer Joan "Tiger" Morse, in the A La Carte shop, New York City, 1964. In the 1960s, Morse opened a Madison Avenue pop boutique called Teeny Weeny that offered illuminated minidresses powered by a small battery pack worn at the waist. A mainstay of the New York underground scene, she delivered a 33-minute-long, amphetamine-fueled, freewheeling monologue in Andy Warhol's film *Tiger Morse (Reel 14 of ****)*.

above Iconoclastic editor, fashion designer, art collector, and entrepreneur Mary McFadden wearing a hand-painted silk tunic of her own design in 1976, one year after she launched her eponymous fashion brand. She is standing among pieces in the private museum of noted patron and philanthropist J. Patrick Lannan, Sr., in Lake Charles, Florida. McFadden was curator of the museum and director of the Lannan Foundation. The wood sculptures are by Romanian artist Gheorghe Iliescu-Calinesti.

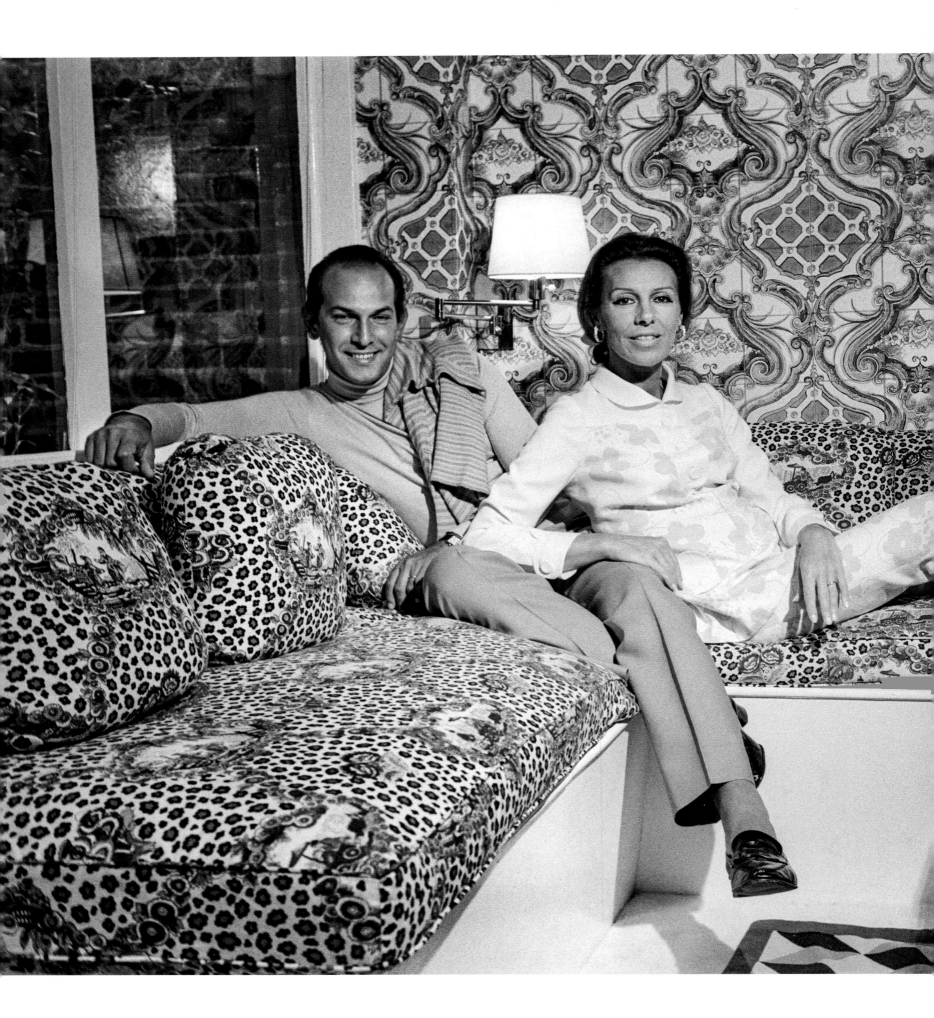

Style at Home

Over the course of his career, Aarons photographed many fashion designers in their homes—Gianni Versace at his house in Lake Como, Emilio Pucci at the family's Florentine palazzo, Oscar de la Renta at his Connecticut estate. In typical Aarons style, the surrounding environment in each image tells as much about the designer as any dress or suit ever could.

In many ways de la Renta and his first wife, Françoise de Langlade, were the perfect subjects for Aarons. Both stylish and curious, the couple were known for their entertaining panache and worldly allure. They also embraced the idea of becoming tastemakers, unafraid to open up their homes to the press and take advantage of every opportunity to be featured in magazines like *Town & Country*, often lounging in one of their beautifully designed homes in the Dominican Republic, Kent, Connecticut, or in their apartment overlooking Central Park.

Although she was not officially employed by her husband, de Langlade proved to be an intangible asset to de la Renta. As a *Vogue* editor—first in Paris, then later in New York—she helped to introduce her husband to international society, elevating his profile and that of his business. She was passionate about her friends and about welcoming the worlds of fashion, art, and politics into her home. Often she would throw two dinner parties in one week during the high social season, inviting an eclectic crowd of artists, socialites, politicians, and fashion designers. Together the de la Rentas looked and felt most at ease at home, where they loved to garden and to cook. Aarons, with his charm and social facility, was able to access their private homes on several occasions, and his image here perfectly evokes the de la Rentas' luxurious but casual style.

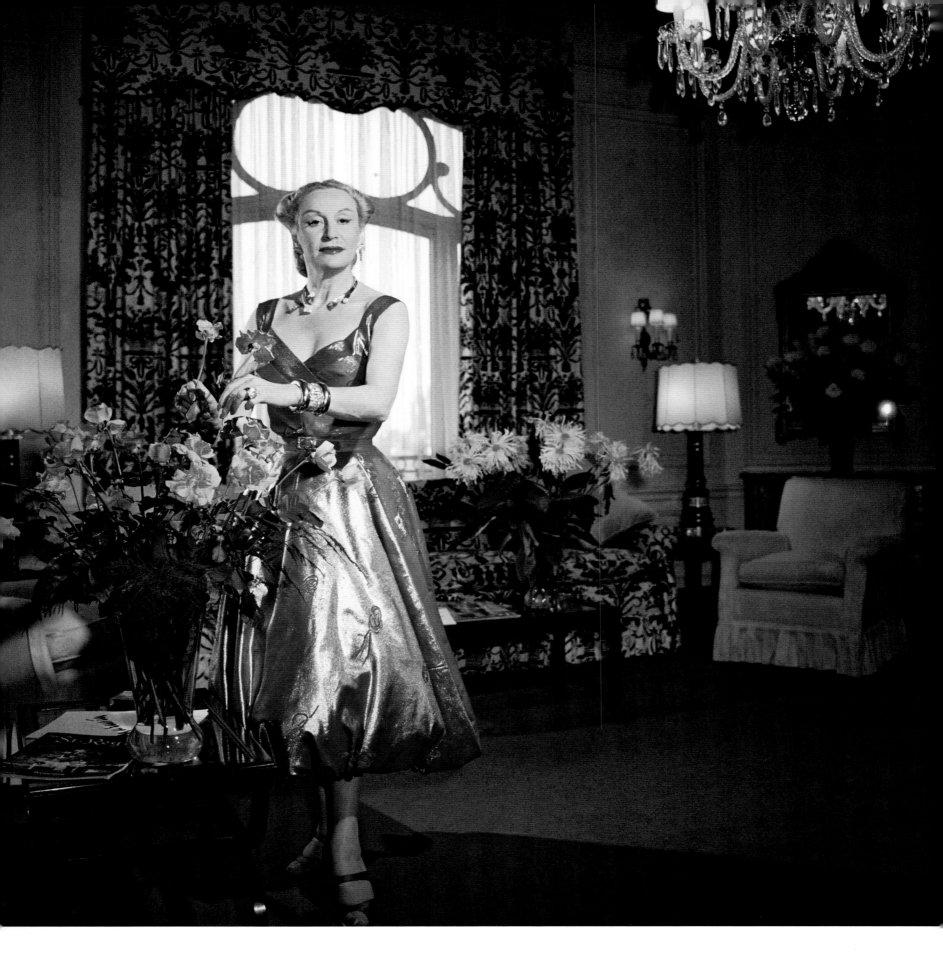

Mariusa Toumanoff Sassi, costume and dress designer for actresses of the stage and screen, in her suite at the St. Regis, 1950s. Polish born, she was one of the first foreign designers to set up a boutique in Hollywood and cater to the industry. Mariusa, as her label was known, dressed Rosalind Russell, Doris Day, Loretta Young, and Lili St. Cyr, among others. Besides being a successful businesswoman and a regular of mid-century gossip columns, she was also a champion backgammon player.

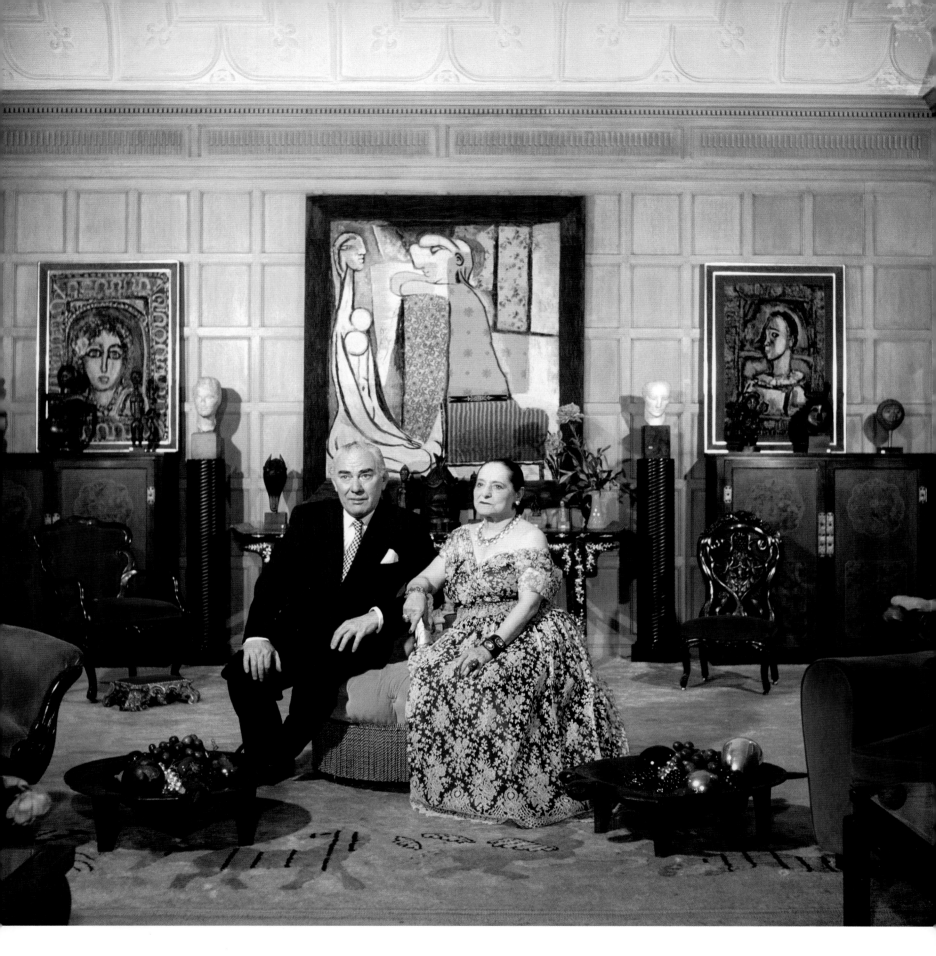

Prince and Princess Artchil Gourielli in their New York apartment, 1955. The princess, better known as cosmetics entrepreneur Helena Rubinstein, was one of the world's richest women and the first self-made female millionaire.

The couple's Park Avenue triplex had twenty-six rooms with ten baths and held their collection of Impressionist and Modern art. The tapestry behind them is by Picasso, and the two paintings are by Georges Rouault.

left Italian designer Gianni Versace in a study of Villa Fontanelle, his treasured seventeenth-century home on Lake Como, Italy, 1983. Versace purchased the neglected four-story building in 1977 and spent three years restoring it.

right Versace and Lalla Spagnol on Lake Como. Villa Fontanelle can be seen in the background.

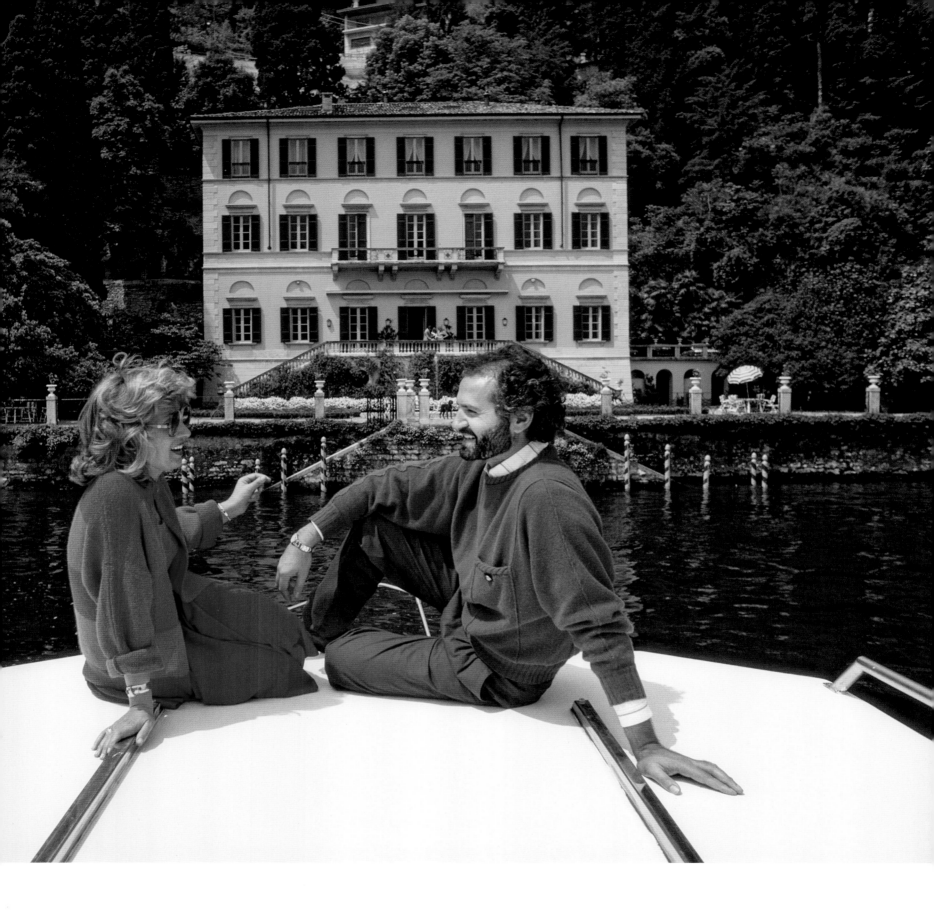

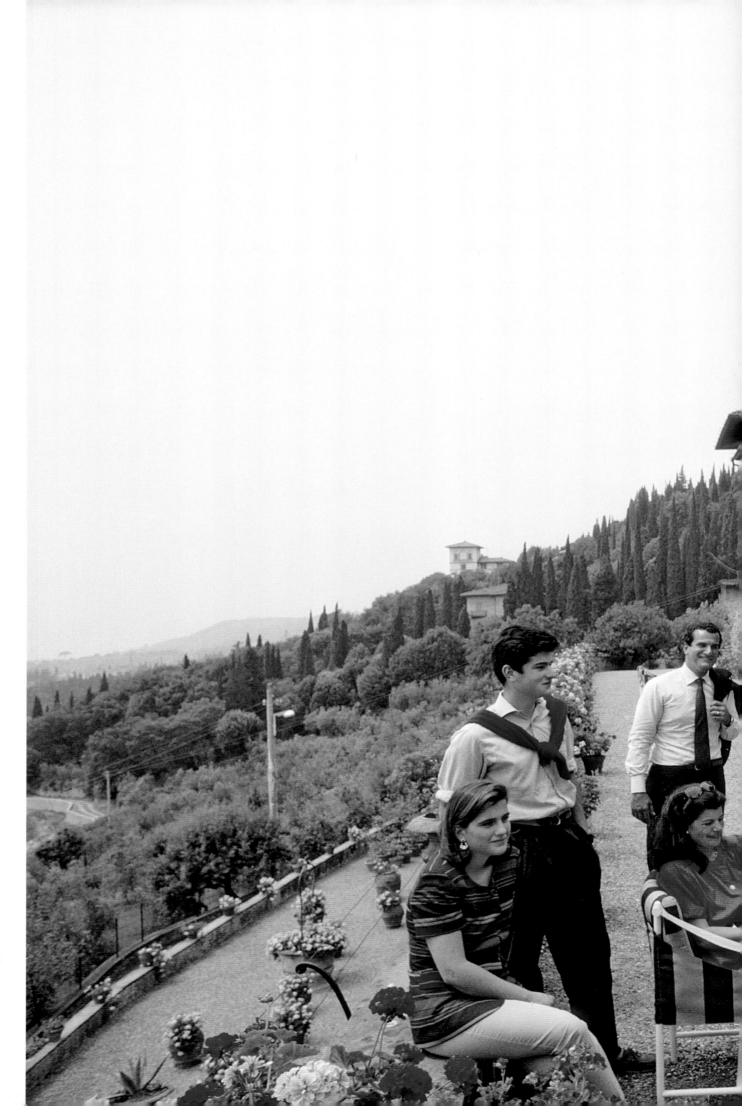

Members of the Ferragamo family on the terrace of their Tuscan estate, 1991. After Salvatore Ferragamo died in 1960, his wife, Wanda, and their six children took over and expanded the operation of his shoe dynasty.

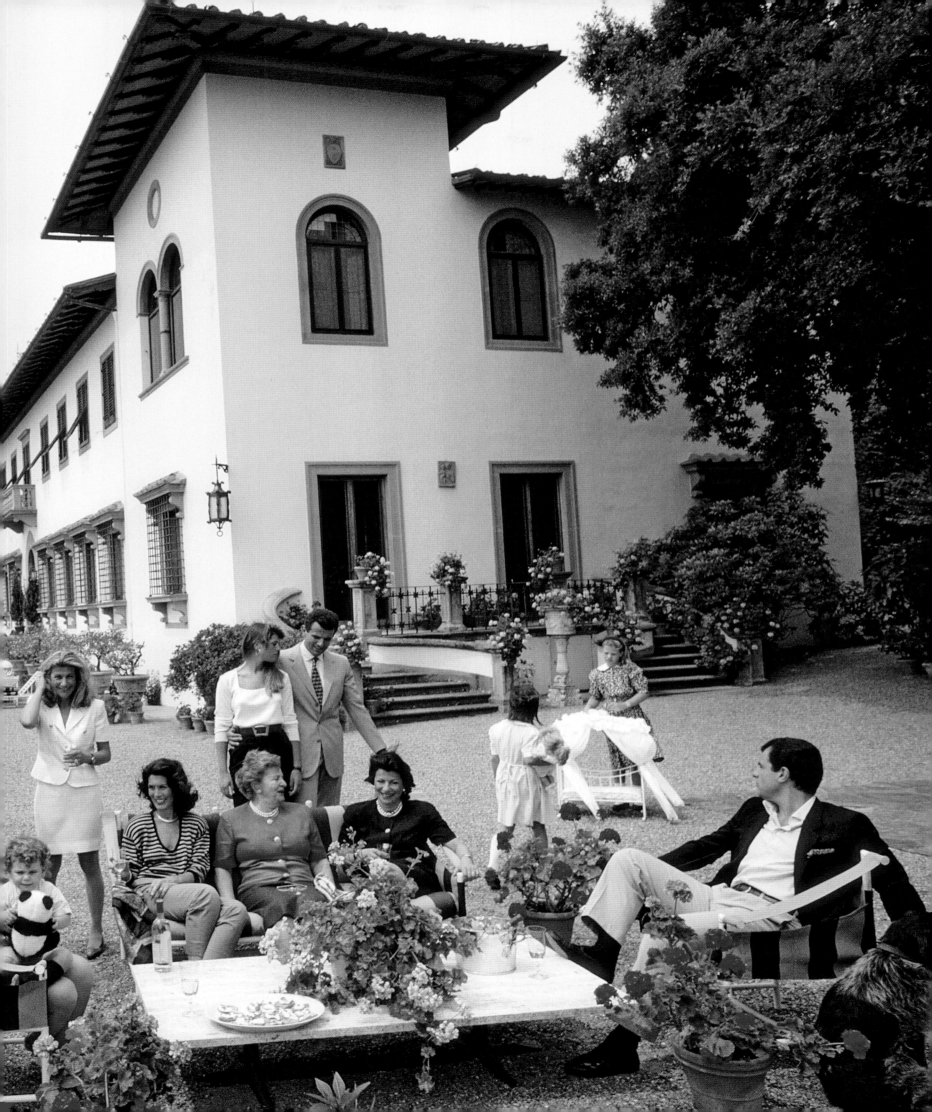

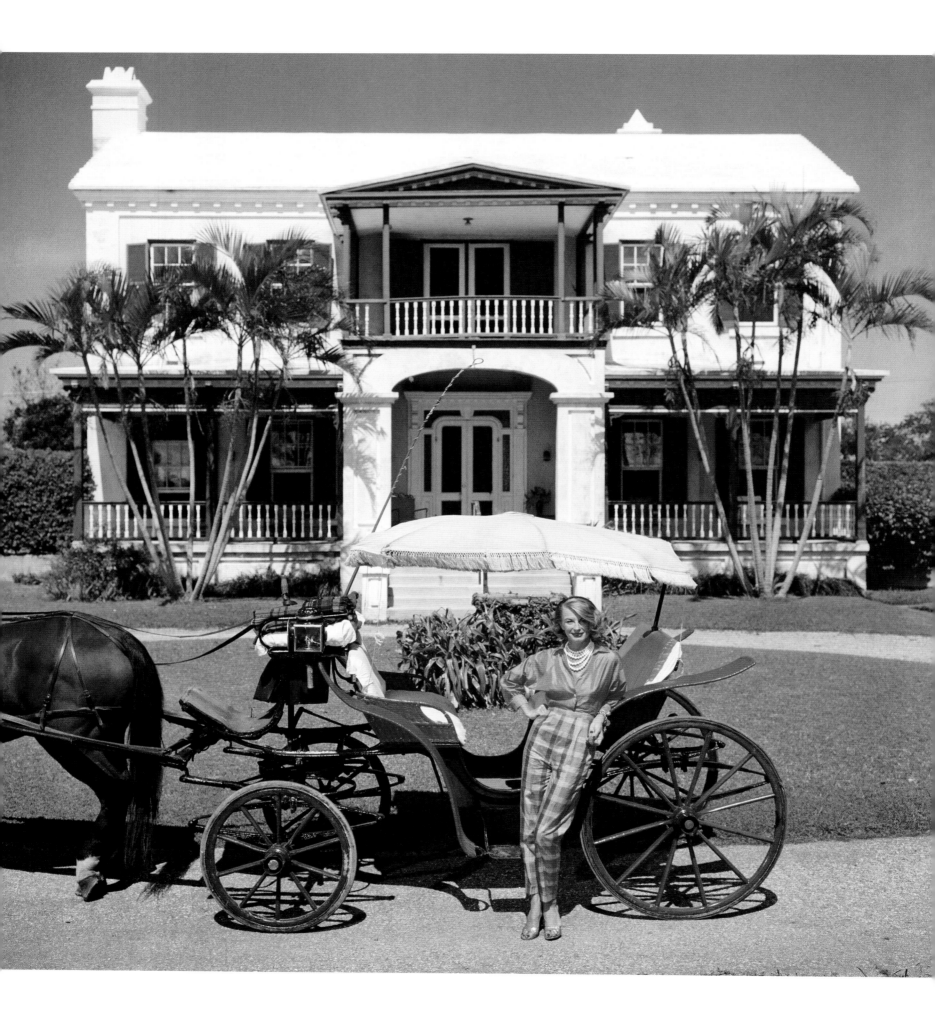

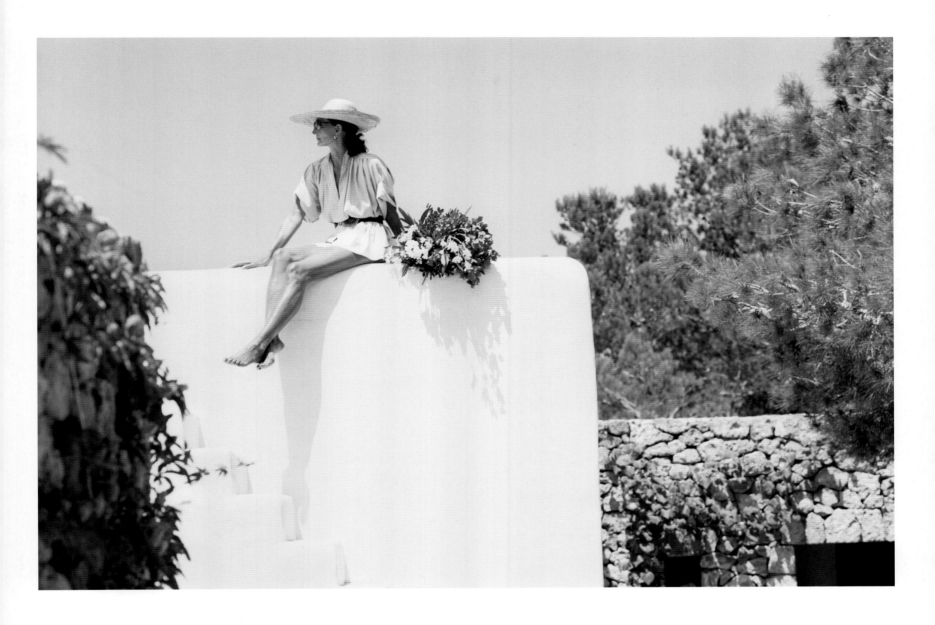

opposite Polly Trott Hornburg wears Thaibok slacks and a shirt of her own design outside of Girvan, her family's nineteenth-century mansion, Bermuda, 1957. Born and educated on the island, she attended college at Briarcliff and remained in the US and worked as a model and stylist. After returning to Bermuda, she ordered a bale of brightly colored African cotton and set about turning the fabric into new designs. Her first retail shop, Calypso, was set up in the gatehouse of Girvan. By 1957, the Calypso line had expanded to boutiques and department stores on Jamaica and in the US.

above Vicomtesse Jacqueline de Ribes poses at her home in Ibiza, 1978. The vicomtesse's idiosyncratic style and flair for the dramatic have proven irresistible to the world's fashion elite for more than half a century. Charles de Beistegui, Diana Vreeland, Richard Avedon, and Oleg Cassini all fell under her spell—and that was just in the 1950s. De Ribes first visited Ibiza in 1968 and was immediately enchanted. In 1982, against advice from her close friend Yves Saint Laurent, she realized a lifelong dream and launched her own fashion line.

The Heiress

The debutante's gaze was one of Aarons's favorite subjects, particularly in the provinces of New York City's Park Avenue duplexes and Palm Beach's oceanfront mansions. As the writer and critic Janet Malcolm once wrote: "If you scratch a photograph you find two things: a painting and a photograph." This 1959 portrait of Standard Oil heiress Peggy Bancroft in the foyer of her grand apartment at 740 Park Avenue is alluring for the way Aarons framed it, like a painting with natural light pouring in through a window. At first it appears like any formal society portrait, set up with the most elaborate signifiers in plain view: the stairway, the chandelier, and the socialite's elaborately embroidered Balmain gown. The style is quintessential high society. And yet, a closer look reveals the youthful tentativeness of Bancroft, her shy gaze, her carefully poised hands. She is too young for her environs, and something about this mysterious juxtaposition creates intrigue.

The singular image represents so many facets of Aarons's style—from the pulled-back perspective to the private, intimate setting, the glamorous socialite subject, and the iconic, enduring style of the image. But mostly it is the way in which the photographer carefully draws the viewer into the photo and then reveals a truth, something not quite right. Peggy had purchased this grand apartment at the age of twenty-three, against her husband's wishes. She had her own resources, which, in addition to her great beauty, made her a fascinating subject to the press.

Peggy's serene appearance in this photo belies a restless and risky spirit. Named one of the "debs of the year" at her coming-out in 1950, she would have a remarkable life, entertaining grandly as the reigning hostess of New York's social set through the 1960s. Her husband, Thomas Bancroft, Jr., was not interested in society or maintaining a high profile, but Peggy did what she wanted. She appeared in *Life* magazine getting her hair done at home by the iconic hairdresser Kenneth. And she traveled widely, from Paris to Nepal to Tahiti. She hosted opulent parties, once famously renting an elephant to feature in her Park Avenue pad. And she was said to have introduced the twist to Maxim's in 1960 in Paris, where she had moved after she divorced her first husband and married a French prince twenty-seven years her senior.

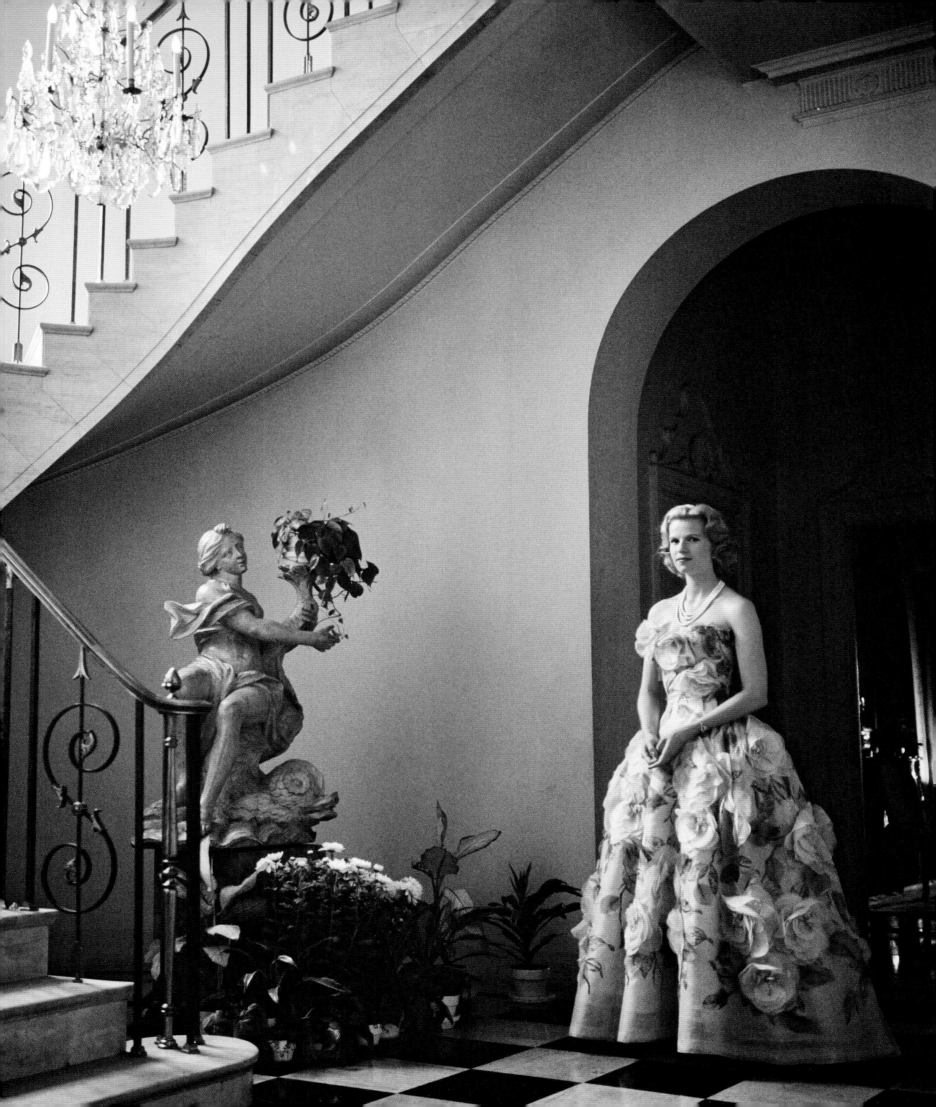

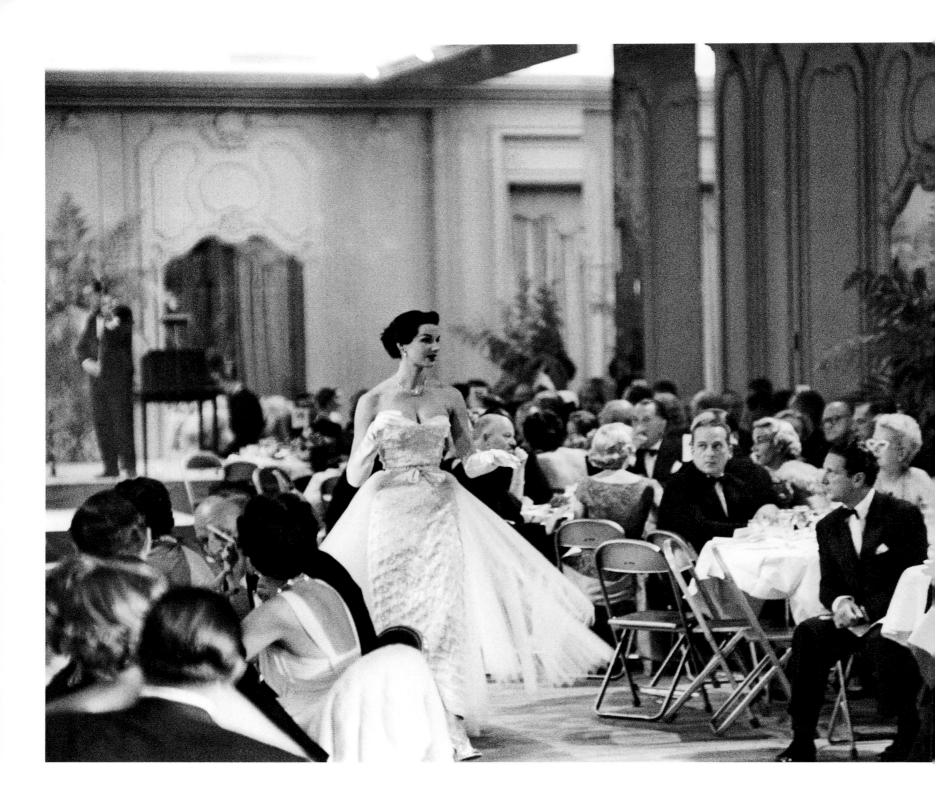

above An evening gown presentation during a New York gala sponsored by Saks Fifth Avenue, 1955.

opposite Mrs. Edward "Nellie" Magnus, part-time resident of Palm Beach and full-time member of the Anheuser-Busch dynasty, views the latest designs with her daughter at the Worth Avenue branch of Saks Fifth Avenue, 1953.

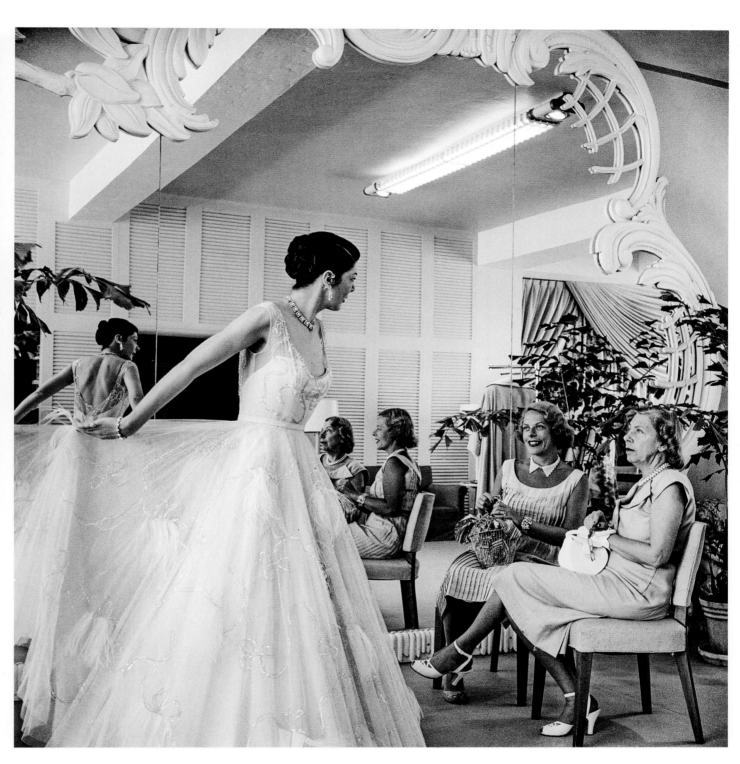

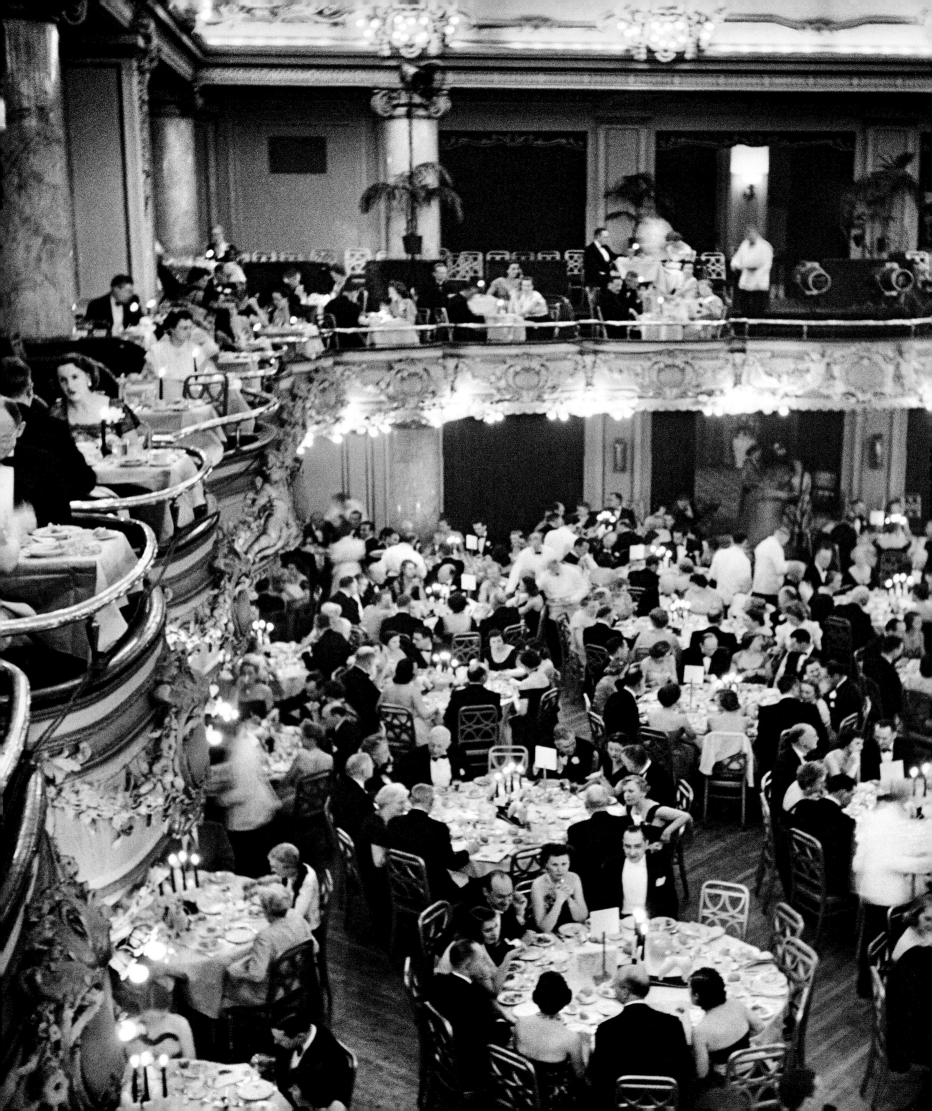

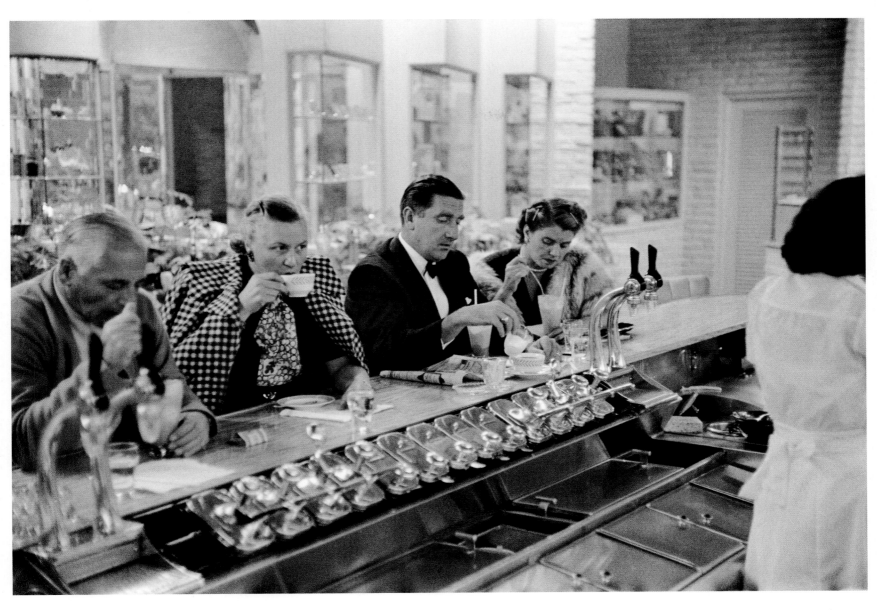

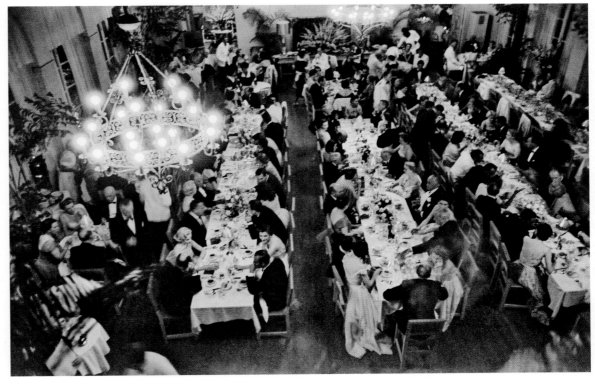

opposite Diners waiting for a fashion show to begin during a New York charity gala, c. 1955.

above Prince and Princess Alexis Obolensky having coffee and milkshakes at a Palm Beach drugstore counter after an evening out, 1953. The prince was a tireless promoter of backgammon throughout the 1960s and '70s.

right Attendees at a Palm Beach gala, c. 1953.

following spread left Jackie Kennedy at the April in Paris Ball, New York, 1958.

following spread right Partygoers at the Le Bal Blanc Gala at the St. Regis, New York, 1969.

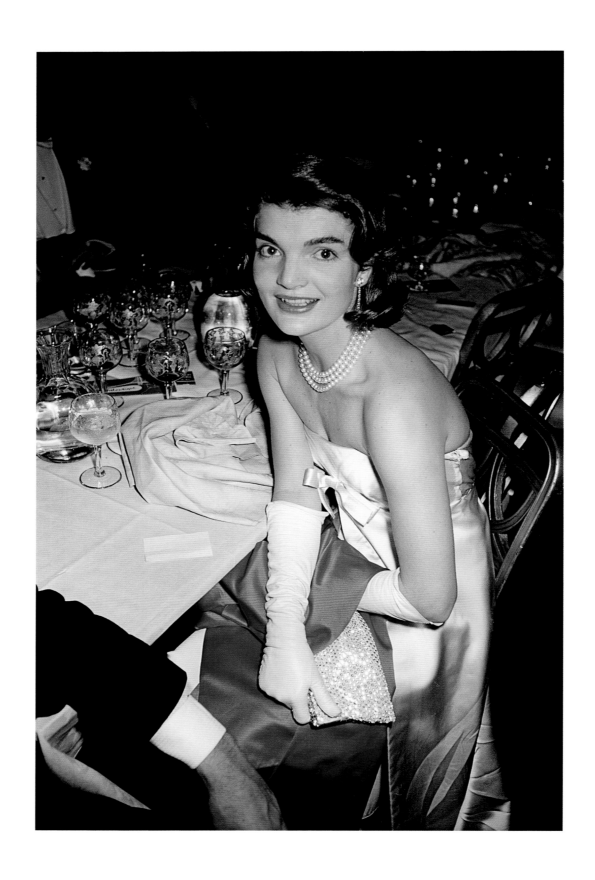

"The images Slim shot look timeless today
because the focus is on the person and their
style—and ultimately that is what endures."

—MICHAEL KORS

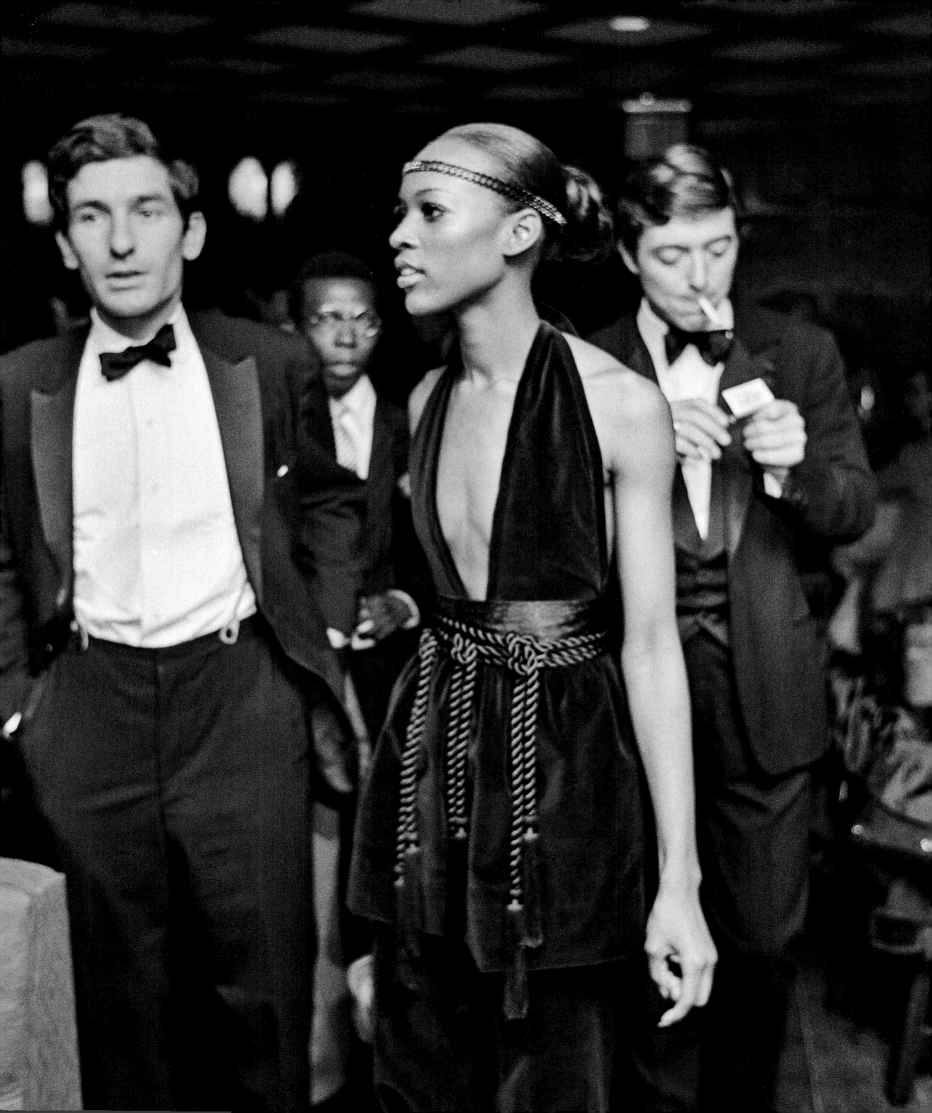

left Prince Serge Obolensky and the Duchess of Feria, Nati Abascal, during the Le Bal Blanc Gala at the St. Regis, 1969. Obolensky, born a Russian prince, was twice divorced; first from a daughter of the tsar and later from Alice Astor, daughter of John Jacob IV. In the 1930s, Obolensky was hired by former brother-in-law Vincent Astor to restore the St. Regis to its former glory. A favorite party trick involved a tabletop dance with six daggers in his mouth. He is also rumored to have had a hand in the creation of the Bloody Mary in the hotel's King Cole Bar. Abascal has been included on the International Best-Dressed List since 1984. The list was created by fashion publicist Eleanor Lambert in 1940 and remained under her control until 2002, when she passed the baton to *Vanity Fair*.

opposite Salvador Dalí at a New York charity gala, late 1950s.

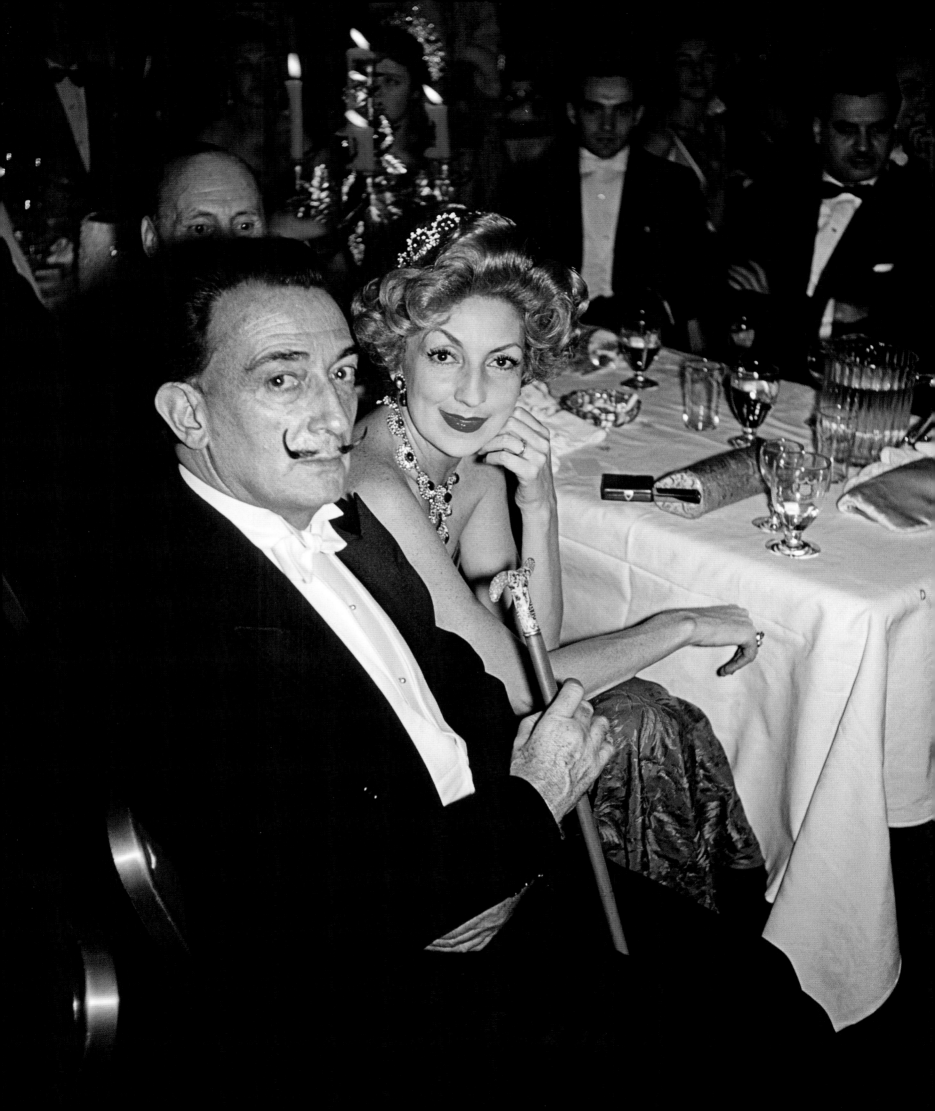

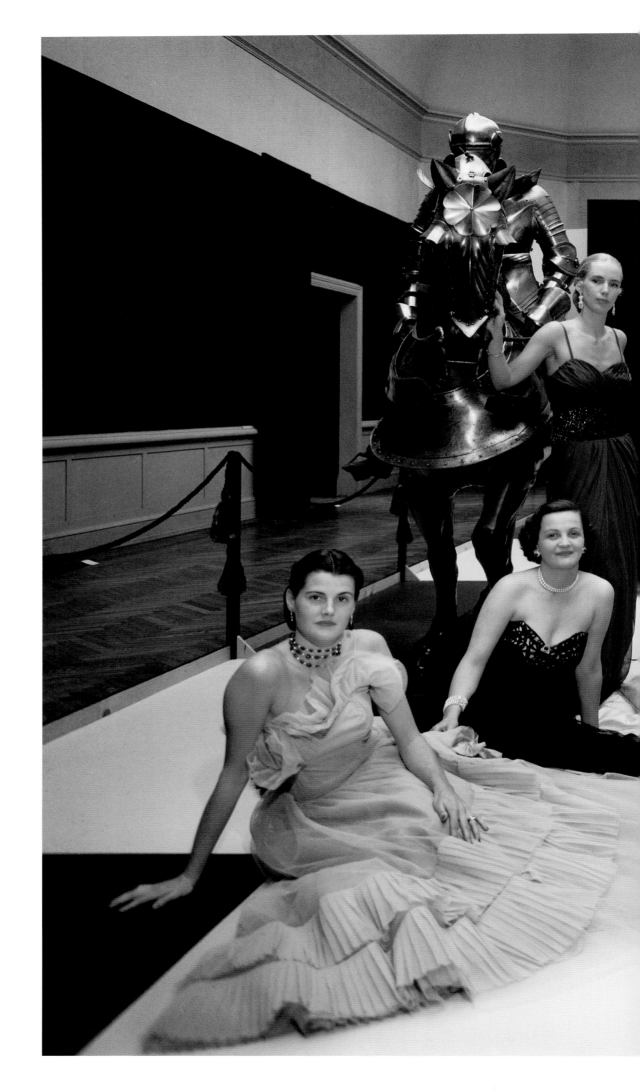

From left: Mrs. Charles de Limur (the former Eleanor Walsh); Mrs. Ferdinand Stent (Yvonne Theiriot); Mrs. Robert Folger Miller (Lori Wurmbrandt), standing; Mrs. William Wallace Mein, Jr. (Sarah M. Nickel); Countess Marc de Tristan (Jane Christenson); Mrs. Edwin M. Wilson (Adrienne Fuller), standing; Mrs. Christian de Guigné (Eleanor Christenson); Mrs. Paul A. Miller (Edmona Lyman); Mrs. Abbott Robertson, Jr. (Roxanna Dabney), San Francisco, 1953. The group, which *Holiday* described as nine of the handsomest entries in San Francisco's Blue Book, pose in the former California Palace of the Legion of Honor, now a part of the Fine Arts Museum.

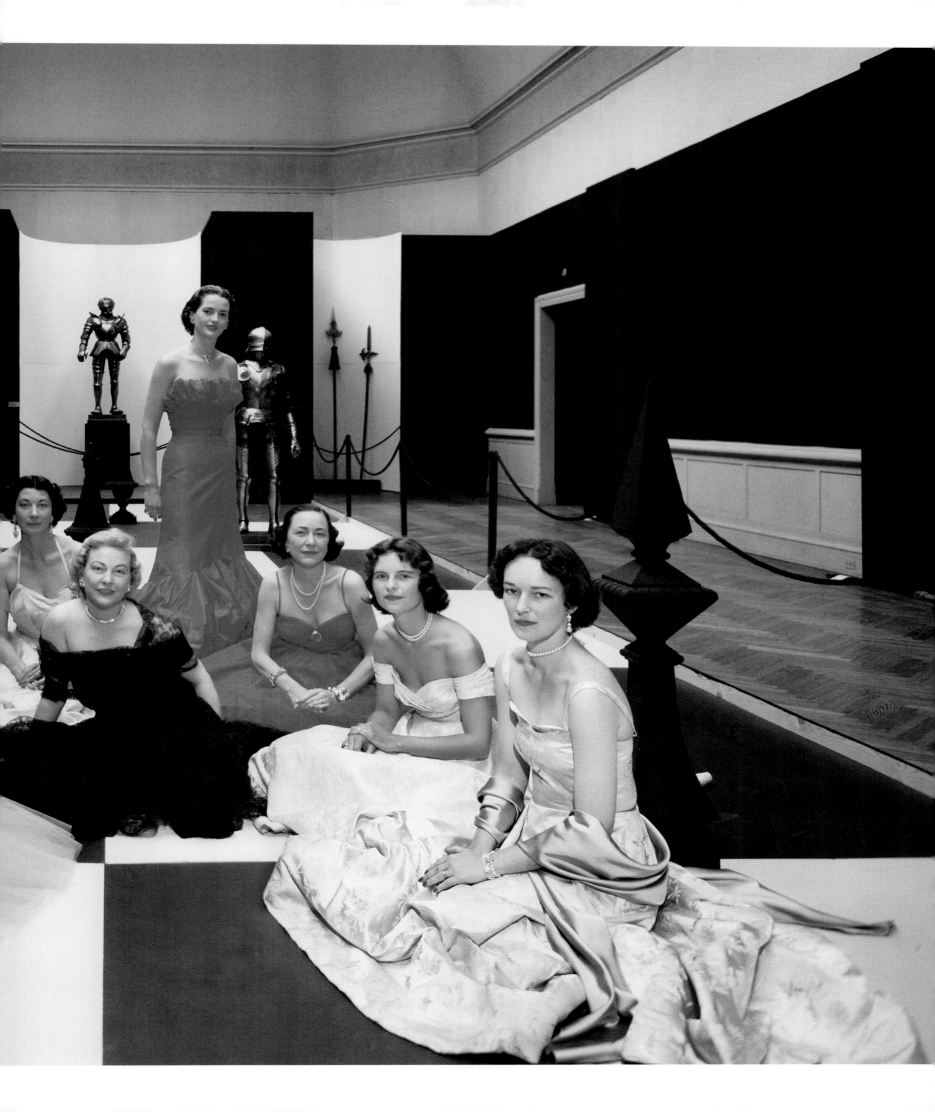

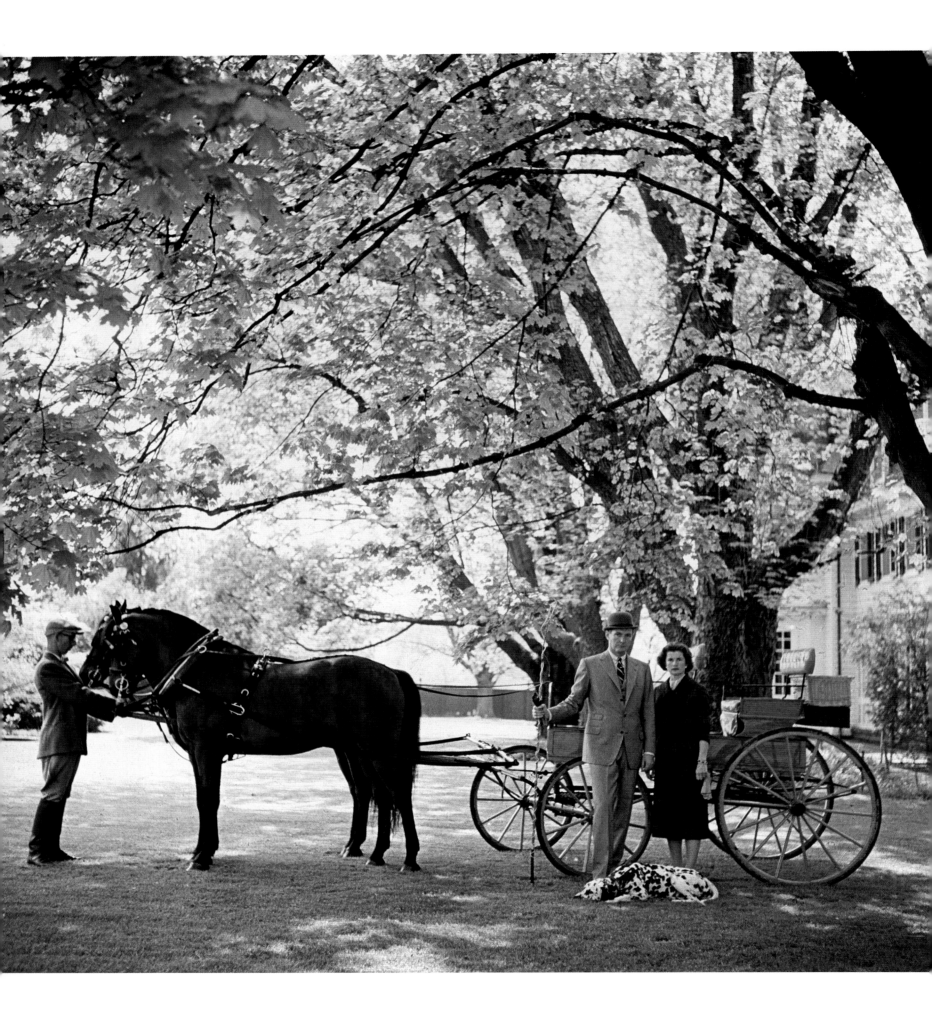

The Image Maker

If style is a construct, then this environmental shot of John M. Seabrook and his wife, Elizabeth, on the family's estate in southern New Jersey is a perfect example of the way Aarons composed his photographs. Even when they appear to be completely natural, not every Aarons picture was. In many instances, serious consideration went into creating a balanced composition and a sense of genteel perfection. This image, which was originally taken to illustrate a Roger Angell piece in *Holiday* magazine in the fall of 1958 titled "The Effete East," depicts the Seabrooks in their well-cut suits, standing in front of a nineteenth-century horse-drawn carriage, their Dalmatian lounging at their feet.

"It was a cherished picture of my dad's," says John Seabrook, the subject's son, who remembers his father telling him how he had carefully set up the photograph for Aarons in order to demonstrate his ease in front of the camera. Seabrook, who was a collector of horse-drawn carriages and a member of the British Coaching Club and a founding member of the Carriage Association of America, was also keen to display the trappings of East Coast establishment on his family's estate.

"He somehow hooked it up. It's kind of hilarious that my mother at that point was less than two years removed from her job as a UP reporter and, far from the Effete East, was a prairie girl from Spearfish, South Dakota. And my father was hardly an aristocrat either. It was mostly smoke and mirrors. All that horse and carriage stuff was my father's invention."

Seabrook's angle worked: Their photo was featured prominently on the opening spread of Angell's story. And Seabrook's father, a Princeton man, officially became one of the Effete Easterners found in the story and described as "faintly condescending, a mite preoccupied with money, a little too glib in talking about the latest books or plays, or the tiniest bit too self-assured." But he was also enthralled with photography and image-making. "My dad curated his life through images long before Instagram," his son explains. "And the camera loved him. It was mutual. He looked at the camera with a kind of rapt attention he never bestowed on us. It was a long love affair."

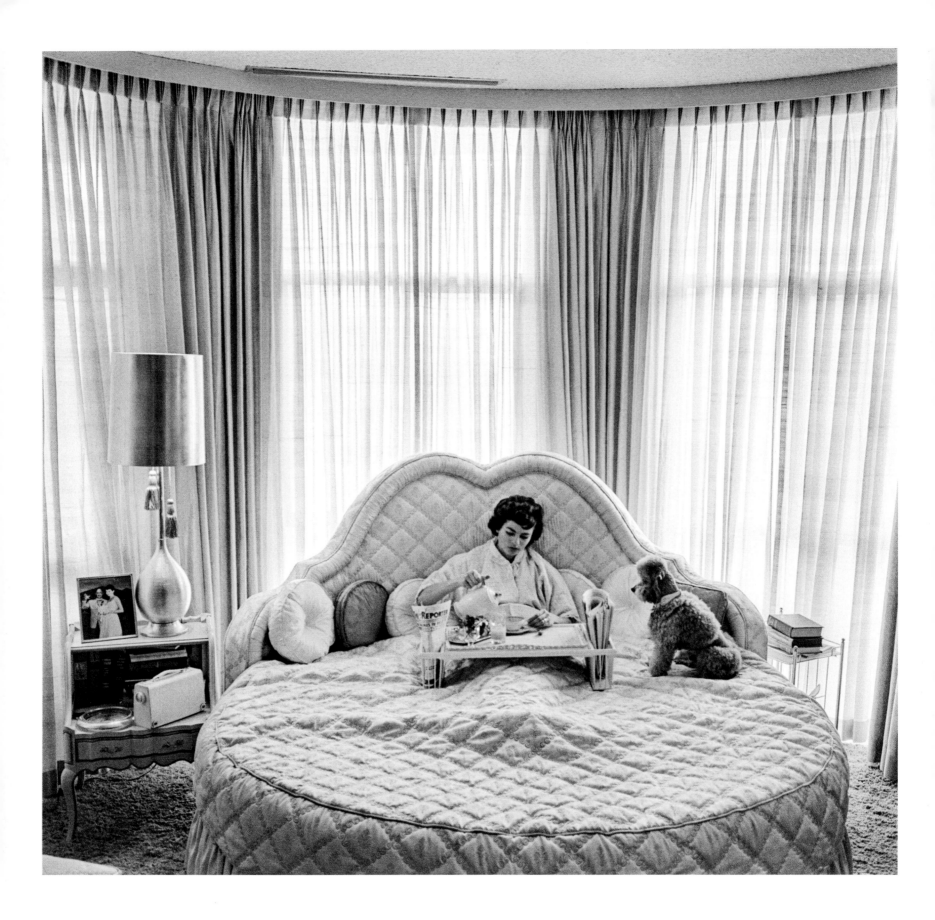

above Actress Eden Hartford, sister to Dee, in the Hollywood home she shared with her husband, comedian Groucho Marx, 1954. The contact sheets from this shoot show Slim and Eden working together to create the perfect image of domestic bliss. The camera never moves, but Eden appears above and below the covers, with and without the breakfast tray, at first in her robe and then a day dress. At one point Groucho appears and plays the role of the doting husband for a few snaps. The frame seen here has never been published.

opposite Film star Joan Collins is pretty in pink, 1955.

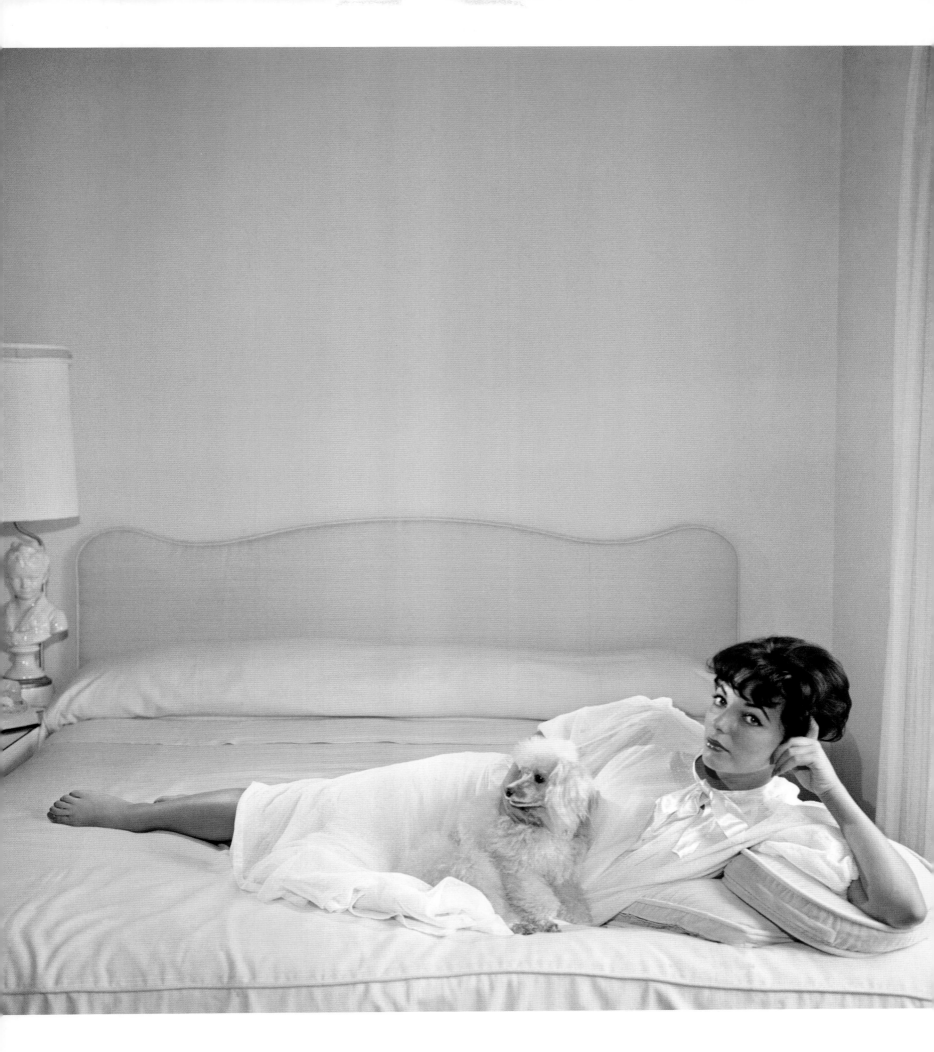

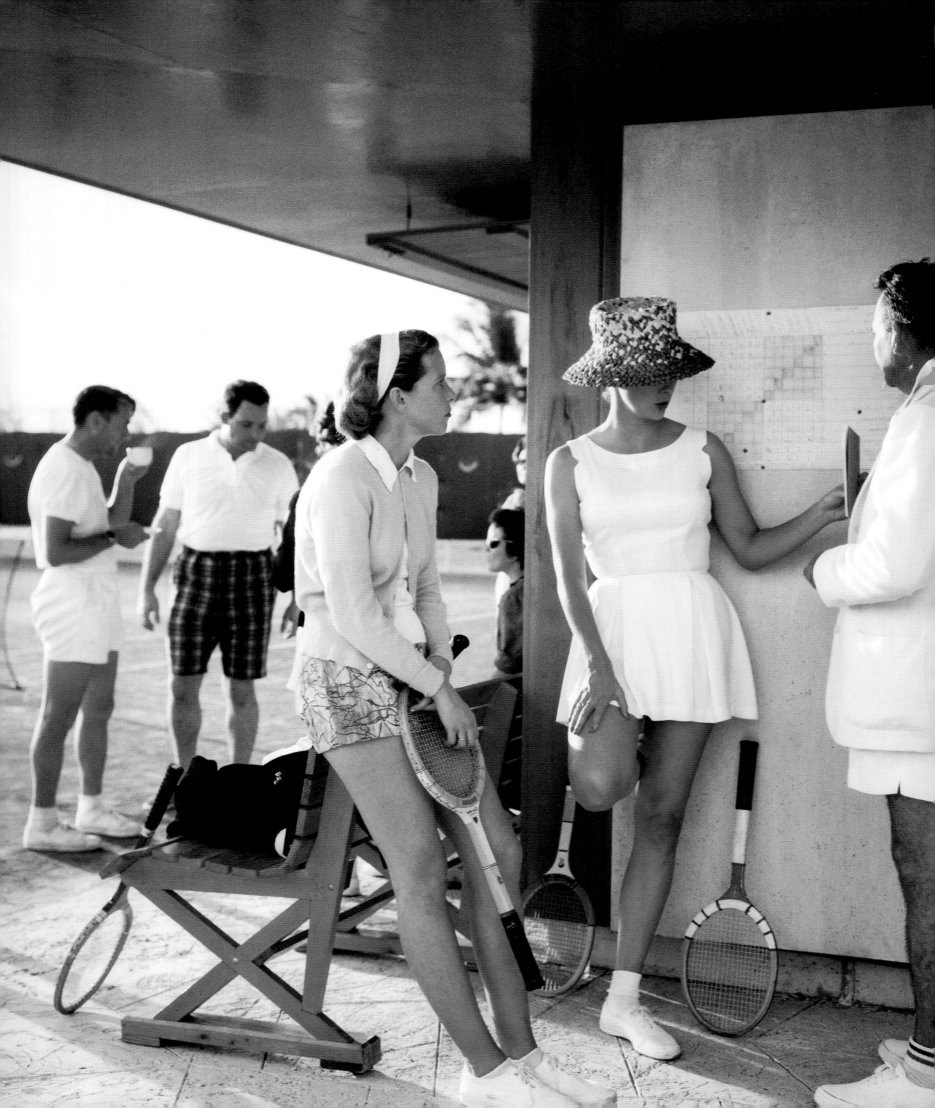

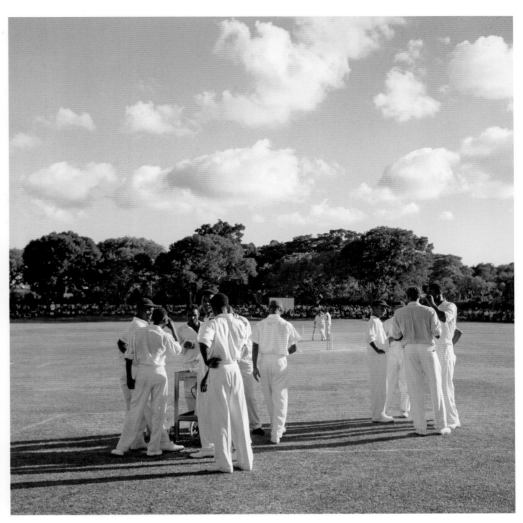

opposite Tennis in the Bahamas, 1957.

above left Traditional croquet attire, including a pair of Bermuda shorts worn with high socks, 1970. As with many informal menswear trends, the famed shorts have military origins, in this case the British army's tropical weather uniform.

above right Cricketers on the field during a match between the Leeward Islands and the Marylebone Cricket Club (MCC), Antigua, West Indies, 1960. The traditional all-white uniform evolved in the nineteenth century as players adopted the color for its reflective properties.

right Elderly men playing bowls, London, 1955.

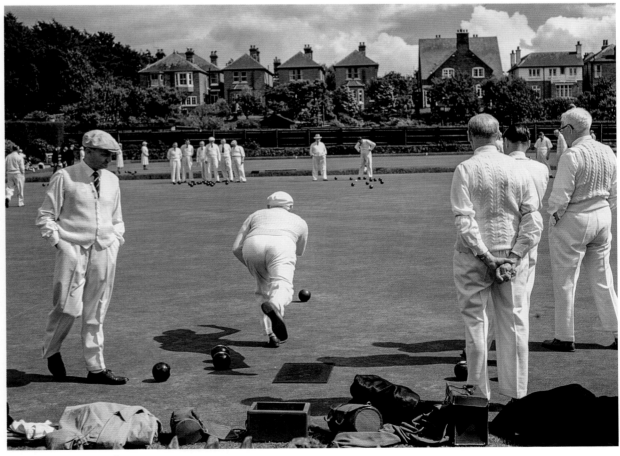

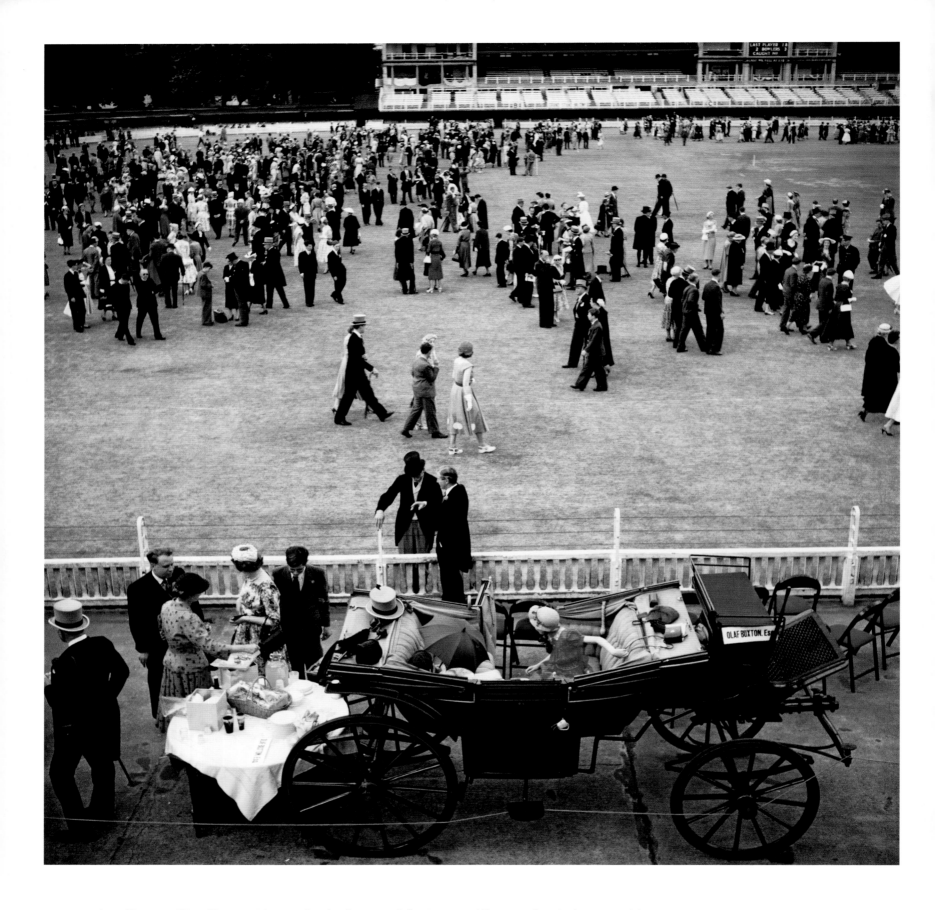

above The annual Eton-Harrow cricket match at Lord's, 1955. The match, which dates to 1805, was the sartorial and social pinnacle of the English season.

opposite The Cricket XI team of the St. George's Dinghy and Sports Club, Bermuda, 1957.

following spread Crew members in their rowing blazers at the Henley Regatta at Henley-on-Thames, 1955. Rowing and the sartorial term "blazers" are intrinsically linked: The term's origins can be traced to the bright red jackets of the Lady Margaret Boat Club of 1825. The coats, brightly colored in order to help fans identify the team on the water, were said to be a "blazing red."

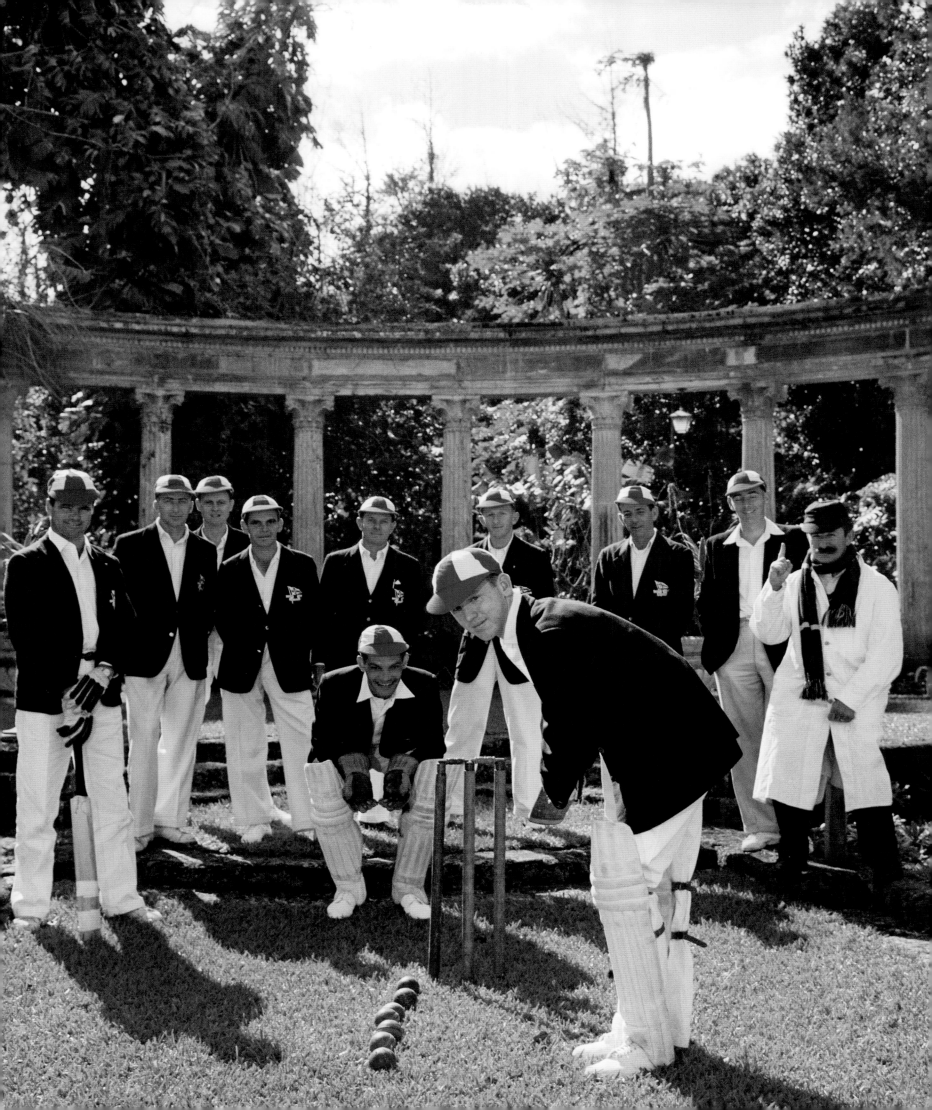

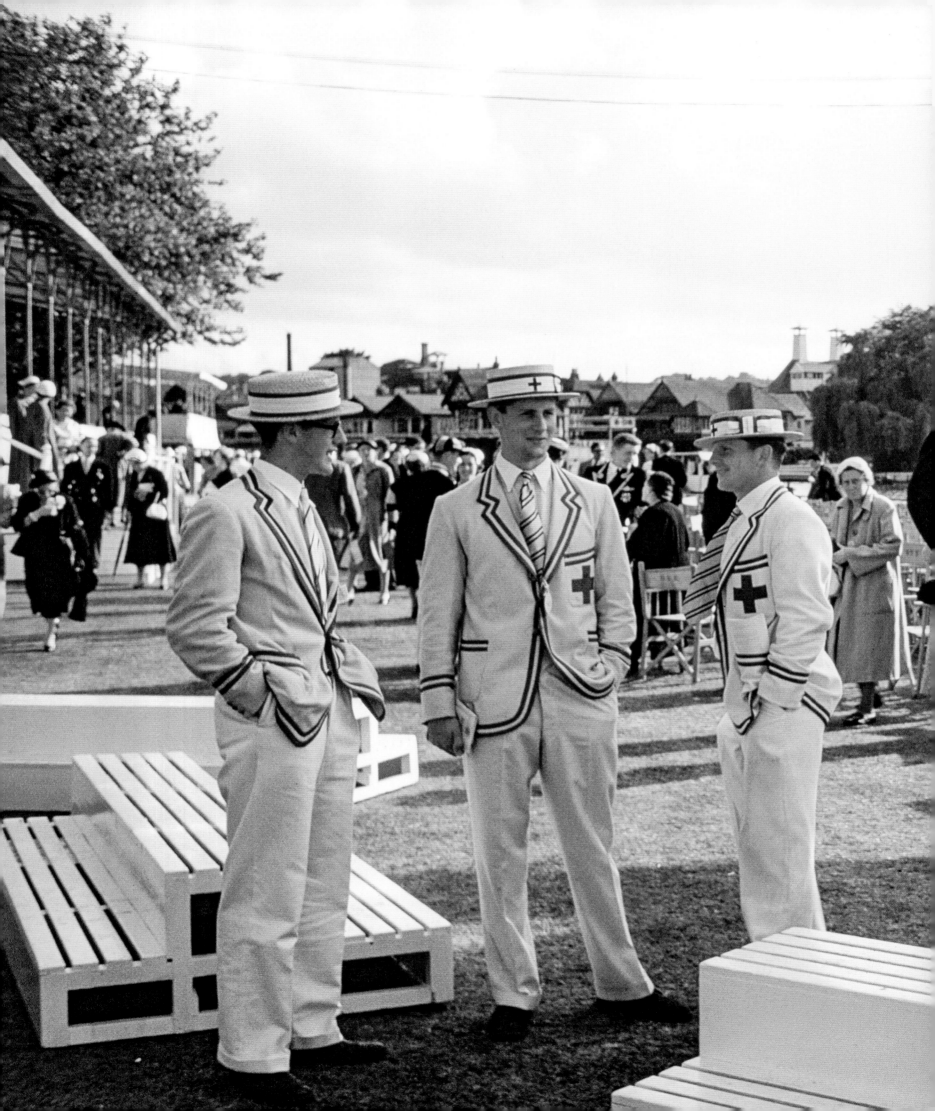

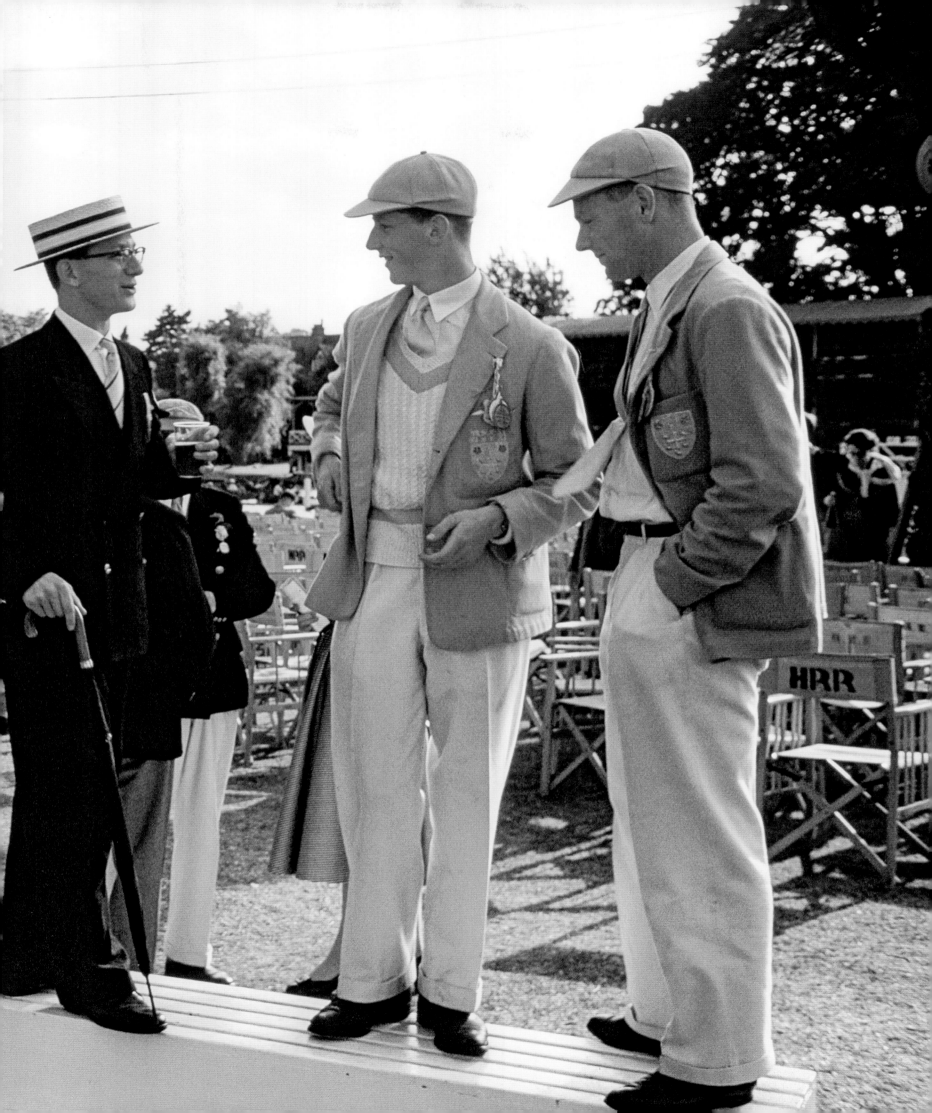

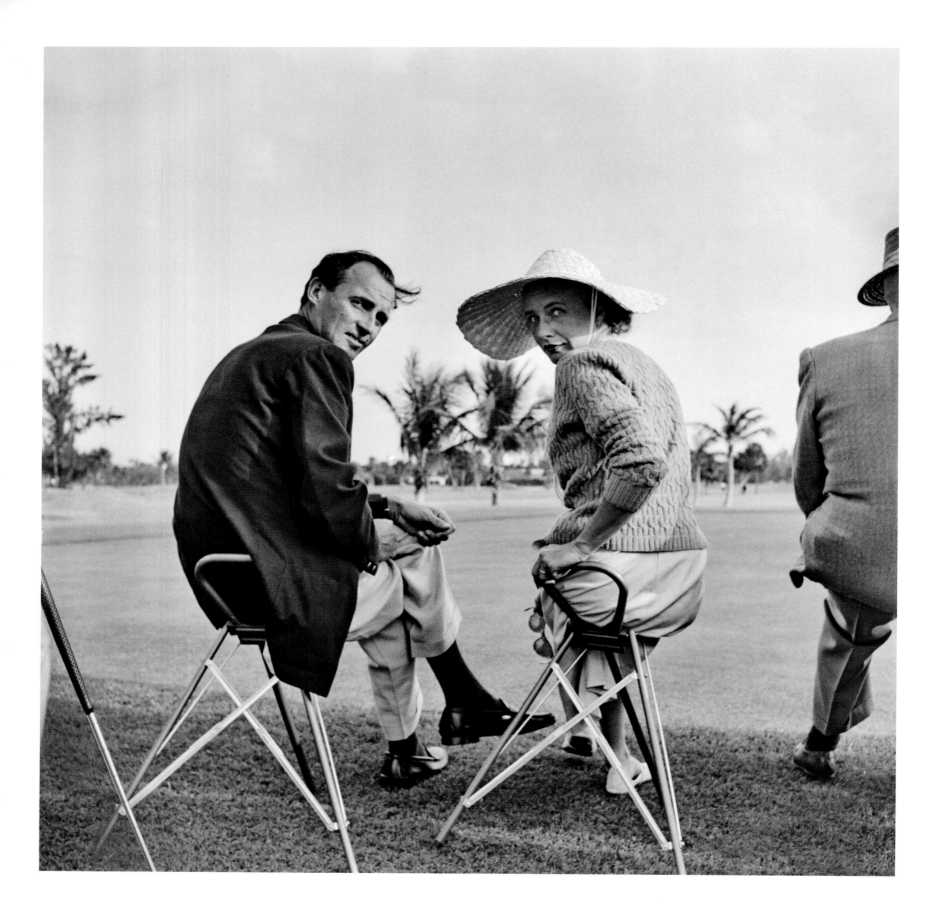

above B.Y.O.C. at a Palm Beach golf
tournament.

opposite Sometimes removing one's
boots requires a bit of teamwork.
Dublin Horse Show, 1963.

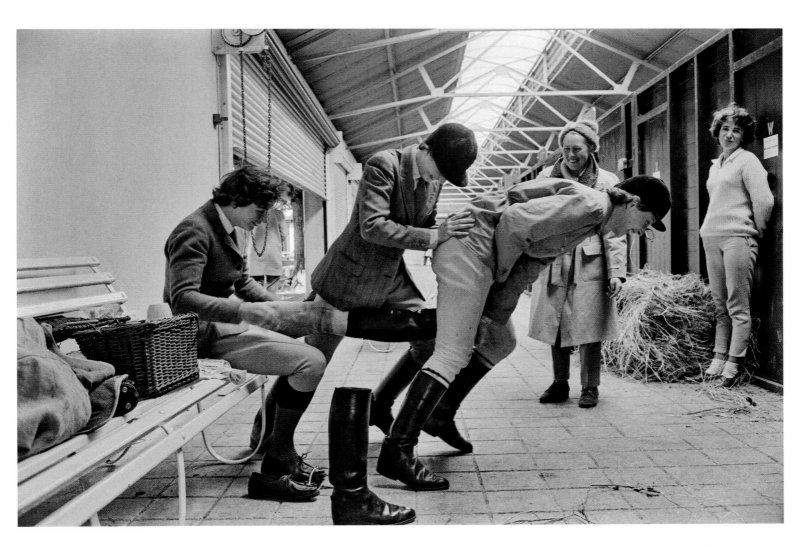

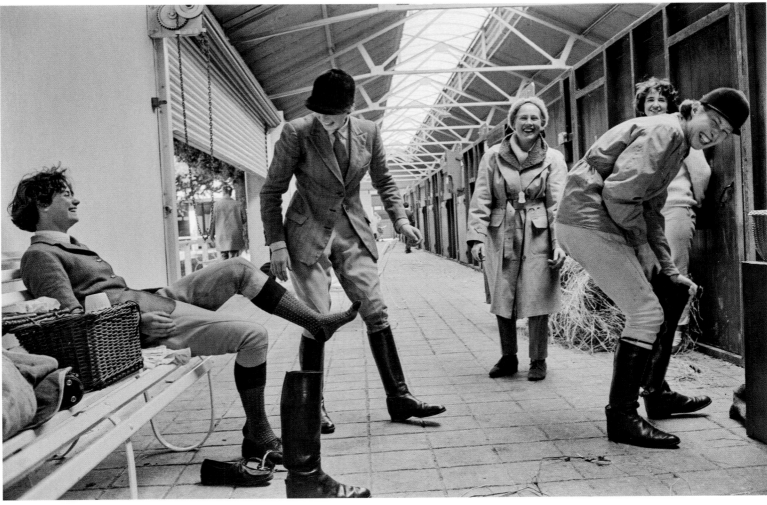

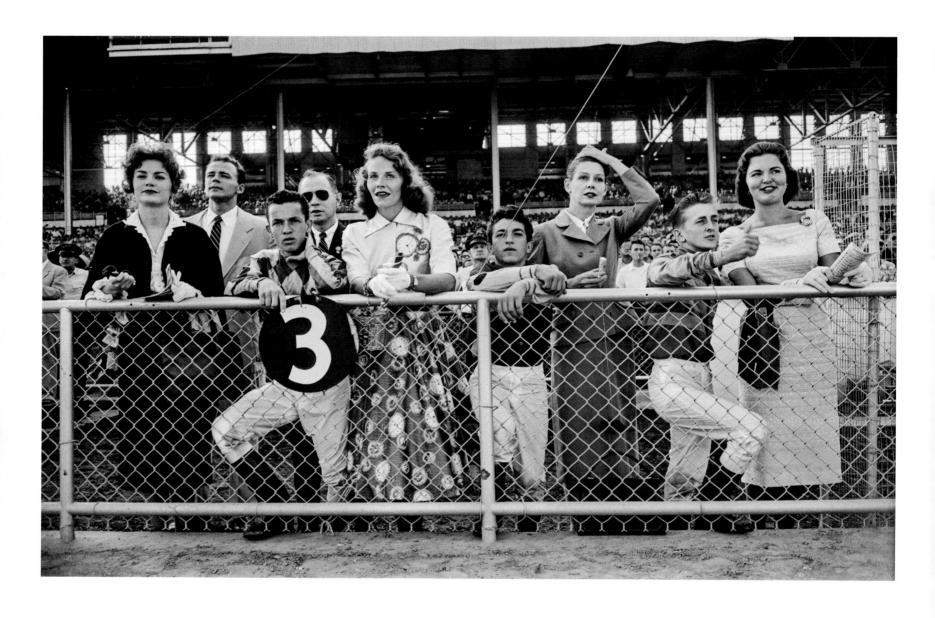

above Local beauties and jockeys at an Atlantic
City track, 1955.

opposite Spectators at the Aiken Trials, the first
event of Aiken's Triple Crown, 1951. The look
of their refined mid-century leisurewear was
first made popular by the influential American
designer Claire McCardell.

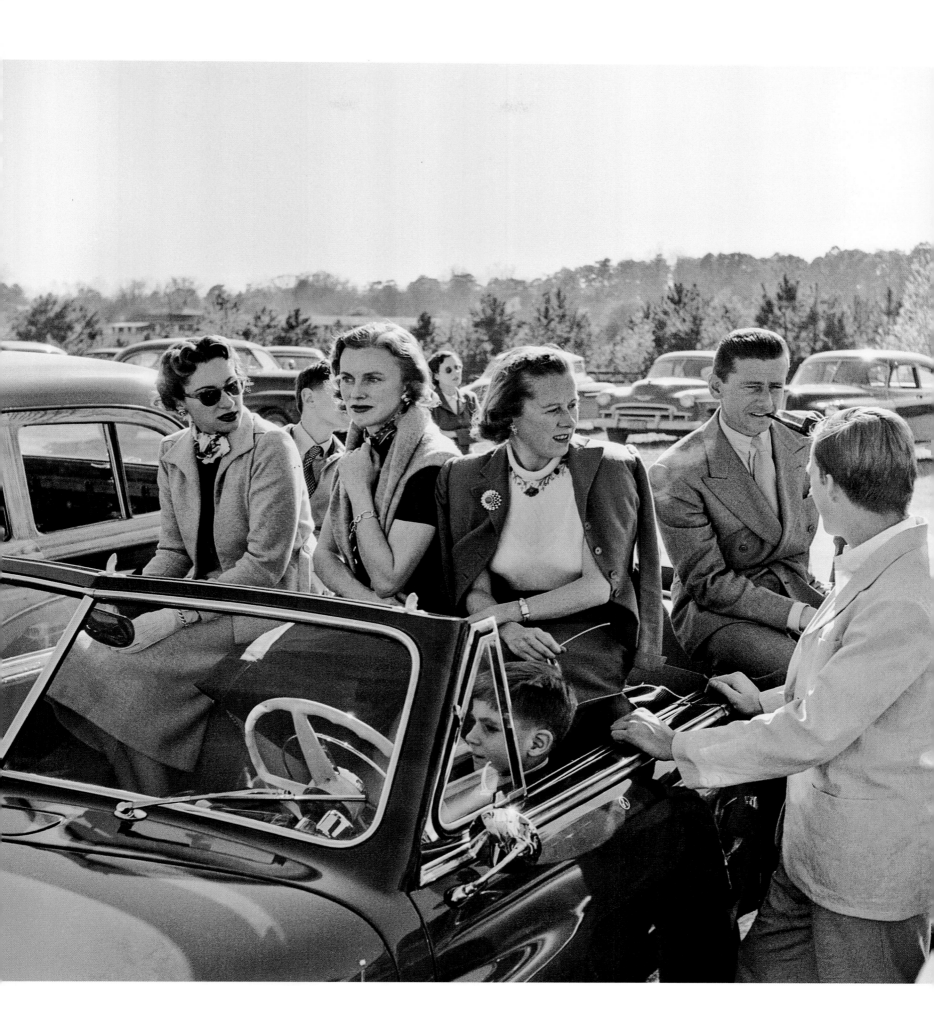

Sporting Style

Aarons photographed many different sporting events, not only for the game, but also for the socializing that happened on and around the fields, courses, and courts—from tennis at Newport's Casino to rowing at Henley-on-Thames and cricket at London's Lord's Cricket Ground. Each event was an opportunity for spectators to dress up and enjoy a picnic or a more formal luncheon. As such, they were ideal opportunities for Aarons to shoot style on location.

The players also had their own chic. At Henley they wore brightly striped rowing jackets and smart straw hats; on the cricket fields they were dressed all in white. But the most stylishly influential sport was polo, which involved colorful polo shirts with bold stripes and maybe even a silk scarf. Aarons often traveled to Palm Beach, London, and even Argentina to photograph the matches, particularly the famous Eton vs. Harrow match in London. Here, Aarons captures six-time U.S. Open Championship winner Paul Butler with his family, one of the sport's foremost, in Palm Beach, 1981.

Known as "the Sport of Kings," polo has been played for two thousand years. In London, the Indian game was originally revived by Lord Cowdray, a one-armed player who was a polo enthusiast and responsible for making it popular after the war. He turned his Cowdray Park into the locale of weekend matches and encouraged the Duke of Edinburgh to play there, in addition to his neighboring Windsor Great Park tournament. The opportunity to host members of Britain's Royal family was too good to be true: the Queen and Princess Margaret were known to attend matches during Royal Ascot Week.

Wearing top hats and tails, or tweedy knickers, the spectators at all of these events became inspiration to legions of Americans and designers—not least of whom was Ralph Lauren, who named his company after the sport, taking cues for his famous knit shirts from the polo players' uniforms, embroidered with the now-ubiquitous pony. The look became popular in American resorts like Palm Beach, where the world's finest players would convene during the winter season for sixteen weeks of matches at the International Polo Club.

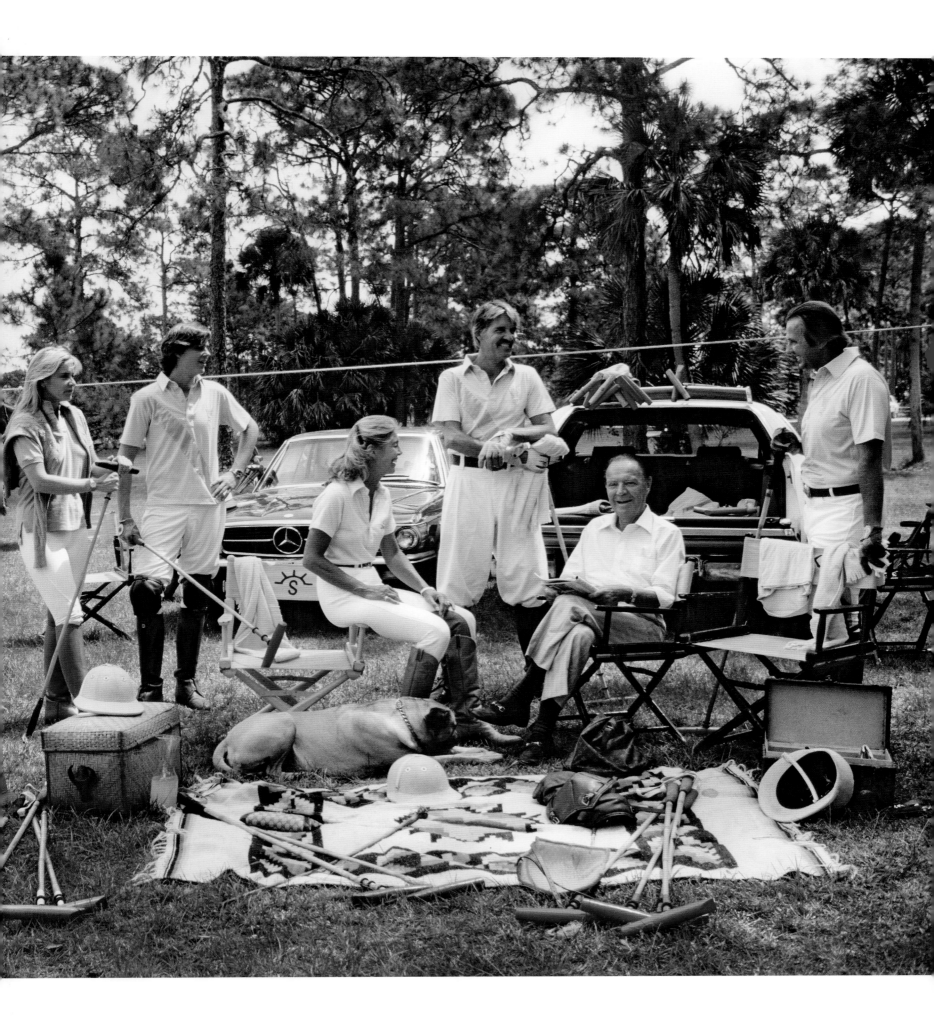

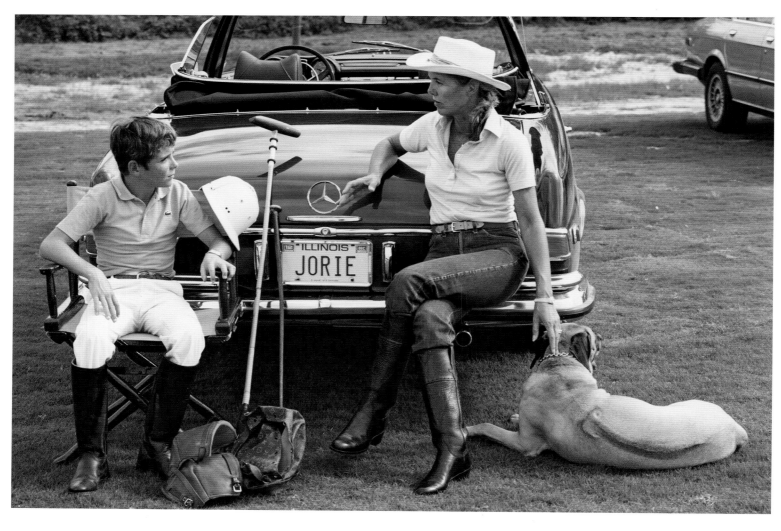

above Businesswoman and philanthropist Jorie Butler Kent, known in the sport as Mrs. Polo, chats with her stepson at Palm Beach Polo and Country Club, 1982.

right Allan Scherer and his son Warren, members of one of the Americas' premier polo families, together for a match in Argentina, 1990.

opposite John T. Oxley at Royal Palm Polo Club, Boca Raton, 1978.

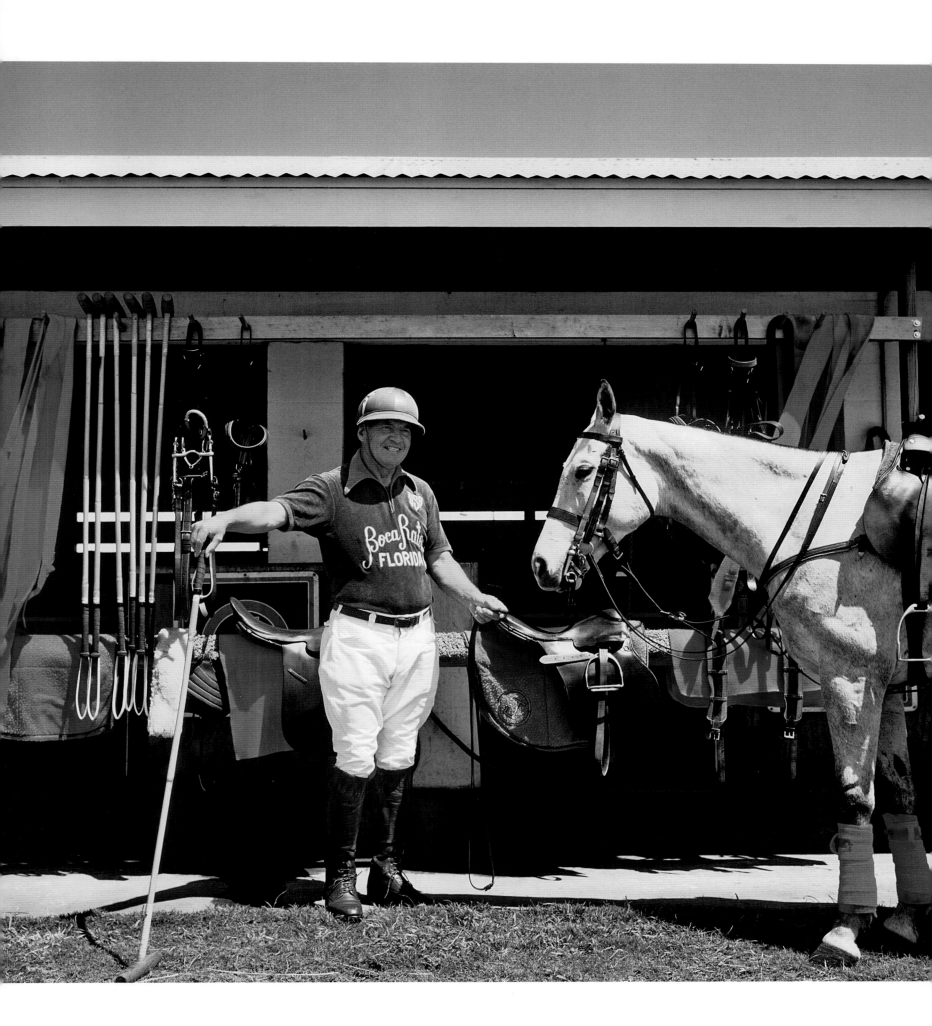

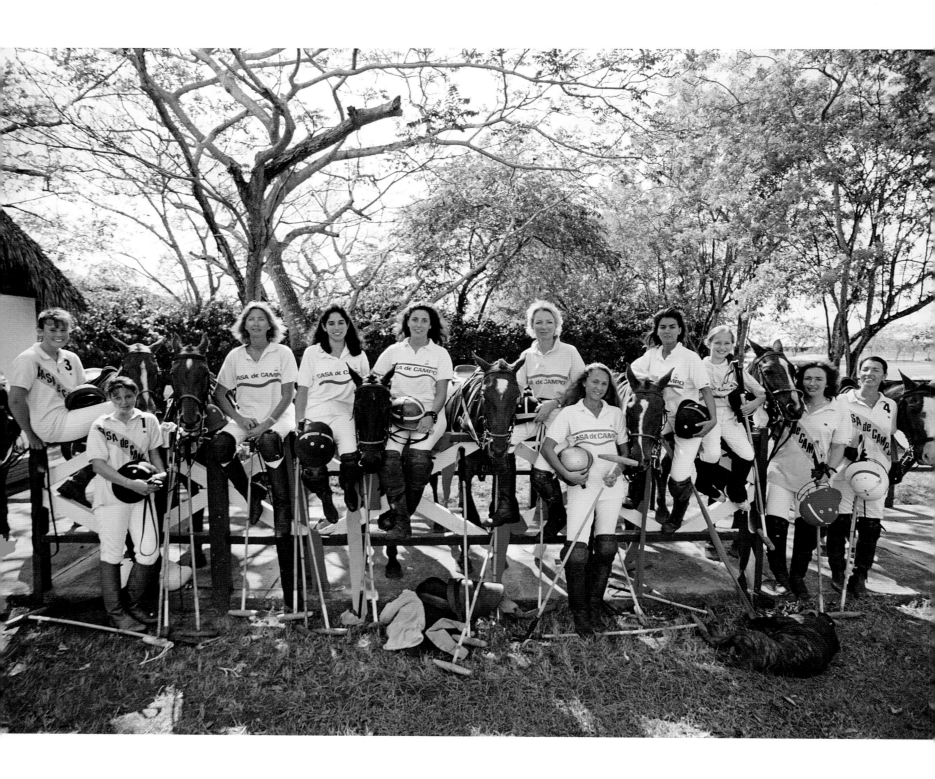

above Polo enthusiasts from around the globe have gathered at the Dominican Republic's Casa de Campo resort for decades. Here members of two all-female teams and their ponies gather between chukkers, 1990. From left to right: Caroline Firmenich; Astrid Wittmer; Stephanie Stevenson; Lillian Fernandez; Pia Hahn; Lillan Pons-Seguin; Antoinette Claessens; Maria Christian Urrea, member of a top polo family in Colombia; Maria-Gemma Huynen and her mother, Dorothée, a founder of Antwerp Polo Club; and Daniela Luyten.

opposite above Polo at Cowdray Park, West Sussex, 1985. Cowdray has hosted matches for more than a century and is the site of the annual British Open Polo Championship. The ruins in the background are Cowdray House, which burned in 1793.

opposite below left Prince Philip, captain of the Windsor Park Team, holds the Windsor Cup after beating India to win the Ascot Week polo tournament, 1955. Queen Elizabeth II presented the cup to her husband.

opposite below right Princess Alexandra of Kent, the Honourable Lady Ogilvy, first cousin to Queen Elizabeth II, at the Ascot Week polo tournament, Smith's Lawn, Windsor Great Park, 1955. The queen and princess are following a traditional rule regarding pearls—ropes are worn in odd numbers.

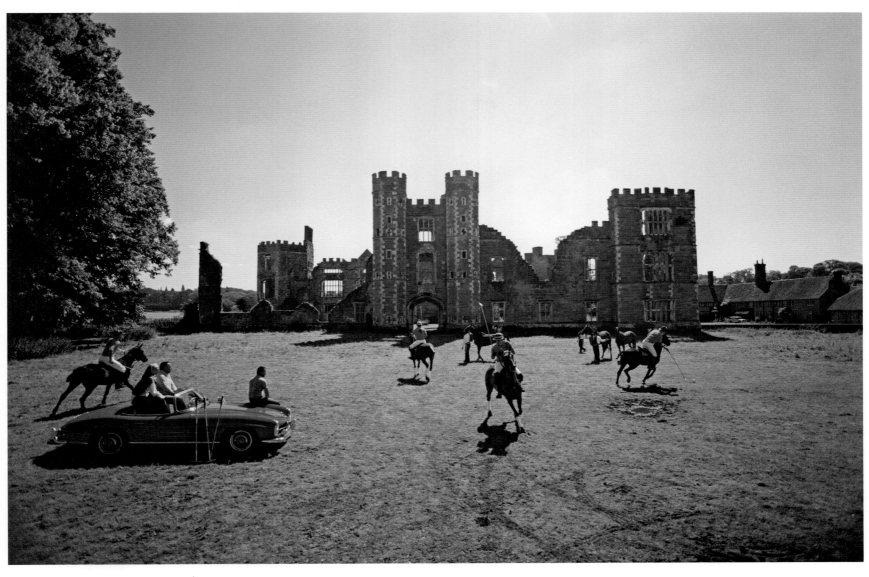

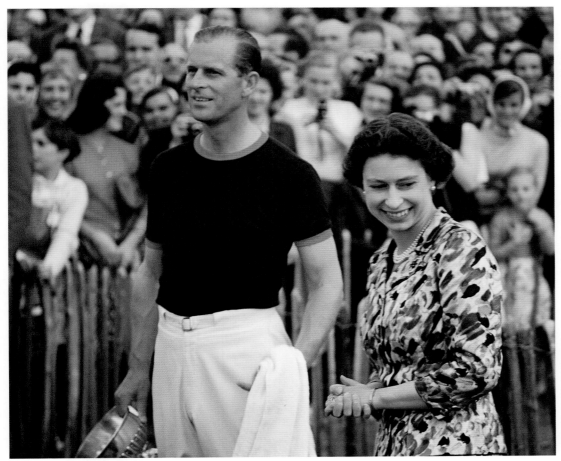

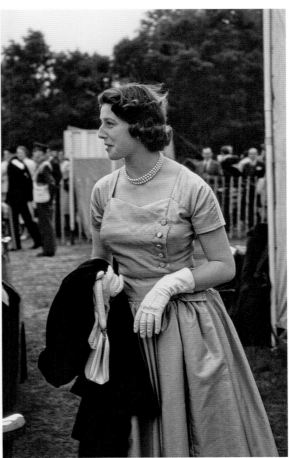

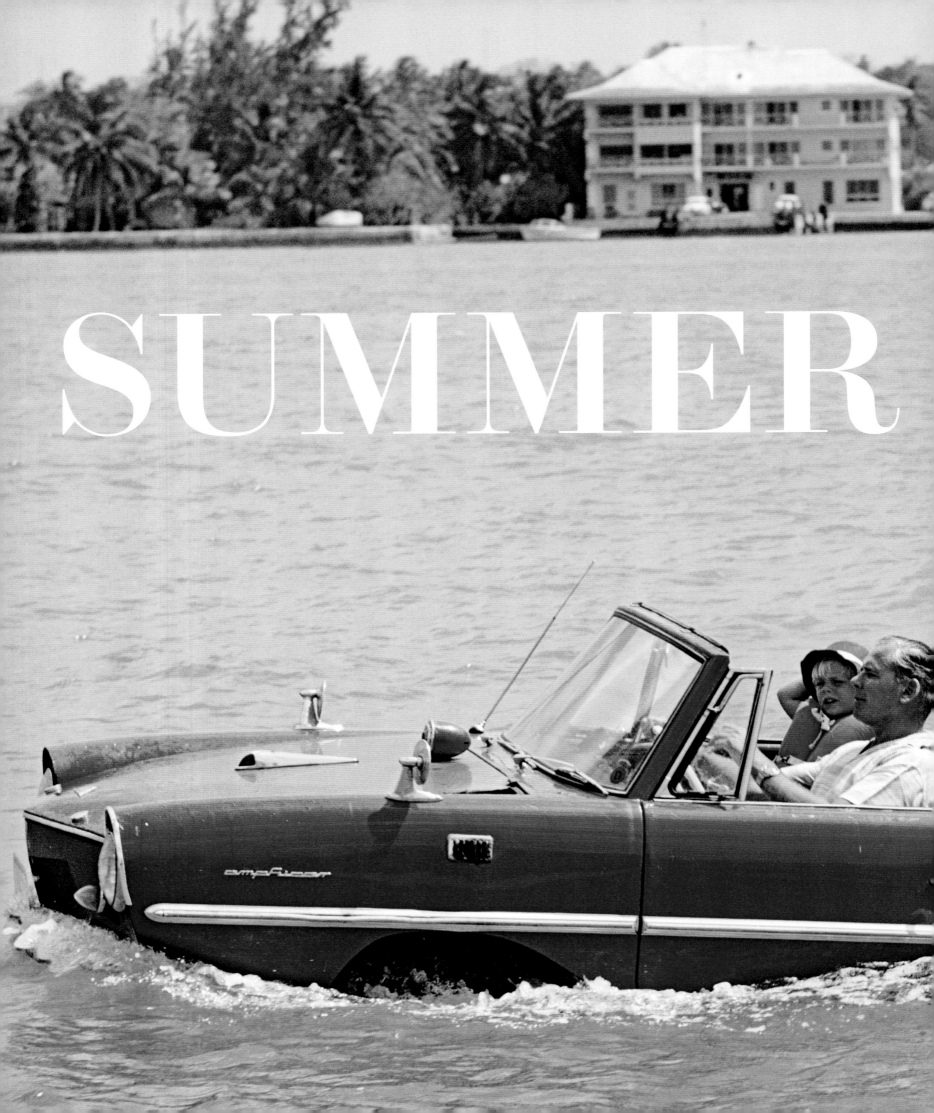

SUMMER

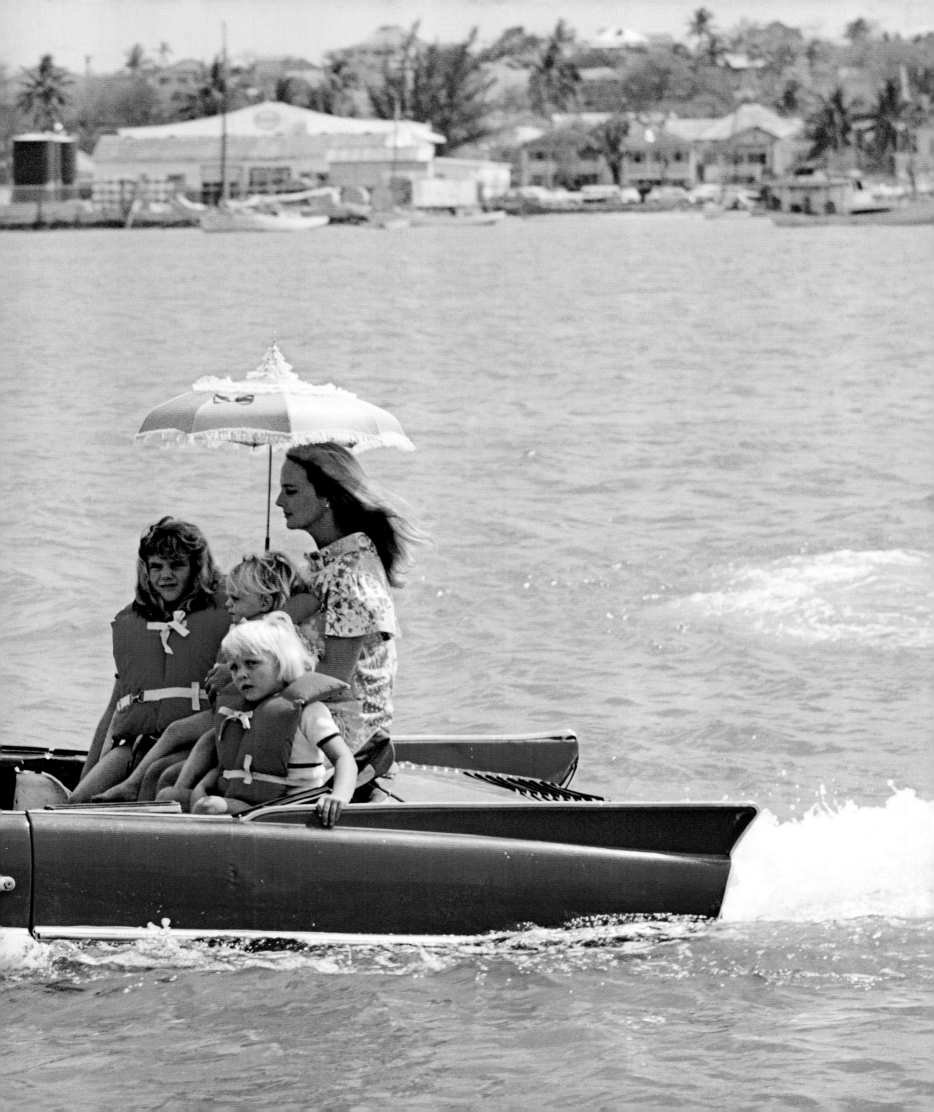

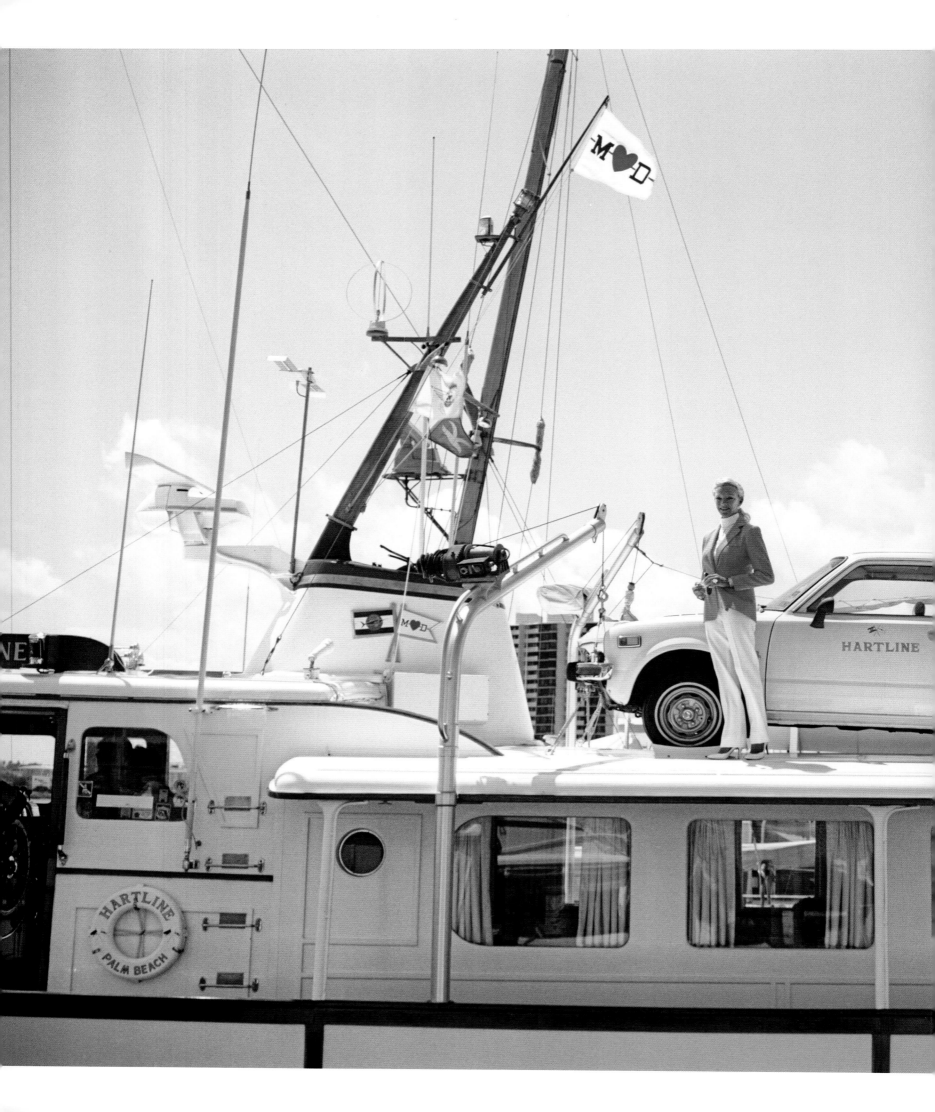

preceding spread Irish film producer and popular local resident Kevin McClory cruising Nassau Harbor with his wife, Bobo Sigrist, and their children during what Slim categorized as "a Sunday drive with a twist," 1967. The Amphicar was an abandoned prop from the McClory-produced Bond film *Thunderball*, which filmed scenes on location around the Bahamas including Huntington Hartford's Paradise Island.

left American model and early television star Mary Hartline Donahue on her 98-foot Feadship motor yacht, *Hartline*, Palm Beach, 1982.

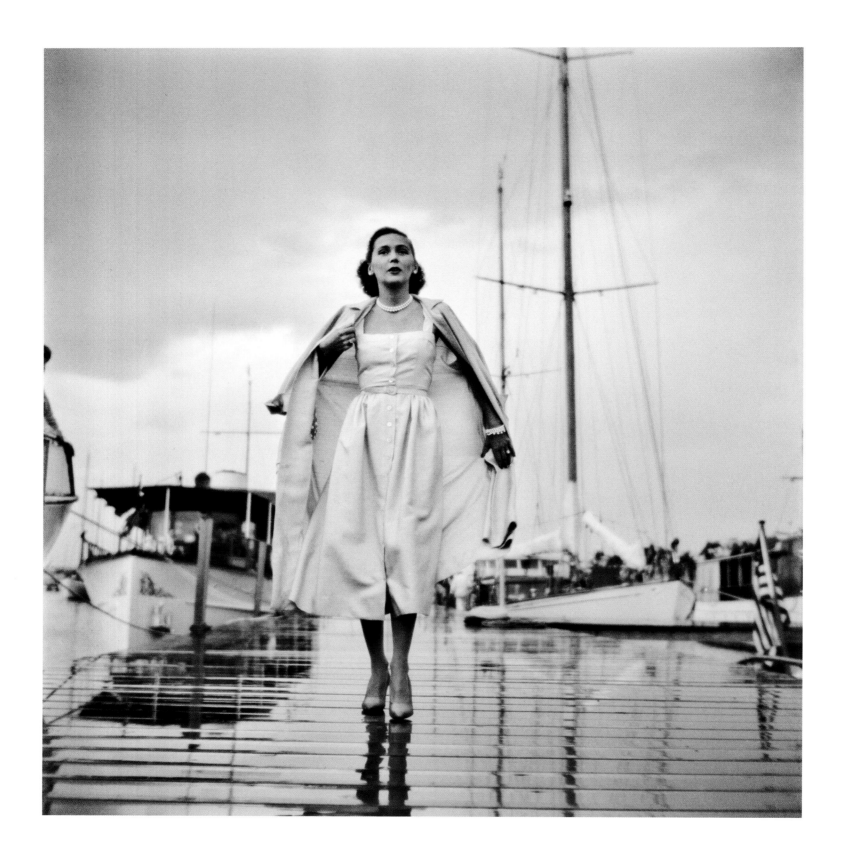

above Model turned fashion editor turned society hostess
Florence Pritchett Smith covers her sleeveless dress of
pink silk shantung with a long coat to match, 1950.
Pritchett met John F. Kennedy in 1944 and remained an
object of his affection for nearly two decades. Her second
husband, financier Earl E. T. Smith, was US ambassador
to Cuba during the revolutionary years and mayor of Palm

Beach from 1971 to 1977. *Town & Country* referred to them
as "the resort's most photographed residents."

opposite Jim Kimberly (far left, in orange), known as a
three-car, three-yacht sportsman and heir to the Kimberly-
Clarke Company's Kleenex fortune, talks with friends on
the shores of Lake Worth, 1968. The car is by Excalibur.

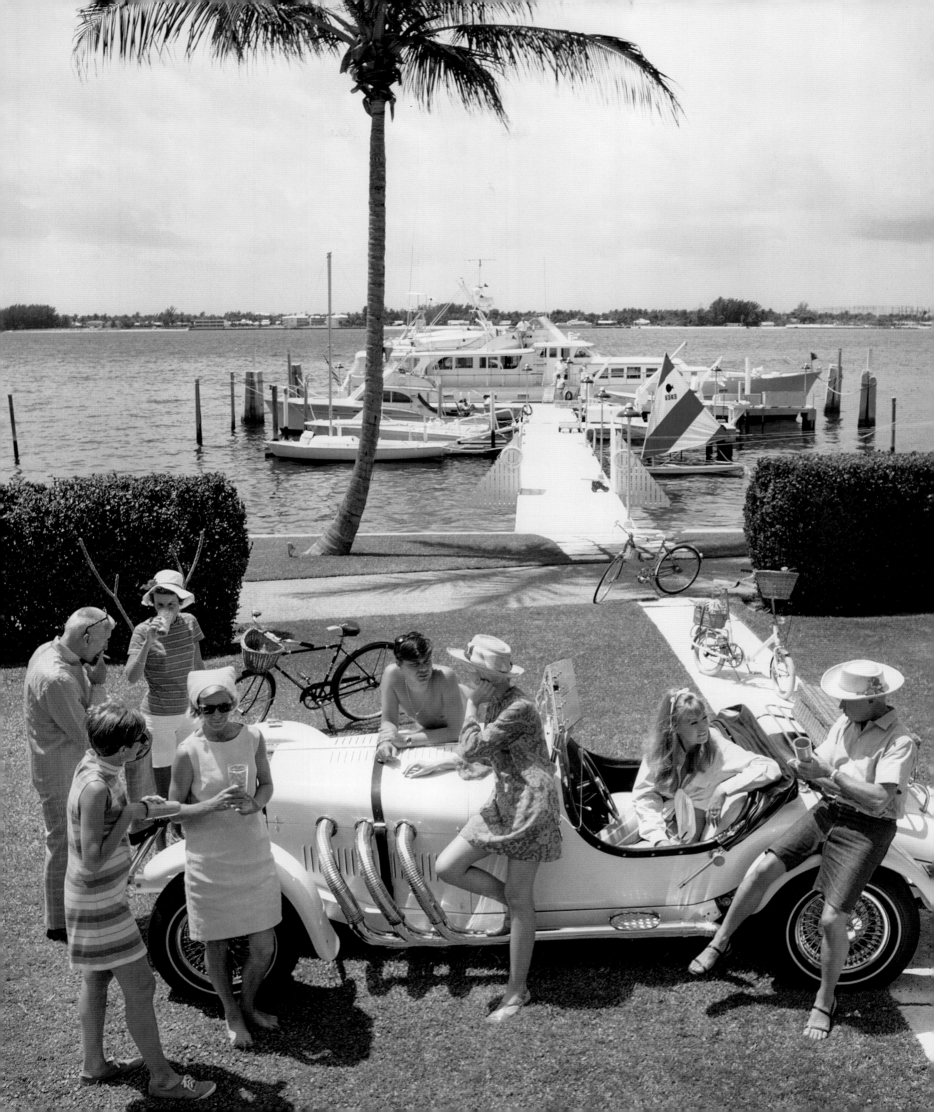

Top Model

If Aarons's favorite subject was style, then his top model was unquestionably the debutante known as C. Z. Guest. Born Lucy Douglas Cochrane in 1920 in Boston, Guest was famous in the society circles of New York and Palm Beach for her patrician beauty and poise, and also for her impeccable style. Before her 1947 marriage to Phipps steel heir Winston Guest, C.Z. was one of Boston society's most sought-after debutantes. Aarons's iconic 1955 image of Guest at her family's Palm Beach home, Villa Artemis, captures her crisp American style and her porcelain beauty. The outtakes of the photo (opposite) show Guest with one of her dogs and highlight her immaculate sense of style, if style may be defined as the repetition of gestures. Although Guest favored designers like Givenchy and Adolfo, her signature style included simple, sporty separates—T-shirts, Capri pants, riding jackets, or ball gowns with a cardigan thrown over the shoulders. Along with her natural elegance, Guest's fiery intelligence and the irreverent twinkle in her pale blue eyes are undoubtedly what captivated Aarons.

A devoted equestrian, Guest derived much of her pristine, all-American style from her love of horseback riding and the outdoors. When she appeared on the cover of *Time* magazine in 1962 in jodhpurs and a tie, she insisted on having a dog at her side, the epitome of horsey high society. But she was never beholden to society and its mores. In her early twenties, Guest dreamed of becoming an actress just so she would be thrown out of the Social Register. But a six-month stint in Los Angeles was enough to dissuade her of a career in Hollywood.

Guest was also passionate about gardens and went on to pursue a career writing about gardening, first for children and then in a syndicated column that appeared in 350 newspapers across the country. Whenever she worked in her gardens at Templeton, her estate in Old Westbury, Long Island, Guest was always followed by several hunting dogs. She had a vivid social life, which included a tight circle of friends like Cecil Beaton, Truman Capote, and the Duke and Duchess of Windsor. Capote once described Guest as "a cool vanilla lady," a fitting appellation for a self-assured, outspoken model who eschewed makeup and trends.

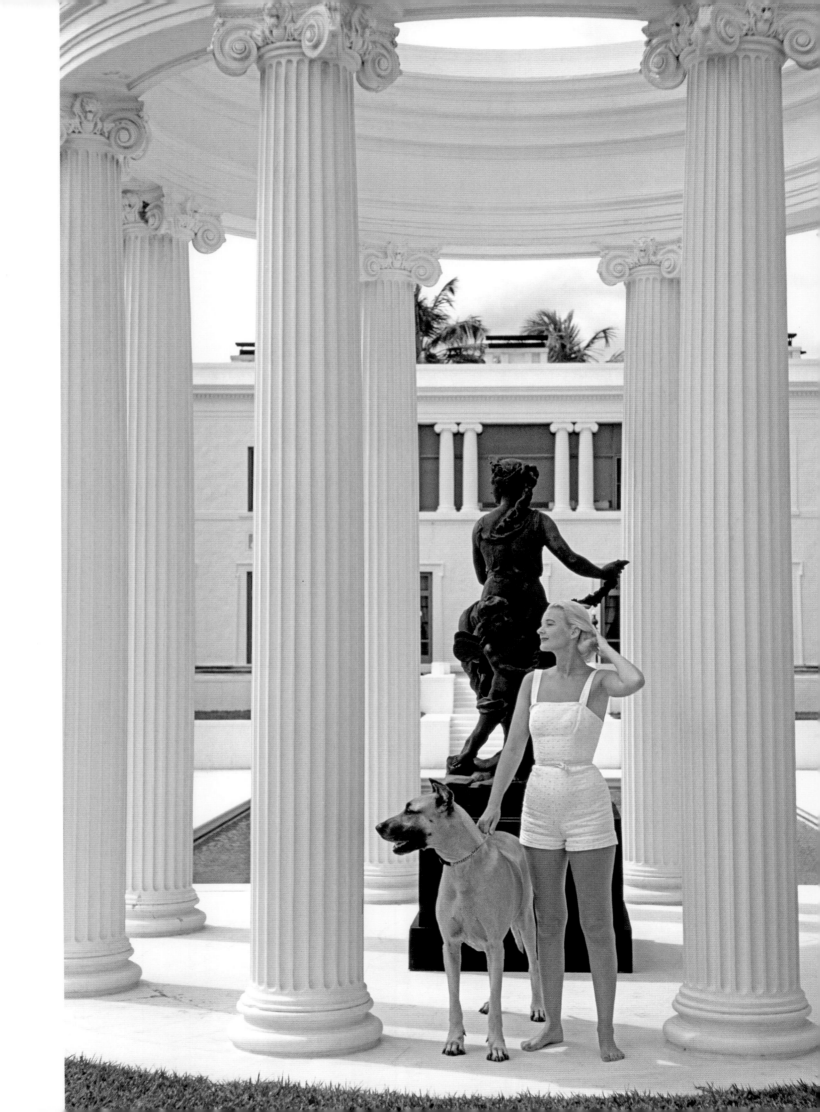

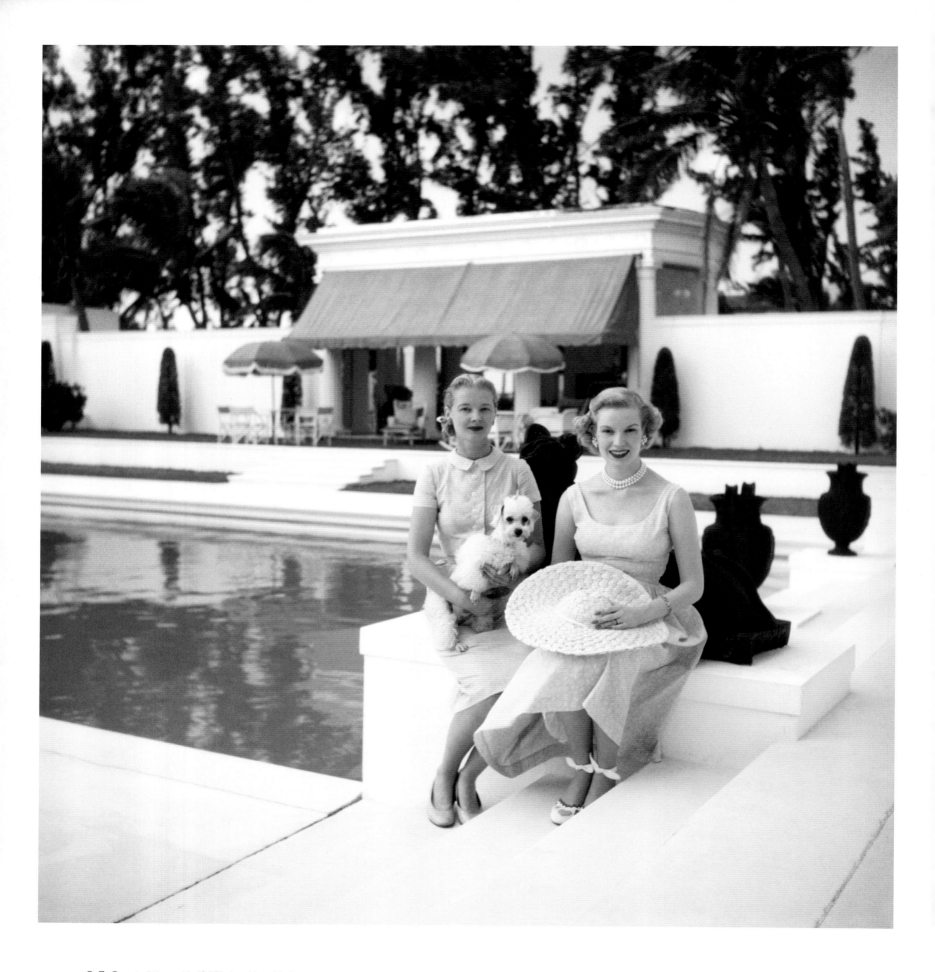

C. Z. Guest sitting with 1948's top New York
deb, Joanne Connelly Sweeney Ortiz-Patino,
at Villa Artemis, Palm Beach, 1955.

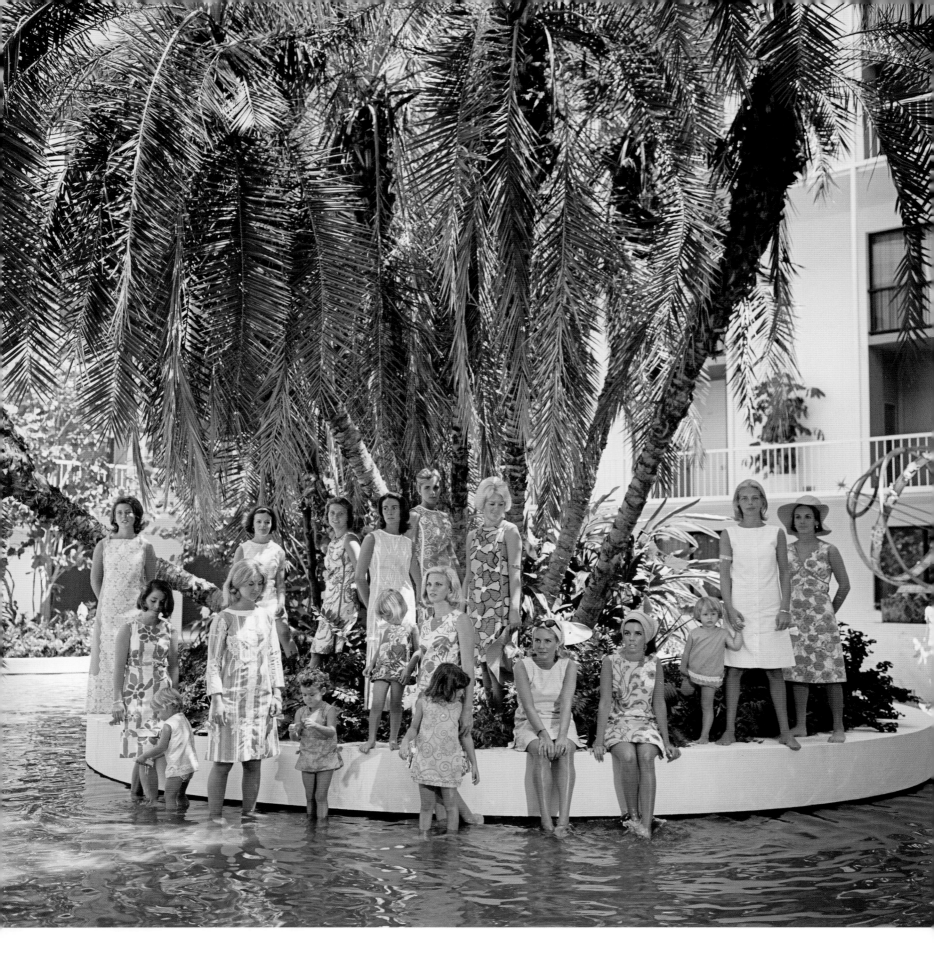

The young matrons of Palm Beach wearing designs by Lilly Pulitzer, 1964. Included among them (in yellow dress and pink head wrap) is New York artist Wendy Lehman Vanderbilt, who appeared in the first advertisements for Pulitzer's fashion line.

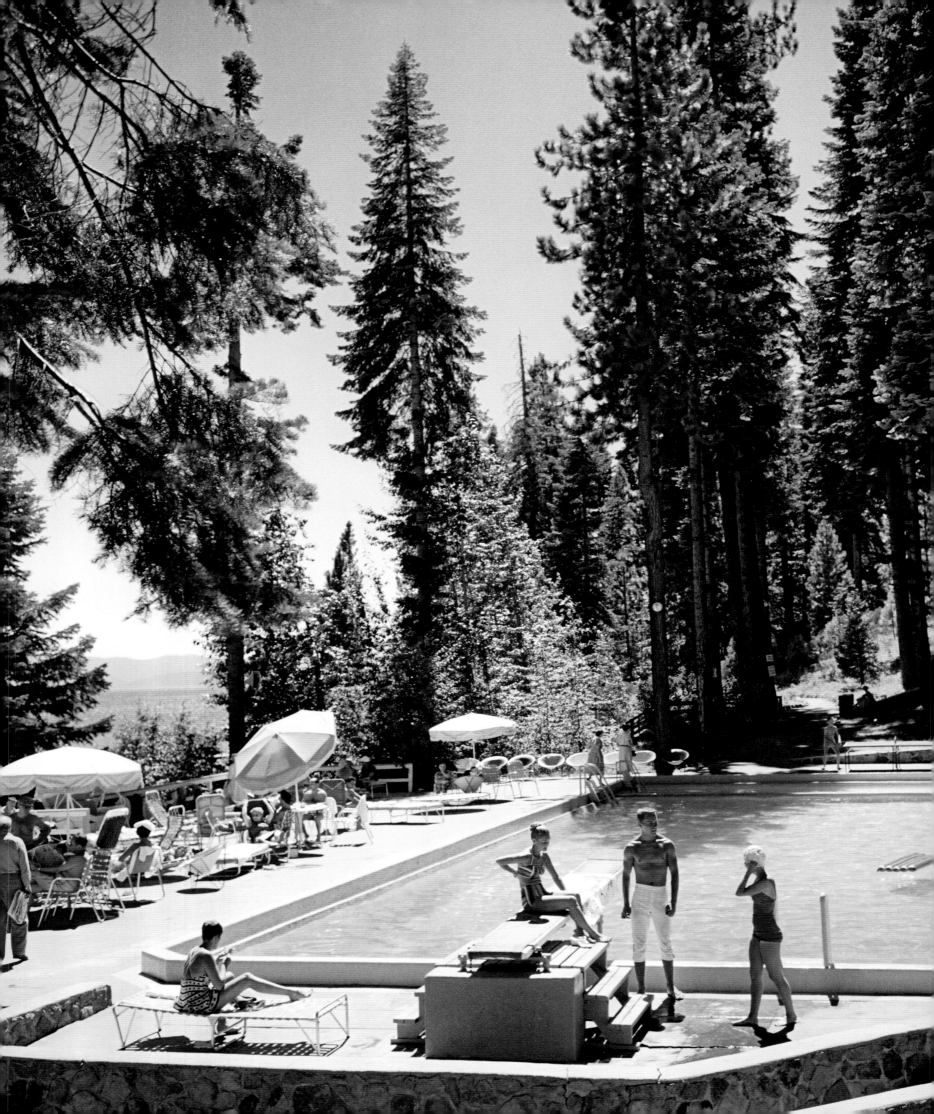

California Dreaming

California was one of Slim Aarons's favorite subjects, and not just the sun-soaked patios of Beverly Hills and sparkling beaches of La Jolla, but also the Nob Hill mansions of San Francisco and the rustic resorts of Lake Tahoe, where West Coast society gathered for lavish parties and vacations.

Aarons first traveled to San Francisco to photograph the city and its socialites in 1953, when he shot a portrait of ladies from the Blue Book, including Mrs. Charles de Limur, Mrs. Ferdinand Stent, and Countess Marc de Tristan, at the California Palace of the Legion of Honor in Lincoln Park, the city's largest museum. He also photographed Nob Hill homes, or what Robert Louis Stevenson christened "the Hill of Palaces," where each house was more grand than the next, one even modeled after the Petit Trianon at Versailles.

Aarons returned to the Golden State in 1959 and headed to Lake Tahoe to shoot a story at the famed Tahoe Tavern Hotel, which had opened in 1902, the vision of San Francisco timber baron and railroad operator Duane Bliss, who outfitted the place with beamed ceilings, elk-horn chandeliers, and simple rustic furniture. The hotel had been designed by Duane's son, architect Walter Bliss, and was grand enough to be called the most luxurious resort between San Francisco and the Rockies. Unlike more formal resorts that required shirt and tie at dinner, the Tahoe Tavern was casual. The historian George Wharton James described life at the Tavern as "not a fashionable resort, in the sense that everyone, men and women alike, must dress in fashionable garb to be welcomed and made at home. Rather the Tahoe Tavern is the most wonderful combination of primitive simplicity with twentieth century luxury." By the 1930s the dress code had become more formal, but guests were still encouraged to engage in the myriad outdoor activities such as mountain climbing, biking, rowing, fishing, and horseback riding and to bring the appropriate clothing for such endeavors.

Eventually the Tavern was sold, and the new owners developed a winter sports program to increase the seasonal attraction of the area. But the iconic pool remained, and Aarons's shot of bathers by the pool surrounded by towering first-growth sugar pines and cedars endures as an indelible vision of mid-century California style.

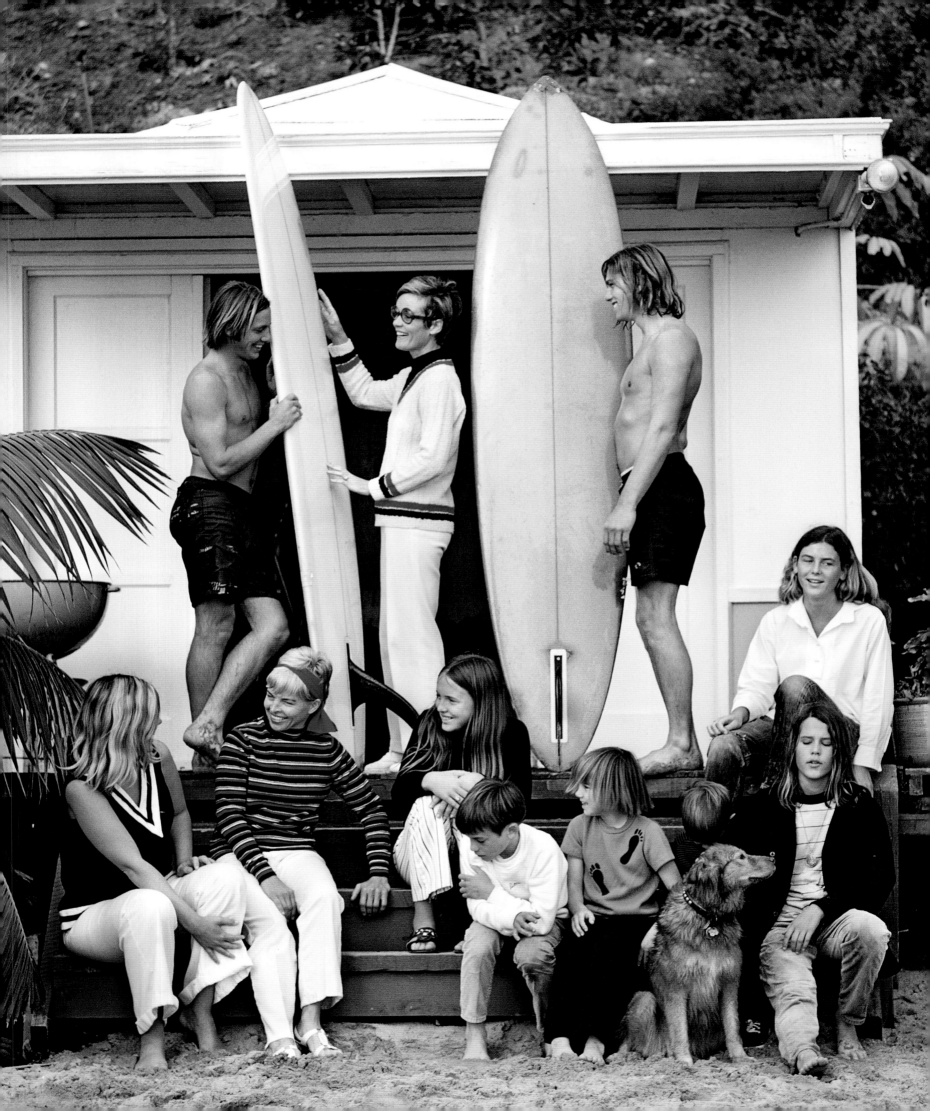

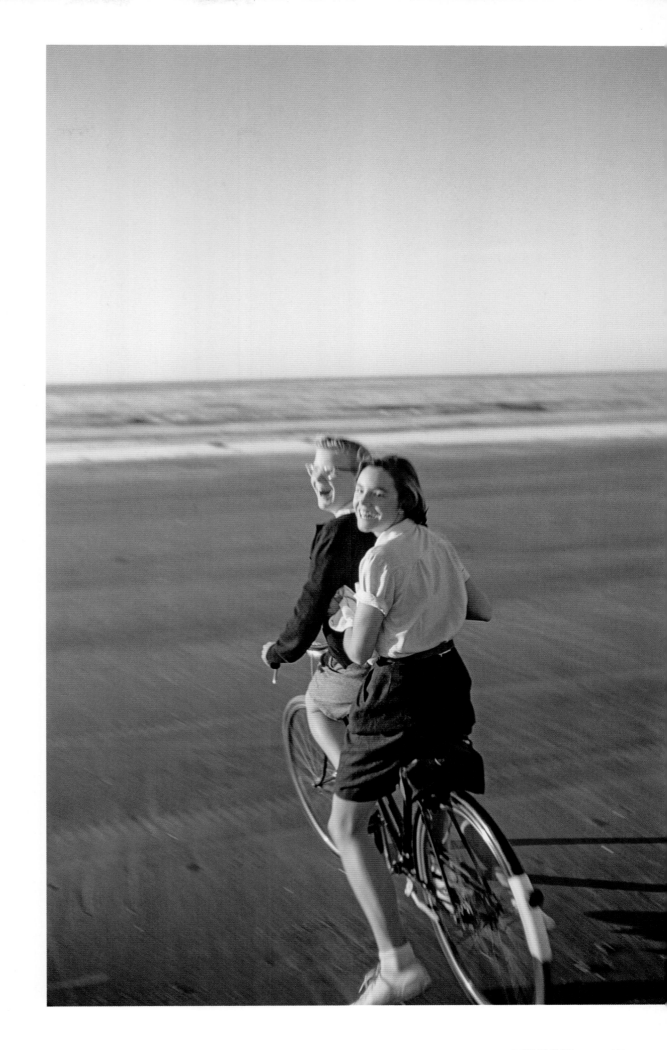

opposite West Coast style in Laguna Beach, California, 1970.

right Susie Willoughby (pedaling) and Carolyn Preston on the beach at La Jolla, 1960.

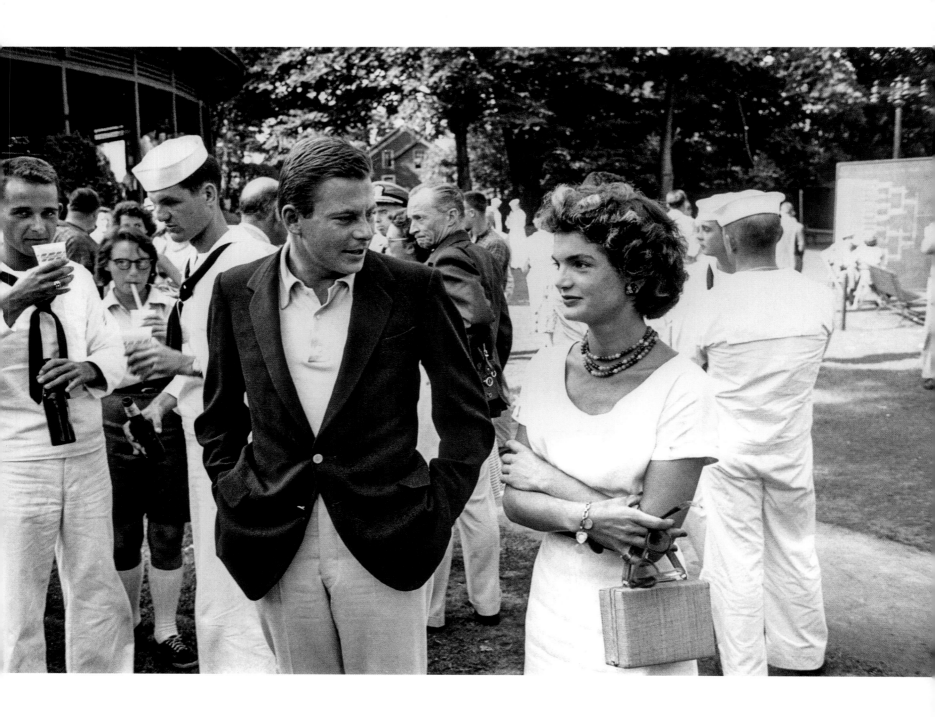

above Jackie Kennedy and her brother-in-law
Michael Canfield enjoy Tennis Week at the Newport
Casino, 1955.

opposite Nancy Talbert with former American football
player and actor Maurice Bennett Flynn, better
known as Lefty, at the Newport Casino, 1955.

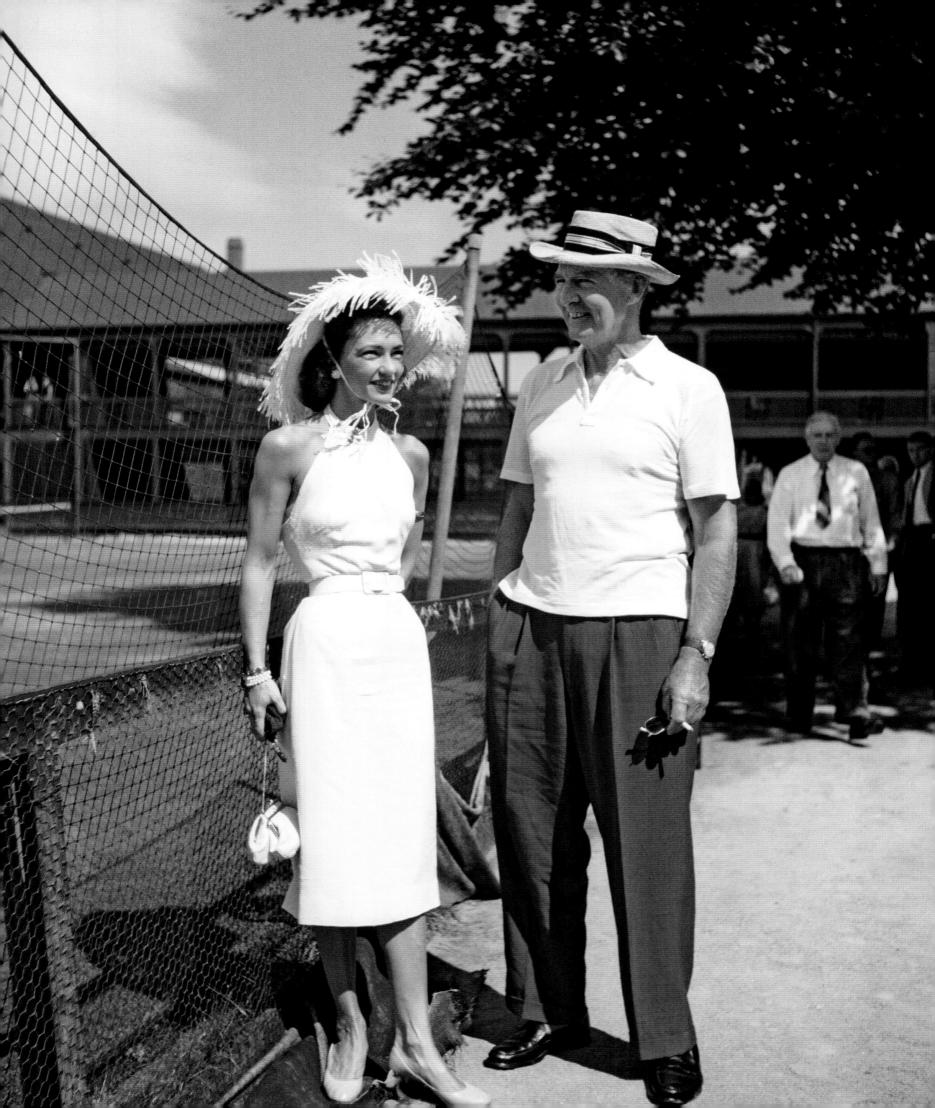

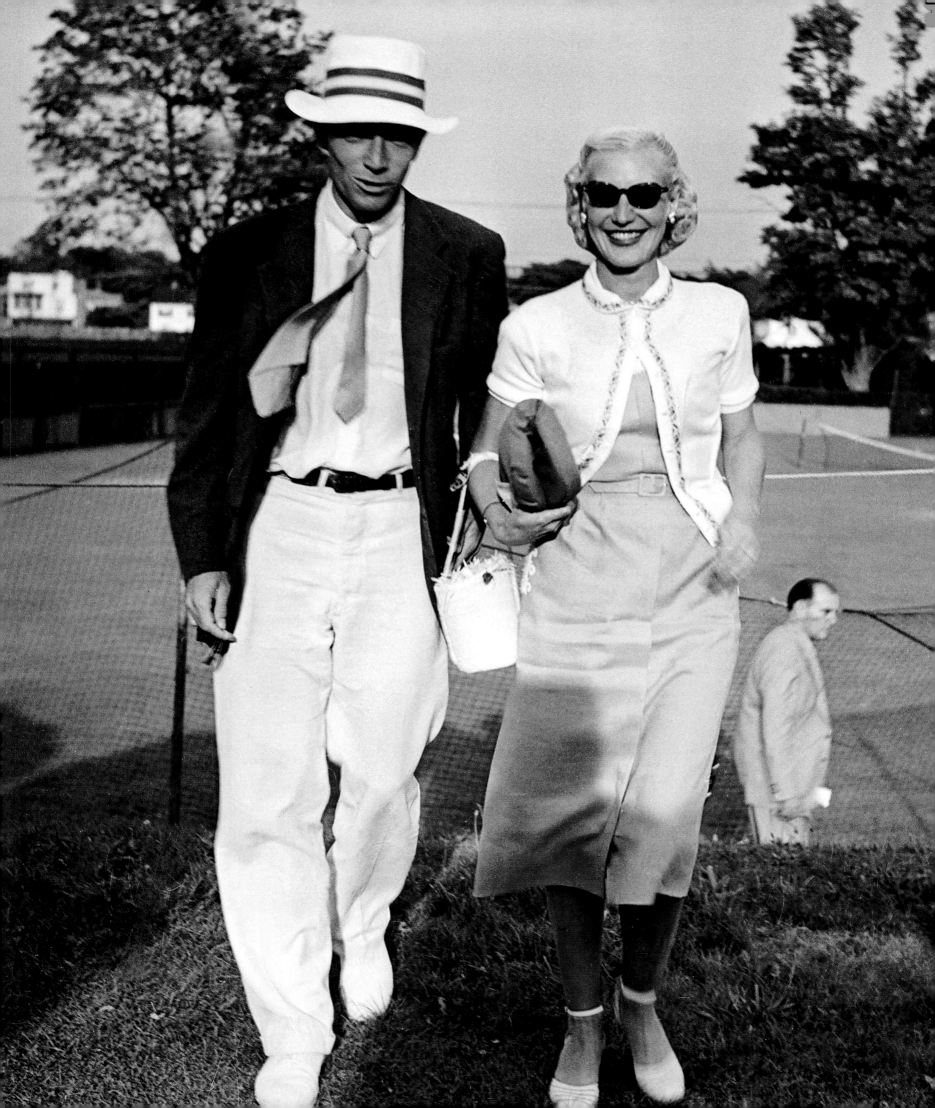

The Season

Newport, Rhode Island, was one of the East Coast's most popular summer destinations in the first half of the twentieth century, and Aarons documented "the season" there many times, reporting on the social comings and goings of each club member. What fascinated him most, though, was the evolution of what *Holiday* magazine called "the dowager resort" from a lavish locale steeped in traditions and codes to a younger, more footloose summer residence where a new generation was unafraid to break the rules and loosen up their style.

Much of the change was attributed to the Newport Casino Tennis Week, which Aarons photographed for *Holiday* in 1954. The article focused on the resort's informal, young, new look, including the invited tennis players who arrived in early August to compete in the annual Newport Invitational Singles tennis tournament at the old Casino. Aarons photographed both the older and the newer generations, including future US senator Claiborne Pell and Alletta Morris McBean (opposite) and the young Jackie Kennedy, who attended with her stepbrother Hugh Auchincloss. For many, the tournament itself was beside the point; the real attractions were the parties and luncheons hosted at Bailey's Beach or in the grand homes—or "gardeners' cottages" of Newporters like the Claiborne Pells.

Some lamented the bygone era of Mrs. Cornelius Vanderbilt and her elaborate balls at the Breakers, when she would import an entire Broadway musical for a single evening performance. But most embraced the new informality, which by 1954 meant more "modern" and austere parties with just a single pianist playing instead of an entire orchestra.

The turning point for the "dowager resort" came at a luncheon hosted by Mr. and Mrs. James M. Beck at their home, Plaisance. Guests were seated at a long, formally decorated table and served three courses, wines, brandy, and liqueurs by maids and butlers. The one modern style accent: the Becks' young child was running around in shorts and bare feet. This unexpected mix of grand luxe and informality would become a hallmark of East Coast society in the late 1950s. As one Newport hostess put it: "It's the lack of in-between that we really enjoy here. In the daytime you can really relax at the beach. You can wear simple cottons or even shorts. But when you dine out—and we dine out—you really do it right."

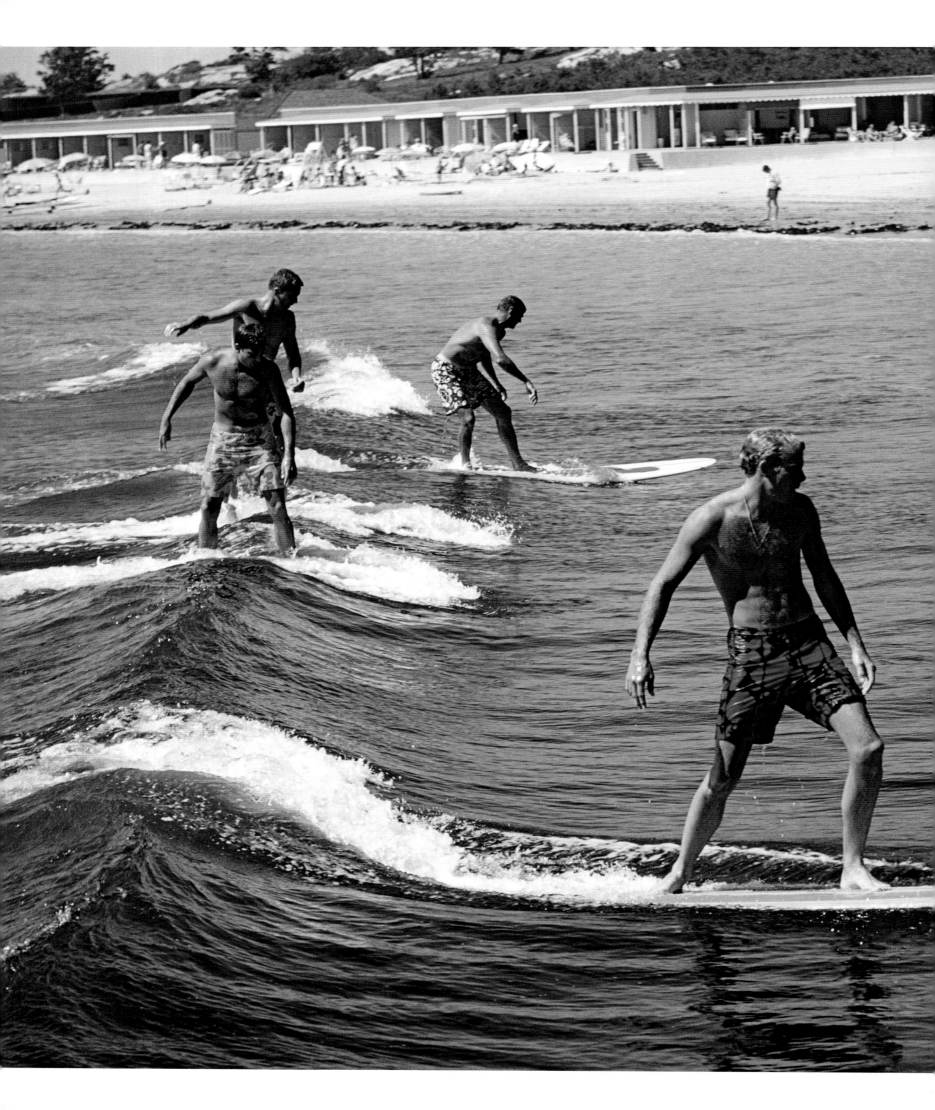

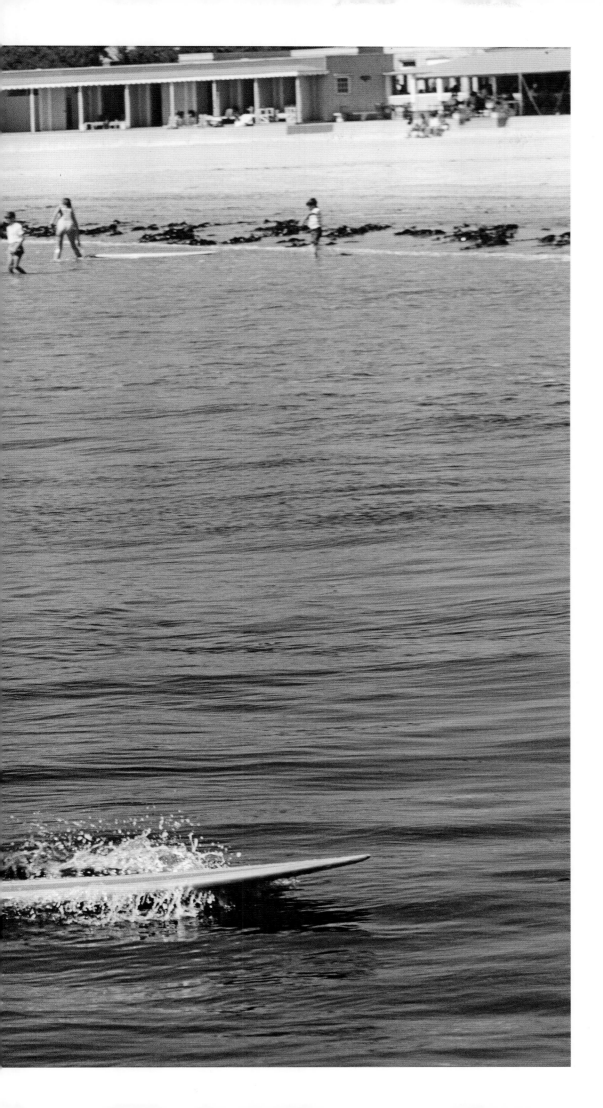

Brothers Freddy and Howard Cushing surfing with friends at Bailey's Beach, the exclusive private beach club formally known as Spouting Rock Beach Association, Newport, ca. 1965. Legend has it that their father, Howard Gardiner Cushing, introduced surfing at Bailey's after bringing boards back from Hawaii in the 1930s.

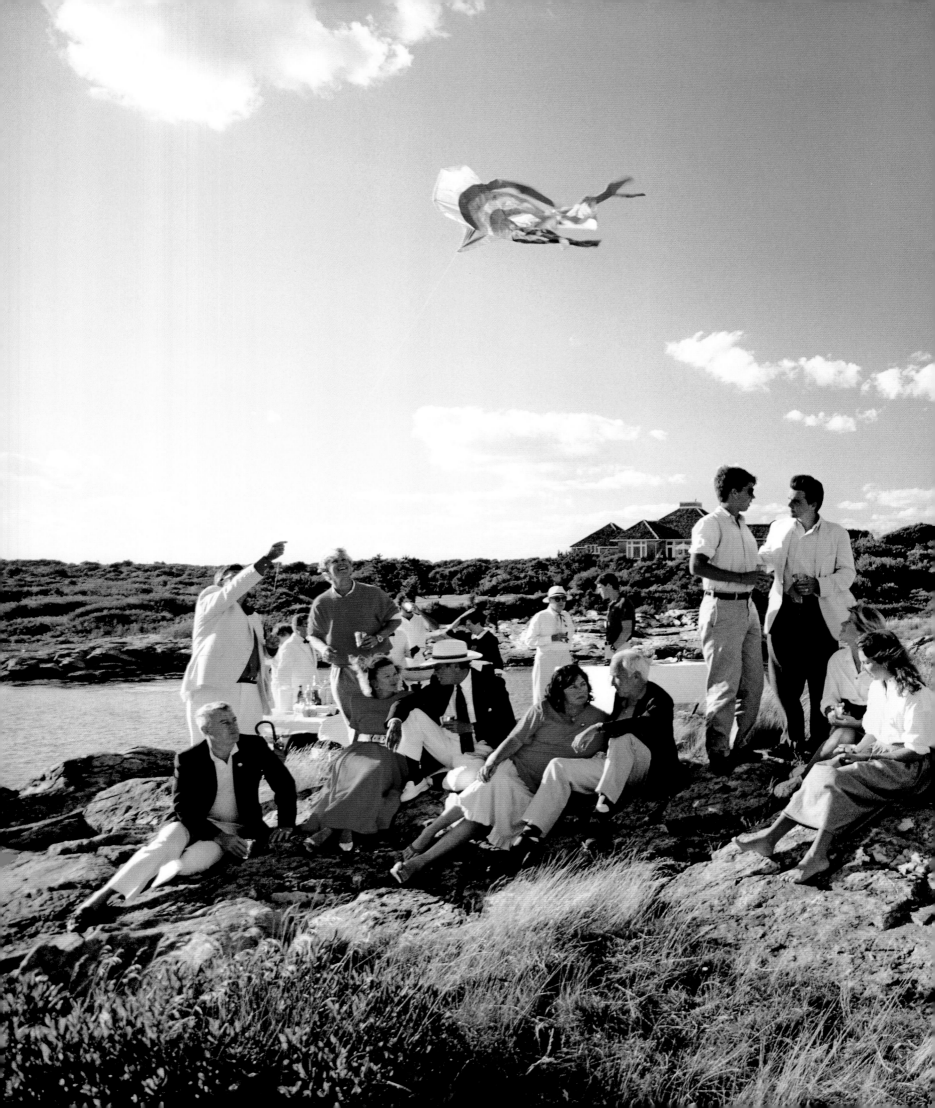

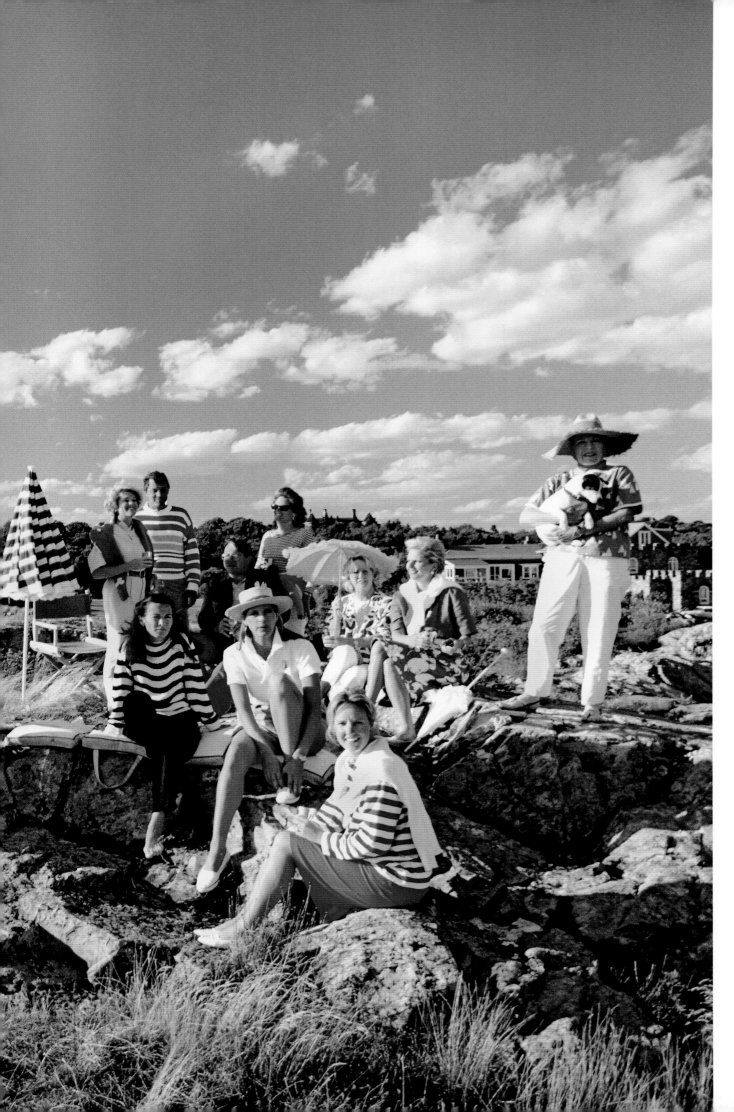

left A picnic organized by Newport summer resident Rudulph Ellis Carter, American diplomat and president of the United States Croquet Association, 1987.

following spread left Henry B. Cabot Jr. (in black) and his host, Barclay "Buzzy" H. Warburton III (in striped shirt), sail off the North Shore of Boston aboard the brigantine *Black Pearl*, 1959.

following spread center A party aboard the racing ketch *Ondine* in Bermuda, 1970. The custom-built high-tech sailing yacht was commissioned by champion ocean racer Sumner "Huey" Long and was one in a succession of Ondines he used to capture every major ocean racing cup during his three-decades-long racing career.

following spread right Colorful holidaymakers aboard a yacht in Bermuda, 1970.

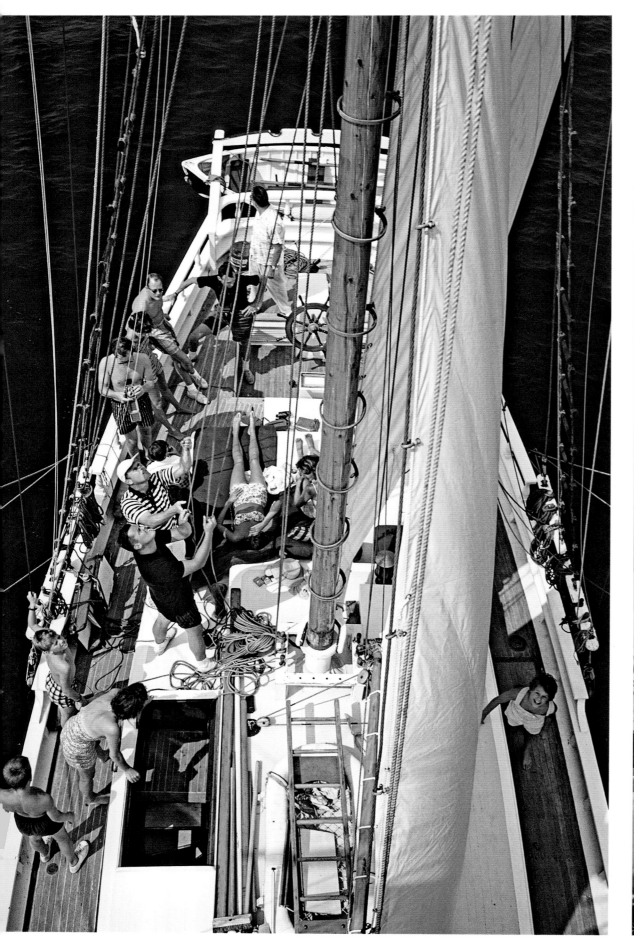
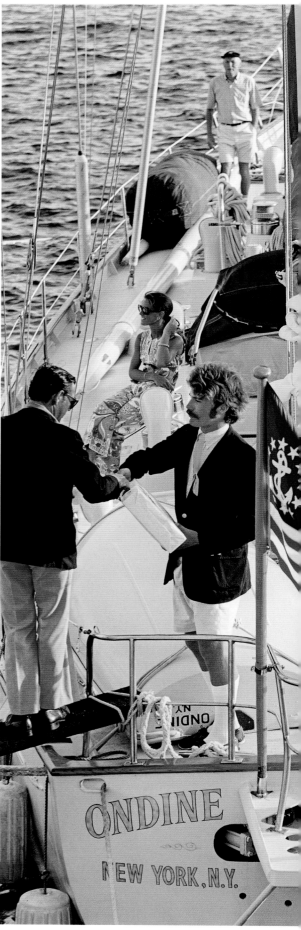

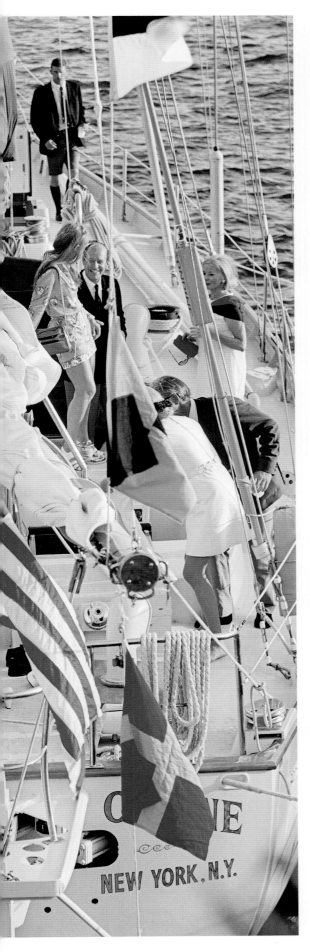

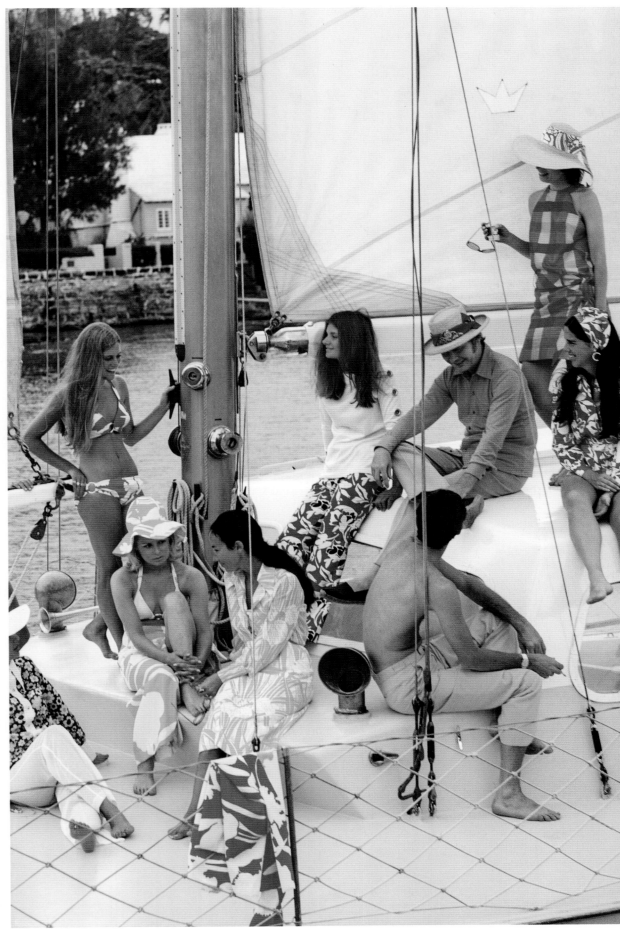

Millionaires' Playground

Before Aarons discovered Newport and Capri and the more glamorous summer destinations favored by American socialites, he ventured north to the Canadian border, where East Coast families had carved out an angler's paradise they nicknamed "the millionaires colony" in an archipelago of wooded islands known as the Thousand Islands. Stretching from the portal of Lake Ontario down through sixty miles of the upper St. Lawrence River, the islands were often called "a place where a man can find an island the size of his soul."

The purified spring water that flows under the St. Lawrence River initially attracted the Iroquois Indians, who called the cluster of 1,800 islands "Manitonna," or "Garden of the Great Spirit," before the French put them on the map in the nineteenth century. By the early twentieth century, the zigzag of islands over the New York State border with Canada was a boon to prohibition bootleggers, and dogged fishermen who often found themselves in the wrong waters with the wrong license. By the late 1940s, vacationers like Sally Benton (opposite) were still drawn to the islands for their privacy and rustic beauty.

Not only was it hard to get to the islands, but many of them—known simply as "The River"—were only big enough for one house. The Thousand Islands Club on Wellesley Island was a favorite summer stomping ground of corporate bosses, while the more private islands had names like "Island 793" or "Wolfe" or "Tom Thumb." In these waters the preferred mode of transport was hydroplanes or small motor boats known as pickerel chasers.

Alexandria Bay is the main town where the "millionaires" of the early twentieth century came to set up house in huge Victorian homes with names like Calumet Castle, which was built by tobacco heir Charles G. Emery. The hotel magnate George C. Boldt allegedly created the area's namesake salad dressing and served it at his New York City hotel, the Waldorf Astoria. He built Boldt Castle in the style of a Rhine castle for his wife, who died before he could finish it, leaving the place a shell.

World War I dealt a fatal blow to the Islands' "millionaire" values, and by the time Slim Aarons showed up, they had become less exclusive, filled with "popular, not pompous" vacationers. But one stand in particular still maintains its exclusivity: Deer Island, owned by Yale University's infamous Skull & Bones Club, is said to be the site of the security society's mysterious initiation ceremonies.

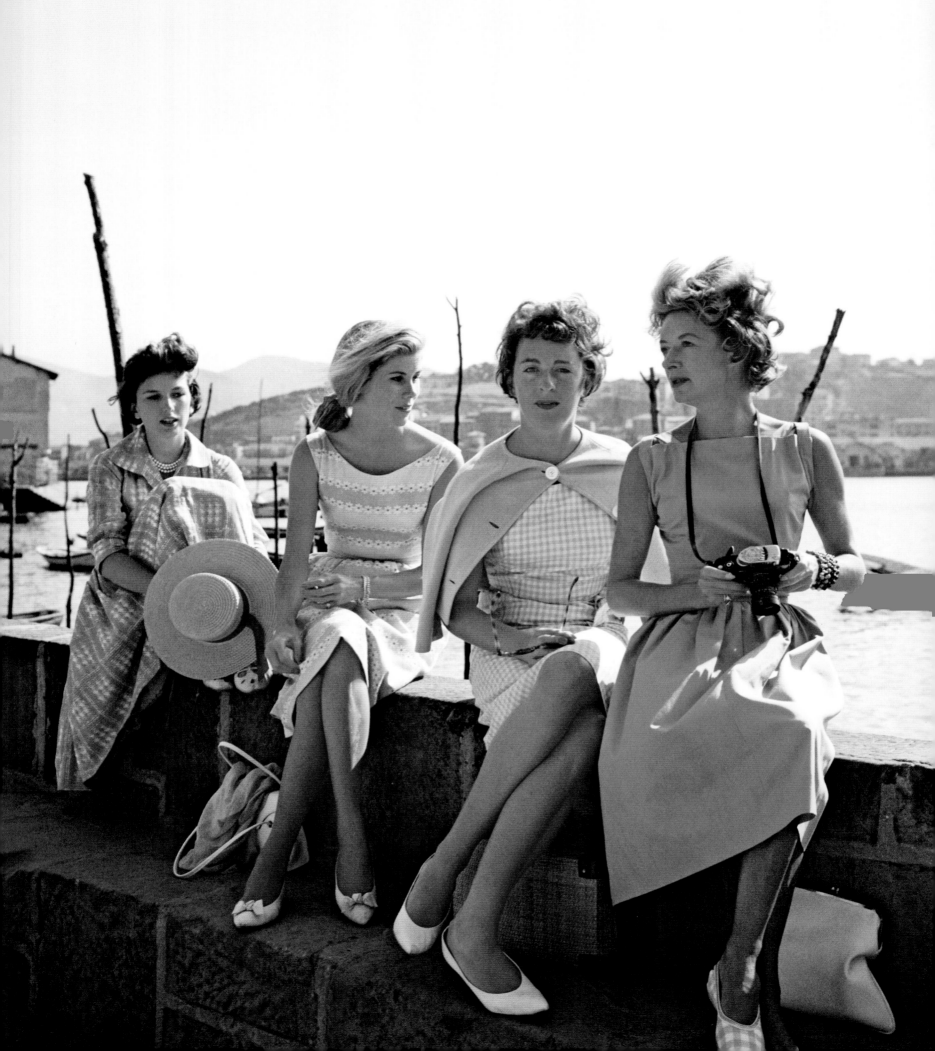

opposite Heiress Nonie Phipps and friends on the waterfront in Biarritz, France, 1960.

above left Viscountess Harriet de Rosiere at Mougins, near Cannes. Born in Columbus, Ohio, and educated at Vassar, she married Viscount Paul de Rosiere, a French nobleman and executive with Cartier and Harry Winston. They lived together in Paris, London, New York, Houston, and Palm Beach. A *Town & Country* editor and repeat member of the best-dressed list, the viscountess hosted dinner parties that were among the most chic in Paris.

above right Brazilian billionaire philanthropist Lily Safra at Villa La Leopolda, her home in the South of France, 1991.

right Jerry Zipkin, close friend and confidant to Nancy Reagan, reclines on the lawn at Villa La Leopolda, France, 1991.

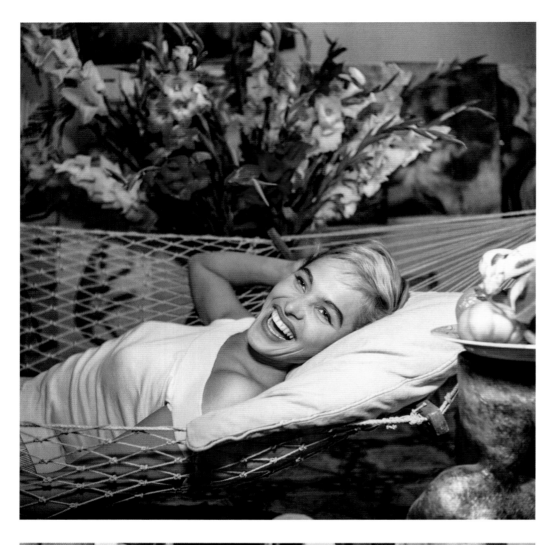

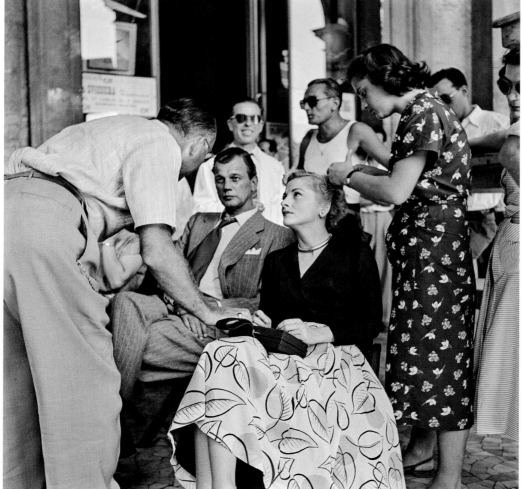

above Swiss actress Ursula Andress in Rome, 1955. Andress's legacy in the histories of fashion and cinema was secured when she emerged from the sea wearing a custom ivory-colored bikini with matching military belt in the 1962 Bond film *Dr. No*.

left Actress Joan Fontaine, born Joan de Beauvoir de Havilland, and her co-star Joseph Cotten receive direction while filming *September Affair* on location in Rome, 1949. The film's costumes were designed by eight-time Academy Award winner Edith Head.

opposite Lucille Armstrong takes control of the Vespa as her husband, Louis Armstrong, is otherwise occupied while on a Roman holiday, 1949.

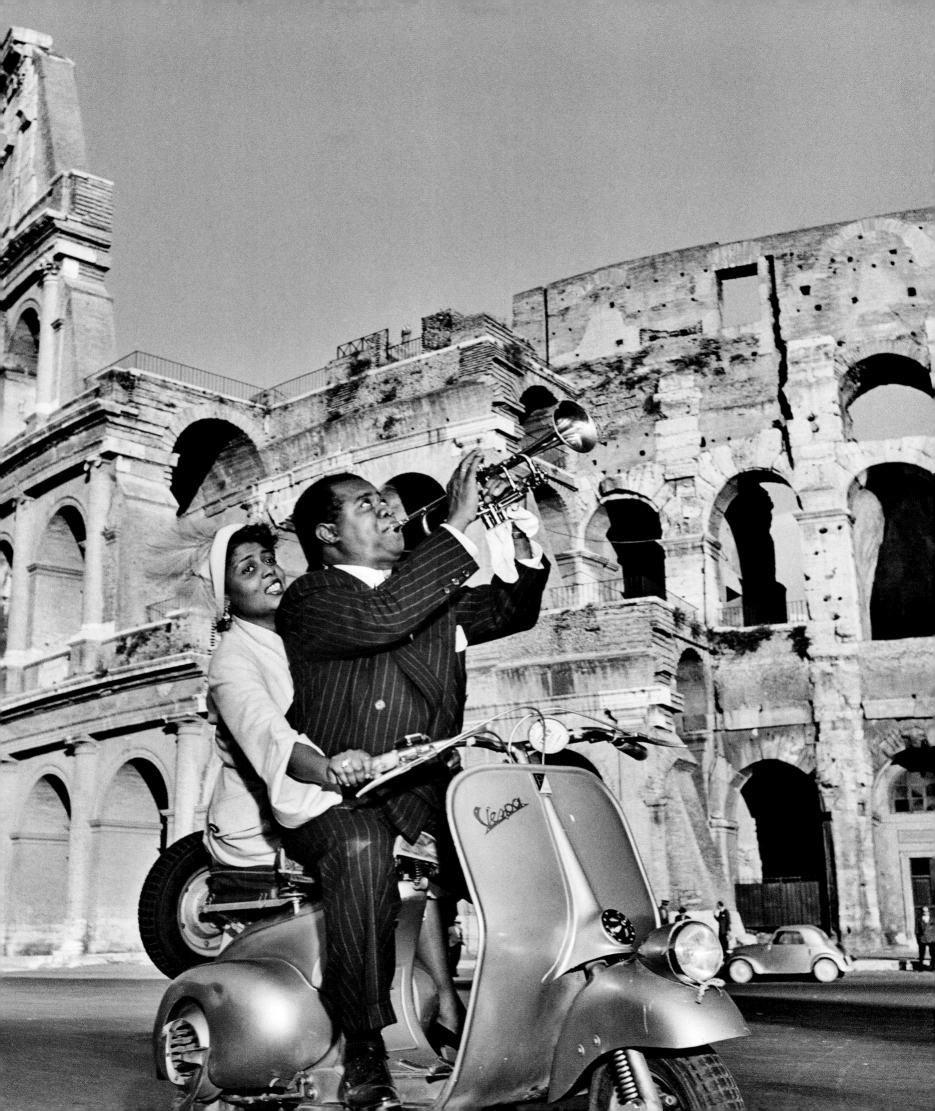

French Savoir Faire

It was the photographer Jacques Henri Lartigue who discovered that French resort towns were a natural locus of style in the 1920s and '30s. Known as a society photographer, Lartigue followed the seasons of style, spending winters in ski resorts like Chamonix before heading south in the summer to shoot the rich and glamorous in resorts along France's Cote d'Azur, where film stars, playboys, and artists mingled with belle époque socialites and demimondaines.

In 1958 Aarons also traveled to the Cote d'Azur, stopping first at Cannes, the visually lush and kaleidoscopic town with its intoxicating mix of glamorous pleasure seekers and local shopkeepers playing their favorite boules pitch. Like other summer visitors, Aarons was attracted to the bikini-clad beachgoers, like the woman seen here, at Cannes's Carlton Hotel, the lovely smell of jasmine on the terraces, and the feathery, yellow-fluffed mimosa growing in the hills above the *croissette*. Like Lartigue before him, Aarons was following an earlier generation of aristocrats who had stopped in Cannes in 1834 on their way to Italy, where the cholera epidemic had run rampant. They found the place so intoxicating, they stayed, and then kept returning every winter for the balmy night air, the wild lavender, rosemary, and thyme, and the exotic villas built into the terrain along the glittering promenade.

Through the 1960s and '70s Aarons would return to the French coast in search of style, photographing all of it—the topless sunbathers splayed out on the decks of yachts parked in Monaco, celebrities in town for the annual film festivals, and the comings and goings of guests visiting the medieval castles hugging the hills above the fishing villages. It was in these extravagant villas where Aarons encountered celebrities like Maurice Chevalier, the Aga Khan, and Picasso. They would convene in the terraced villas such as the sumptuous Villa Dubeau in Cap d'Antibes, or the Villa Iris in Villefranche, which was owned by the French Royalist Bourbon-Parma family. Guests—sometimes up to eighty at a time—would arrive by car and boat and while away the afternoon swimming, drinking, and eating. They wore casual "play clothes" and held forth over long, languid lunches of bouillabaisse and rosé. The French called this part of the Riviera *La Californie* for its Spanish architecture and exotic gardens filled with gum trees, cottonwoods, and baobab trees. And the style of the place—that nonchalant chic only the French have truly mastered—perfectly mirrored the natural surroundings.

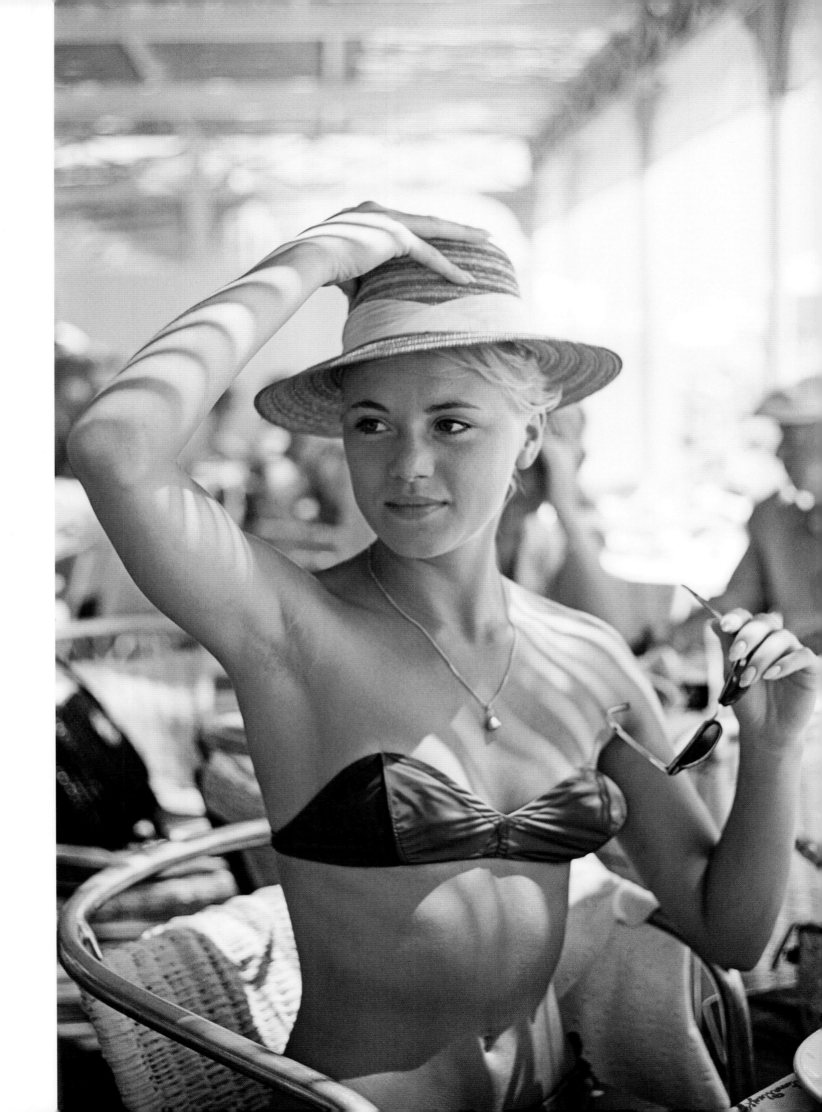

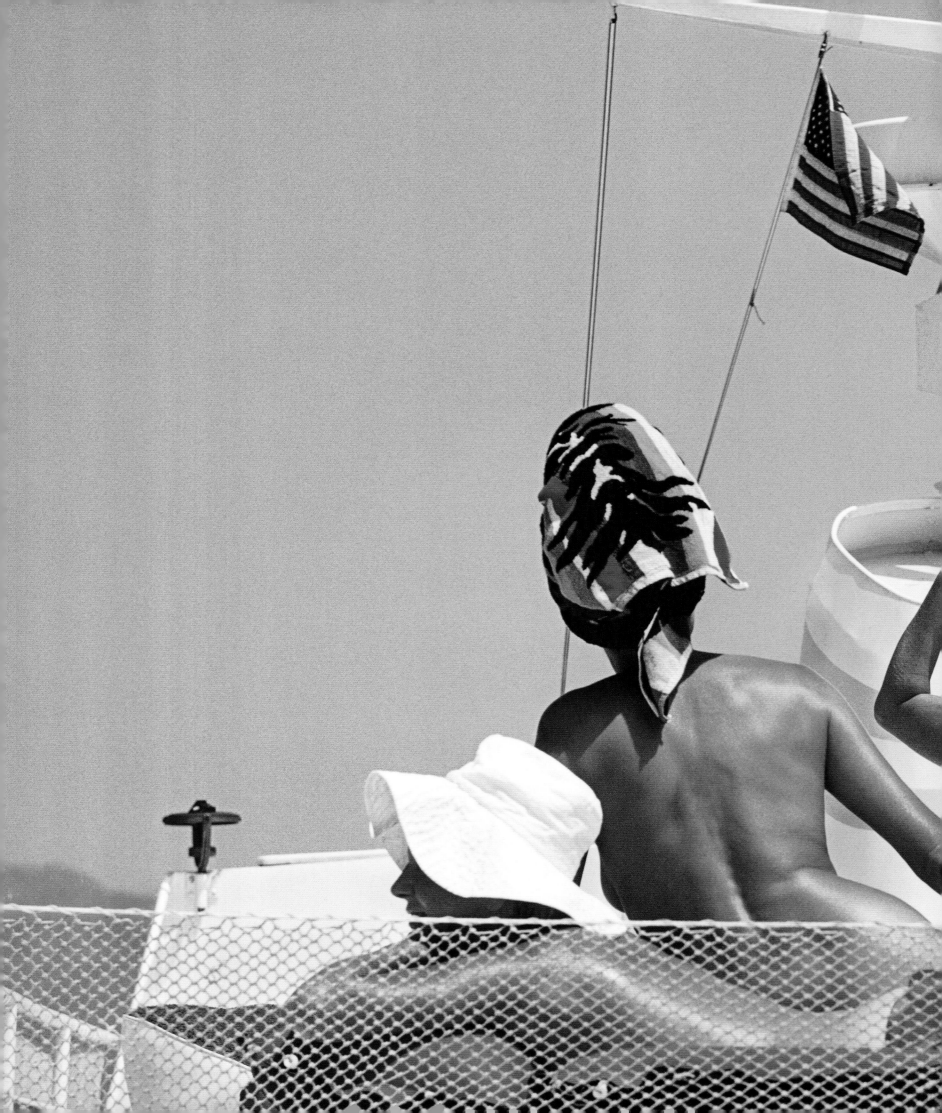

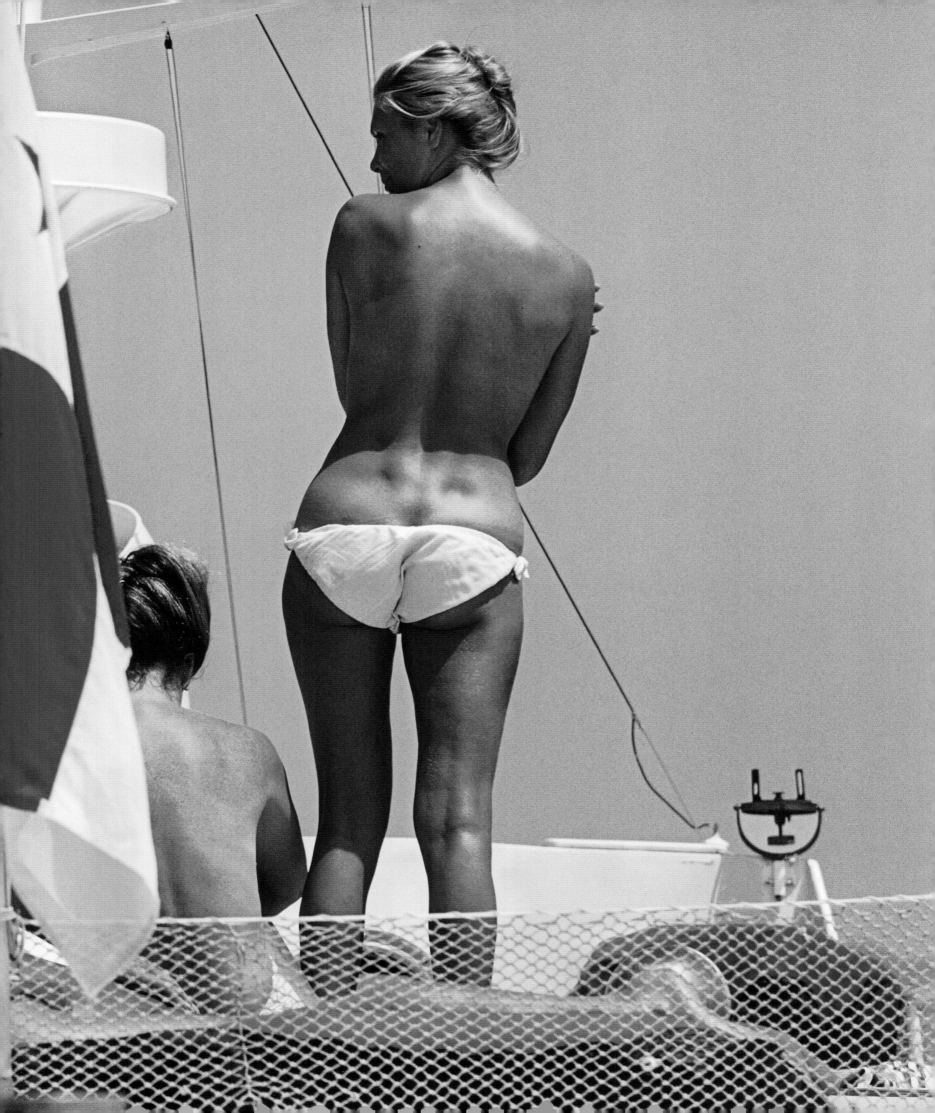

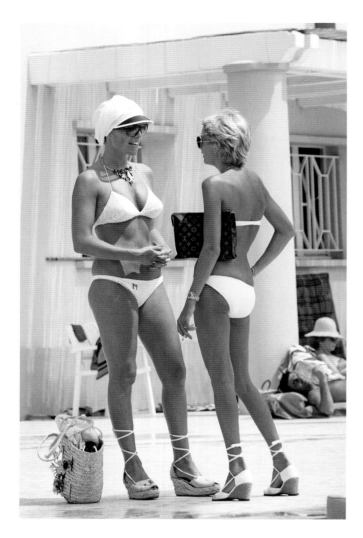

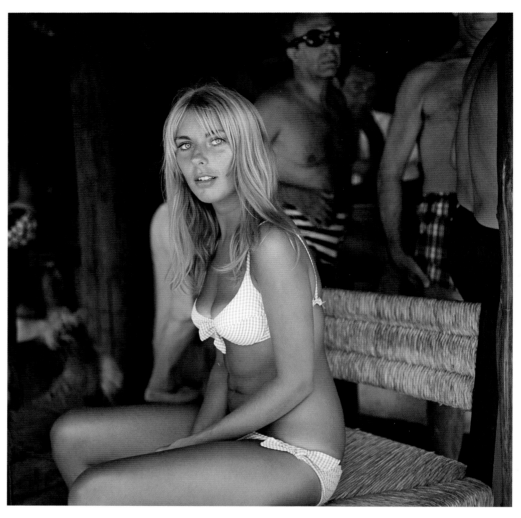

While two-piece suits had been regularly worn for decades, the bikini's low slung, navel-baring bottom pushed the suit into risqué territory.

preceding spread Guests tanning on the deck of Count Ferdinand "Dino" Pecci-Blunt's yacht in Marbella harbor, 1967.

above left Matching poolside style in Monte Carlo, 1975. The espadrille dates back to the thirteenth century, but Yves Saint Laurent brought the shoe roaring back into fashion in the 1970s with his heeled version.

above right A beachgoer takes a respite at the Marbella Club, 1976.

right Dani Geneux (left) and Marie-Eugenie Gaudfrin sunbathe at the Hotel du Cap-Eden-Roc, Antibes, 1976.

opposite Bikini-clad holidaymakers enjoy a glass of rosé outside the Carlton Hotel, Cannes, 1958.

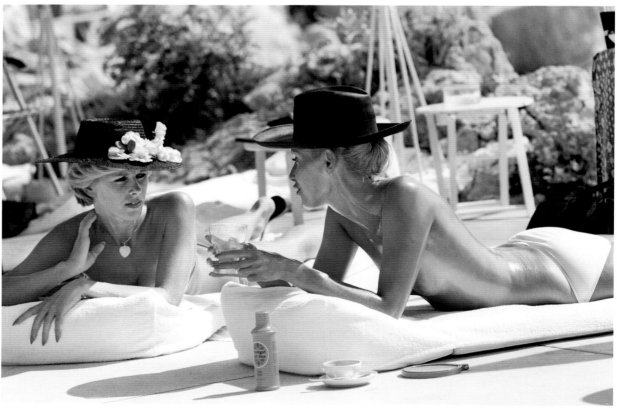

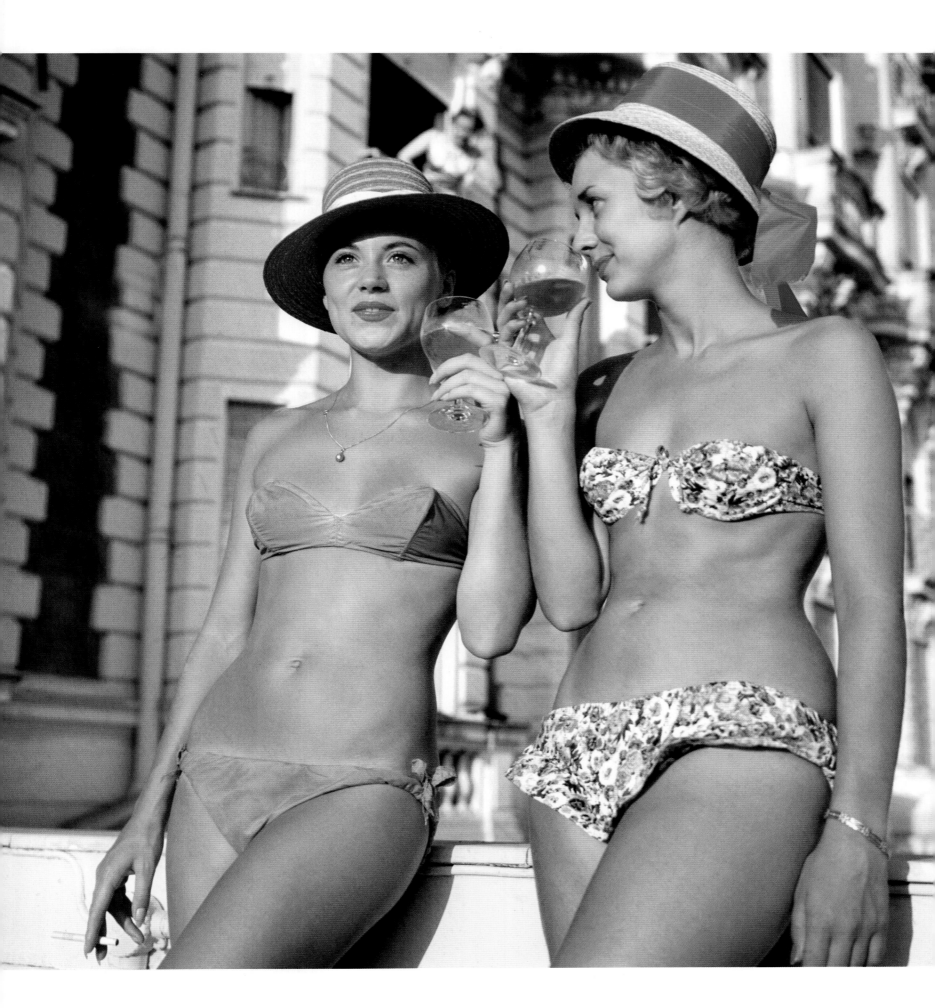

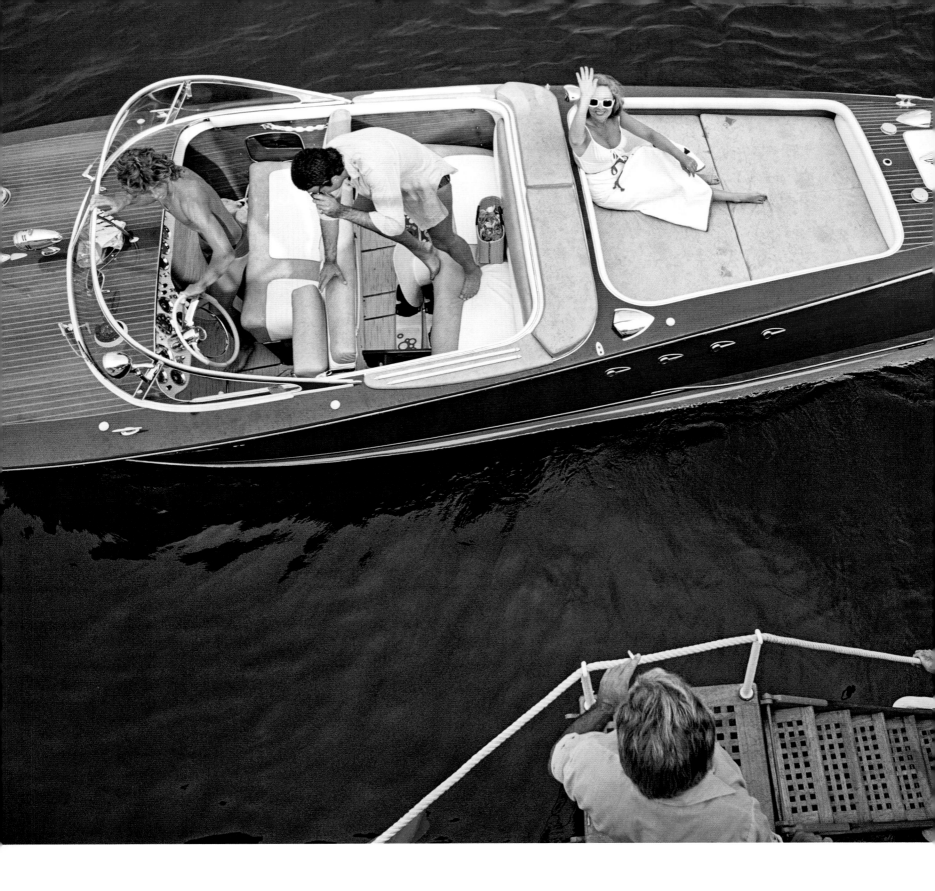

above Ship-to-shore transport aboard a Riva
boat in Monte Carlo, Monaco, 1975.

opposite Summer traffic in Saint Tropez, 1970.

Spanish architectural designer Alfonso Zóbel de Ayala near the pool of his Moorish villa in the sportsman's paradise Sotogrande, Andalucía, Spain, 1975. The white marble pillars are from the late seventeenth century and were brought from the ruins of a small palace near Seville.

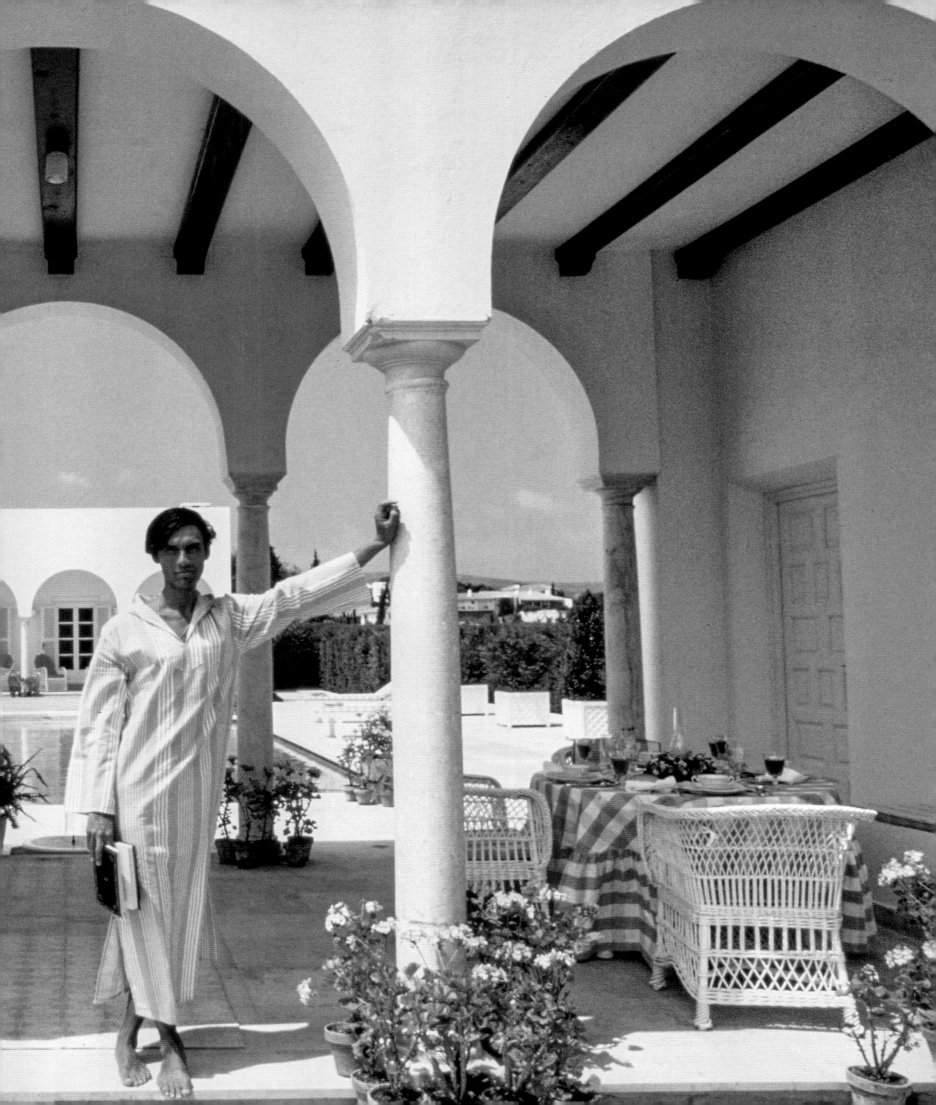

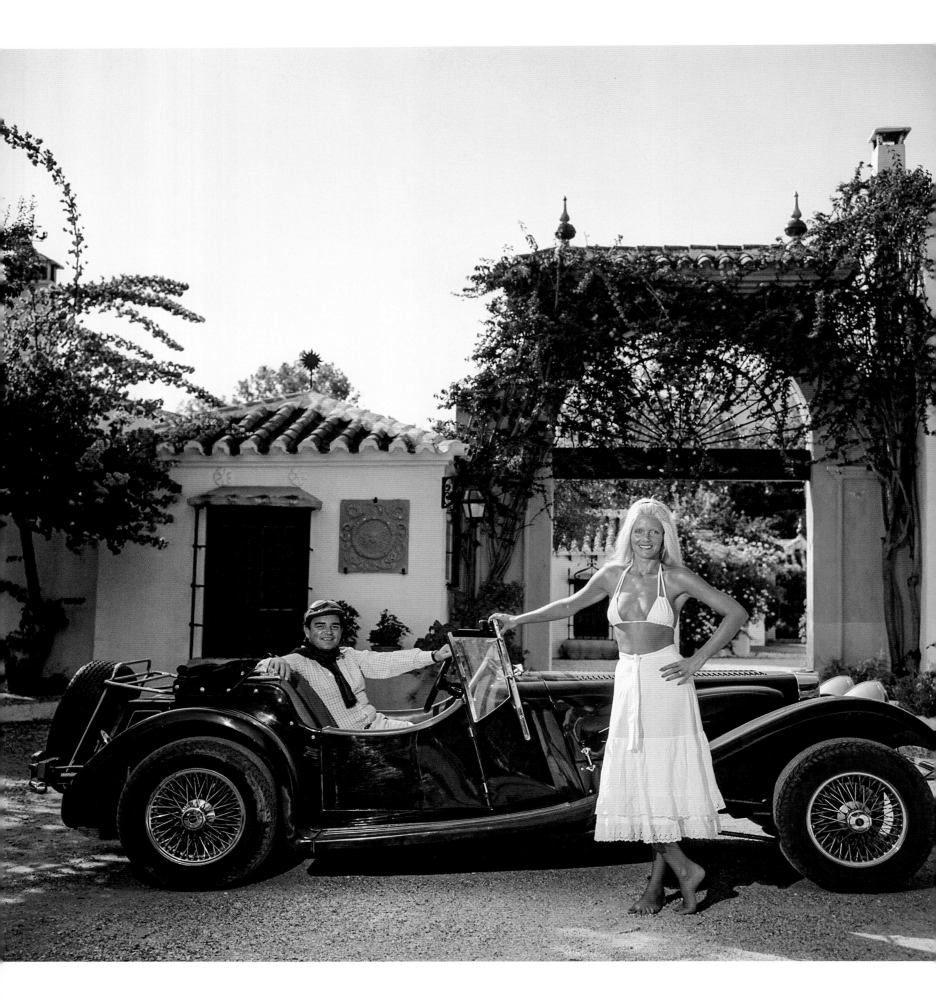

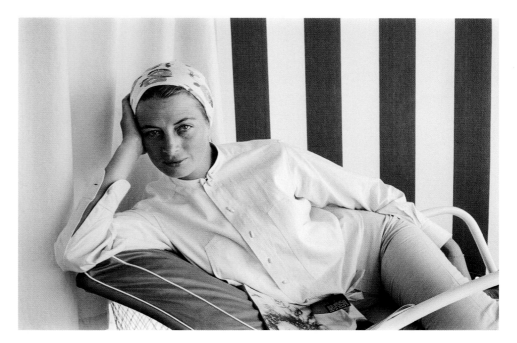

opposite Countess Gunilla von Bismarck and Marbella Club director Count Rudolf Graf von Schönburg, widely known as Count Rudi, in a Panther J72 automobile, 1976.

above French actress Capucine (Germaine Lefebvre), looking fresh faced after a day in the sun on holiday in Monaco, 1957.

right Count and Countess Jaime de Mora y Aragon at their farm near Marbella, Spain, 1980. The Count, who was nicknamed Uncle Jimmy, was the unofficial king of Marbella. He, along with Prince Alfonso de Hohenlohe, transformed the Costa del Sol resort into one of Europe's most glamourous destinations by convincing displaced royals, film stars, businessmen and Arab sheikhs to holiday there. In the 1970s, Jaime de Mora managed public relations for arms dealer and owner of the world's largest yacht, Adnan Khashoggi. He and the Countess, a Swedish model, were married in 1962; they separated and reconciled three times before finally making it official with a full Catholic ceremony in 1978.

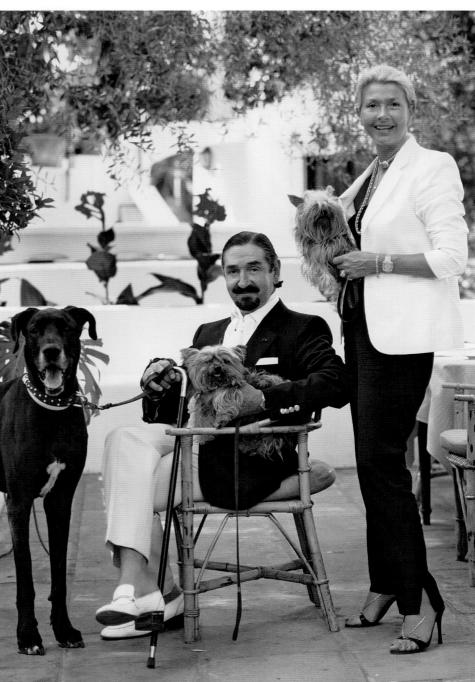

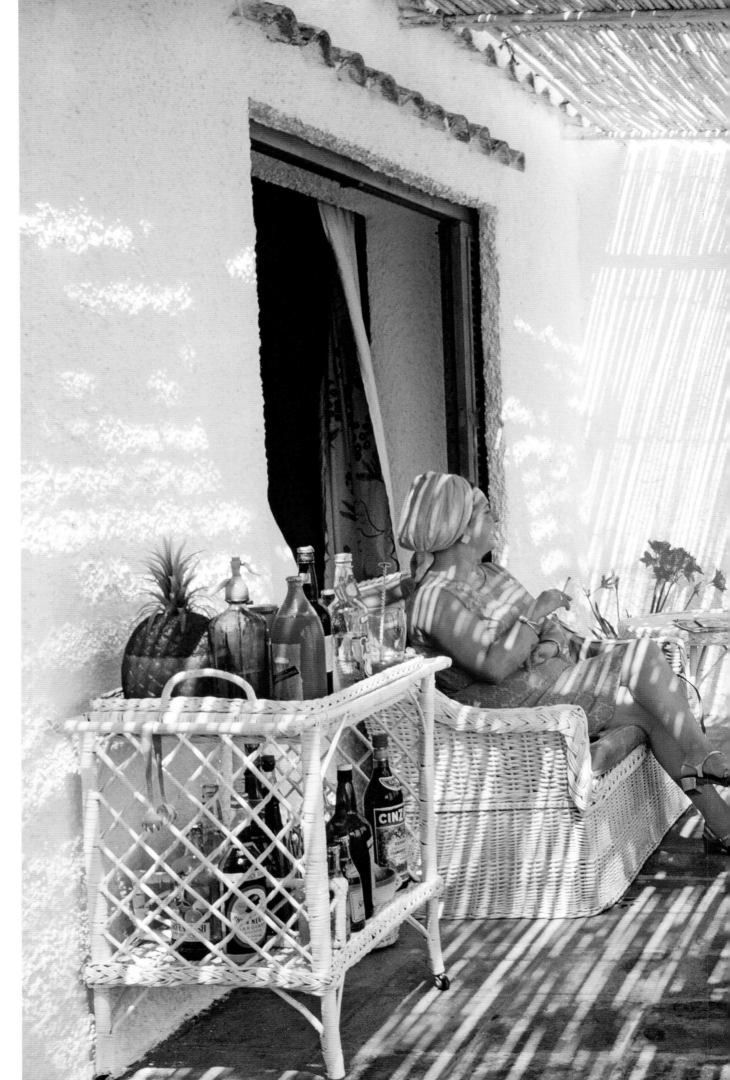

Marquesa de Villalobar, née Isabelle de Ligne Noailles (in turban) is joined by friends, including Princess Patricia Anne zu Hohenlohe (center) at Las Jacarandas, her home in Marbella, 1967.

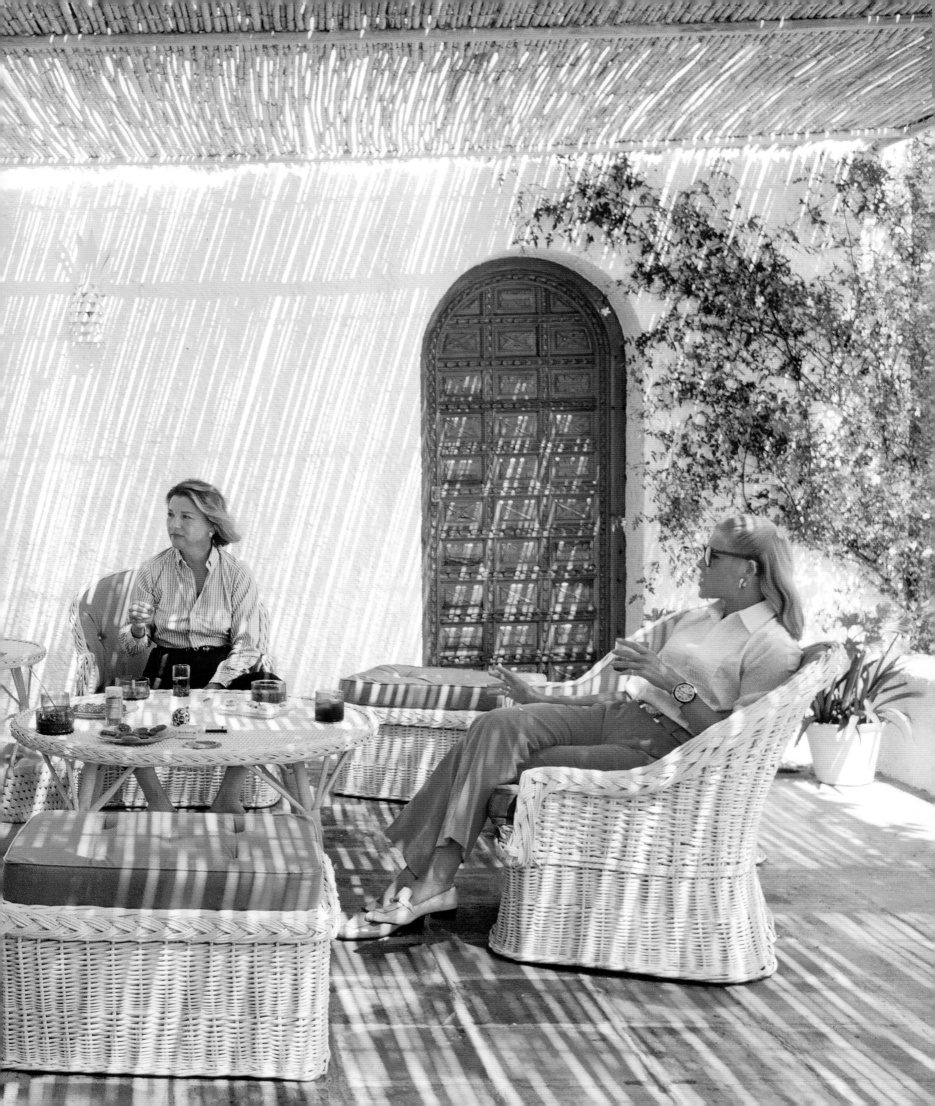

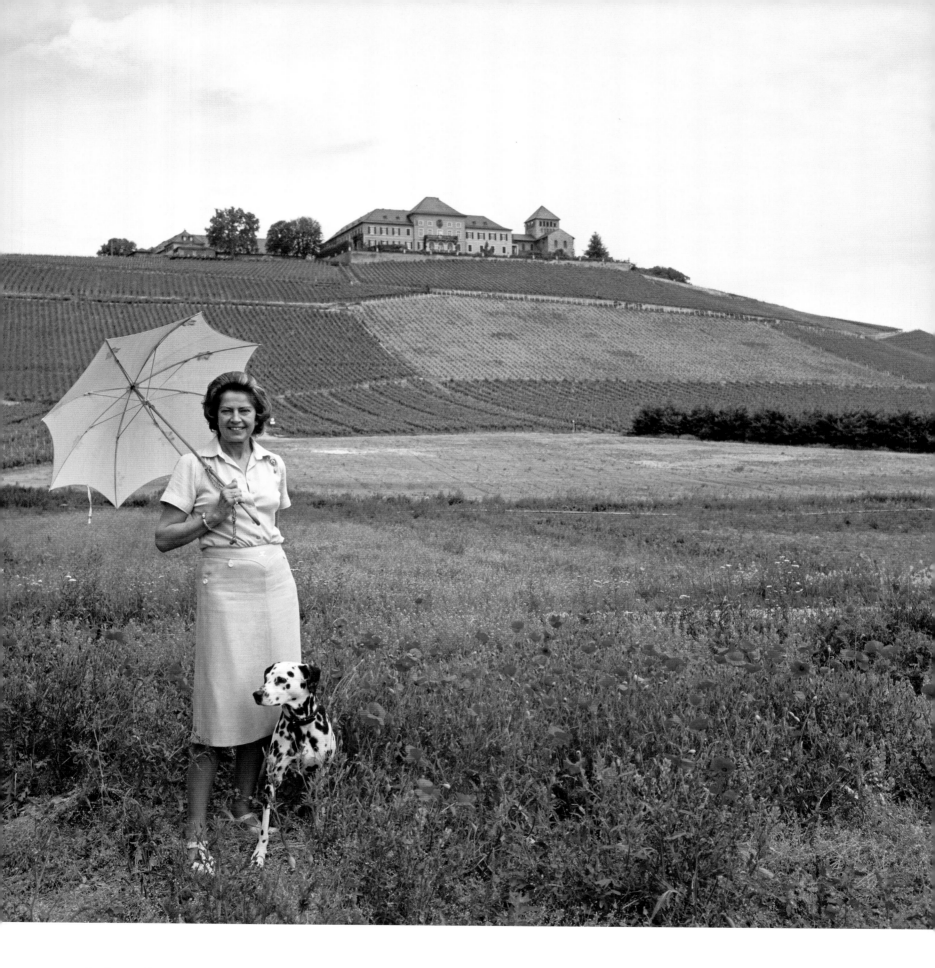

Her Serene Highness Tatiana Furstin von
Metternich-Winneburg at Schloss Johannesberg,
her family estate and the birthplace of Riesling.

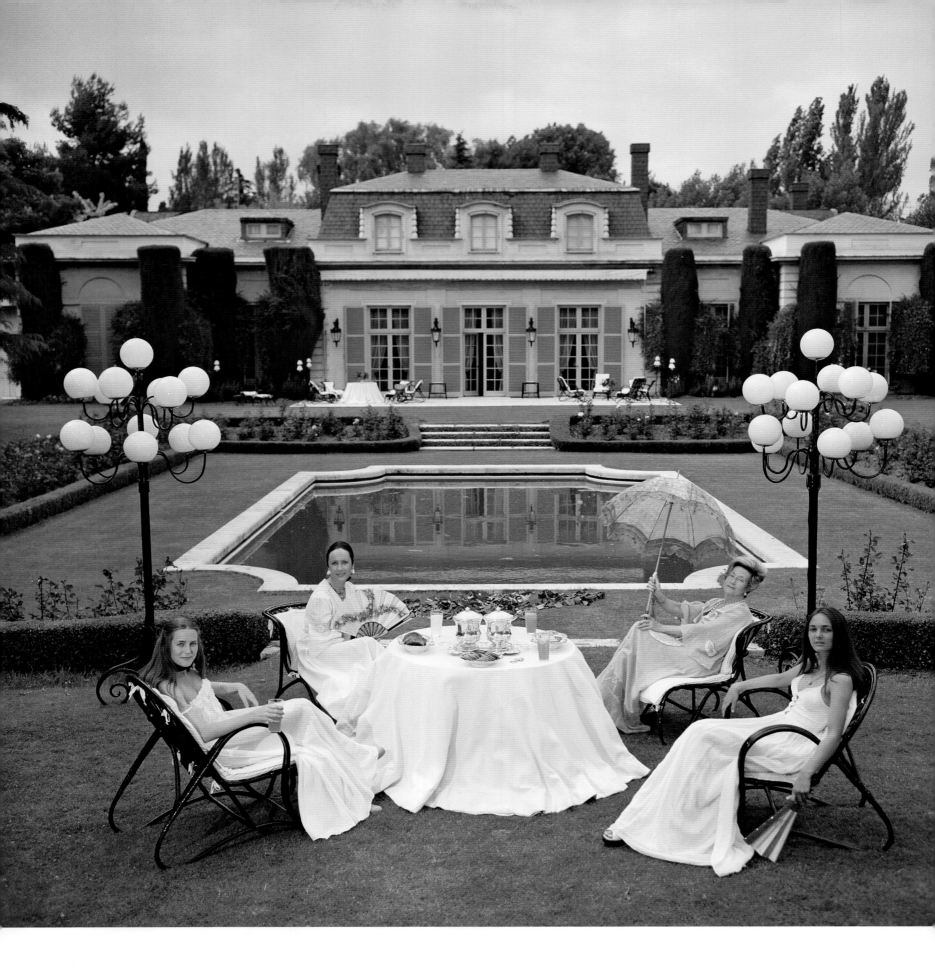

Dowager Countess of Romanones Blanca de Borbon (with parasol) with her daughter, the Marquesa of Tamarit, and granddaughters at the Countess's home in Madrid, 1976.

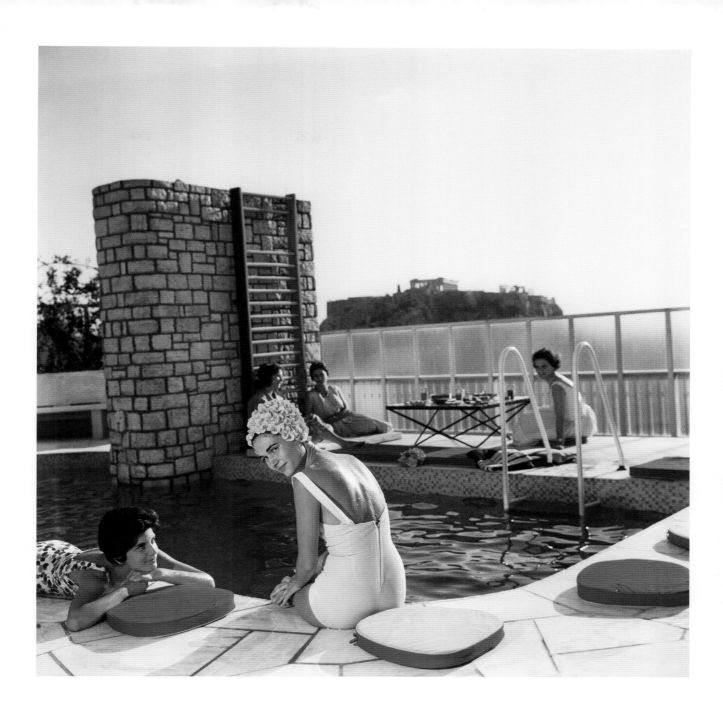

left Dimitris Kritsas, a young Greek couturier, shows off his latest collection among the gleaming Doric columns of the temple to Poseidon at Sounion, 1961. This is one of Slim's last shoots to incorporate hired models.

above The rooftop pool above the Athens home of antiquities collectors Paul and Alexandra Canellopoulos, 1961. The couple's vast collection was donated to the Greek state in 1972 and their former home turned into a museum.

following spread Miss Lilian Hansen poolside while on holiday at the Burgenstock Resort, Switzerland, 1955.

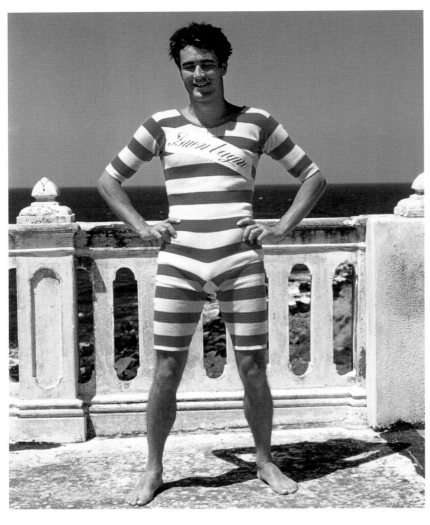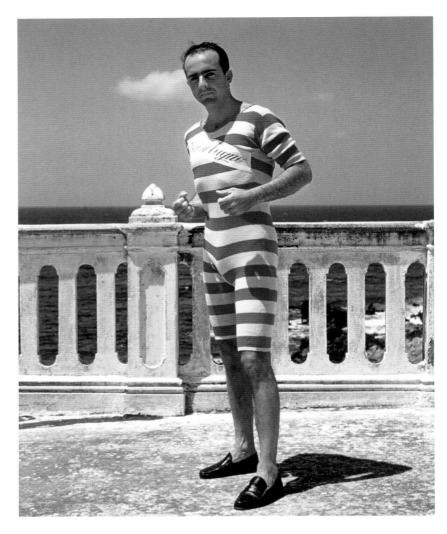
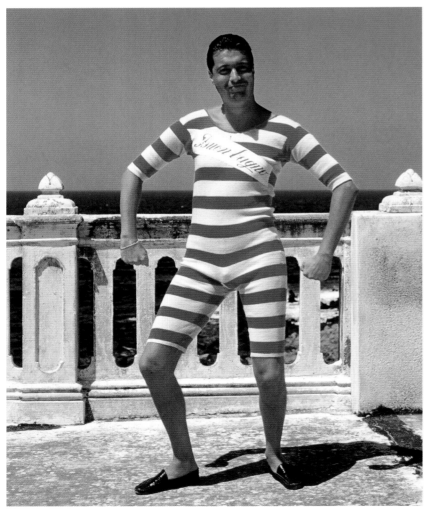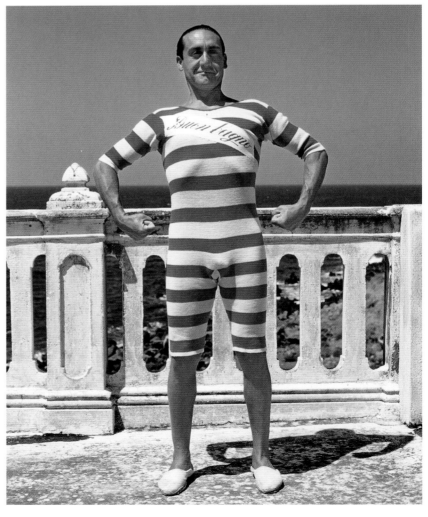

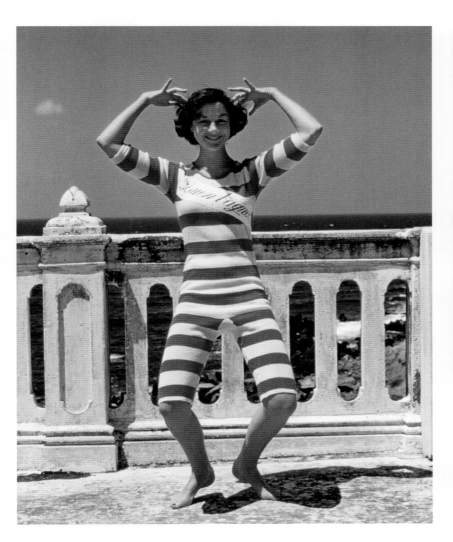

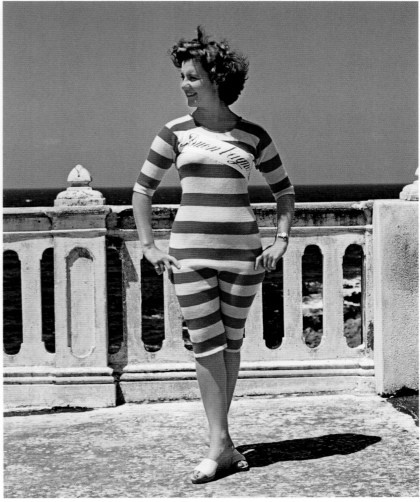

Young Italian nobles and friend enjoying the summer on the island of Sicily, 1954. Their one-piece suits, worn for a bit of fun, read Buon Bagno. They spent the summer traveling from Rome, first by island hopping in the Tyrrhenian Sea, followed by a week in Capri, then Portofino, and finally to Venice.

From top left, they are: Conte Don Andrea Hercolani, the 10th Prince Hercolani; Prince Lillio Sforza Ruspoli; Contessa Consuelo Crespi; Countess Marina Cicogna; Count Rodolfo "Rudy" Crespi; and professor Mario Sposito.

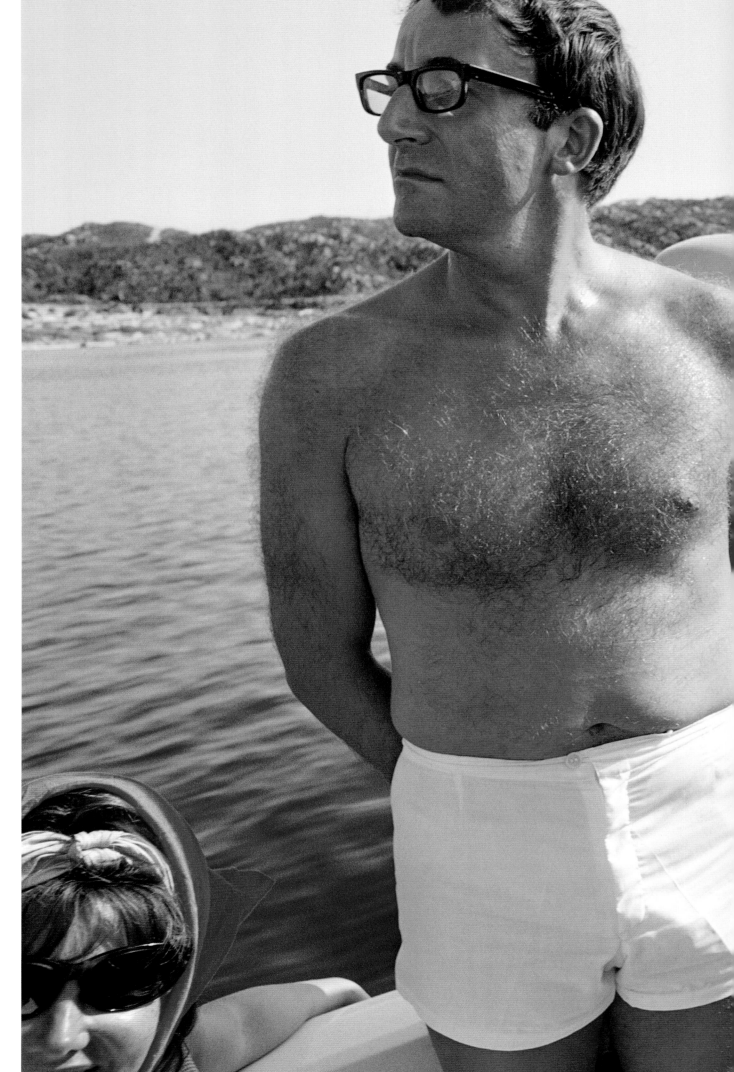

Comedian Peter Sellers, Dolores Guinness (in white), and Princess Margaret aboard a tender, *Costa Smeralda*, 1967. The princess and Lord Snowdon often spent three weeks in August aboard the Aga Khan's yacht *Amaloun* to celebrate her birthday. In 1964, newspapers reported the *Amaloun* ran aground and began taking on water; the royal pair was asked to don lifejackets and jump overboard to be ferried ashore. The boat was later towed away for repair, and the incident was never confirmed nor denied by any of the parties involved.

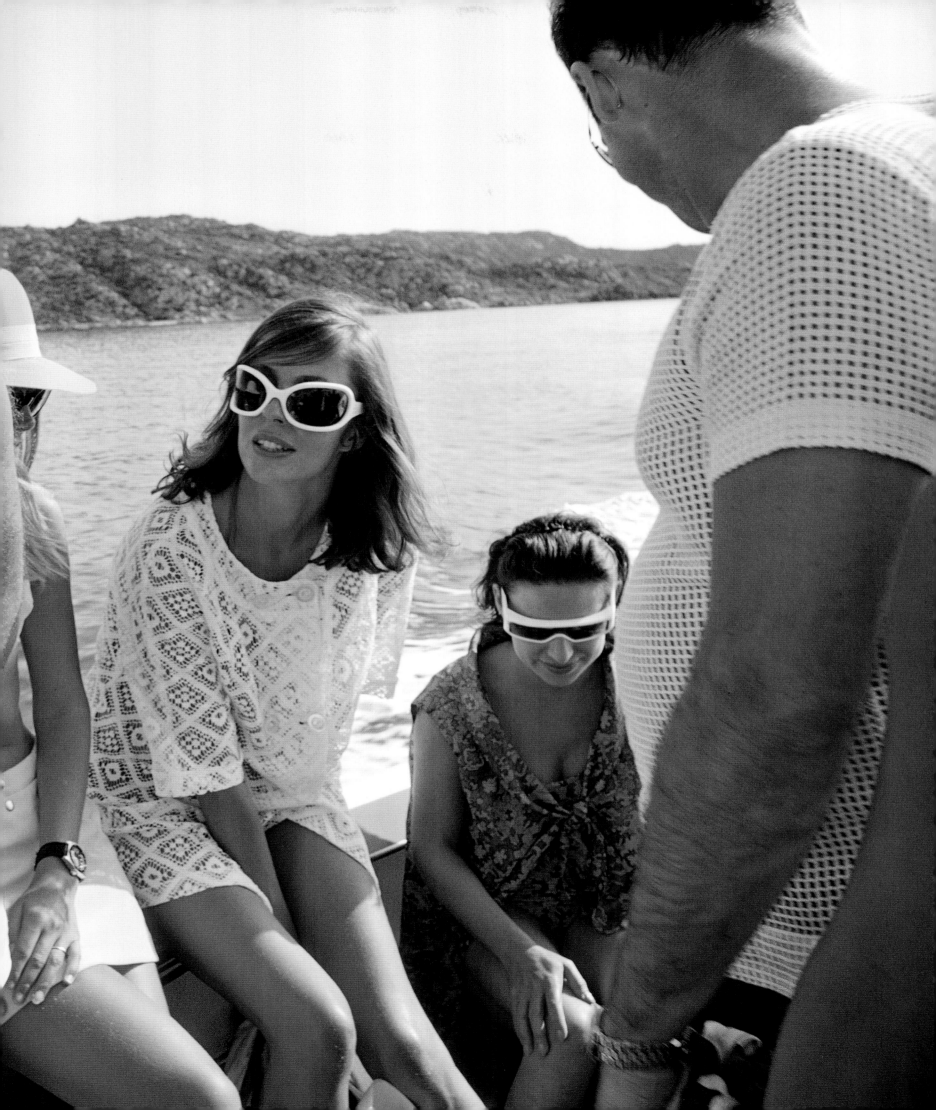

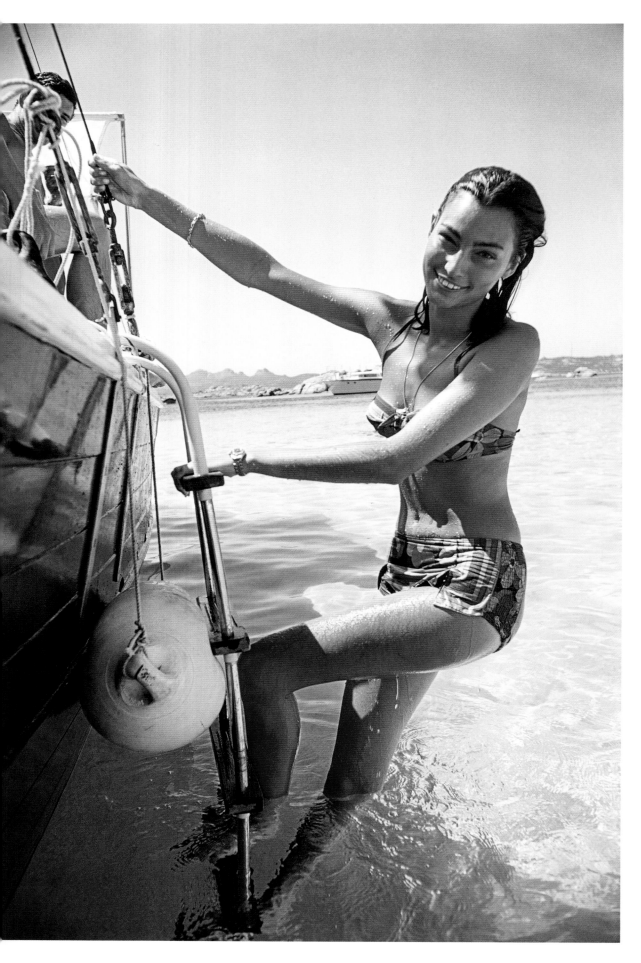

left Selvaggia Borromeo d'Adda, one of the late '60s "It" Girls, enjoys a yachting holiday on the Costa Smeralda in Sardinia, 1967. *Town & Country* described her as "slender-slender, endlessly chic, and as any fool can see, ravishingly beautiful."

opposite above left German-born socialite Dolores Guinness in the Costa Smeralda, Sardinia, 1965.

opposite above right Brazilian actress Florinda Bolkan in Porto Rotondo, Sardinia, 1983. The actress was discovered by Visconti and appeared in the director's celebrated historical drama *The Damned.* A favorite among the art-house crowd, Bolkan excelled at playing unconventional roles. Throughout the 1960s and '70s she was romantically involved with the photographer and film producer Countess Marina Cicogna, granddaughter of Count Giuseppe Volpi, at one time the richest man in Italy.

opposite below left Italian photographer Elisabetta Catalano, who was mentored by Slim, checks her makeup in a hand mirror, Porto Ercole, Tuscany, 1969.

opposite below right Pilar Crespi and her mother, the American-born Countess Consuelo Crespi, in Costa Smeralda, Sardinia, 1968.

following spread left Italian fashion designer and socialite Marta Marzotto spins a James Brown record at home in Tuscany, 1969.

following spread right Bianca Volpato sun worshipping on Capri, 1958.

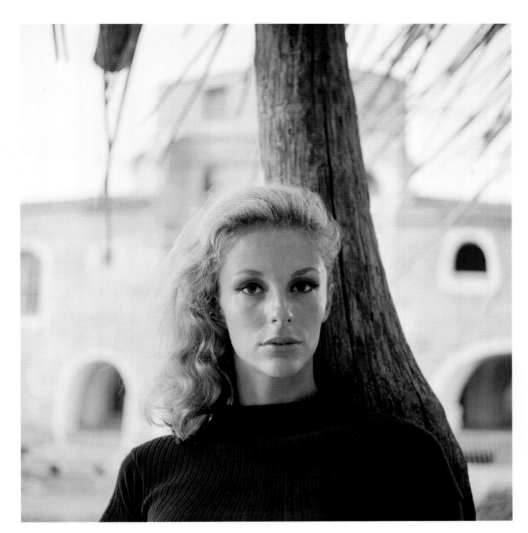

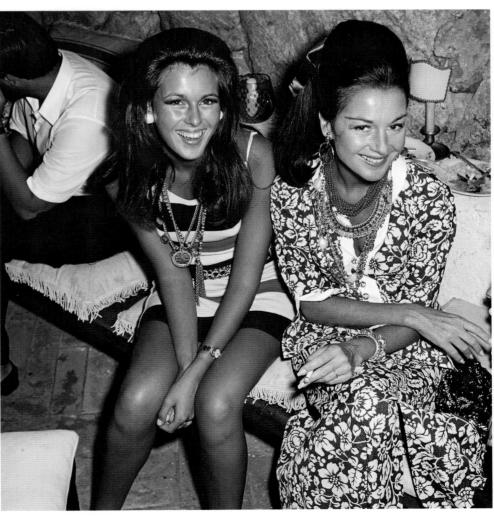

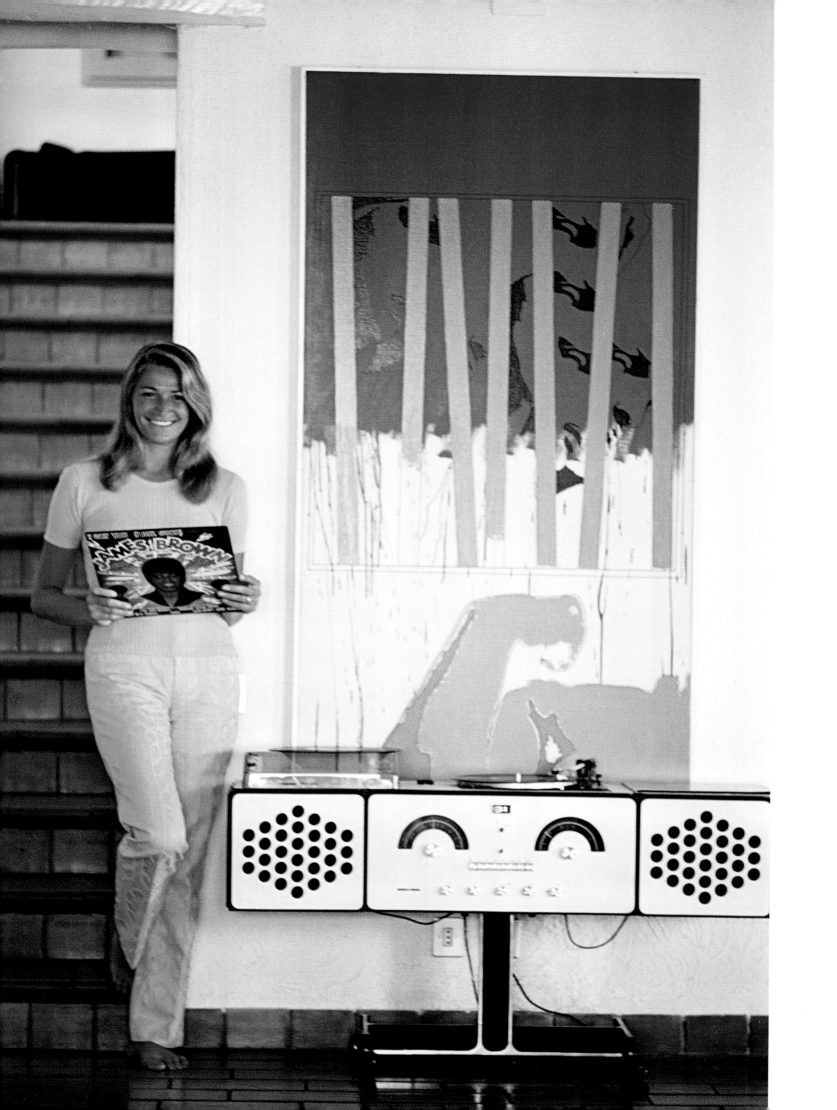

"A Slim Aarons photograph is simultaneously a dream and an invitation; I want to escape right into his world."

—TORY BURCH

Dolce Far Niente

No one destination sums up summer style as neatly as the glamorous island of Capri, where Aarons traveled frequently to shoot European and American regulars who flocked to the island to misbehave and soak up a bit of the Italian "do nothing"—or *dolce far niente*—spirit. A short ferry ride from the Bay of Naples, Capri was once best known as the hedonistic playground of Tiberius Caesar, the second Roman emperor, who retreated there in 26 CE. More recently, as crowds of Roman *ragazzi* and American tourists take their afternoon apertivo on the piazzetta or stroll through the winding Via Camerelle on their evening *passegiatta,* it's hard not to notice the stylish uniform of bejeweled sandals and colorful long, flowing caftans. Or to recall images of Jackie Onassis arriving with her sister Lee Radziwill, wearing a bright silk scarf wrapped around her head and a pair of giant dark sunglasses. Later, on her annual pilgrimage to the Italian island, she would make headlines, leaping off a boat or strolling in the back streets with Aristotle Onassis in tow, her crisp white Capri pants the perfect summer uniform.

Capri's crowded streets and whitewashed houses festooned with great bursts of pink bougainvillea have always invoked a festive and fashionable mood. From the late 1960s onward, Aarons would visit Capri to follow in the footsteps of style setters like the English photographer Patrick Anson, 5th Earl of Lichfield, shown with a trio of Italians —Donna Ines Theodoli-Torlonia, Marina Ripa de Meana, and Signoria Gancia— in September 1968. That year there was even a fashion show, part of the Mare Moda fashion festival at the Grand Hotel Quisisana, Capri's most exclusive resort.

Aarons also famously photographed sunbathers at the Punta Tragara Hotel, with its views over the dramatic Faraglioni rocks, and the happening Marina Piccola, where socialites would bask and bathe. And he followed celebrities like designer Valentino, actor George Hamilton, and the actress Marisa Berenson as they would arrive at La Canzone del Mare, the luxurious club owned and designed by English singer and comedian Gracie Fields as a hideaway for her friends in the theater and film businesses.

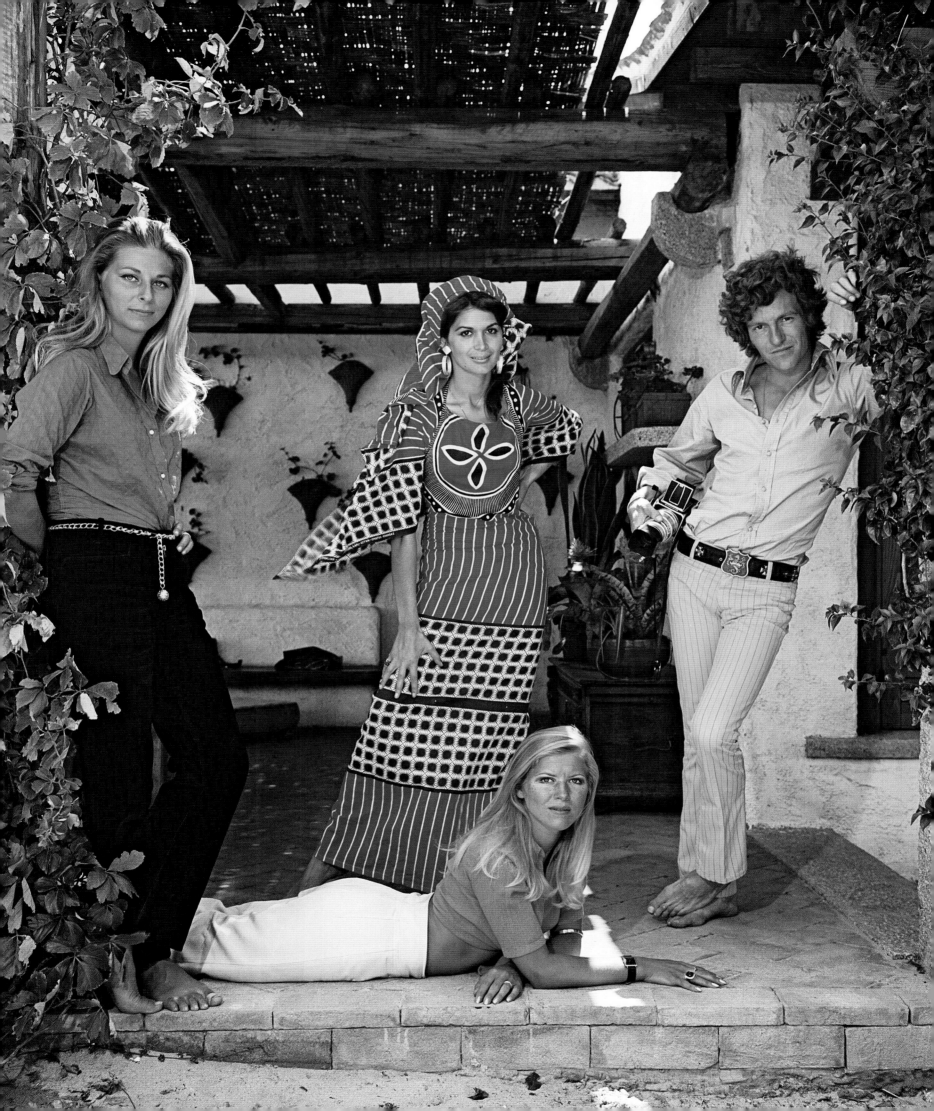

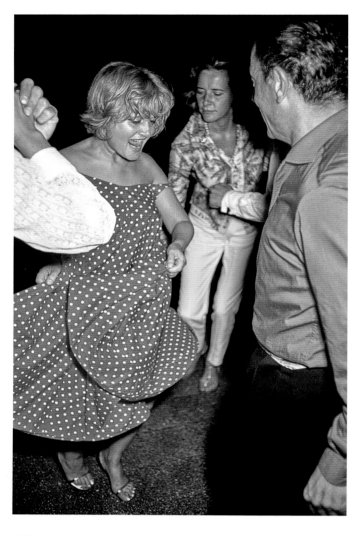

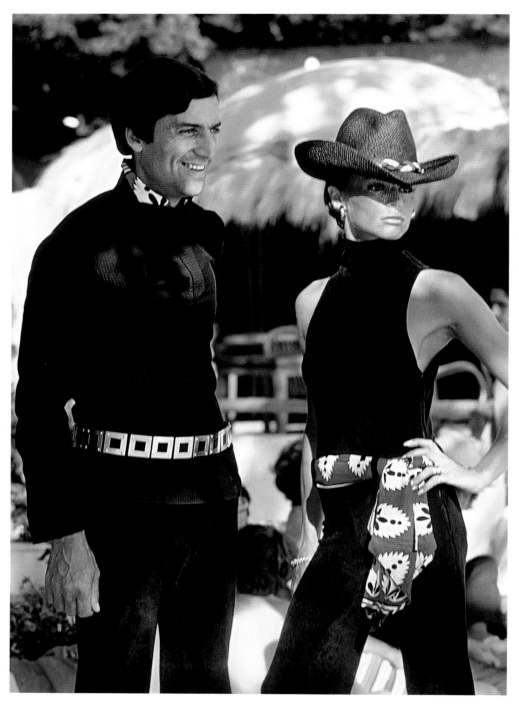

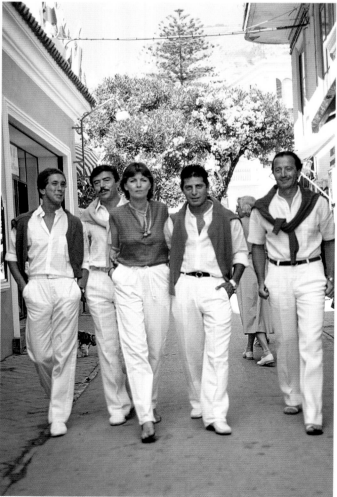

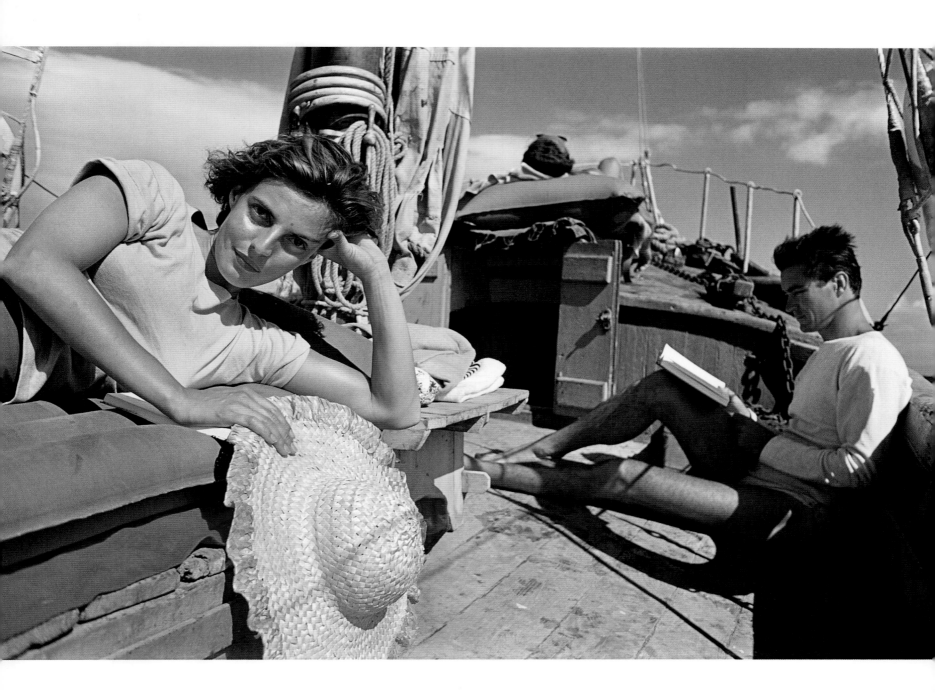

opposite above left Italian artist Novella Parigini cuts loose at a party on Capri, 1958.

opposite above right Designer Nino Cerruti with a model in Capri, 1968. The garment industry was in Cerruti's blood—his grandfather's 1881 textile mill remained in the family for generations. He launched the retail menswear line Hitman in 1957, then opened the Paris-based shop Cerruti 1881 a decade later. An inquisitive man with a wide range of interests, including cutting-edge technology, Cerruti installed a state-of-the-art IBM system to manage the shop's inventory of two thousand suits. In 1969, the *New York Times* credited Cerruti and Lord Snowdon for "doing more to abolish the traditional necktie than any two men."

opposite below left Rodney Pleasants and Alessandro Spicaglia, both of New York, embrace Italian style while visiting the island of Capri with Pauline Cappa, Don Napolitano, and Luigi Boscaln, c. 1980.

opposite below right Model Penelope Tree at Capri, 1968.

above Prince Andrea and Princess Laudomia Hercolani cruising the remote Aeolian Islands aboard a fishing boat hired for the weekend, 1954. Members of the Black Aristocracy, the prince and princess were one of Europe's most glamorous couples.

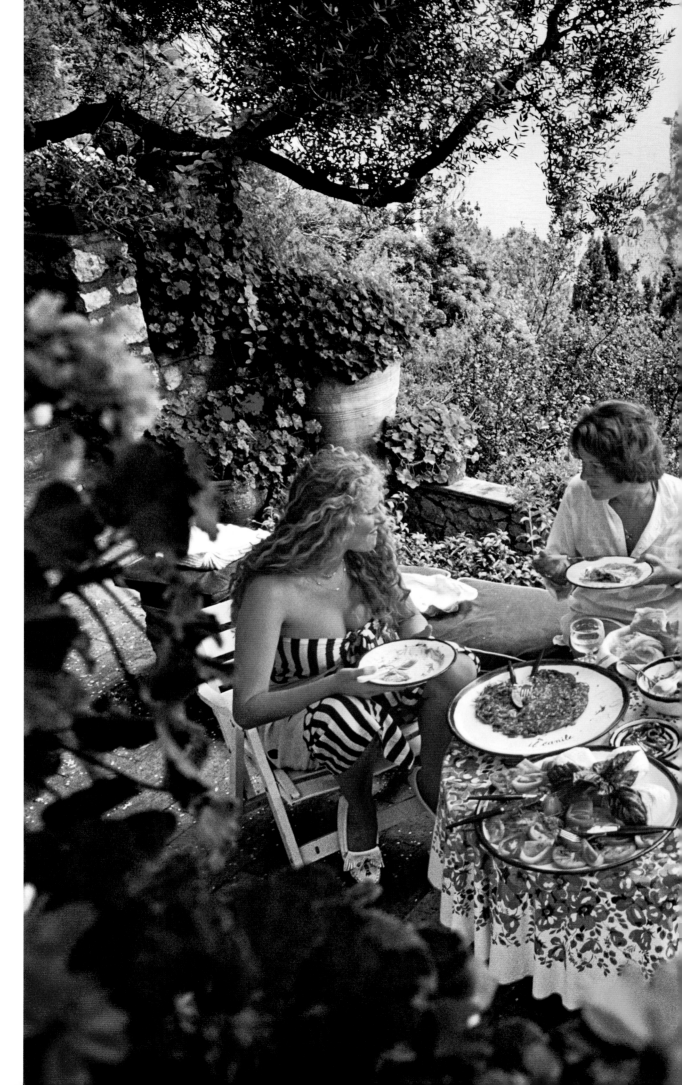

Domiziana Giordano, Francesca Sanvitale, Dino Trappetti, and Umberto Terelli dining al fresco at Il Canile, Terelli and Trappetti's Capri villa, 1980. Tirrelli was Italy's premier costume maker, designer, and collector. Over the course of fifty years, he built a personal collection of more than 15,000 vintage garments while designing for legendary opera and cinema stars. Trappetti took over control of Sartoria Tirelli and the collection upon Umberto's death in 1990. Behind them are the iconic Faraglioni rocks, location of the romantic Grotta Azzurra, or Blue Grotto.

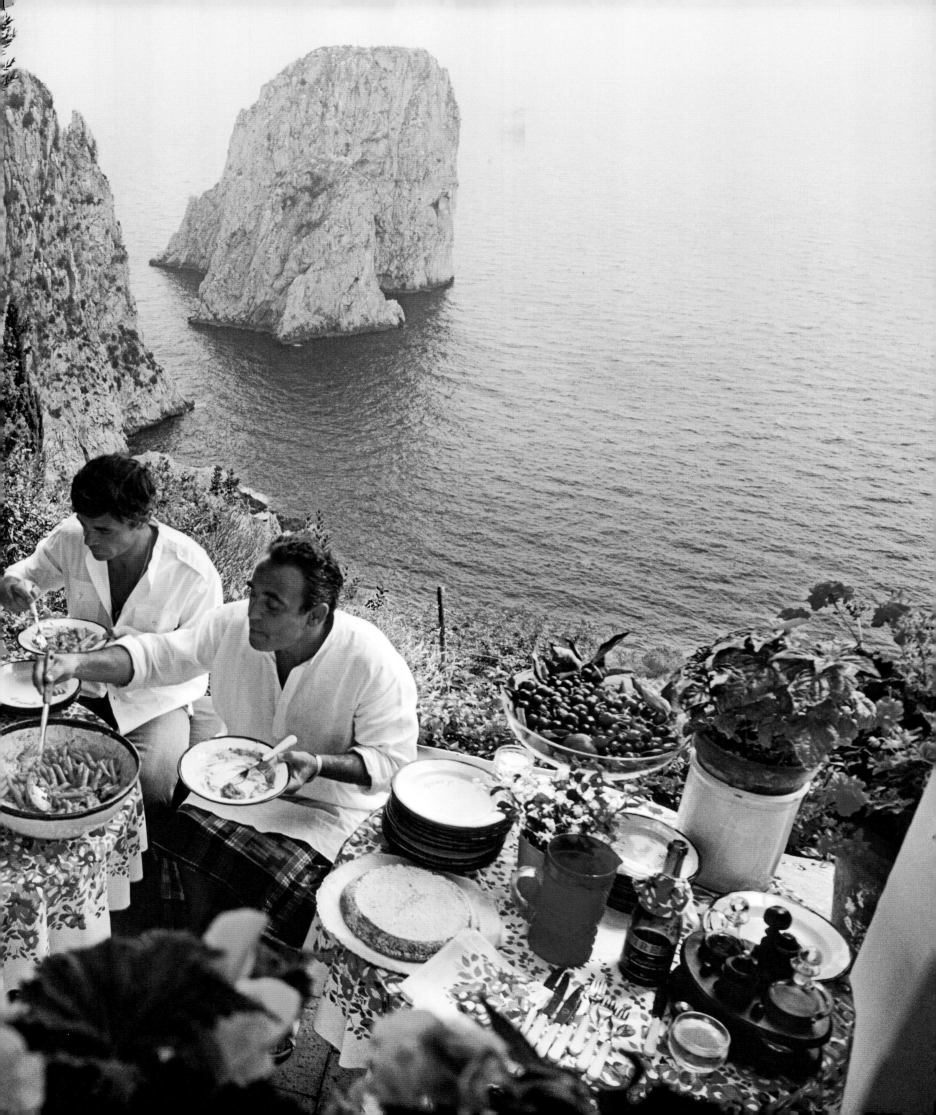

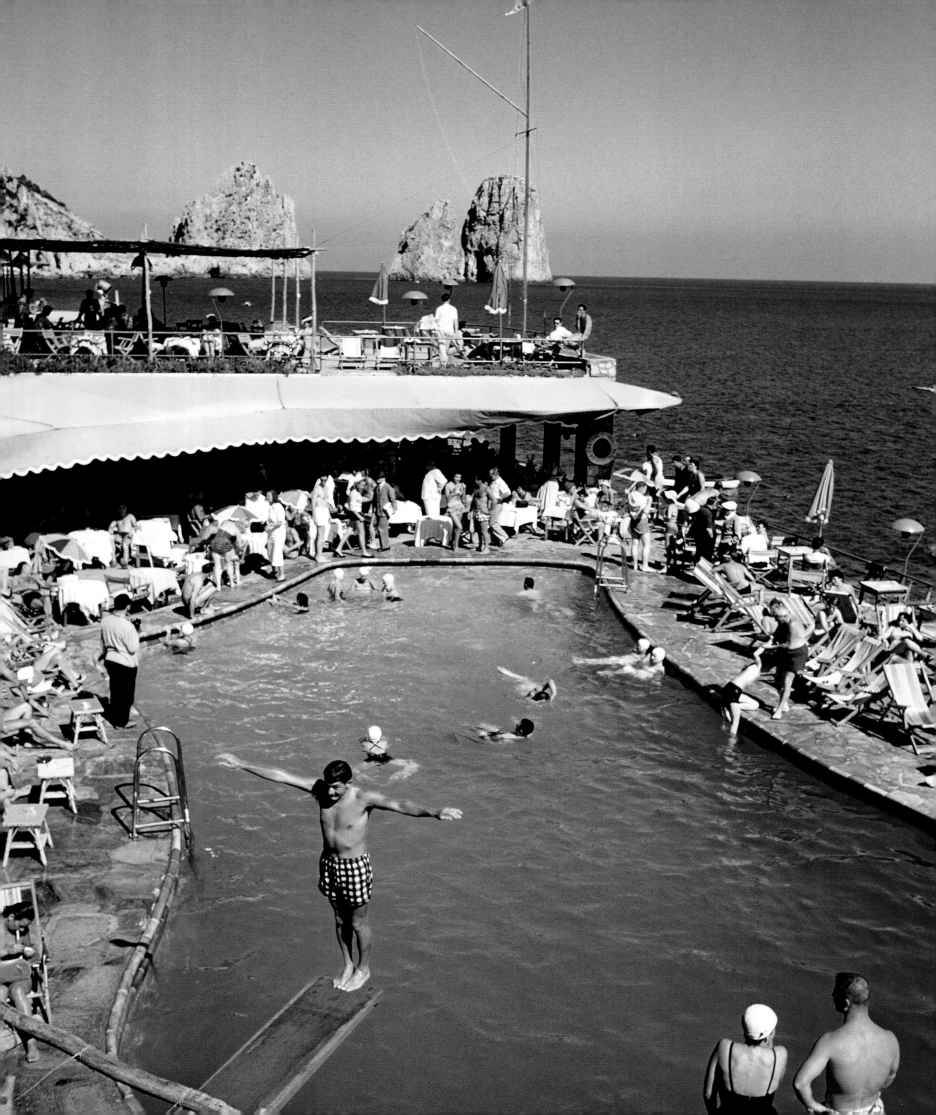

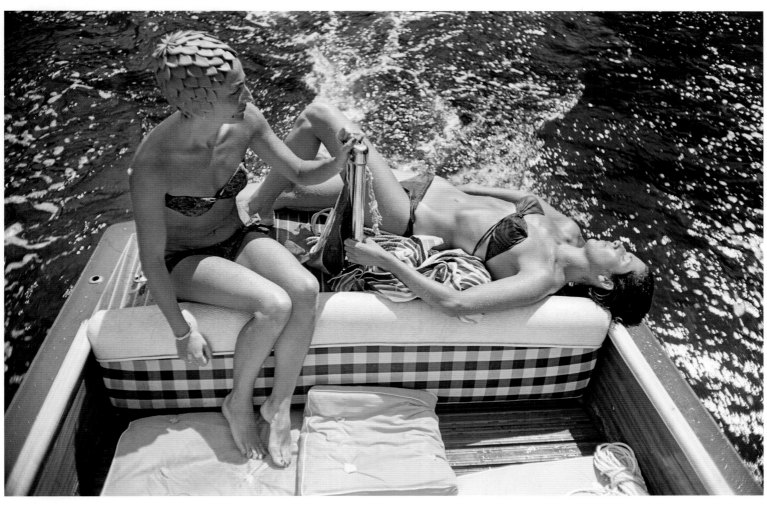

opposite Holiday makers at Canzone del Mare at the Marina Piccola, Capri, 1954.

above Carla Vuccino, in swim cap, and Marina Rava cruising the waters off the coast of Capri aboard a Riva boat, 1958.

right Alana Collins, later Alana Stewart, shows off her skill for accessorizing during the 1968 Mare Moda festival, Capri. The three-day festival culminated with a fashion show in the ruins of a fourteenth-century monastery and drew a who's-who of European and American jet-setters, including Marisa Berenson, who took an ingenious approach to avoiding tan lines, far right.

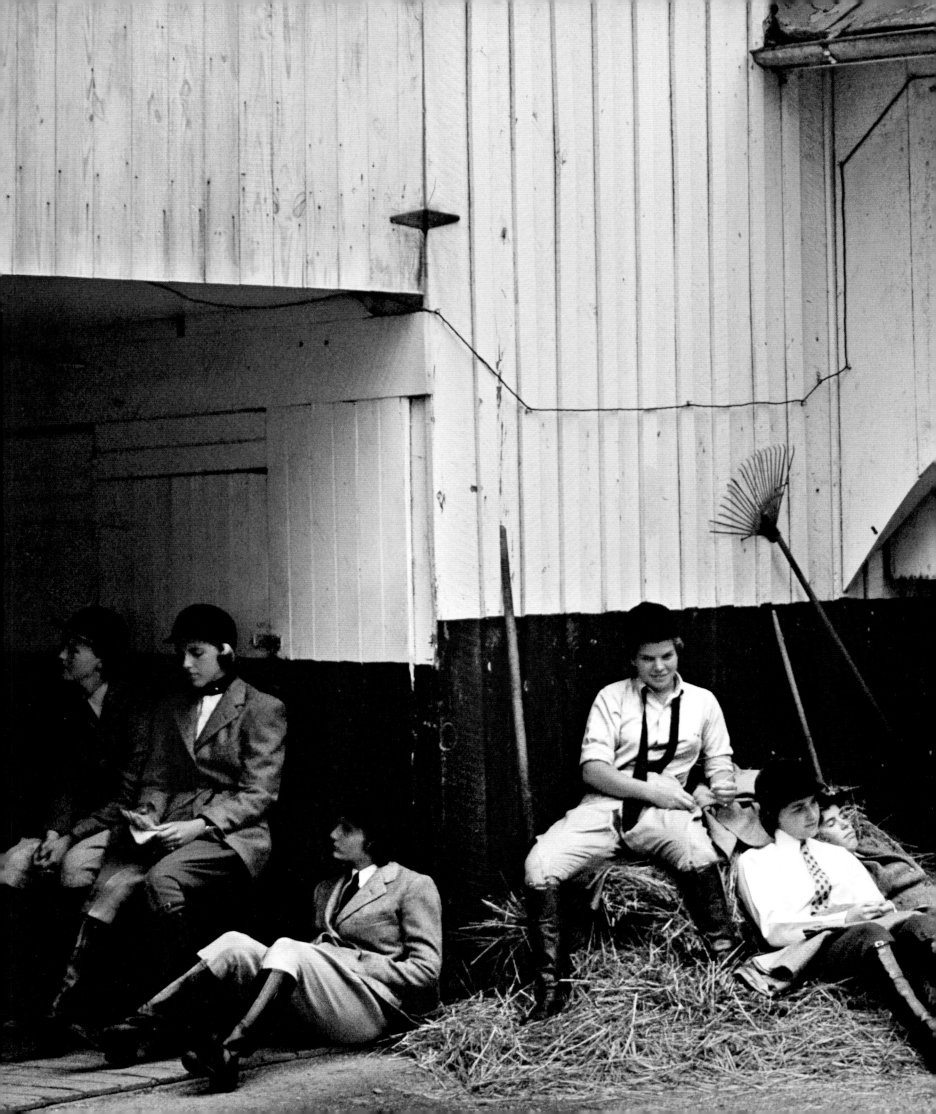

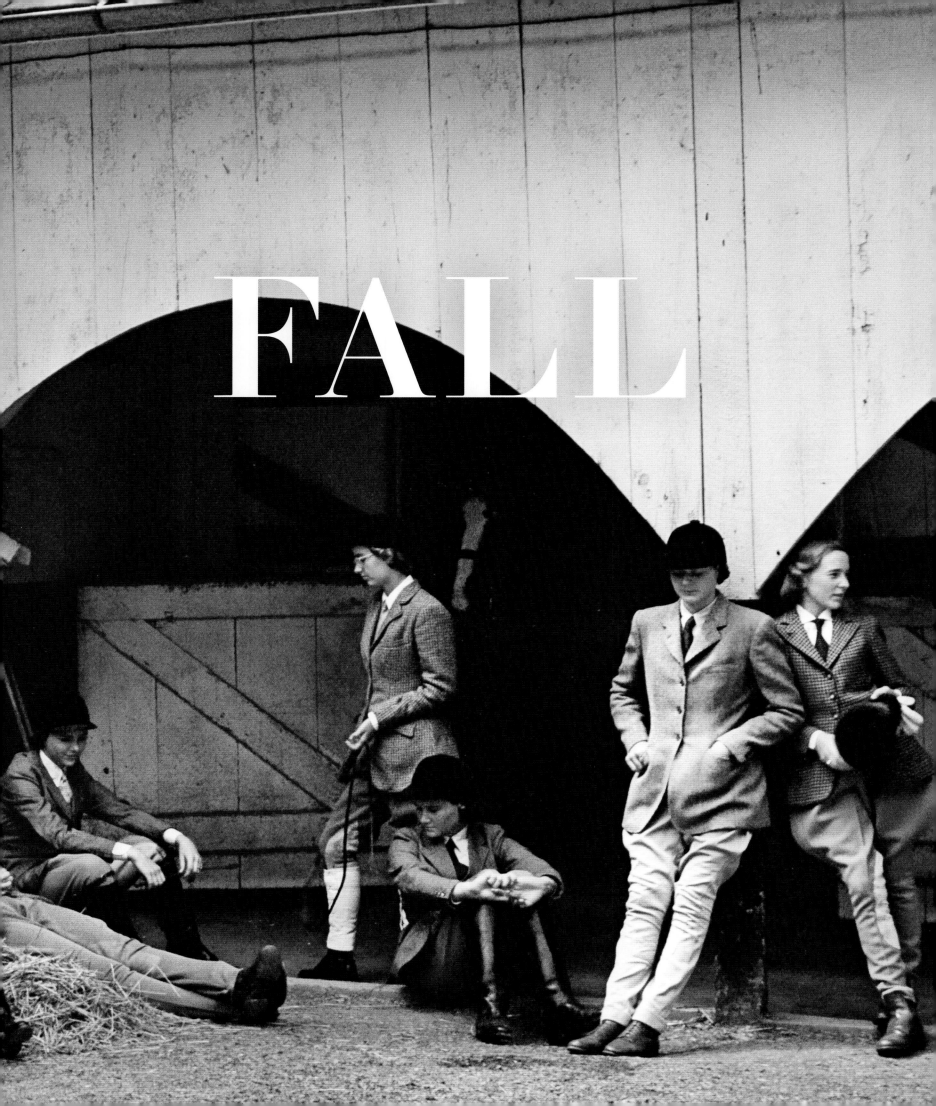

FALL

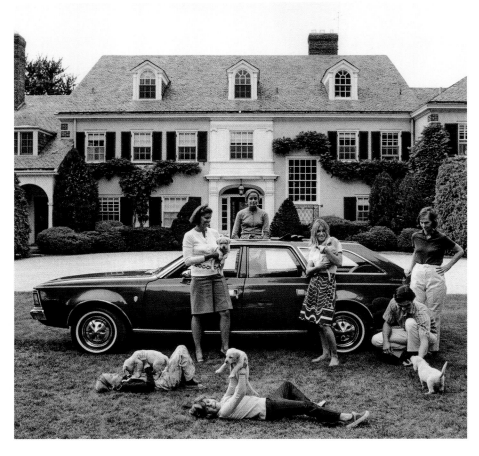

preceding spread Students at Foxcroft School before their daily riding class, 1960. The elite all-girls private school was founded by Charlotte Haxall Noland in 1914 and was still under her command when Slim photographed the school for *Holiday* in 1955. Buildings on the historic campus outside Middleburg, Virginia, predate the school's founding—Washington's parents met in the Brick House, and Cornwallis used the stables as a Hessian prison. Headmistress Noland believed athletics to be a key component in girls' education, an idea she reinforced through the school motto, *mens sana in corpore sano* ("a healthy mind in a healthy body").

above Louise Chapin, her three children, and their Labrador puppies outside their Grosse Pointe, Michigan, home, 1972. Her husband, Roy, was chairman of the American Motor Corp.

left A Dalmatian and his trainer during the 38th Annual Westchester Kennel Club show in Rye, New York, 1955.

opposite Swedish model Inga Lindgren, wife of Argentinian finance minister Ceferino Alonso Irigoyen, wears designs by Vera Stewart with her standard poodles Ajax and Wacky on Park Avenue, New York, 1956. In the fall of 1946, Lindgren was recruited by the model Natálie Nickerson to join her in a new agency model spearheaded by Nickerson's friend Eileen Ford. The scheme not only worked, but revolutionized the modeling business and paved the way for what would become the Ford Model Agency.

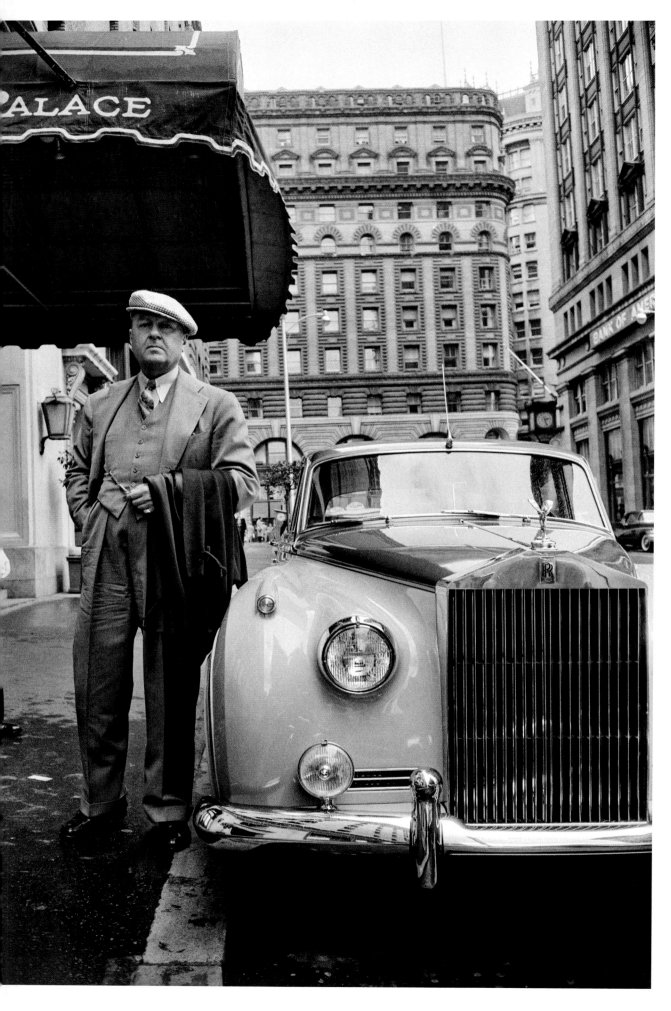

left Writer, journalist, and gourmand Lucius Beebe outside the Sheraton Palace Hotel during a four-day tour of San Francisco's finest restaurants for *Holiday*, 1958. Beebe was one of the twentieth century's great characters and best-dressed journalists. Born with deep Boston Brahmin roots and educated at both Harvard and Yale, Beebe was openly gay and had long-term personal and professional relationships with photographer Jerome Zerbe and author Charles Clegg. Beebe and Clegg shared a passion for railroad cars and history. Besides producing more than twenty books on the subject, they also purchased, restored, and traveled the country in two private railcars, the Gold Coast and the Virginia City. The latter was the most lavishly appointed railcar in the US and featured $375,000 in antique furnishings and artworks, including two Murano glass chandeliers, a painted reproduction of the Sistine Chapel ceiling, a curved brocade velvet sofa, a marble fireplace, and lamps from Asia, Greece, Africa, and the South Seas.

opposite Window shopping in London's Burlington Arcade, the world's oldest, 1955.

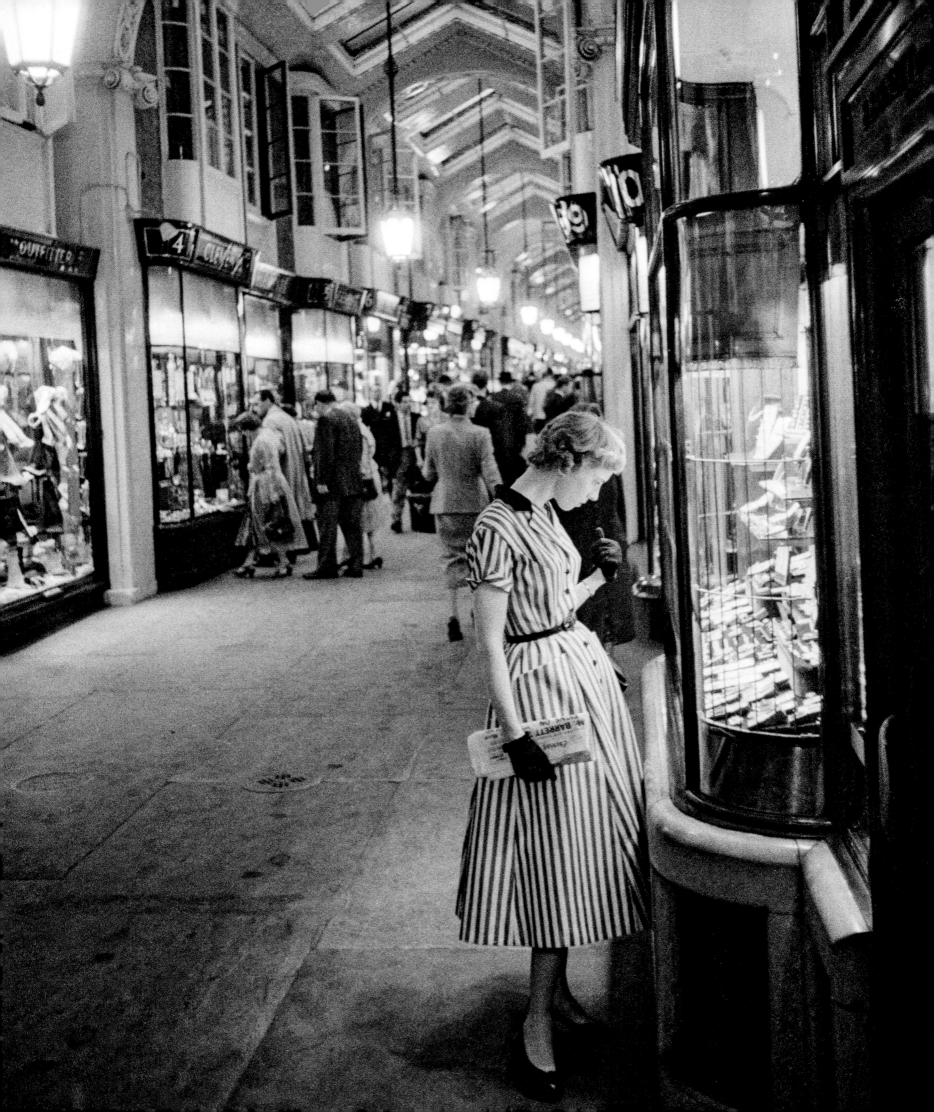

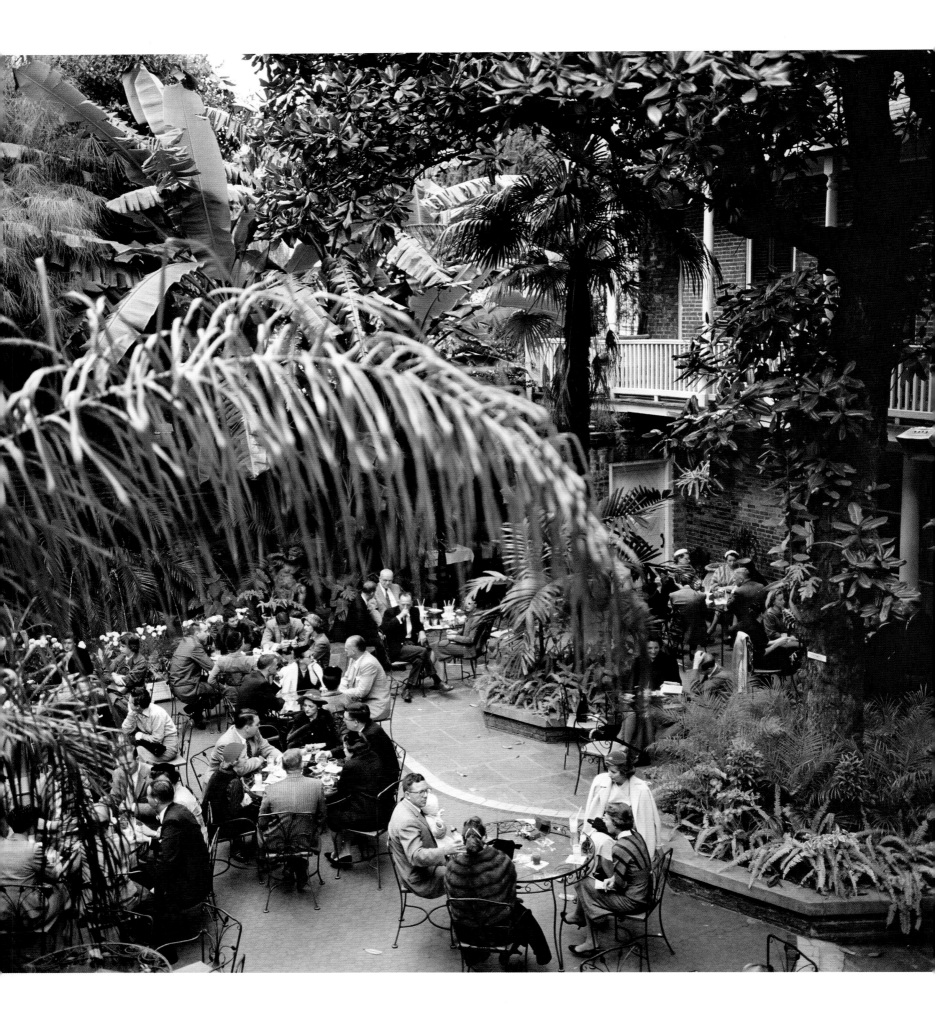

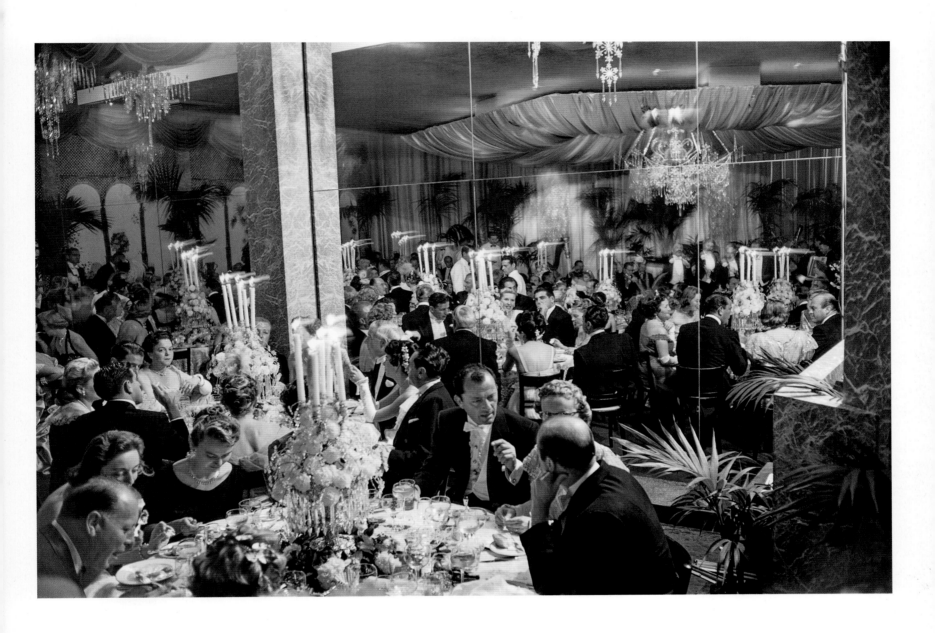

opposite Sunday brunch at Brennan's restaurant, c. 1960. The famed New Orleans restaurant was best known as the inventor of the decadent dessert Bananas Foster.

above A party at the world-famous Romanoff's restaurant, a prime location for Slim. The brainchild of the self-made and -mythologized Mike Romanoff, the restaurant was one of the hottest in Hollywood during the 1940s and '50s. The host frequently rubbed elbows with the brightest stars and famously snubbed anyone that wasn't an A-lister. Romanoff also preferred taking his meals with his dogs, who joined him daily at one of the restaurant's famed, and highly coveted, booths.

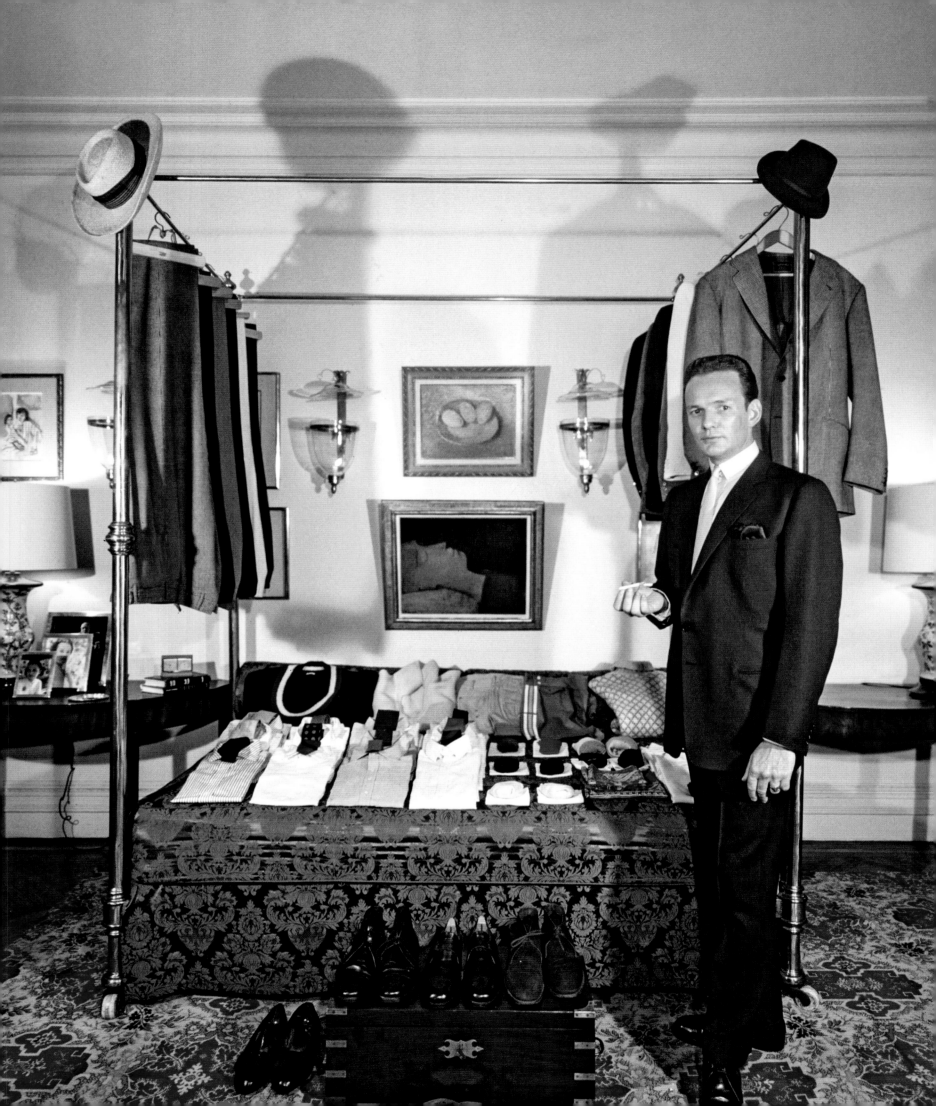

Details, Details

Slim Aarons was famous for saying he did not shoot fashion, but many of his photographs inspired fashion, especially menswear. He created a fad for khakis in the late 1960s when he shot citrus grower and restaurateur Peter Pulitzer wearing a pink button-down shirt and pressed khakis on the patio of his Palm Beach home. When Aarons asked Charles Dana, the founder of the legendary Lyford Cay Club, to change into a pastel lavender jacket for a photo shoot, he unknowingly launched another fashion trend.

Perhaps haberdashery and the particulars of menswear from the 1960s through the 1980s were the most influential changes in men's fashion—with jacket collars growing wider and ties narrowing each season. These minutiae of tailoring fascinated Aarons. He would go to London to shoot the pattern cutter at Turnbull & Asser, and in New York he shot the tailors at Bernard Weatherill, one of the handful of Savile Row shops that opened New York outposts. But his greatest triumph in menswear detail was this photograph taken in 1958 inside the New York apartment of Patrick O'Higgins, a former British Infantry captain in the Irish Guards turned aide-de-camp to Madame Helena Rubinstein, who agreed—with Guard-like precision—to display his complete all-season wardrobe including five medium-weight and two tweed suits, custom shirts, ties, socks, sweaters, accessories, and a winter and a summer hat. O'Higgins posed in a single-breasted, dark gray British worsted, cut by Weatherill, although it should be noted that he bought many of his clothes abroad, and rarely spent more than $500 a year on his wardrobe.

above View from inside the New York location of Savile Row tailor Bernard Weatherill, 1964. Weatherill was awarded a Royal Warrant by King George V for riding clothes and livery tailors in 1920 and currently holds the same for Queen Elizabeth II. The firm was one of three Savile Row tailors to open New York locations in the 1960s.

left Finishing touches on a bespoke jacket at Kilgour, the traditional Savile Row firm then known as Kilgour, French and Stanley, 1955. Kilgour, which dates to 1882, began a long-running relationship with Hollywood when the firm was tapped to design Fred Astaire's tailcoat for the 1935 musical *Top Hat*. As can be seen from the patterns along the back wall, Kilgour's clients at the time included producer Louis B. Mayer and the actor Tyrone Power, along with a global assortment of royals and aristocrats. Other famous clientele included Frank Sinatra, Cary Grant, and, more recently, Jude Law and Daniel Craig.

opposite Mr. Clark, head pattern cutter at shirtmaker Turnbull & Asser, London, 1955. When Prince Charles was granted the power to bestow Royal Warrants in 1980, one of his first was to Turnbull.

above Diane and Allan Arbus (she is on far right; he is center, turned and holding film) during a fashion shoot on the corner of Seventy-Second Street and Park Avenue, c. 1953. Slim happened upon the couple while photographing Park Avenue on assignment for *Holiday*. Diane and Allan, who, like Slim, had been an army photographer, operated a fashion-oriented commercial studio for ten years following the war. In the late 1950s, Diane struck out on her own, and in 1963 she was awarded a Guggenheim Fellowship. The funding

helped support her intensely personal and influential project documenting those on the edges of society.

opposite Abercrombie and Fitch, New York, 1959. Slim shot this during a two-year period of intense society documentation for *Holiday*. The store's interior was designed to be a respite from the urban bustle and reflected the company's nineteenth-century roots as a purveyor of specialized outdoor clothes and equipment.

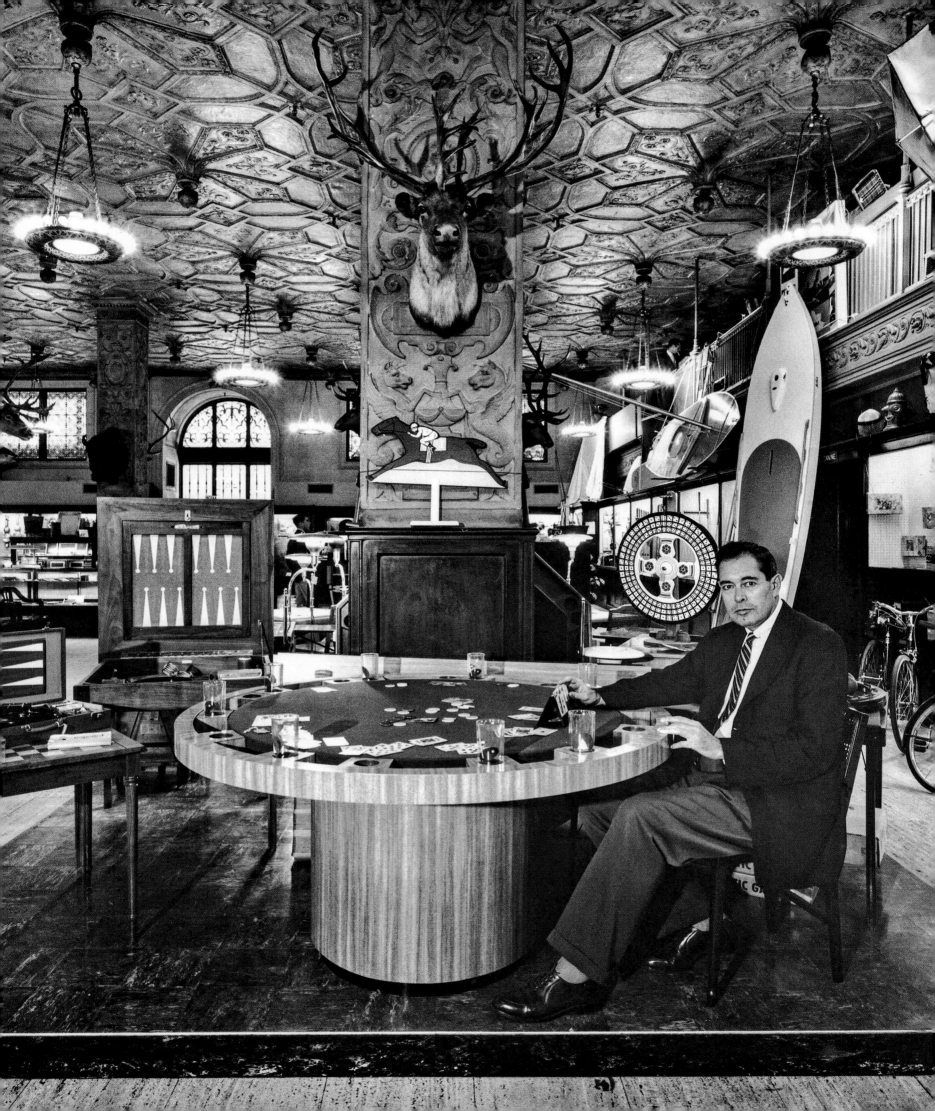

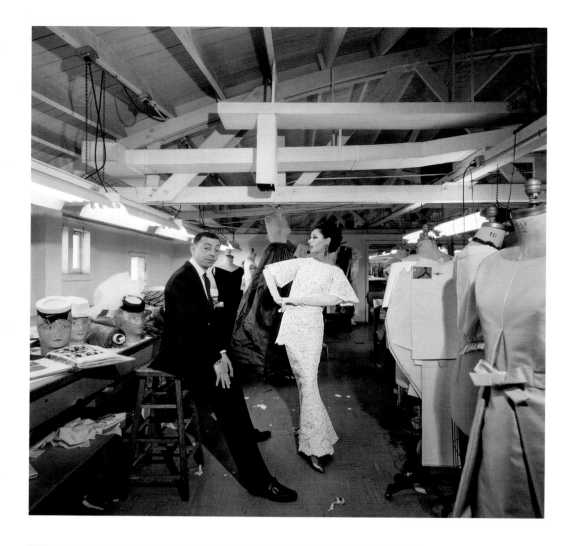

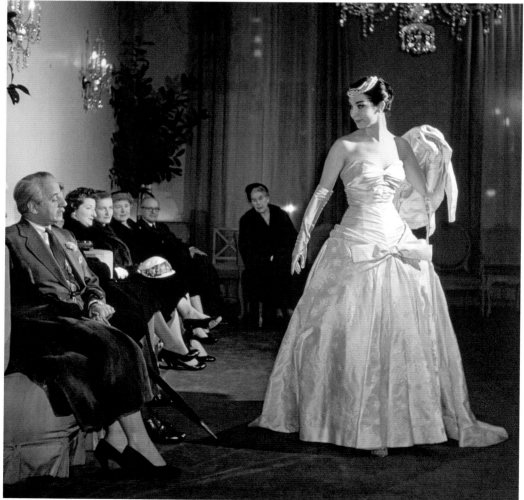

above American fashion designer and master craftsman James Galanos with supermodel Dovima at his New York atelier, 1960. Galanos was an inspired designer who rejected artifice and superficiality. He shunned celebrity clientele and instead focused on a small and devoted group who could afford his particular vision of luxury and glamour, saying, "I'm only interested in designing for a certain type of woman. Specifically, one that has money."

left A presentation at the Burton Street salon of British couturier Norman Hartnell, seated on the left, 1955. Educated at Cambridge, Hartnell learned the fashion trade in the house of Lady Duff-Gordon before setting out on his own in 1923. Appreciated for his bold use of color, Hartnell designed specifically for a British audience and became increasingly popular among the aristocracy. He was hired to design the wedding gown and trousseau of the Duchess of Gloucester, earned the Royal Warrant as dressmaker to the Queen Mother, and designed both the wedding and coronation gowns for Queen Elizabeth II.

opposite Vogue editor Denise Lawson-Johnston tries on a hat in the Fifty-Seventh Street salon of Mr. John, known as the King of Hatters, 1960.

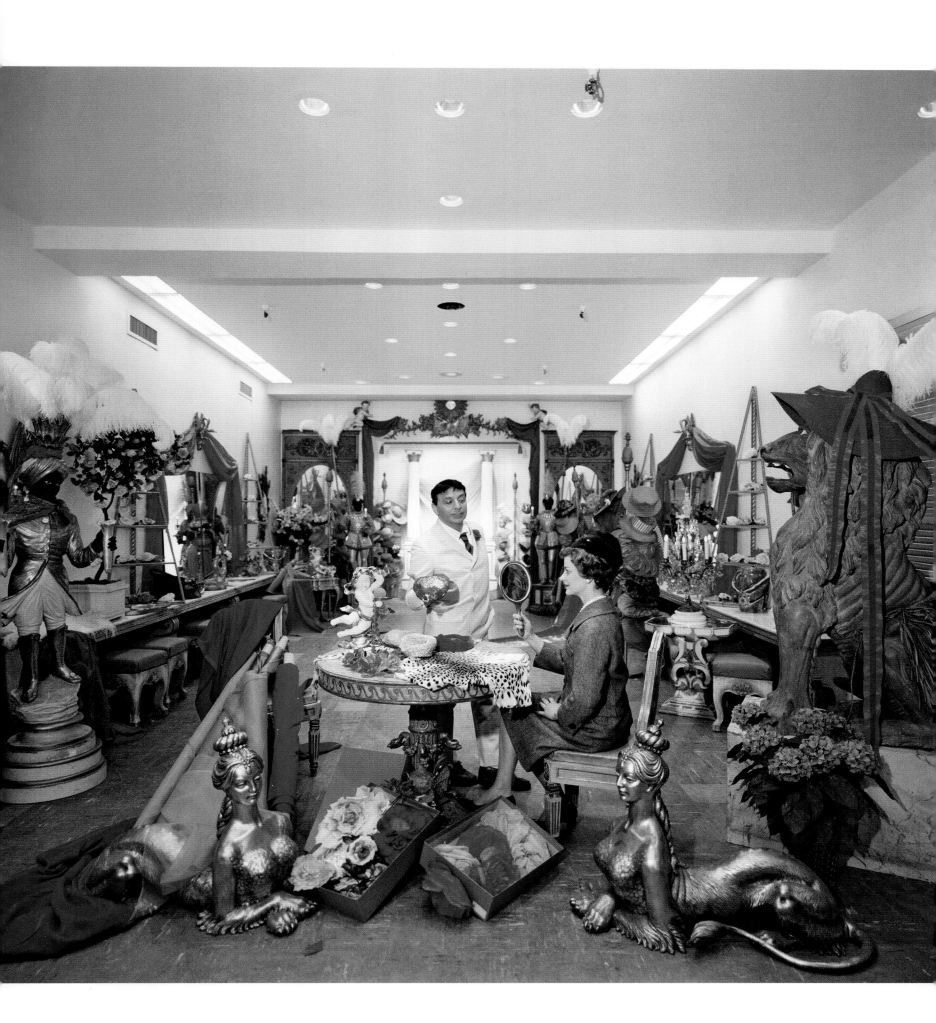

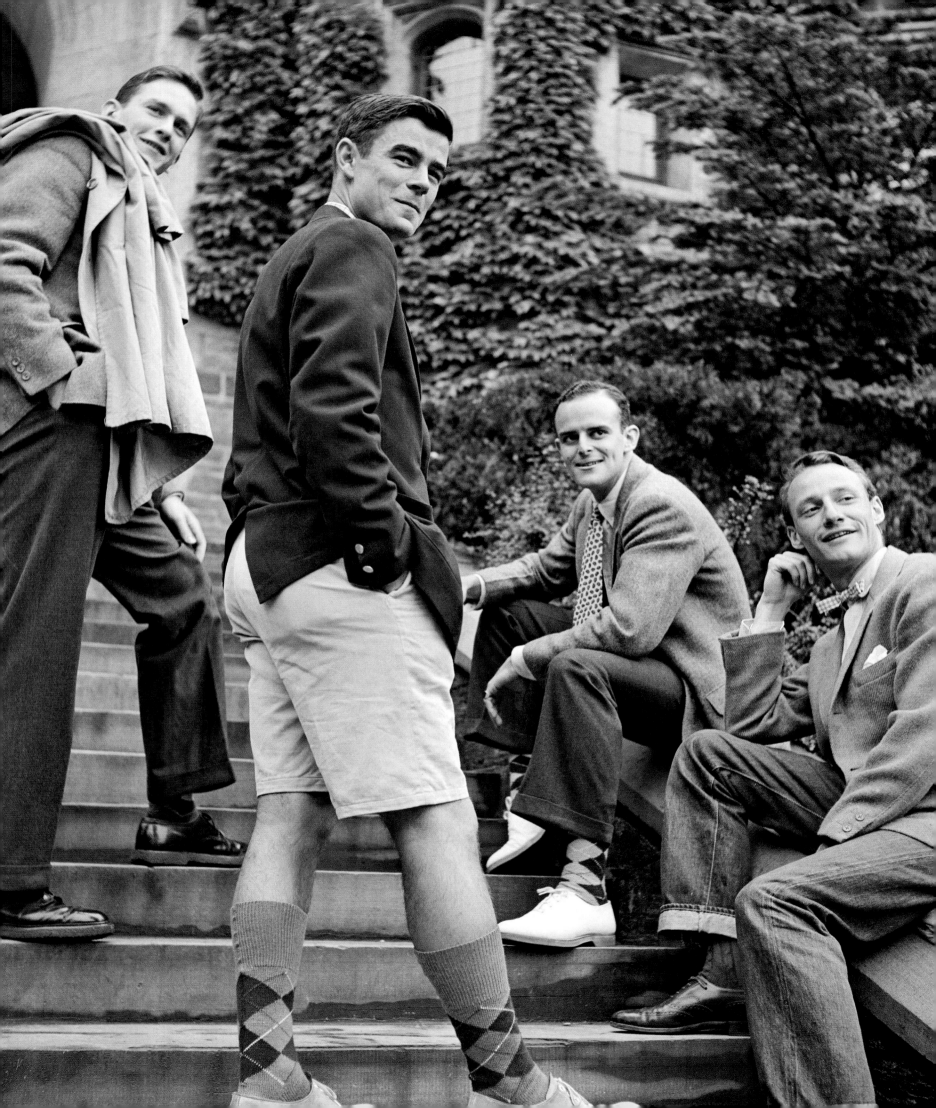

Ivy Style

Ivy style became a phenomenon on college campuses in the 1950s, when photographers from publications like *Town & Country* and *Women's Wear Daily* would venture to schools like Princeton and Yale in search of fashionable students. They would attend tailgate parties at football games and linger outside the campus library, looking for young coeds who could model the collegiate look. (And rest assured, collegiate style in those days had a more formal slant—tweed jackets, brogues, poodle skirts, and cashmere twinsets.)

The term "Ivy League" first appeared in the *Christian Science Monitor* in 1935 in reference to the formation of the sports league, which dates back to 1876, when representatives from four universities met to decide on the rules for football. Sports culture influenced many aspects of Ivy style, from the tasseled loafers of golf to the crested blazers worn by rowers at the Henley Royal Regatta in England. After World War I, this idea of sports-influenced clothes took root on Ivy League campuses such as Yale's.

Clothing companies such as Brooks Brothers became key resources for young collegians who adopted button-down oxfords, plain-front trousers with cuffs, diagonally striped rep ties, and navy blue blazers. Later, in the 1950s, newspapers featured fashion spreads with the look, and students on Ivy League campuses would model, combining their formal, casual, and sports clothing—mixing and matching pieces such as shorts with jackets and socks with brightly colored ties. By the 1960s, Bermuda shorts, tennis sweaters, and argyle socks were added to the repertoire.

While Aarons always insisted he only liked shooting people in their own clothing, with very little makeup or hairstyling, he resolutely refused to shoot anyone in jeans, T-shirts, or sneakers. Here is perhaps the one exception: In a shot taken at Princeton in front of Blair Arch, one young man is wearing jeans—albeit neatly cuffed.

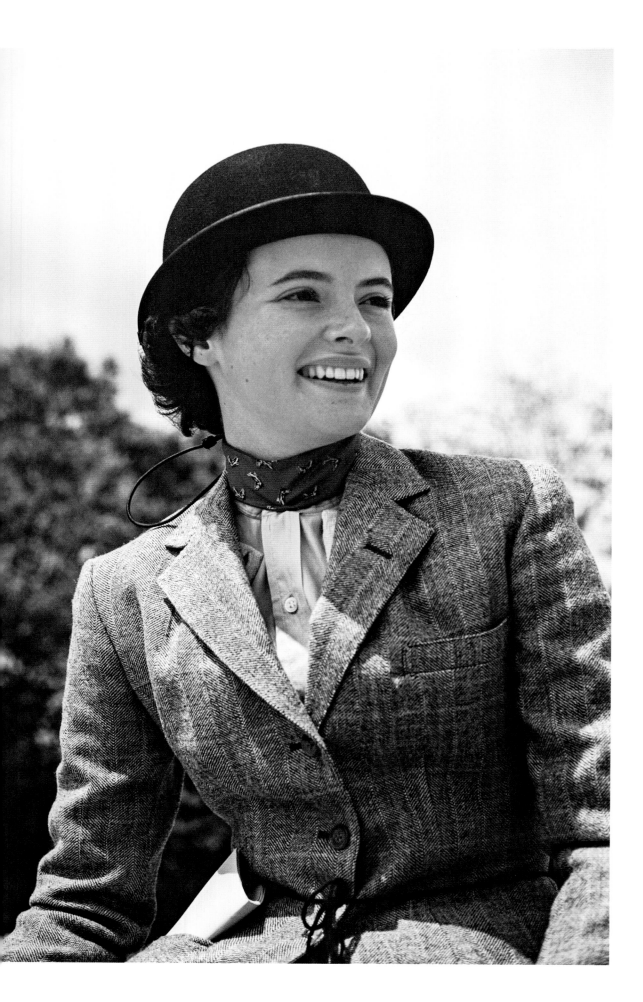

left Miss Elizabeth Guest, the No. 1 debutante of 1955, during Foxcroft School's annual horse show, 1955.

opposite above left Coeds chatting over cans of Ballantine ale by Lake Carnegie on the Princeton campus, 1950.

opposite above right Tailgating at Princeton, c. 1950. Ralph L. Tompkins (right), president of New York's Princeton Club, wears a Norfolk jacket, a staple of nineteenth-century British country attire that was popular among American youth in the 1920s and again in the early 1950s.

opposite below left John Michael White, nephew of revered *Harper's Bazaar* editor in chief Carmel Snow, chats with a friend while waiting for the train back to Princeton University, 1950.

opposite below right Cambridge University coeds, England, ca. 1949.

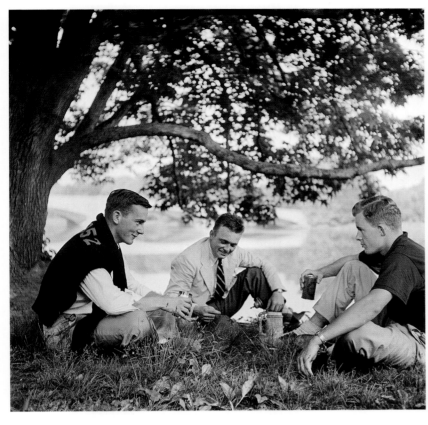

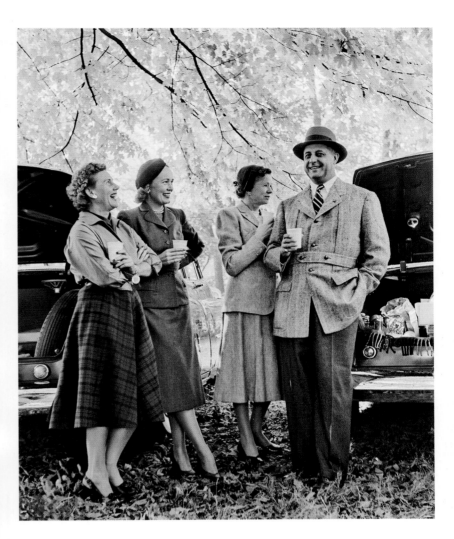

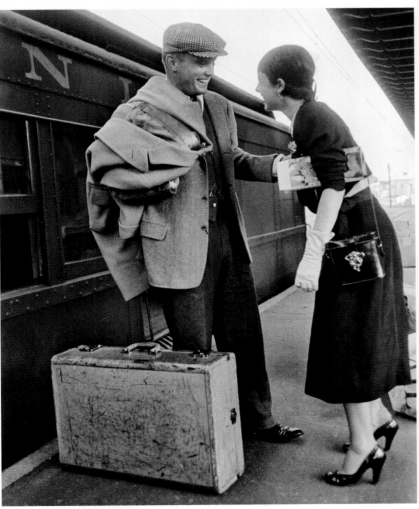

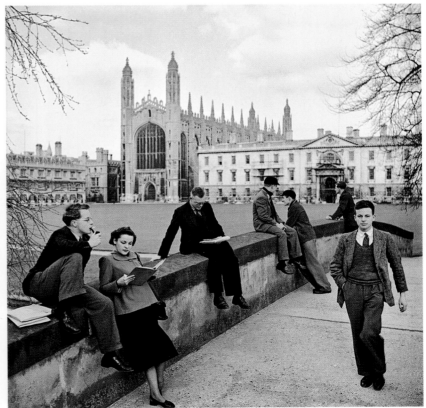

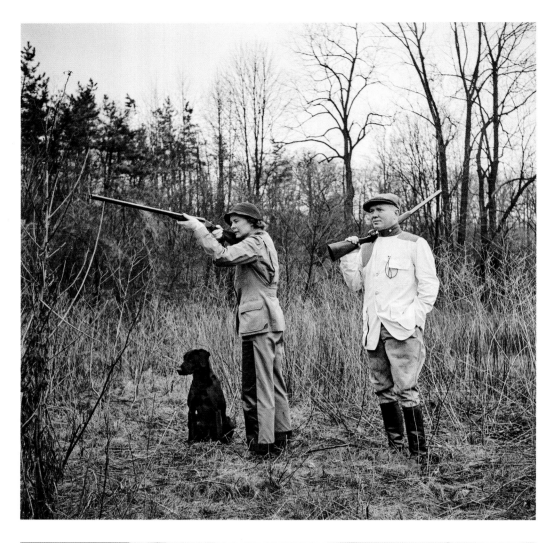

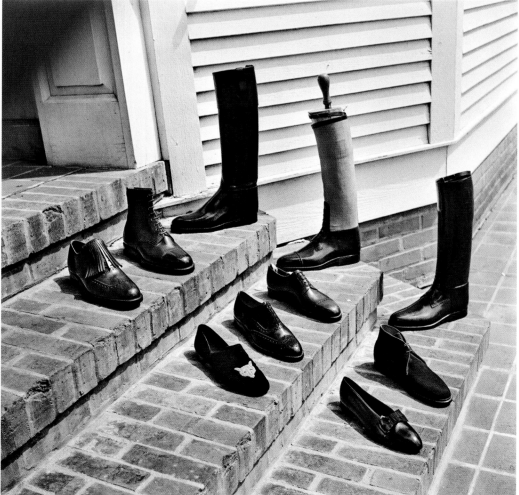

above Mr. and Mrs. Alexander J. Cassatt shooting at Huntley Farm, Broad Run, Virginia, 1951. Their hunting attire is from Meyers of New York and Philadelphia, a tailor known for producing custom shooting attire with the perfect balance of toughness and elegance. Her suit is cotton twill faced with dark brown goatskin. His white poplin jacket features a red flannel collar, while the olive drab poplin breeches are faced with cowhide and closed at the knees with zippered elastic insets.

left Shoes for city and country belonging to J. Gordon Douglas, Jr., Huntley's owner, on display at the farm in 1951.

opposite Riders gather for the stirrup cup libation prior to the Pebble Beach Hunt with English and American foxhounds, 1977. The four red-coated riders are (left to right) whip Janet Ellis, joint master John Love, president of the US Pony Club, huntsman Patrick Ellis, and joint master Richard Collins.

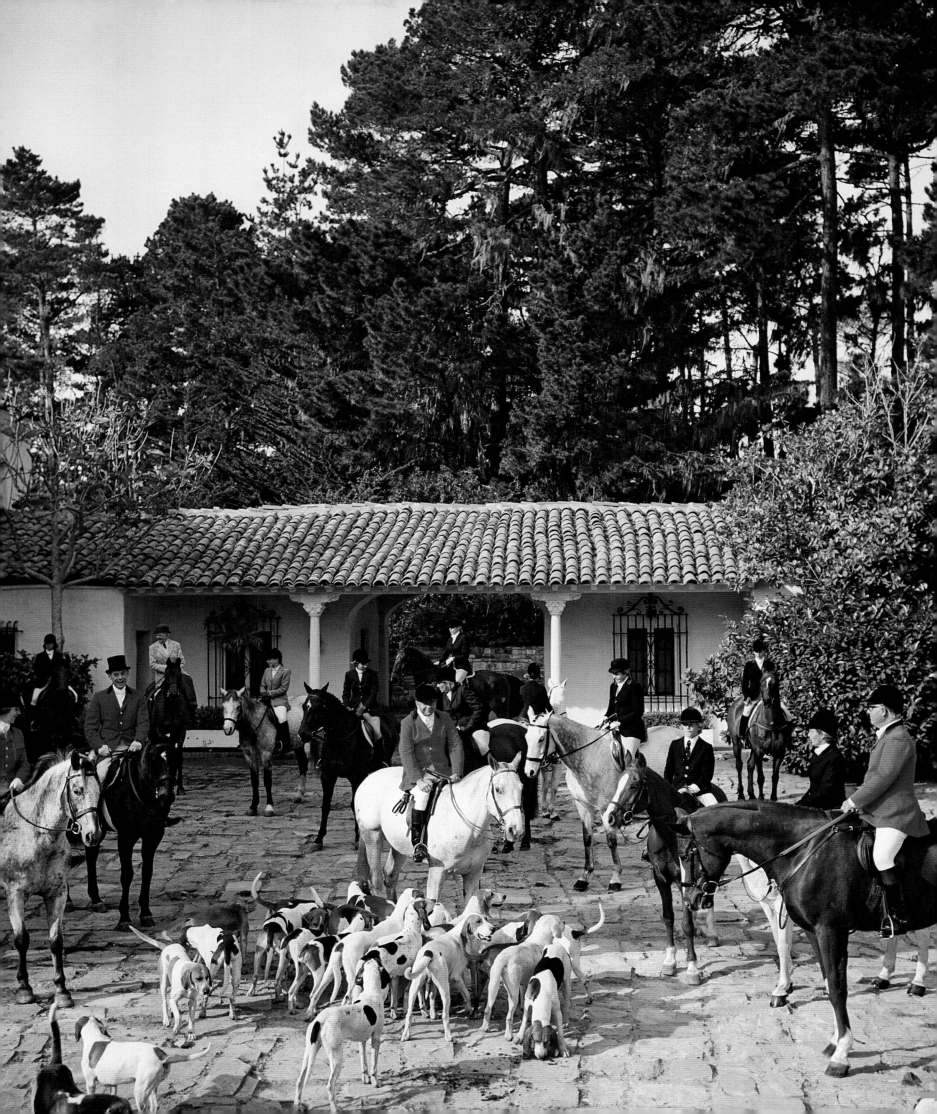

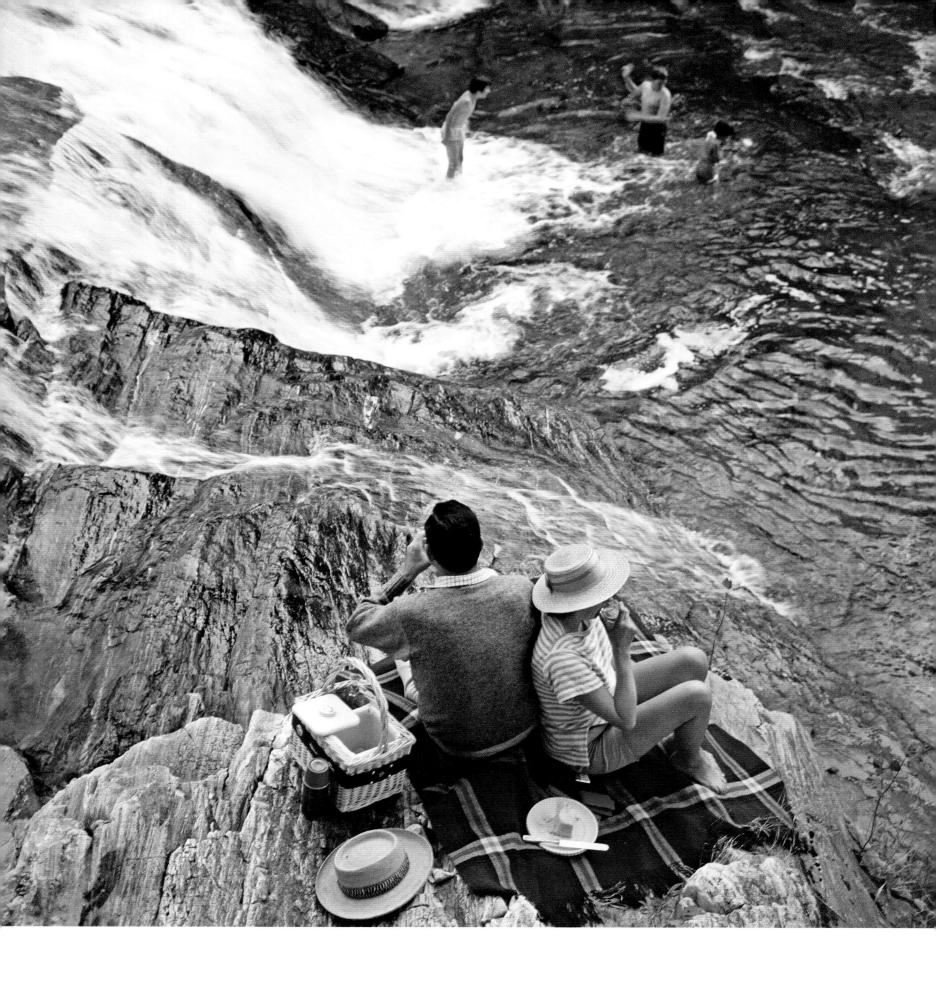

A family picnic at Campbell Falls,
Massachusetts, 1959.

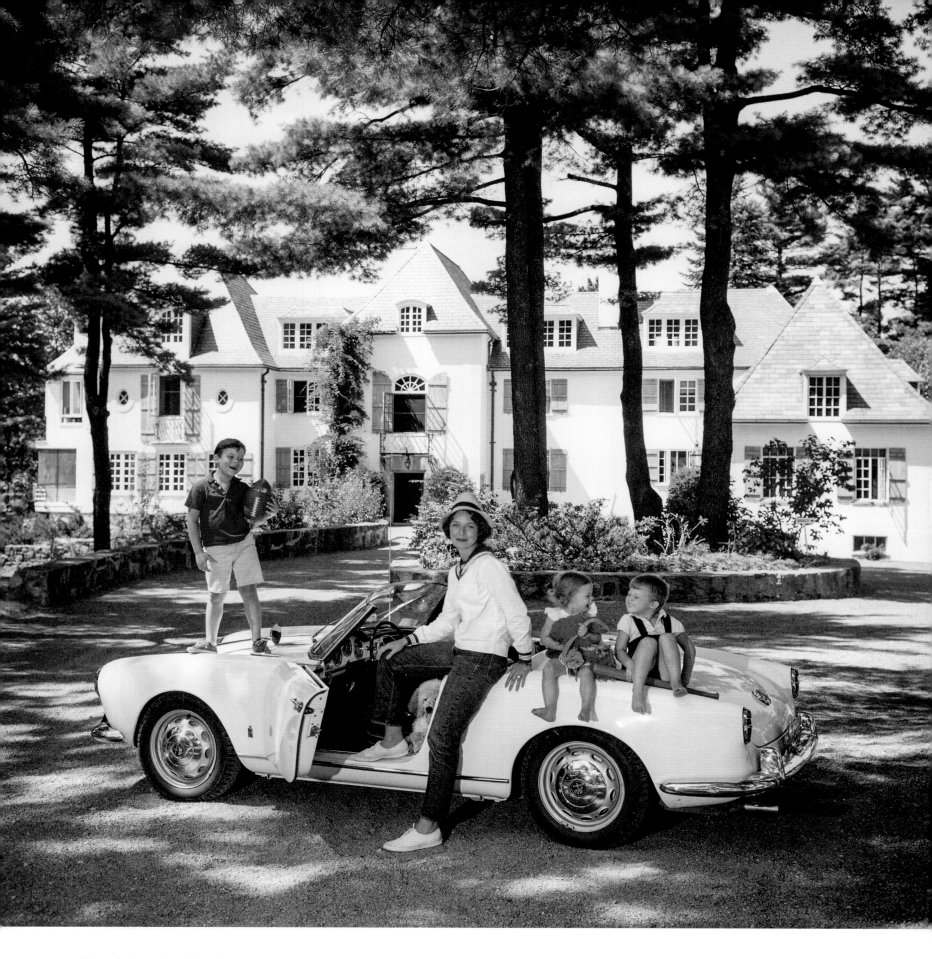

Elenita Lodge, wife of Henry Sears Lodge Sr., and three of their four children at Rollingstones, the Lodge family's Manchester, New Hampshire, country home, 1960. Born Elenita Ziegler, she was a writer and editor. The Lodges were one of the original Boston Brahmin families and a long-standing political dynasty featuring US senators, governors, and Henry Cabot Lodge, Jr., the Republican candidate for vice president under Richard Nixon in the 1960 general election.

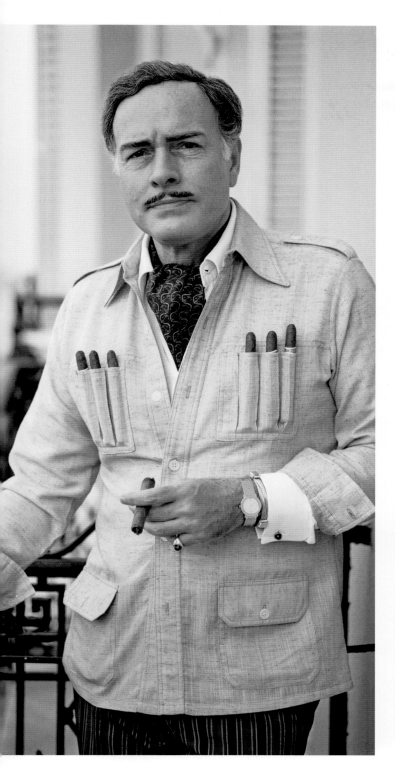

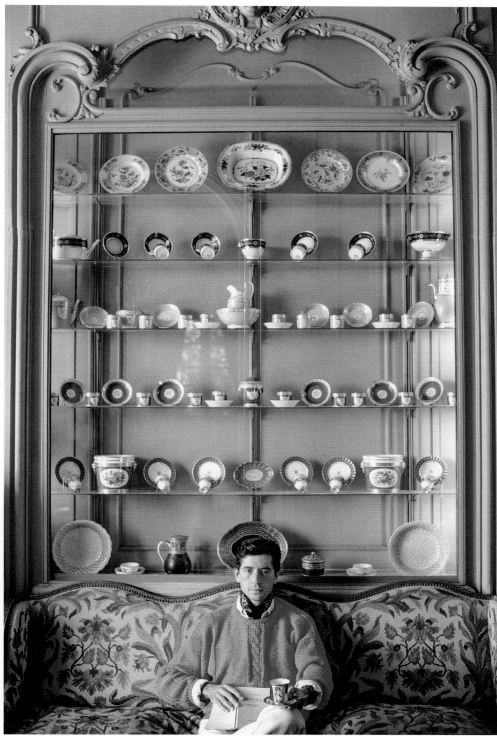

opposite Proprietor Traudi Eder stands in the doorway of Trachten Sport Couture boutique in Kitzbühel, 1990. Traudi ran the shop while her husband, Helmut, designed the garments. The Eders were tireless promotors of the region's traditional clothing, known as Tracht. Tyrolean dress has influenced fashion and pop culture throughout the decades, most notably in *The Sound of Music*. Coco Chanel was said to have designed her four-pocket jackets after admiring the uniform of a lift operator at Schloss Mittersill. Karl Lagerfeld channeled the brand's (and his own) past for Chanel's 2015 Métiers d'Art collection presented, naturally, in Salzburg.

above left Baron Enrico di Portanova, grandson of the Texas wildcatter Hugh Roy Cullen, in Monte Carlo. His cigar jacket was a custom design by Angelo Vitucci, the former manger of Brioni turned proprietor of Angelo Roma.

above right Michel, Comte d'Arcangues, against a wall of Sèvres and Compagnie des Indes porcelains at his chateau d'Arcangues, Biarritz, France, 1986. The Sèvres factory has produced finely detailed gilded and hand-painted porcelain pieces since 1738 and was personally run by King Louis XV for a period in the mid-eighteenth century. The factory works were a favorite of the king's mistress, Madame de Pompadour.

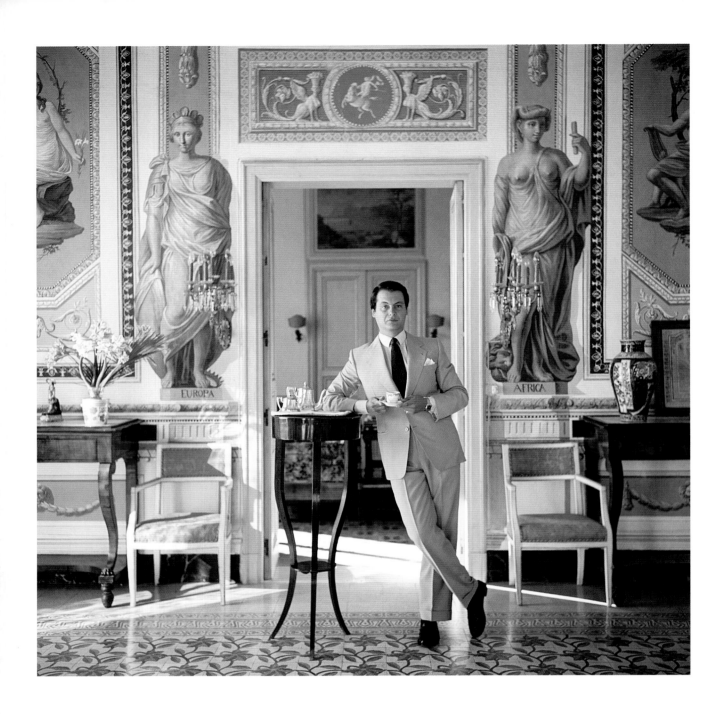

"Slim captured privileged spaces and the
sort of environments people dream of
inhabiting, but the scenes—the people, the
places—are idealized. He knew, the subjects
knew—and ultimately the viewer knows—
this is not *exactly* real life."

—JACK CARLSON

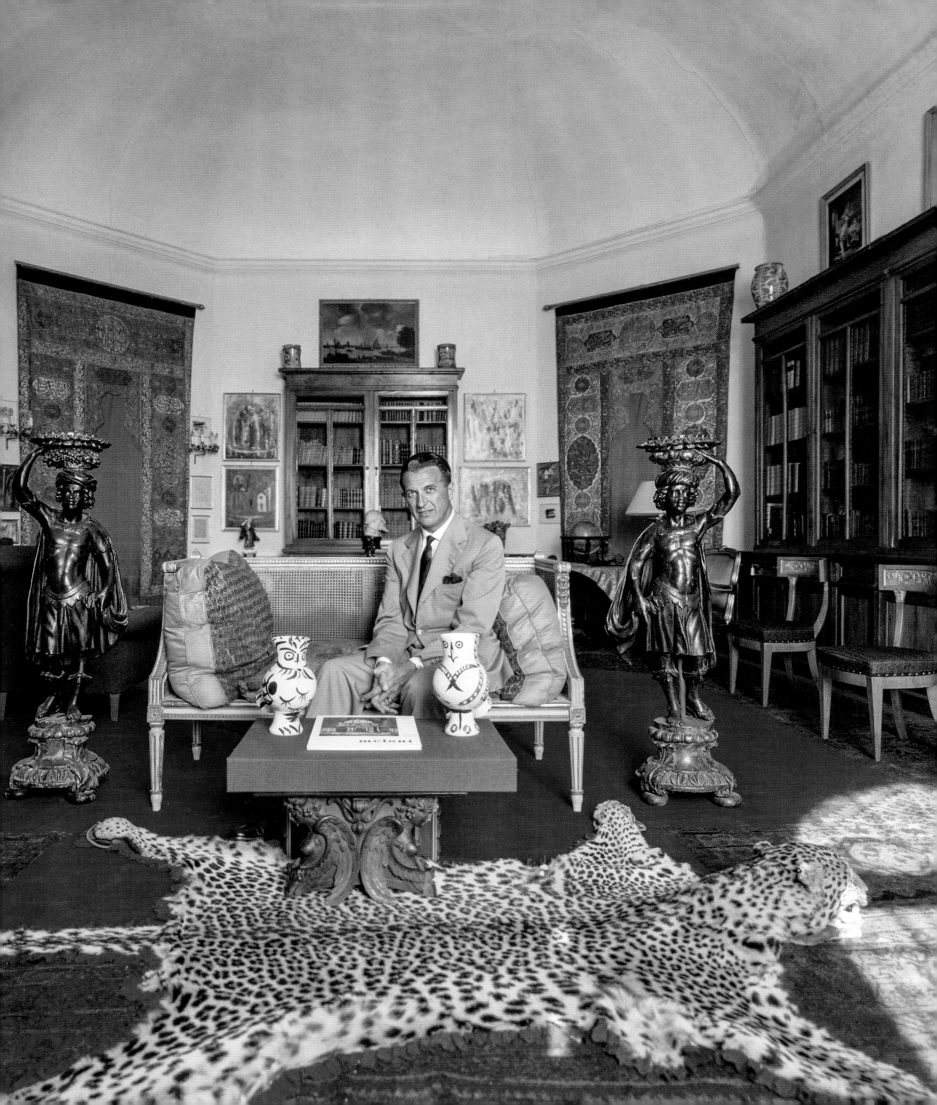

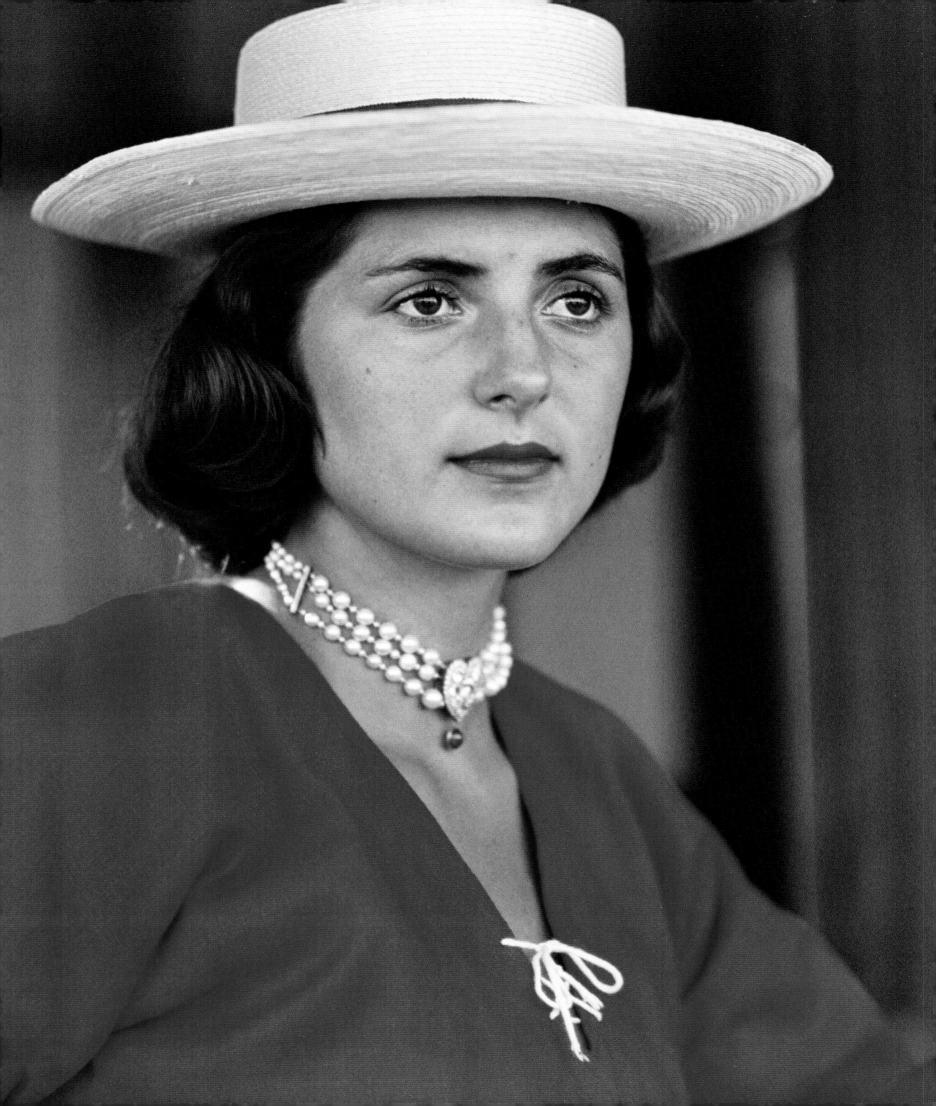

preceding spread left Don Achille Paterno di Spedalotto at Villa Spedalotto, his family's Sicilian country retreat, 1984. Known to friends and family as Tito, Paterno descended from the Norman adventurer Robert d'Ebrum, who arrived in Sicily in 1060.

preceding spread right Agriculturist Count Filippo Visconti di Modrone and his cheetah-skin rug in his medieval castle outside Milan, 1960. At the time, the castle had thirty hospitable rooms while the rest stood in ruins. The Visconti di Modrone are a branch of the noble Visconti dynasty that includes Luchino, the famed cinema director and father of Italian neorealism. The two ceramic owls on the table are by Picasso.

opposite Ursula Pacelli, daughter of Prince and Princess Marcantonio and grandniece to Pope Pius XII, poses at the Venice Lido, 1957. Pacelli was sent to school in New York and made her debut at the 1955 Gotham Ball, where she and thirty-six other debutantes were presented to Francis Cardinal Spellman. The debs wore customary white gowns at cotillion but broke tradition by carrying flowers dyed red to match the prelate's robes. In 1959, Pacelli and her mother were feted by President Eisenhower at the White House before their goodwill tour of the US promoting the Italian fashion industry.

above German horse trainer Count Adrian von Borcke greets Maren Bauer outside the Brenners Park Hotel in the resort town of Baden-Baden, 1978.

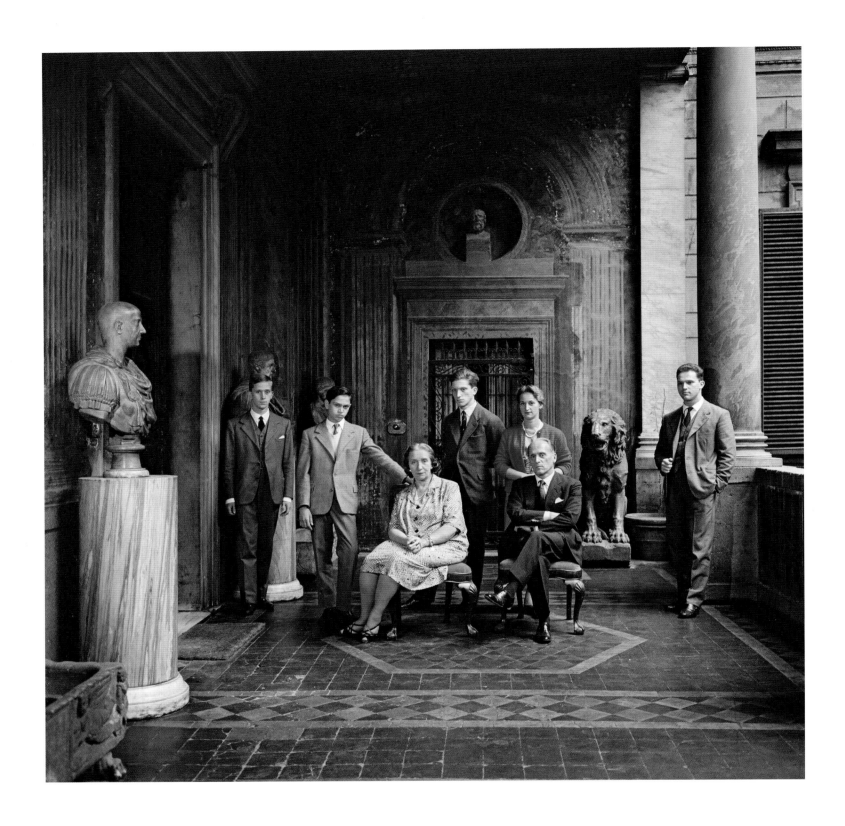

above Prince and Princess Massimo with five of their six children in their family residence, Palazzo Massimo alle Colonne, 1960. The noble family, which claims a direct line to a third-century BCE Roman consul and two popes, is one of Europe's oldest. The family seat, a massive Roman palazzo built in the sixteenth century, is closed to visitors, except for a single room on the second story that opens to the public every March 16. On that date in 1583, fourteen-year-old Paolo Massimo is said to have died, to be resuscitated by St. Filippo Neri, only to then die a second time. In recognition of the miracle, the family patriarch declared the public would forever be welcomed to pay homage on the anniversary of Paolo's death.

opposite Princess Alexander Hohenlohe in Mittersill, Austria, 1958. A former New York showgirl and tabloid regular known as Honeychile Wilder, she had a reputation for breaking hearts and marriages all over New York both before and after her own marriage to the prince.

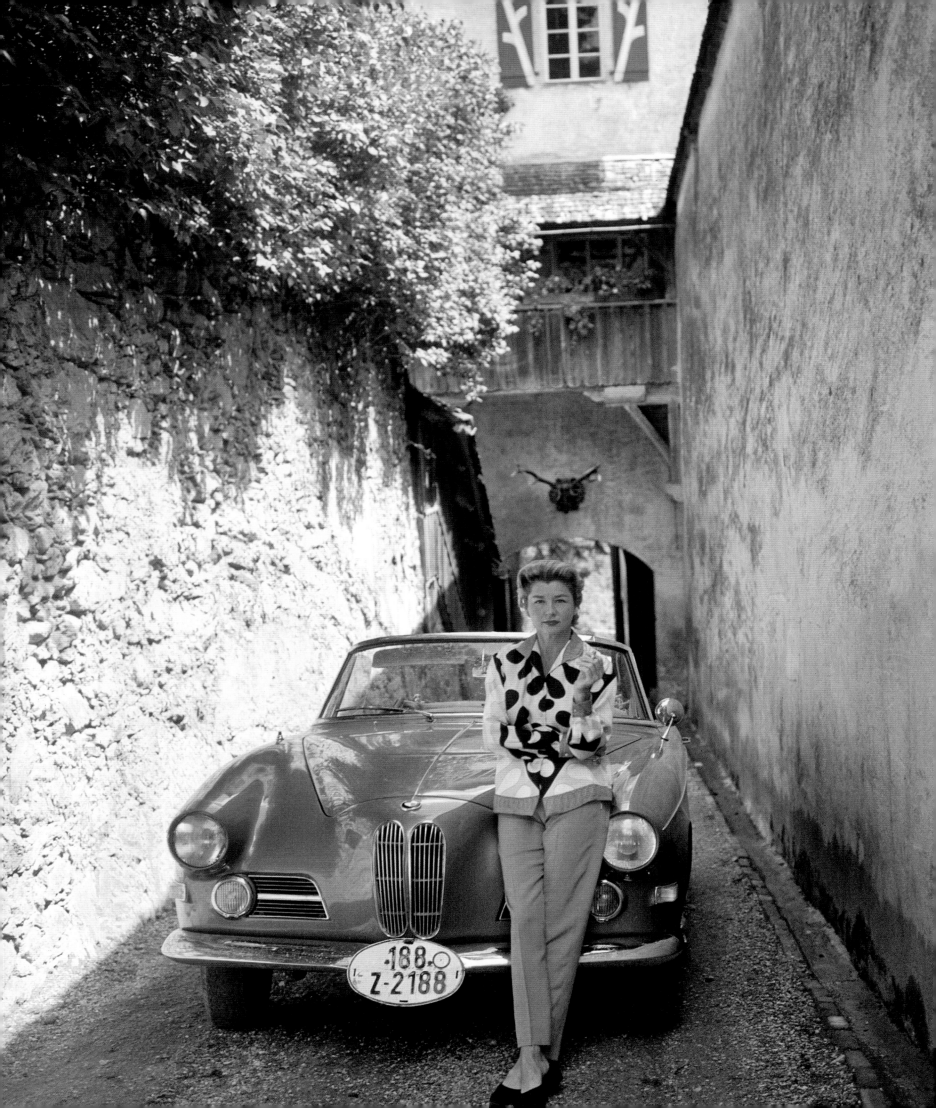

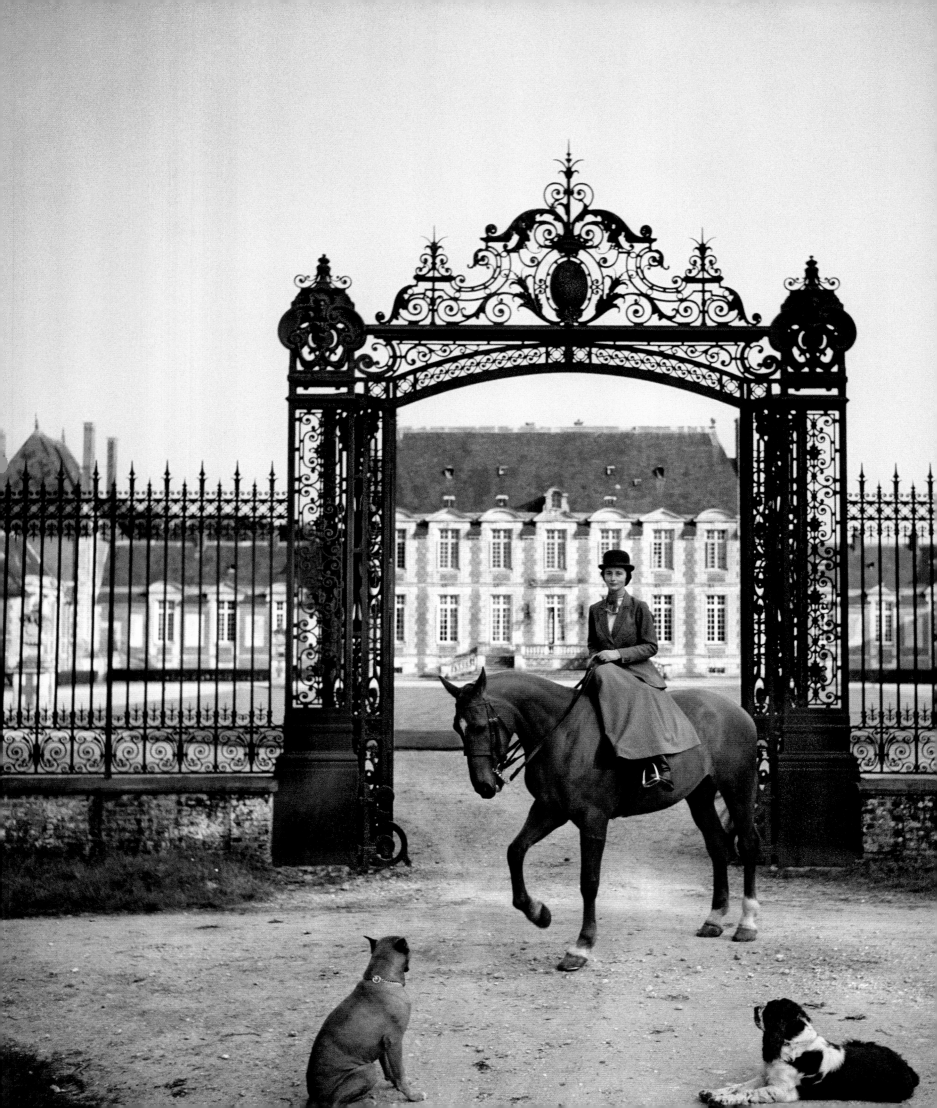

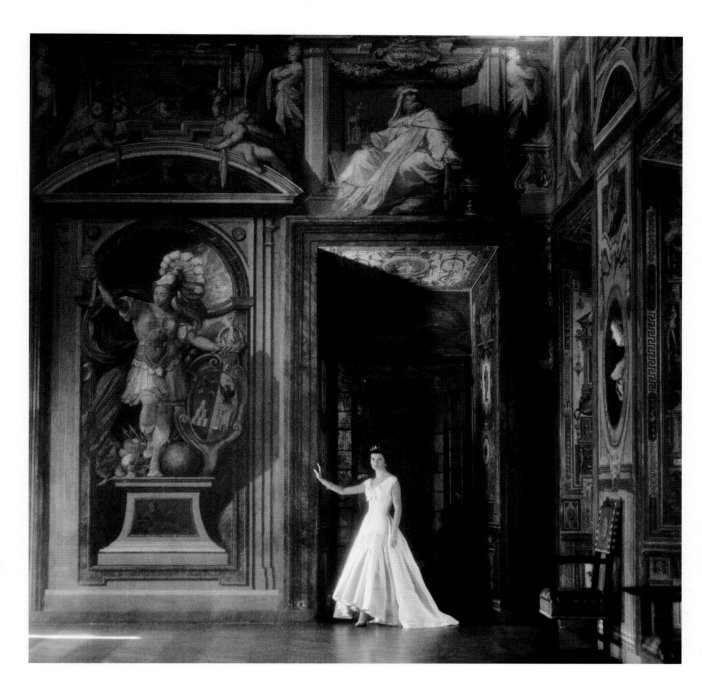

left Madame de la Haye-Jousselin outside the gates of her Normandy chateau, 1957. When asked how he was able to get the horse to pose, Slim replied, "To be a good photographer you have to have luck and the right setting. A pretty girl and dogs help, too."

above Donna Domitilla Ruspoli among the seventeenth-century frescos at Palazzo Ruspoli, Rome, 1960. The palazzo was constructed along the Via del Corso in the sixteenth century and has been in the Ruspoli family since 1776.

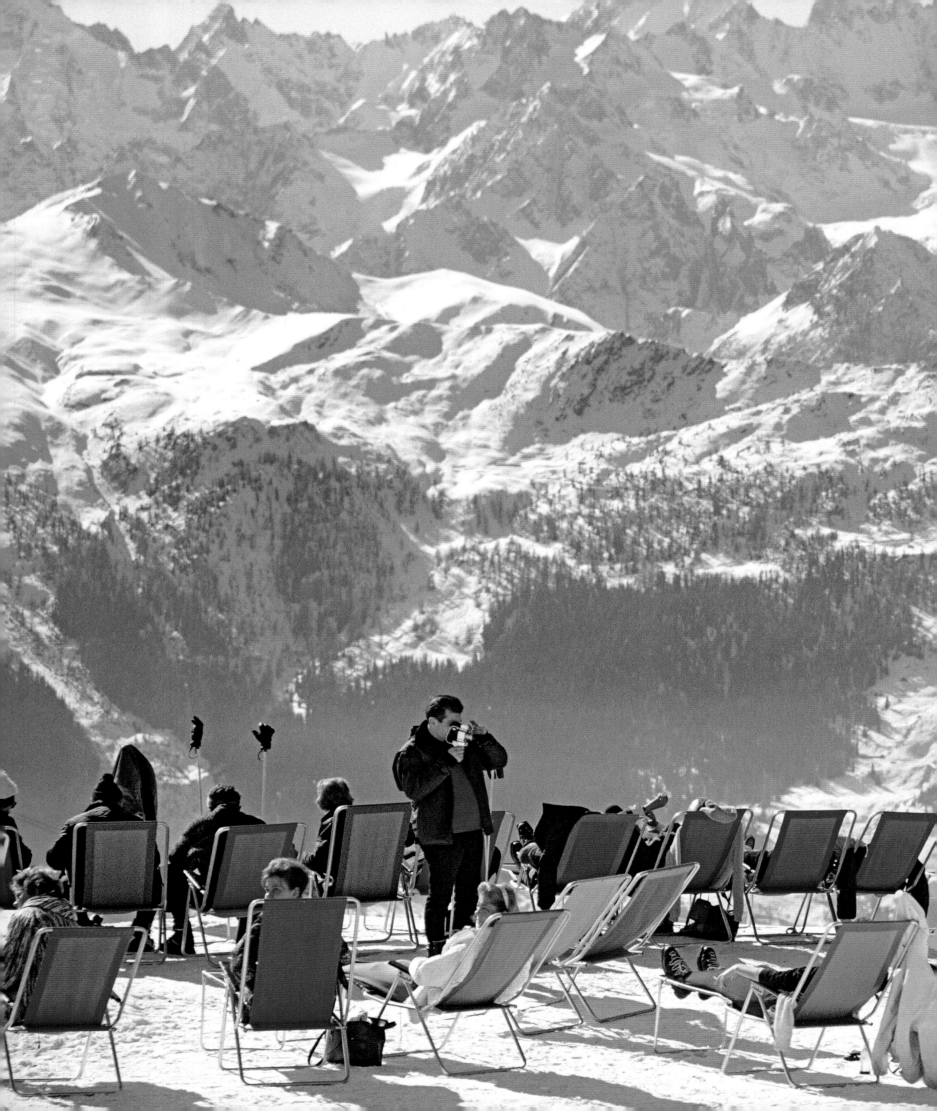

WINTER

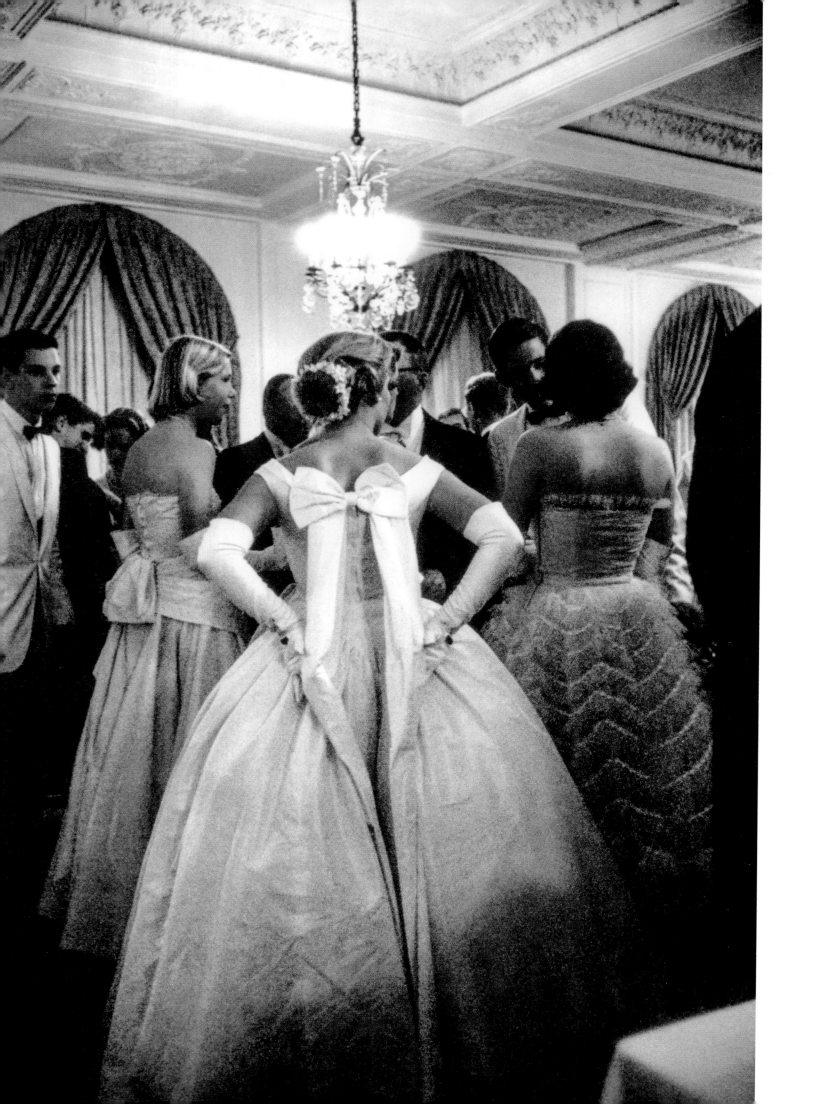

The Black and White Balls

For young society women in the 1950s, the winter season meant only one thing: black-tie debutante balls, when the social register set made their debut in society. In "social register" cities like New York, Boston, Philadelphia, and Chicago, young women from schools like Foxcroft and Ethel Walker would sign up for a charity and present themselves to eligible men their age in the grand Art Deco ballrooms of hotels like New York City's Waldorf Astoria or Boston's Copley Plaza. These debuts consisted mostly of debs singing "The Coming Out Waltz" as they performed deep curtsies, one at a time, in the center of the ballroom or even onstage, accompanied by bands like Lester Lanin. Each debutante wore a long white dress that approximated a wedding gown and carried a lavish bouquet. The Boston socialite Rebecca Draper is pictured opposite, arranging the bow on her dress while waiting to line up with her father in the ballroom of the Copley Plaza hotel.

The tradition of coming out dates back to the seventeenth century, when young women of marriageable age were presented at European courts to the approval of court ladies and sometimes the monarch. Debutantes have changed over the course of history. In the 1920s they were known for being "brittle, animated and witty, and were admired for their boyish gaiety, their ability to swing from chandeliers and to mix and drink cocktails," according to *Holiday* magazine. But sometime in the 1930s, when Hollywood discovered glamour, debutantes became more languid and seductive. They hankered for roles in movies, and hung out with "café society." It wasn't until Brenda Frazier appeared as the "Number One Glamour Debutante" that the old guard decided to begin classifying debutantes, hoping to restore their more dignified reputation.

By the middle of the twentieth century there was a hierarchy of debutantes, beginning at the bottom with those who made their debut only at the Cotillion in New York and rising to the highest rung of very important debs, those who came out at the Junior Assemblies and the Junior League Ball and the Cotillion.

In 1959 Henry Ford II spent $250,000 for his daughter Charlotte's debut. He decorated the Country Club of Detroit with eighteenth-century French tapestries and imported two million magnolia leaves from Mississippi. Guests with names like Roosevelt, DuPont, and Churchill danced to the music of the Meyer Davis bandstand as Charlotte descended the stairs, dressed in a white strapless satin gown embroidered with pink tourmalines and pearls. By the 1970s, this lavish tradition had fallen apart as affluent young society women embraced more radical causes on campuses across the country. It wasn't until Ronald Reagan got to the White House and made flaunting wealth proper social conduct again that deb balls came roaring back into style.

Today cotillions like the New York Infirmary Ball and the Viennese Opera Ball still exist, and young women still curtsy in their long white dresses and gloves, but their purpose is more charitable than social.

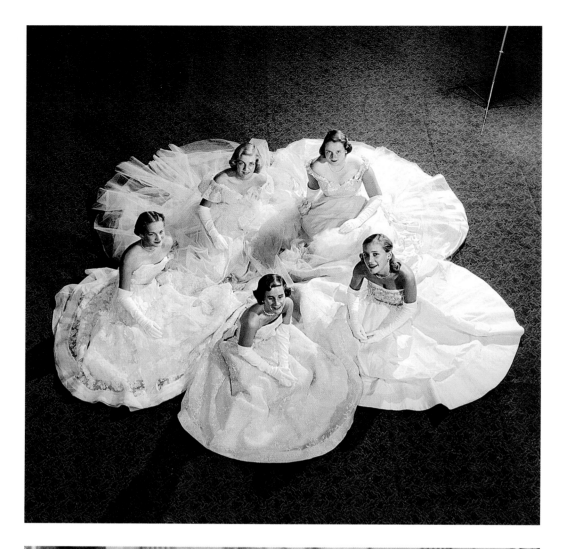

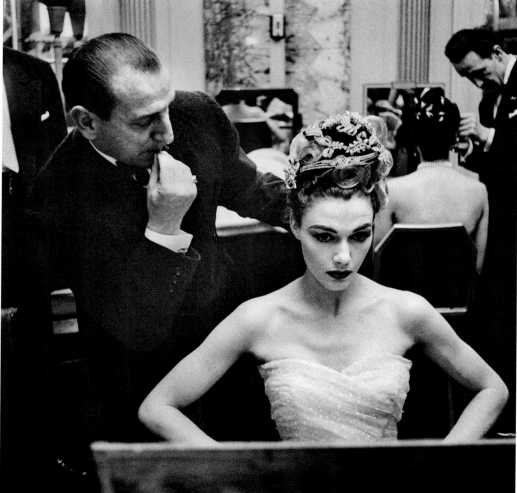

pages 172–173 Holidaymakers enjoying the view at Verbier, Switzerland, 1964.

above Clockwise from bottom: Ann Firestone, Venetia Arlen, Mary Audrey Weicker, Sarane Hickox, and Peggy Hitchcock rehearse for the third annual Christmas Ball at the Waldorf Astoria, 1951. The charity ball was held on December 21 along with the annual Debutante Cotillion, where more than a hundred debs made their society debut wearing the traditional white formal dress. The dominant style for 1951 included strapless gowns with full skirts in layers of sheer fabrics. For the finale, the young women sat on the center of the floor in the form of a Christmas star. As each lit a candle, the ballroom's lights were dimmed, and the attendees sang carols led by the American baritone Charles Danford.

left A New York deb has her headpiece pinned, 1950s.

opposite Last-minute adjustments, 1950s.

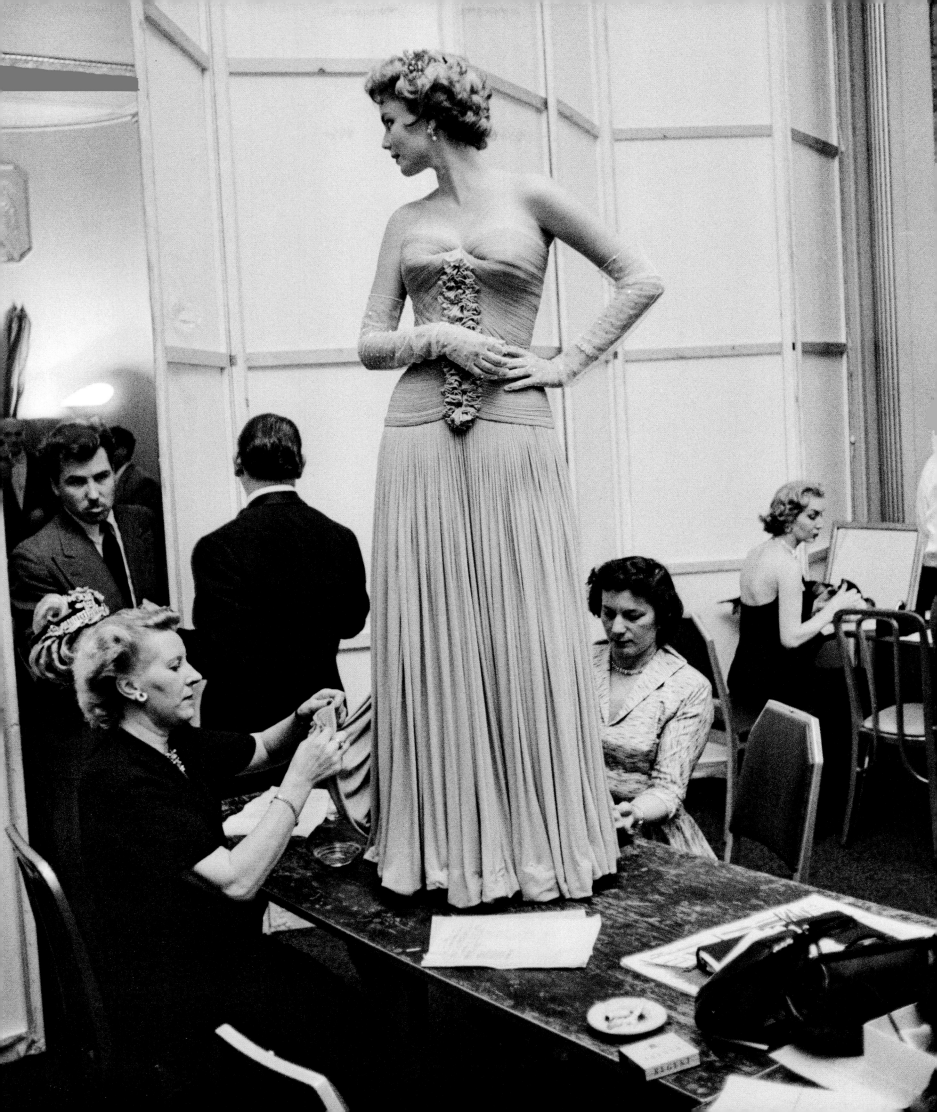

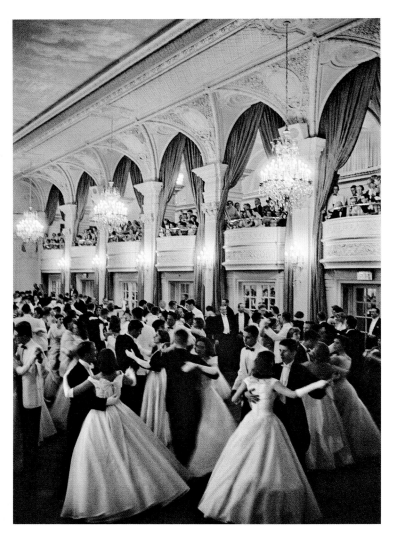
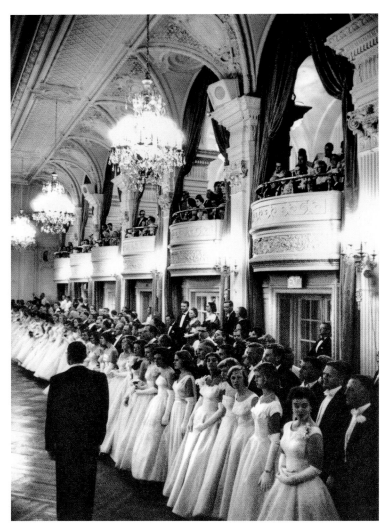
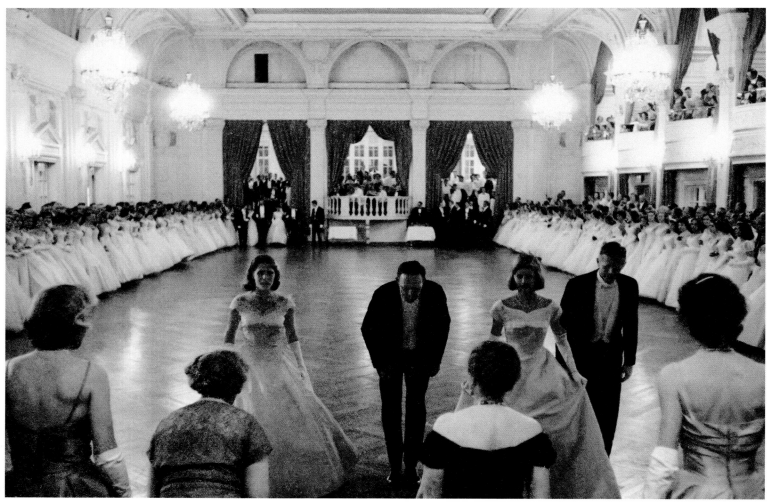

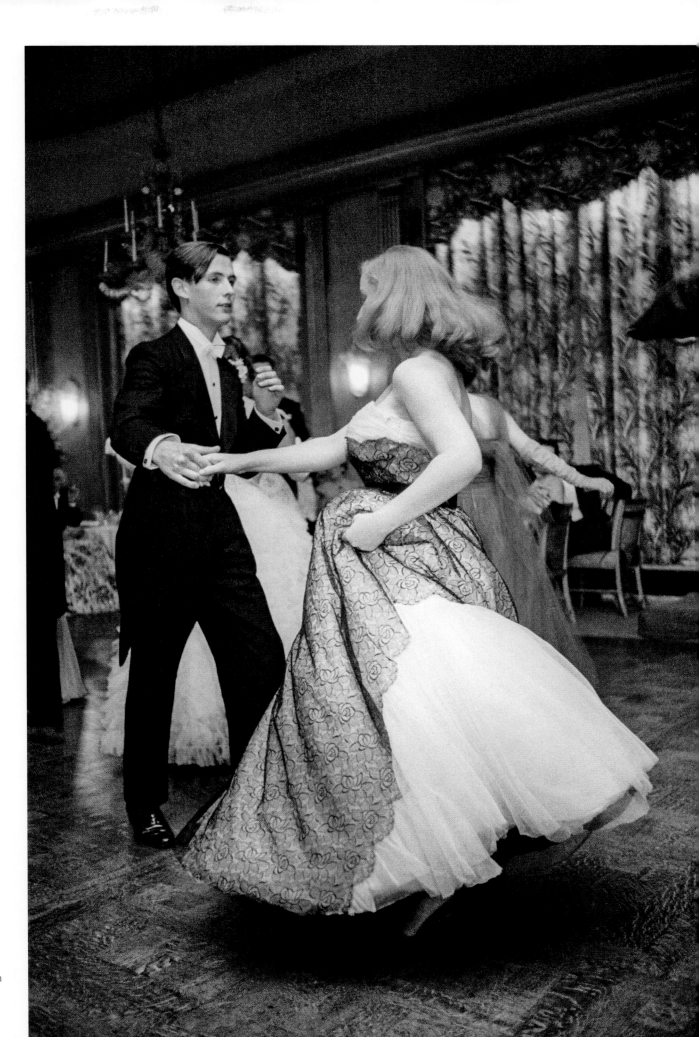

opposite Three scenes from the 1958 Debutante Cotillion at Boston's Copley Plaza hotel. Debutantes with their fathers (top right), formal presentation to the patronesses (bottom), and debs and their escorts on the dance floor (top left)

right Miss Daphne Battine and the Honourable Charles Wilson at the Cygnet's Ball, Claridge's Hotel, London, 1955.

In the Swing

Style is about so much more than how you dress. It's about manners and poise and how you speak. It's about movement and posture, and, for many socialites of New York City's Upper East Side, style was also about ballroom dancing. In order to make your debut at a cotillion or to escort a deb, you had to know how to do the foxtrot or waltz. It didn't matter if your movements were robotic or you had no sense of rhythm. You had to know the steps and carry yourself correctly.

So, come September each year, just as young women and men seeking access to "real society" were enrolled in kindergarten at prestigious private schools like Buckley and Spence, so too were they signed up for obligatory dance lessons at Mrs. Vera de Rham's school in the River House. In the photo opposite, Aarons captures a student curtsying to Mrs. de Rham at the end of a class in 1958.

Well-bred kids from ages four to fourteen from Manhattan's best private schools would show up in their lace-collared velvet dresses, white socks, patent leather shoes, and white gloves, or blazer and tie or dark suit and carefully combed hair, to learn to do the foxtrot. Later, as teens, they would learn to do the Hustle, the bus stop, and the tango. But first they had to learn to curtsy, bow, and shake hands, introducing themselves as they would at a party. Then the boys would form a stag line, and proceed to ask a girl to dance, when they were instructed to take partners. Mrs. de Rham, a former dancer and model, stood ramrod straight and coaxed kids with surnames like Astor, Whitney, and Hearst into perfecting their social graces.

At the annual Christmas dance, each aspiring young Fred Astaire and Ginger Rogers would line up and choose a partner, and the crowd of four hundred kids would sway along to the Mexican hat dance. With mothers hovering in the background, the kids would spend an hour giggling and dancing and trying to look the part of a young socialite.

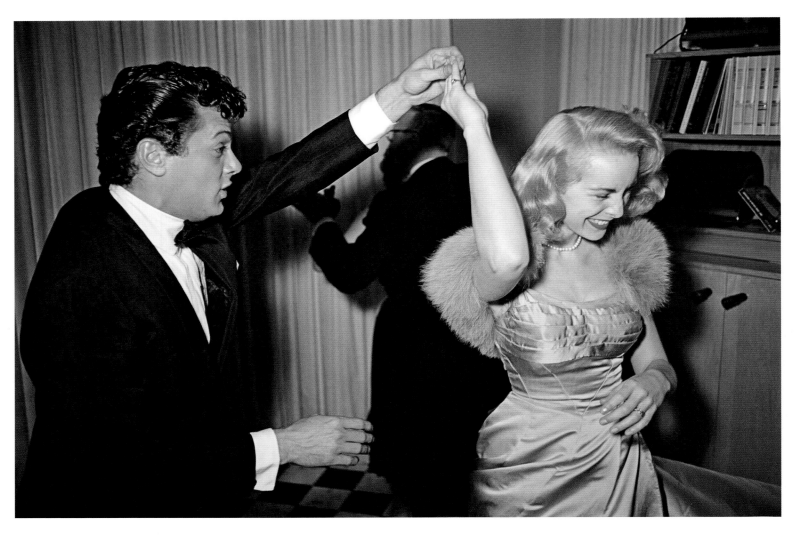

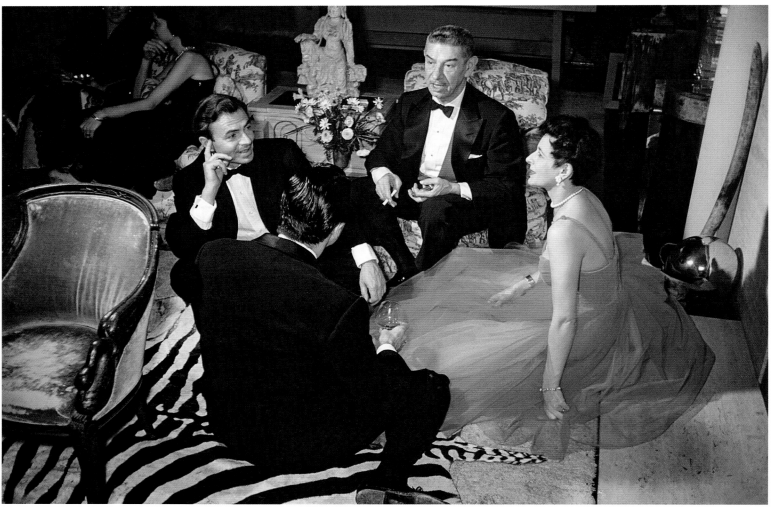

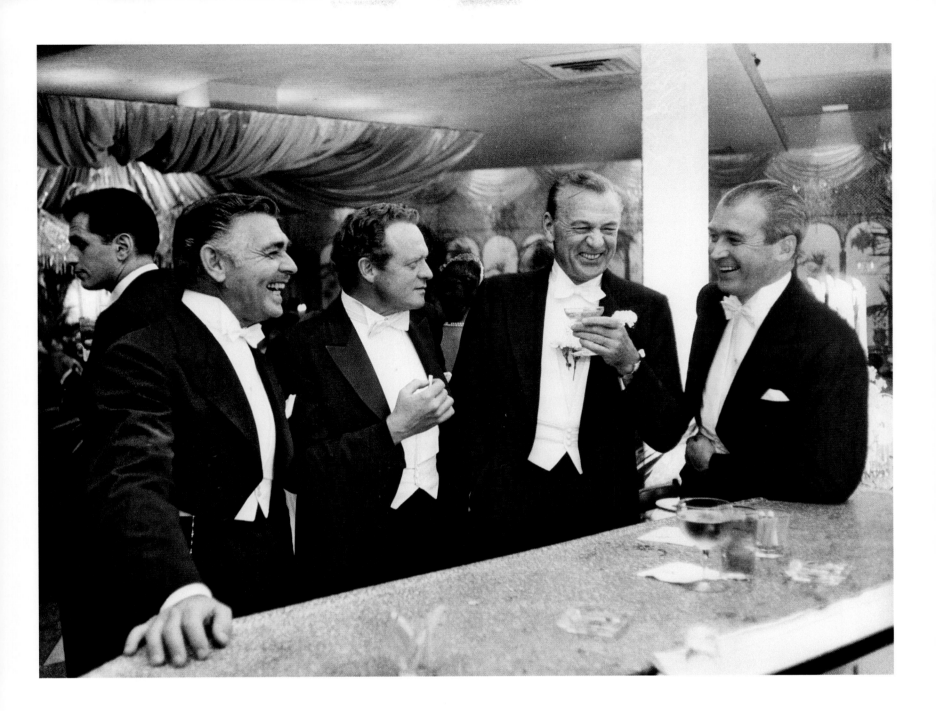

opposite above Married film stars Tony Curtis and Janet Leigh jitterbug during a party for Lauren Bacall at the home of noted Hollywood hosts James and Pamela Mason, 1953. The Masons' Beverly Hills villa was built by Buster Keaton in 1926 and previously occupied by Marlene Dietrich as well as Cary Grant and his wife, Barbara Hutton.

opposite below Actors James and Pamela Mason chat with restaurateur Mike Romanoff during a party at the Beverly Hills home of Hollywood costume designer Adrian and his wife, the actress Janet Gaynor, 1954.

above The Kings of Hollywood—Clark Gable, Van Heflin, Gary Cooper, and James Stewart—enjoy a joke at Slim's expense during a New Year's party at Romanoff's in Beverly Hills, 1957.

Celebrity Style

Aarons was known to charm his way into the cocktail parties and dressing rooms of many a Hollywood star. No image of his is more famous than "The Kings of Hollywood," a black-and-white photograph of Clark Gable, Van Heflin, Gary Cooper, and Jimmy Stewart lined up behind the bar in the Crown Room at Romanoff's in Hollywood on New Year's Eve, 1957. *Smithsonian* magazine called it "a Mount Rushmore of stardom." And, indeed, it is the epitome of the Hollywood candid moment, showcasing both the formality and the personality of some of the world's most famous actors.

But there were many more stars in Aarons's portfolio, and most of them were women, including Marilyn Monroe, opposite, whom he photographed in 1952 shortly after her breakout supporting role in John Huston's film noir *The Asphalt Jungle*. Slim taught the young actress to relax in front of the camera by thinking of the nicest thing she could imagine. He also famously captured Marlene Dietrich dressed in top hat and tails while entertaining the crowd at the April in Paris Ball in New York in 1959. And he gained entrée into a private party in Hollywood on New Year's Eve 1953, where he captured Tony Curtis and Janet Leigh dancing.

This was decades before the arrival of celebrity publications such as *InStyle* and *Us Weekly* and, of course, before so many handlers and managers made it quite impossible to capture a star in a natural moment, with natural light. And yet, 1950s Hollywood embodied style at its most artificial and, probably, most difficult to capture in a natural fashion. Silver-screen sirens like Dietrich were accustomed to the kind of elaborate makeup and hairstyling that made them so alluring and popular in the 1930s, when studios dictated how their stars would appear to the public and any number of airbrushing tactics were employed to enhance the mythology of each image.

It would take a photographer like Slim Aarons, unafraid, charming, and familiar with Hollywood, to break down these barriers and capture his famous subjects in a way that illustrated not just their fame and beauty but also something of their authentic personal style.

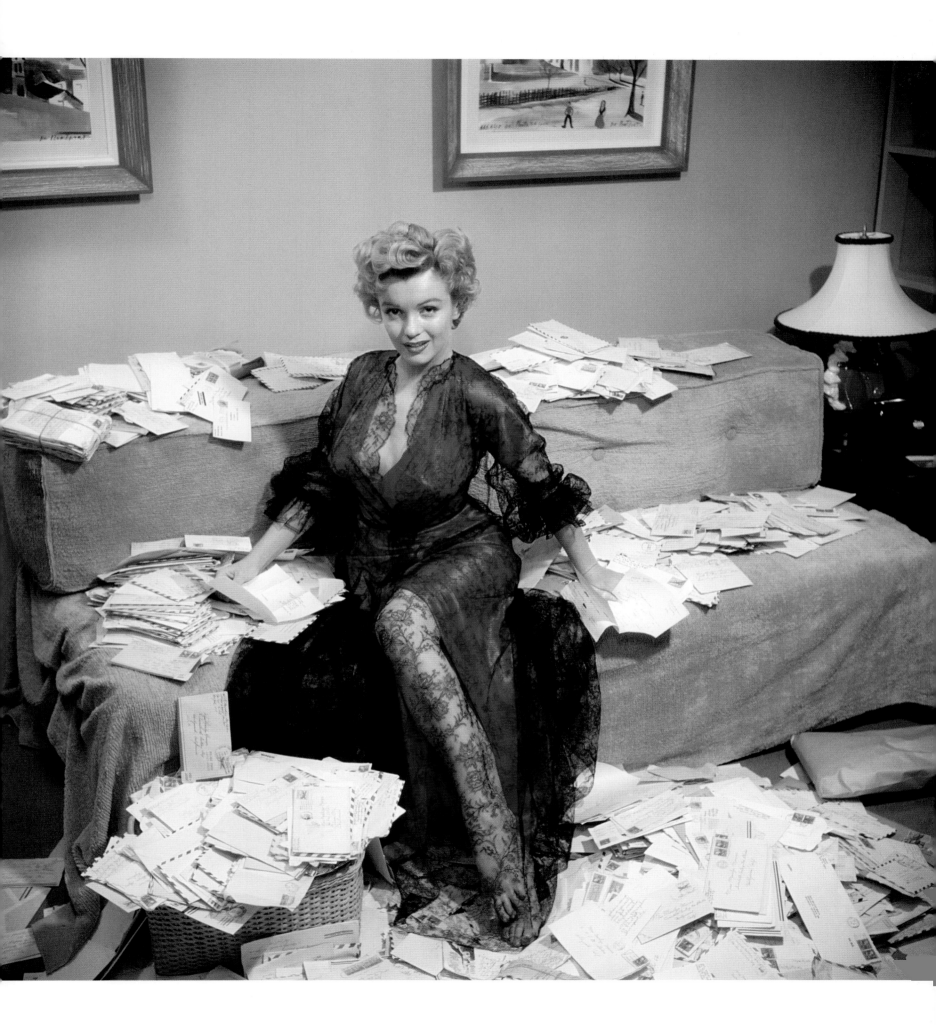

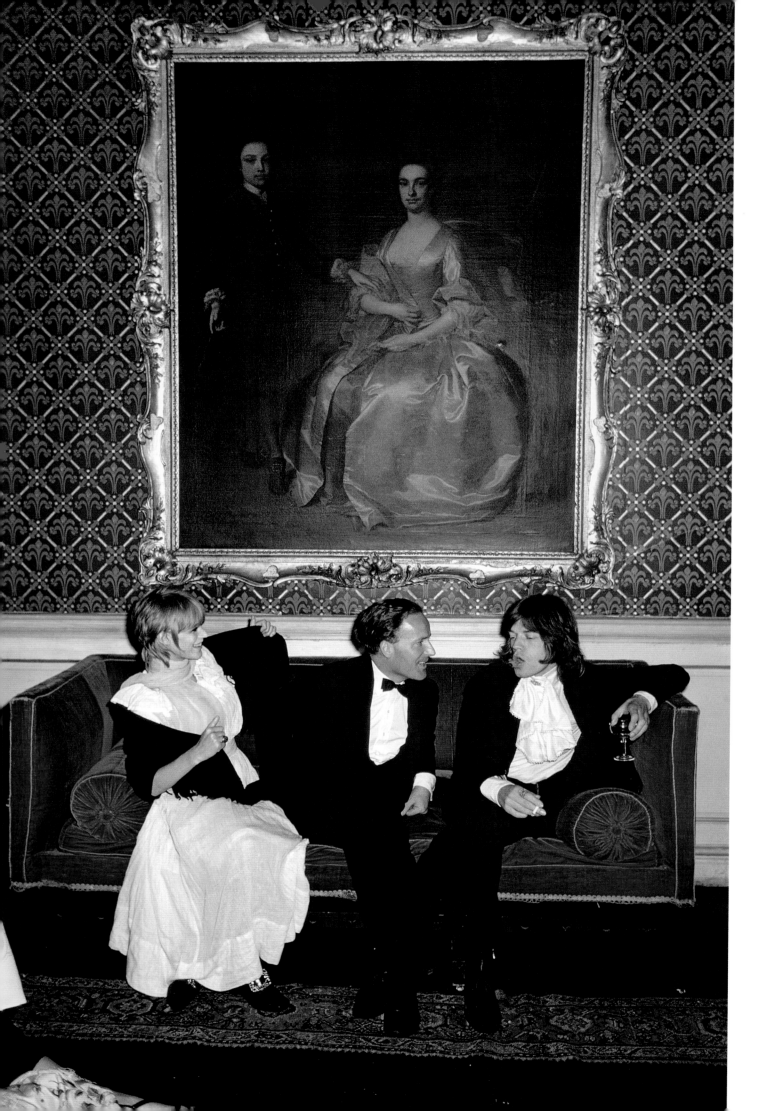

opposite Singer Marianne Faithfull, the Honorable Desmond Guinness, and Mick Jagger attend a party at Castletown House, Ireland. Slim traveled to the party with the threesome and, after spotting the painting in a hallway, asked them to sit for a portrait. Members of the press saw him setting up the shot and elbowed their way in. Asked about it years later, Slim raised his hands and said, "I spent my life setting up shots other people used. That's life in the photography business."

above Fleur Cowles chats with Cecil Beaton at a Park Avenue New Year's Eve party, 1952. Cowles was a painter, writer, and renowned hostess but is best remembered for convincing her husband, Gardner "Mike" Cowles, Jr., the publisher of *Look* magazine, to begin publishing *Flair* magazine in 1949. *Flair*, which was entirely her brainchild, covered fashion, literature, travel, art and interiors and was aimed firmly at the elite. Each issue—only twelve were published—was a work of art and is now highly collectible. Covers featured peek-a-boo cutouts, while inside pages incorporated fold-outs, popups, and removable pages on different paper stocks. A spring issue dedicated to the rose, her lifelong obsession, was scented with rose fragrance. Mike pulled the plug after one year, having lost an estimated $2.5 million.

Winter Gardens

After all holiday galas had been enjoyed and winter really set in, society abandoned cold, dreary urban centers for diversion elsewhere. If they weren't hitting the slopes in the Alps, they looked to tropical climes: Florida, Mexico, or a Caribbean isle—and Slim Aarons would follow.

The overview, or environmental shot, became a Slim Aarons signature. He would back up or climb a ladder so that he could take in the whole vista of an image—the whole of Central Park, or San Francisco Bay, or an elegant garden party in Miami. The idea was not just to capture a scene, but to show style in a broader context, as an expression of a place, the definition of a way of life—in this particular case, that life being the private enclaves of Miami Beach in the winter of 1970.

Aarons knew he had a better chance of gaining access to the private parties of this genteel world if he didn't carry around a lot of baggage and equipment. He traveled with one assistant and a stainless-steel briefcase containing a single Leica camera. His list of rules for assistants was famously strict and included "no heavy suitcases, no tennis rackets, no hairdresser appointments, no minibar tabs, no shopping, no dry-cleaning, no days off, no boyfriends, no sightseeing and for God's sake no cameras."

Like so many other vacationers in the mid-1950s, Aarons was drawn to the sunshine and Gulf Stream waters of Miami Beach. At that time Miami Beach was considered a destination for the new rich, who hailed from Broadway and Hollywood and liked to bask in their cabanas, or mix with the middle-class vacationers who crowded the hotels along Collins Avenue. Aarons called it the Riviera of the New World; the Manhattan of the Gold Coast. The big hotels such as the Fontainebleau would lure celebrities like Jimmy Durante and Eddie Cantor in an attempt to outshine the competition by adding newsworthy names to their registers, and supplying each room with stationery embossed with guests' names. The elite Bath Club became a popular destination for midday dancing, often to the strains of a rumba band. In fact, each hotel had its own outdoor rumba pavilion, and the ladies were known to show up with furs draped over their beach attire. More low-key residents would stick to their sumptuous villas on Sunset Isles, entertaining in their walled gardens.

Aarons understood the mood of a place and was primarily interested in capturing the codes and gestures of each location. In Miami he sought a more urban sophistication than in Palm Beach. He called it "razzle dazzle" and saw it in people's personal style, such as the way men wore straw boaters, or the way women topped off long skirts with casual cardigans and wide-brimmed hats. Even the string quartet accompanying an afternoon tea lent a subtle style accent to the Miami Beach scene.

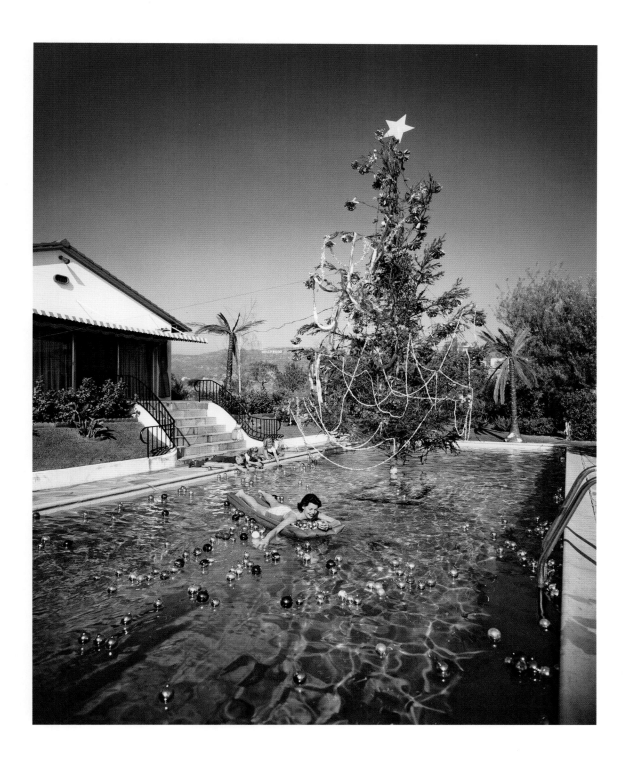

left Slim discovered this scene while on assignment in Miami Beach in 1954, but needed talent to bring his vision to life. Since Miami did not have a model agency at the time, he paid a visit to the fashion coordinator at Burdines, the famed Florida retailer, for suggestions. She pointed him toward a local beauty named Mary "Miki" Ballou, now Stevenson, who was working as a model in Burdines's Tea Room. The first setup, which was used on the cover of *Holiday*, features Mary alone, holding the hat in a straightforward fashion pose. For the next setup, seen here, Slim flagged down a man walking along the beach and added him to the scene, creating a whole new dynamic. The whole shoot happened so quickly, Mary never caught the man's name.

above Rita Aarons, wife of Slim, in a Christmas-themed pool, Hollywood, 1954.

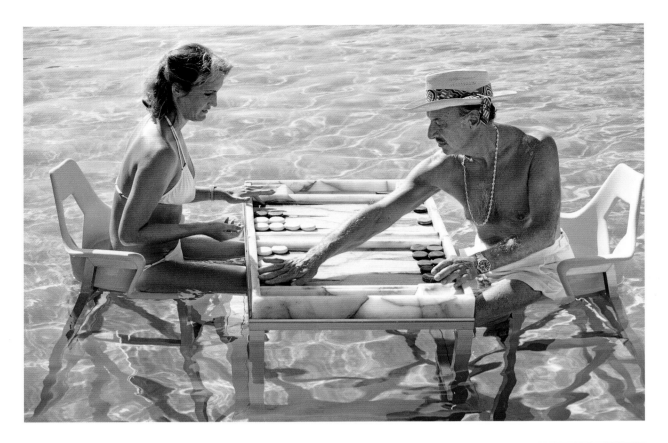

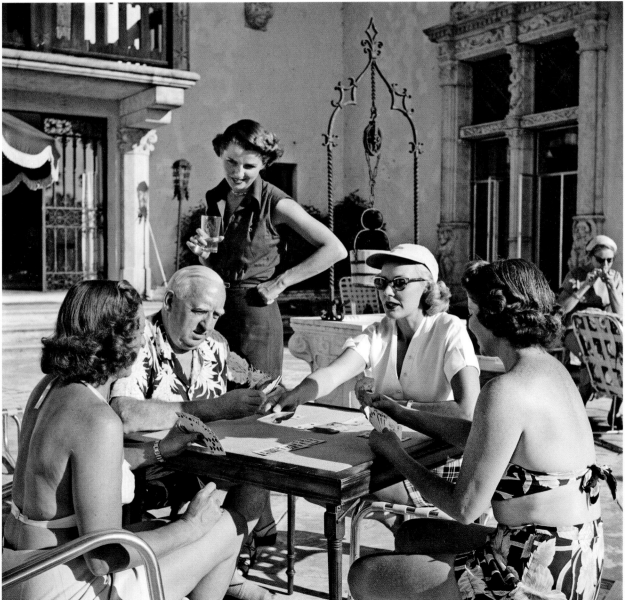

above Carmen Álvarez keeps cool while enjoying a game of backgammon with Colonel Frank "Brandy" Brandstetter, founder and operator of the Las Brisas Resort, Acapulco, 1978.

left Gambling is a favorite pastime at Palm Beach, and canasta was the game of choice in the 1950s. Here Mrs. Benjamin Black, private eye to the stars Raymond Schindler, Jerry Rowen, Betty Bosworth, and Mrs. Schindler play al fresco, 1955.

opposite Snowbirds lounge at the Fontainebleau Miami Beach, 1955. Designed by neobaroque architect Morris Lapidus, the grand hotel opened in 1954 and immediately became the crown jewel of Miami's Millionaire Row. The exterior features an elegant curved façade, and the lobby offers the famed Staircase to Nowhere. The resort, which served as Frank Sinatra's unofficial Miami headquarters, was so popular with tourists that owner Leo Morrison had to "station bellboys just to keep people from coming in and feeling the drapes."

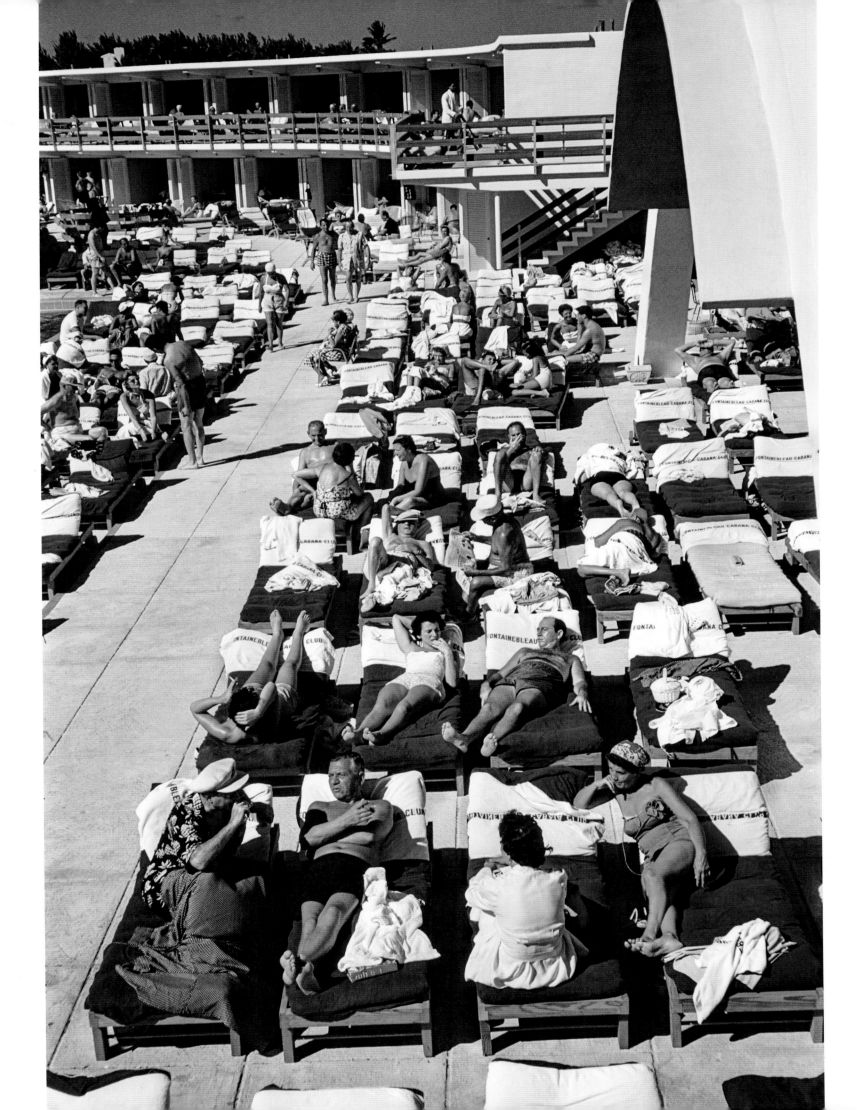

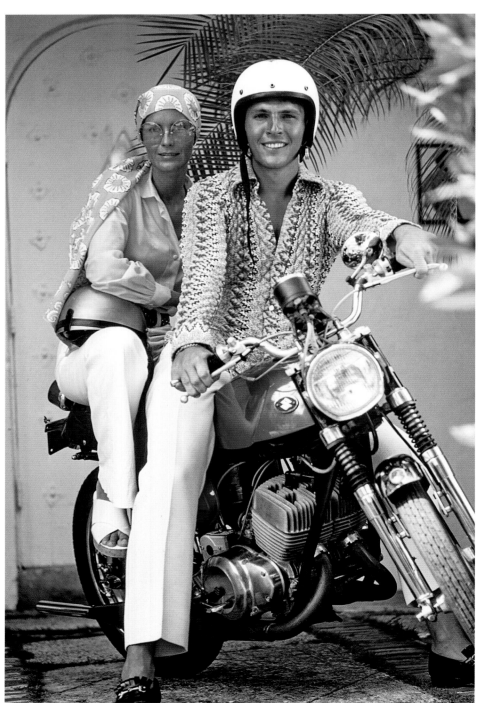

above Poolside party, Palm Beach, 1961.

left Fashionable Palm Beach couple Inger and Harry Loy Anderson, Jr., at their family home, Casa Alta y Seco, 1970. Harry became the youngest bank president in the US at age twenty-six and, together with Inger, purchased an orange grove, which she transformed into a local attraction and tourist destination. His flame-patterned knit shirt was popularized by the Italian fashion house Missoni.

opposite Palm Beach hostess Florence Pritchett Smith (left) and designer Lilly Pulitzer, wearing a top of her own design, share secrets at a poolside party, Palm Beach, 1961.

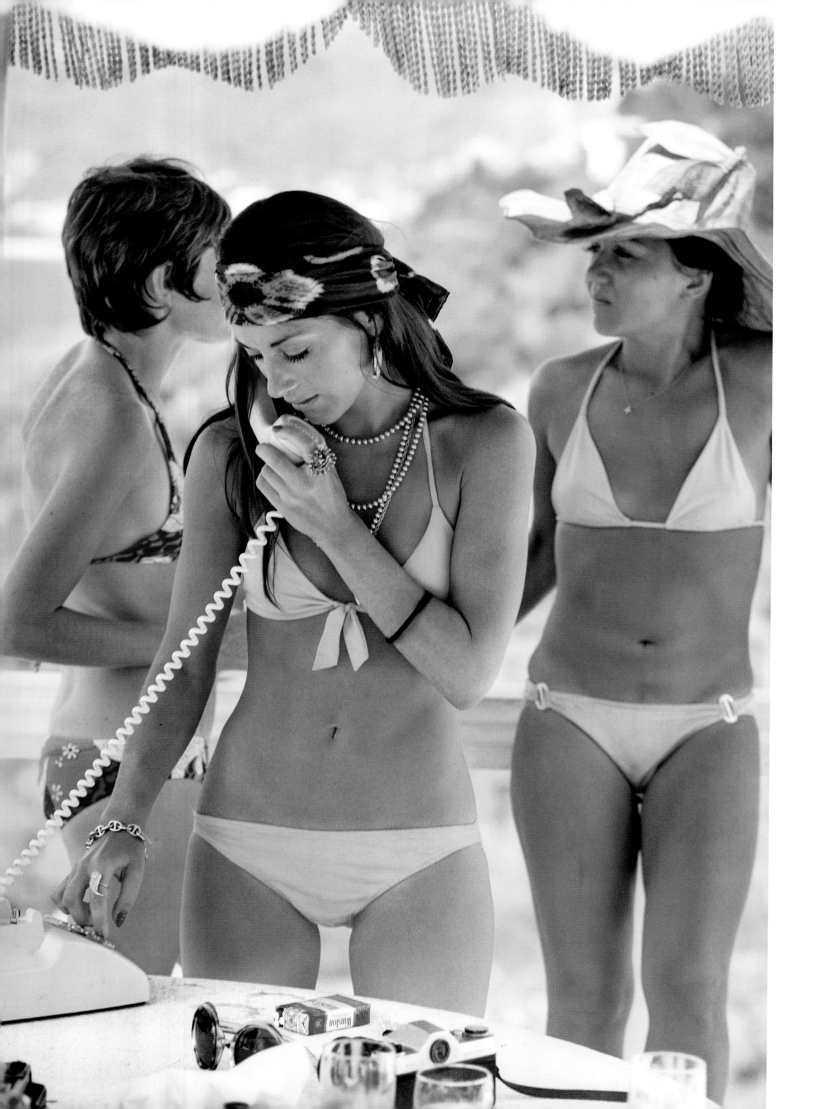

Tropical Breezes

By the late 1960s and '70s Acapulco, a sun-soaked town on the Pacific coast of Mexico, had become the fashionable vacation spot for socialites, entrepreneurs, and the Hollywood jet-set. Situated four hours south of Mexico City, it was named after the ancient Nahuatl word for giant reeds and had been discovered by Hollywood types in the 1930s, when John Wayne and Errol Flynn purchased the Los Flamingos Hotel, which later became known as the "Hotel of Stars" because it attracted boldfaced names like Nancy and Ronald Reagan, Rock Hudson, Debbie Reynolds, and Orson Welles.

By the time Aarons showed up in the 1960s, he was photographing private luncheons at the Villa Vera Hotel Spa and Racquet Club with guest lists that included the likes of Douglas Fairbanks, Jr., Emilio Pucci, and Merle Oberon, who owned the Villa Nirvana.

Later, in the 1970s, the clifftop Las Brisas villas became the location for elaborate—and constant—parties hosted by vacationers like the rental car king Warren Avis. With guests including everyone from fashion designer Oscar de la Renta and his French wife, Françoise de Langlade, to models like Marisa Berenson, these hedonistic parties became the perfect backdrop to the evolving style of the 1970s—string bikinis, headscarves, ropes of beads and baubles, and endless games of backgammon by the pool. Opposite, socialite Charley Weaver makes a "social call" at the Las Brisas resort in 1972.

Socialites, fashion designers, and entrepreneurs weren't the only visitors to Mexico's Gold Coast resort. Elvis Presley filmed *Fun in Acapulco* there, John F. Kennedy and his bride, Jackie, honeymooned there, and Elizabeth Taylor became a regular along with Frank Sinatra and Sammy Davis, Jr., who frequented the El Mirador hotel.

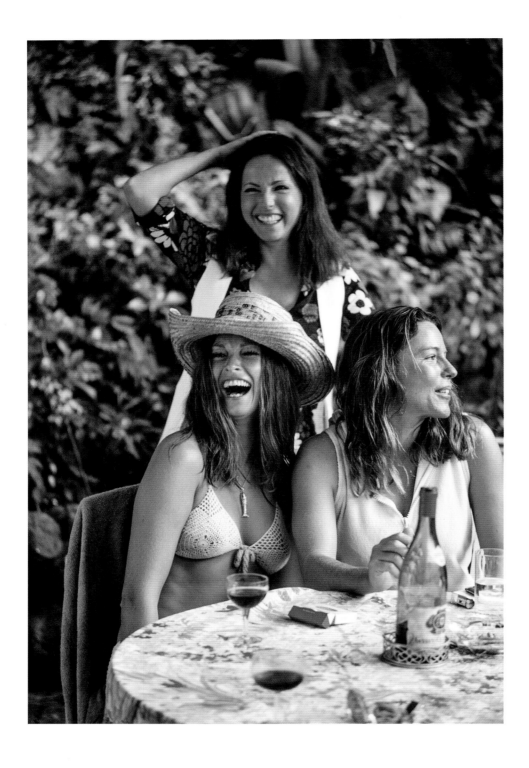

above Three friends share a laugh at British hotelier Stanley Vaughan's home in Montego Bay, Jamaica, 1970. Vaughan was the perennial bachelor who in 1967 wasn't afraid to go on the record with his thoughts on current island style. "Socks are out. Socks are middle class. So are suits and ties. For day, open neck shirts and ascots are divine. For night, white. By all means, white. It shows off your tan."

right Ava Marshall, a native Barbadian, relaxes among the bougainvillea in the lush gardens of a private villa on Alan Bay, Barbados, 1976.

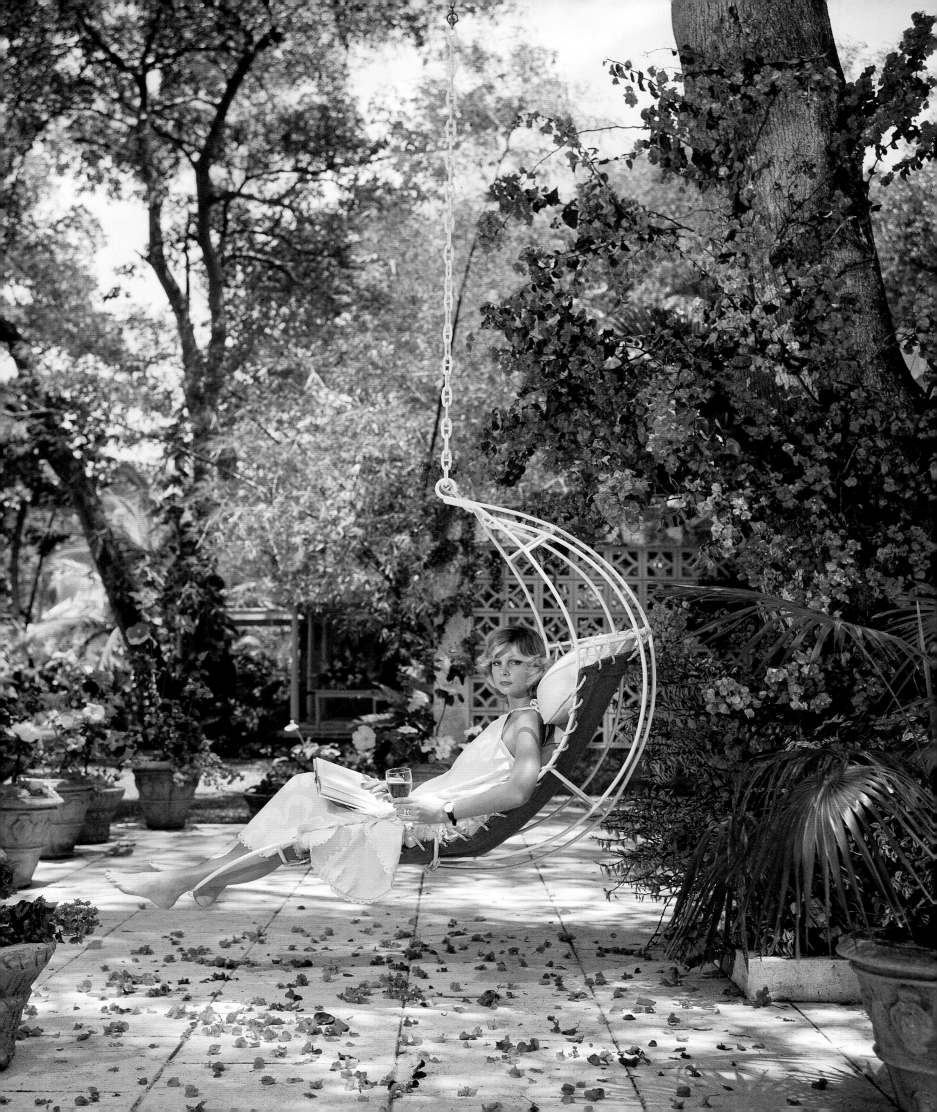

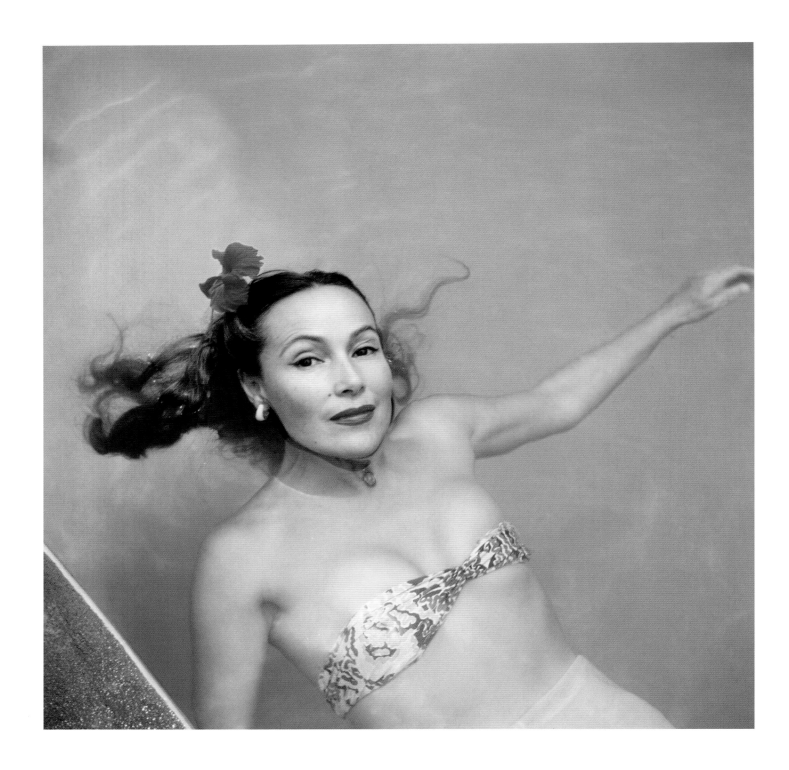

above Mexican film star Dolores del Río floats in Acapulco, 1952.

opposite above left Suzy Gilly, socialite Anita Colby, advertising executive Mary Wells, *Women's Wear Daily* reporter Sloan Simpson, and Doris Kleiner, wife of Yul Brynner, chatting in Acapulco, February 1966. They were in town for a party in honor of Emilio Pucci, the Italian fashion designer known for his eye-popping garments.

opposite above right *Vogue* editor Lesley "Topsy" Taylor in Acapulco, 1966. She was married to George McFadden, brother to fashion designer Mary. Taylor became fascinated with flying as a child and made her first solo flight at the age of twenty. She earned her pilot's license for both private planes and commercial helicopters. At first she used them to shuttle her children from boarding school or friends for weekends away, but later she started a successful aviation company.

opposite below left 1960s supermodel Countess Vera Gottliebe von Lehndorff, better known as Veruschka, dances the limbo while wearing Pucci fashions in Acapulco, 1966. Veruschka was featured in a series of legendary *Vogue* spreads and a brief but memorable appearance in Antonioni's cult-classic film *Blow Up*.

opposite below right Partygoers revel at the mountaintop home of Emi Fors, venerable Acapulco hostess, 1966.

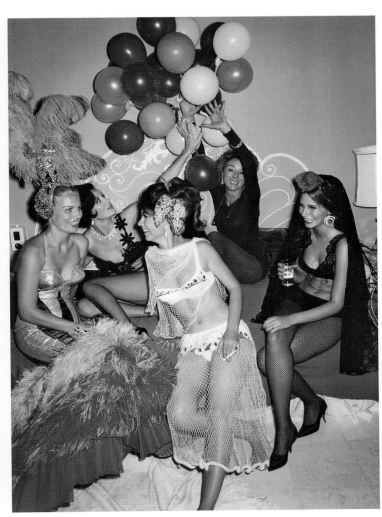

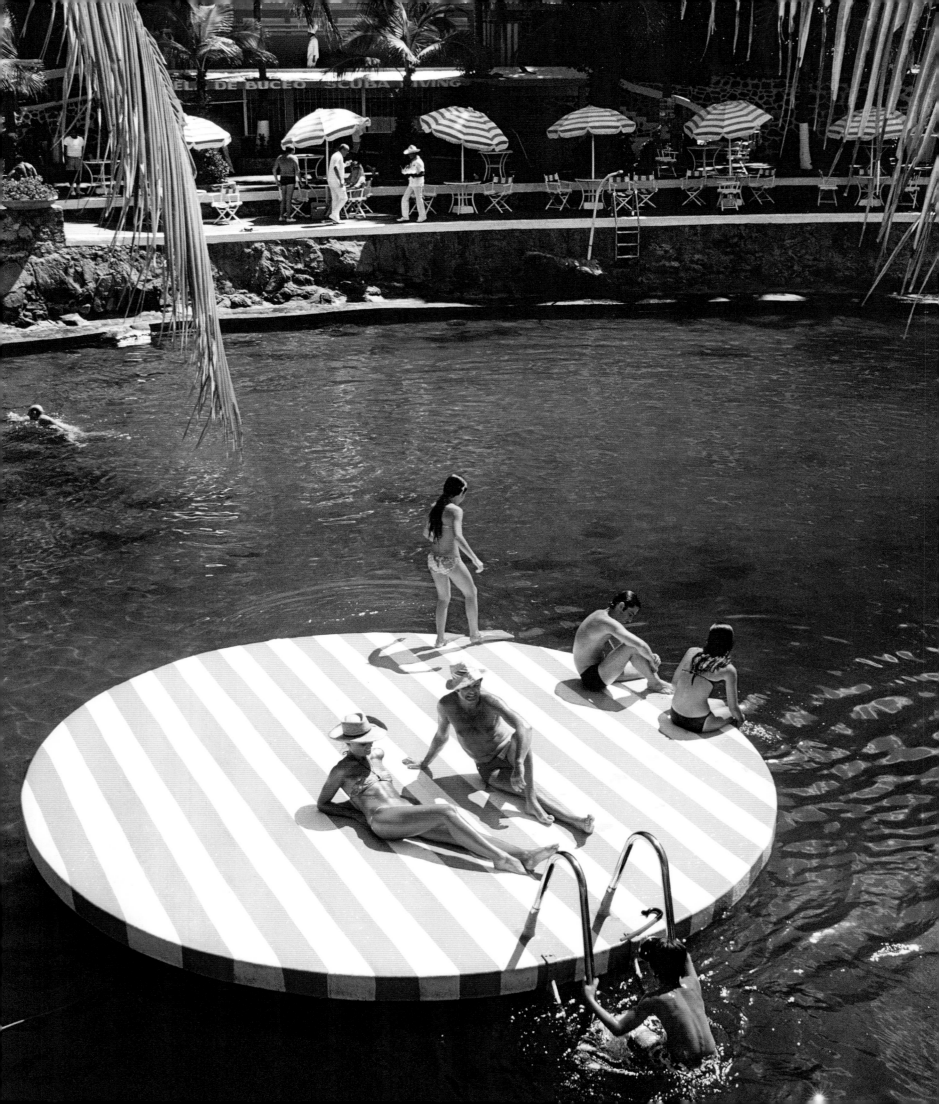

opposite Bathers relaxing at Las Brisas, Acapulco, February 1975. Known as the Pink and White Paradise, the resort covers 40 hilltop acres overlooking Acapulco Bay. The highly romantic location was popular with the Hollywood crowd for its 231 private casitas—Liz Taylor honeymooned there following her wedding to Mike Todd and left her handprint behind in pink cement to prove it.

right Guests at Las Brisas lean against one of the resort's trademark pink and white jeeps, Acapulco, 1972.

following spread left Fashion editor Babs Rawlings and her photographer husband, John, alongside an MG TD on the beach at Montego Bay, Jamaica, 1953. The couple met in 1942 at American *Vogue*, where she was chief fashion editor and he a staff photographer. In the 1940s and '50s Babs was considered the best-dressed editor at *Vogue*—no minor feat—and was known for her plunging necklines, head wraps, and exquisite feet, which she showed off in open sandals even on the coldest of winter days. She was often trailed by her two long-haired dachshunds and John, who was handsome and gracious and rivaled Horst P. Horst as the best color fashion photographer of the 1940s.

following spread right Former model and actress Dee Hartford, third wife of film director and screenwriter Howard Hawks, sips a Pussyfoot, Jamaica, 1958.

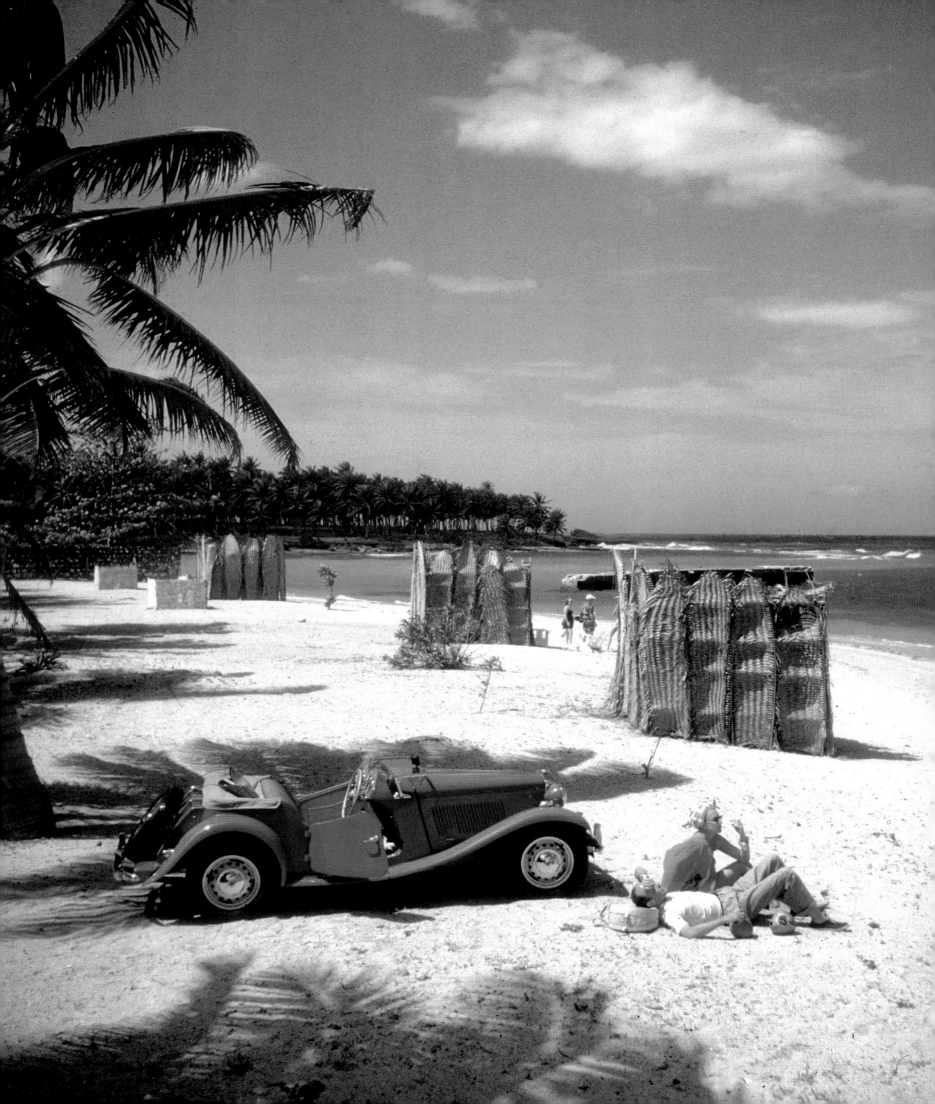

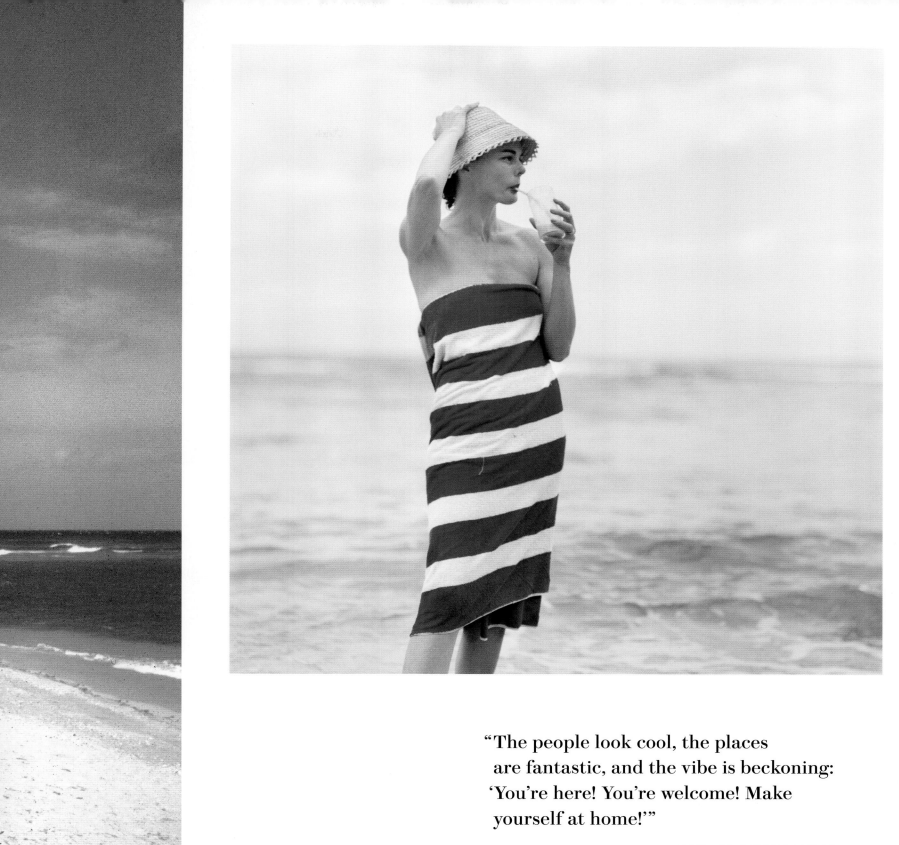

"The people look cool, the places are fantastic, and the vibe is beckoning: 'You're here! You're welcome! Make yourself at home!'"

—SID MASHBURN

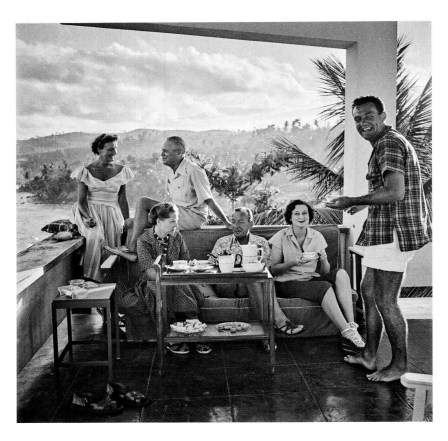
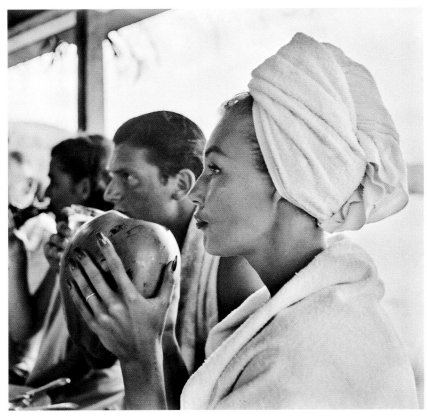
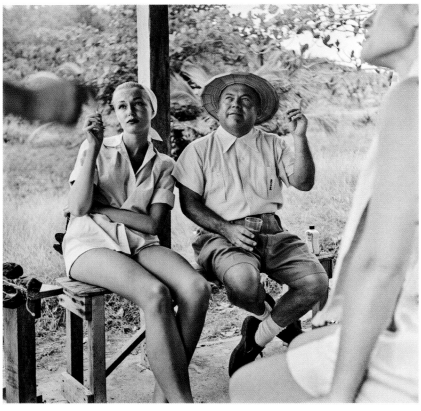
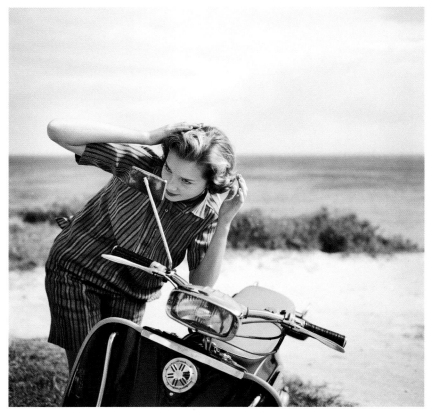

opposite above left Tea time for actress Joyn Carey, producer John C. Wilson and his wife, Princess Natalia Paley, playwright Noël Coward, Lady Rothermere, and actor Graham Payn, Jamaica, 1950. Coward was one of the first celebrities to regularly visit, and ultimately invest, in a Jamaican resort.

opposite above right Liz Pringle, Round Hill, Jamaica, 1953.

opposite below left Liz Pringle, née Benn, and Dick Reynolds at the Round Hill resort, Montego Bay, Jamaica, 1953. At the age of fourteen, Liz turned down the starring role in *National Velvet* ahead of Liz Taylor, reasoning she could earn more money modeling. By 1950, she regularly featured in *Vogue* and *Harper's Bazaar*. She met John Pringle in Jamaica while there for a fashion shoot; together they began developing Round Hill. John was a Jamaican-born Brit with deep roots in hospitality—his mother owned the Sunset Lodge—and had a unique vision for the resort.

In what was a new scheme, privately owned cottages were purchased by investors who then shared in the resort's profits. It was a gamble but paid off when Sir Noël Coward, already a dedicated visitor to the island, signed on, followed by Adele Astaire, Bill and Babe Paley, the Oscar Hammersteins, the Marchioness of Dufferin, and others. Liz became a tireless promotor of Round Hill and scheduled her future fashion shoots there to help promote the property. John F. Kennedy was also a frequent guest and wrote and rehearsed his inauguration speech poolside in Villa 25.

opposite below right Bermudian Faith Gibbons playing the role of holiday maker, 1958. She wears a striped Irish linen overblouse by Donald Davies of Dublin. Slim often recruited photogenic locals to model the latest fashions while on assignment.

above Swinging in a beachfront bar, Bahamas, 1967.

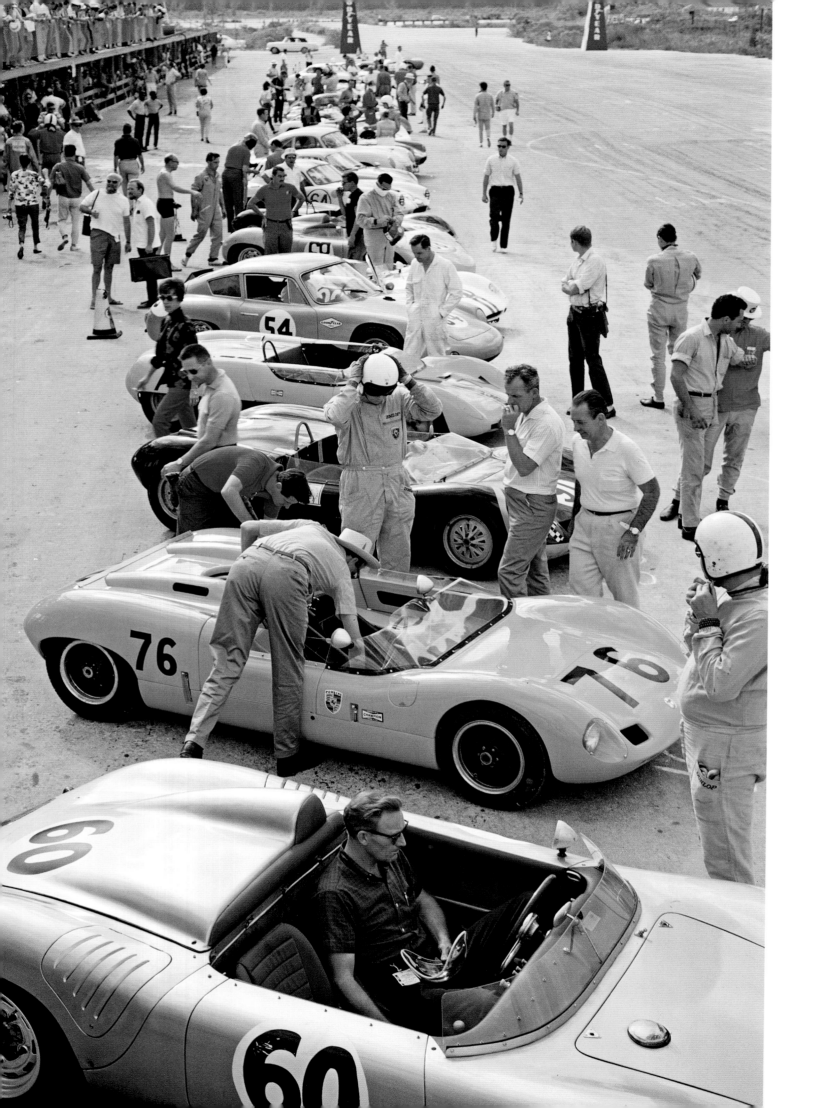

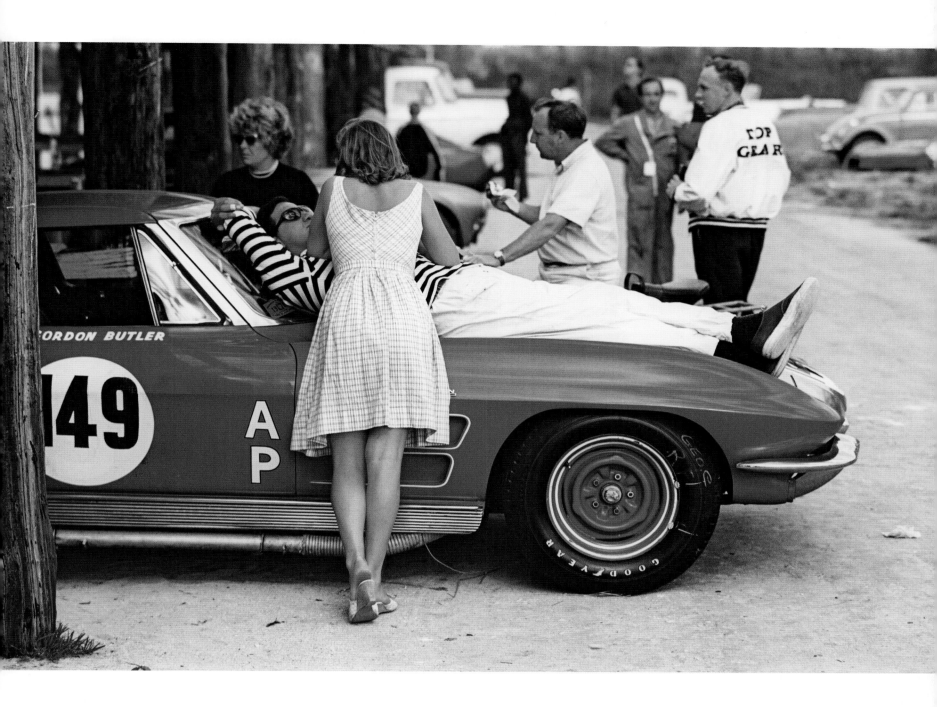

opposite A pre-race lineup during Bahamas Speed Week, Nassau, 1963. The event, held annually in December, began in 1954 as an off-season casual race for wealthy drivers and enthusiasts looking to give their GTs a serious run around the track while taking the sun and cutting loose. By the time Slim photographed the event in 1963, competition for the Nassau Trophy had tightened up beyond the reach of your average owner and began to feature souped-up cars from Ferrari, McLaren, Porsche, Ford, and Chevrolet.

above Boston Chevrolet dealer and race enthusiast Gordon Butler reclines on the hood of his Corvette Stingray during Speed Week.

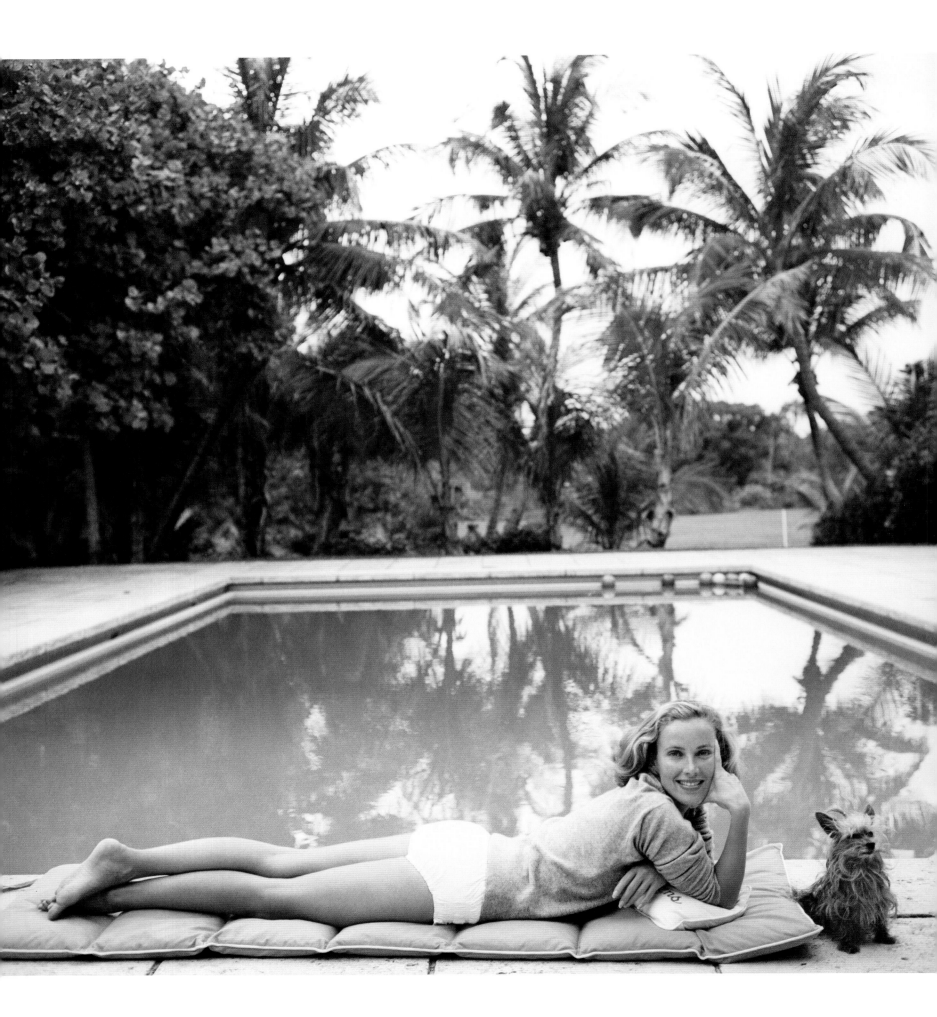

Real Society

In the 1950s, style was defined by society and the socialites who made up what came to be known as "Real Society." Alice Topping, the former wife of Daniel Topping, the owner of the New York Yankees, was one of Slim Aarons's favorite socialite subjects in Palm Beach. She posed for Aarons in the winter of 1959 for a *Holiday* magazine story titled "Who Are Real Society?" At the time, the question was an important one for followers of upper-crust America. It defined "Real Society" as the upper echelon of society—people so exclusive they didn't necessarily know or care who made up the rest of society.

Real Society was described as older families, and "nicer," "better" people than "ordinary society." Real Society didn't go to the Stork Club or El Morocco, and they didn't go to parties where the Duke and Duchess of Windsor might be. They did not appear in Cholly Knicker-bocker's column (or any column, for that matter). Another indication of this exclusive slice of society was that many of its members no longer lived in cities, but preferred to reside full-time in resort communities like Palm Beach, Southampton, or Tuxedo Park. They belonged to clubs like the Knickerbocker, the Brook, Piping Rock, the Century, and the National. In society, form was absolutely more important than money.

Although Topping was younger, she was connected to Real Society by marriage and by her seasonal migration from Palm Beach in the winter to Southampton in the summer. This photograph was considered risqué at the time, because people thought Topping was in her underwear, which in Real Society would have been considered a major faux pas.

Eventually, Topping's generation distanced themselves from the restrictive codes of Real Society, opting instead for a more footloose and exciting lifestyle. Instead of fussy Palm Beach, they ventured farther afield, pushing the boundaries of Social Register style by skiing in Gstaad, jetting off to Antigua, or lunching on Aristotle Onassis's yacht in the Greek Islands. These escapades gave Topping and her pals a new identity: They were quickly labeled the Jet-Set and lived up to the moniker for decades to come.

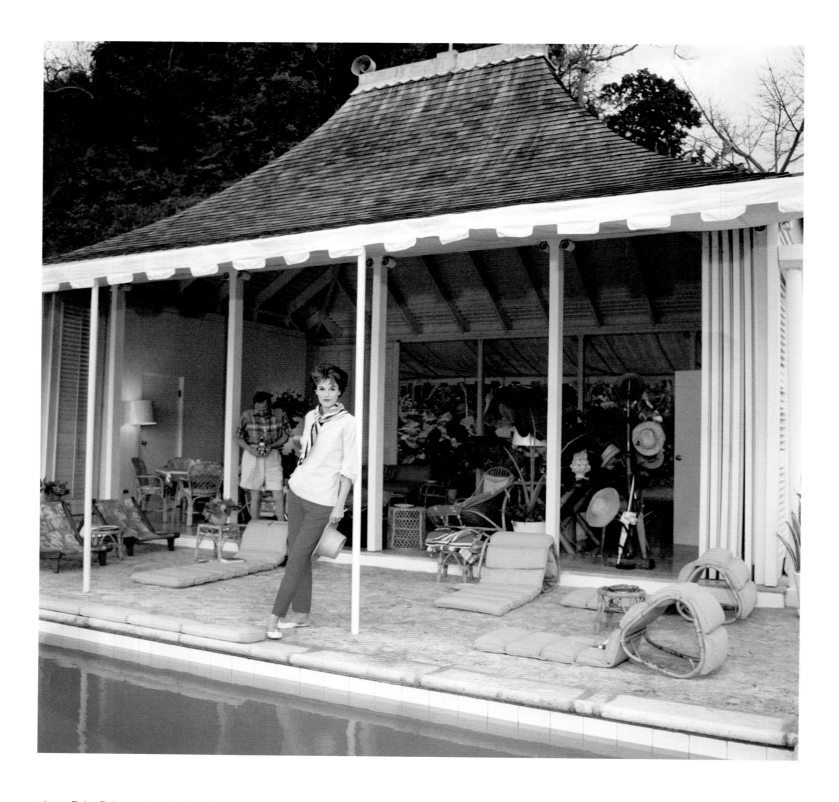

above Babe Paley and her husband at their cottage, Round Hill, Jamaica, 1959.

opposite above left French-born Olivier Coquelin and his wife, the Hawaiian singer and actress Lahaina Kameha, in Haiti, 1981. Coquelin opened the first American discotheque, Le Club, in New York City on New Year's Eve 1960.

opposite above right Maria Kromer on holiday in Casa de Campo, Dominican Republic, 1990. Maria and her husband Michael launched MCM Worldwide in 1976 and built the luxury handbag company into one of the world's most coveted brands. Propelled by Michael's gift for marketing, MCM had more than 250 stores worldwide by the early 1990s, but trouble was on

the horizon. Besotted with legal and financial trouble, the brand was left for dead until a South Korean group acquired it in 2005 and rebuilt it into a modern-day luxury juggernaut.

opposite below left Princess Caroline of Monaco in the winter garden of her private house on the palace grounds, Monte Carlo, Monaco, 1981.

opposite below right Patricia O'Neil of Boston during a winter holiday on the Caribbean island of Anguilla, 1993.

following spread Swimmers enjoy the heated pool after a day on the slopes, Vail, 1964.

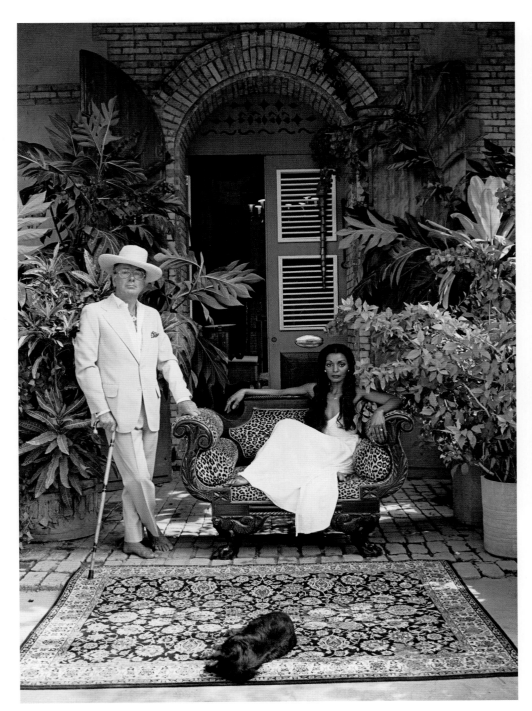

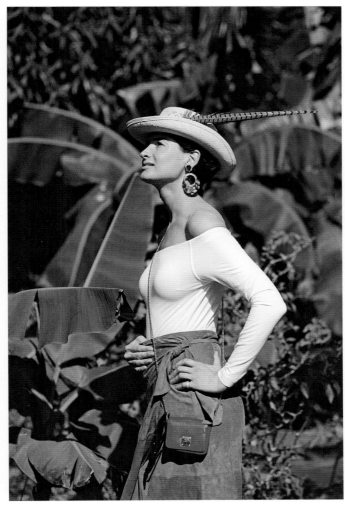

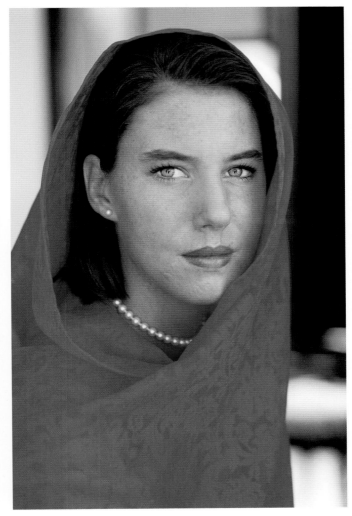

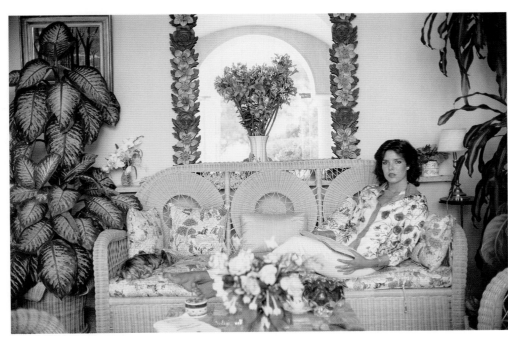

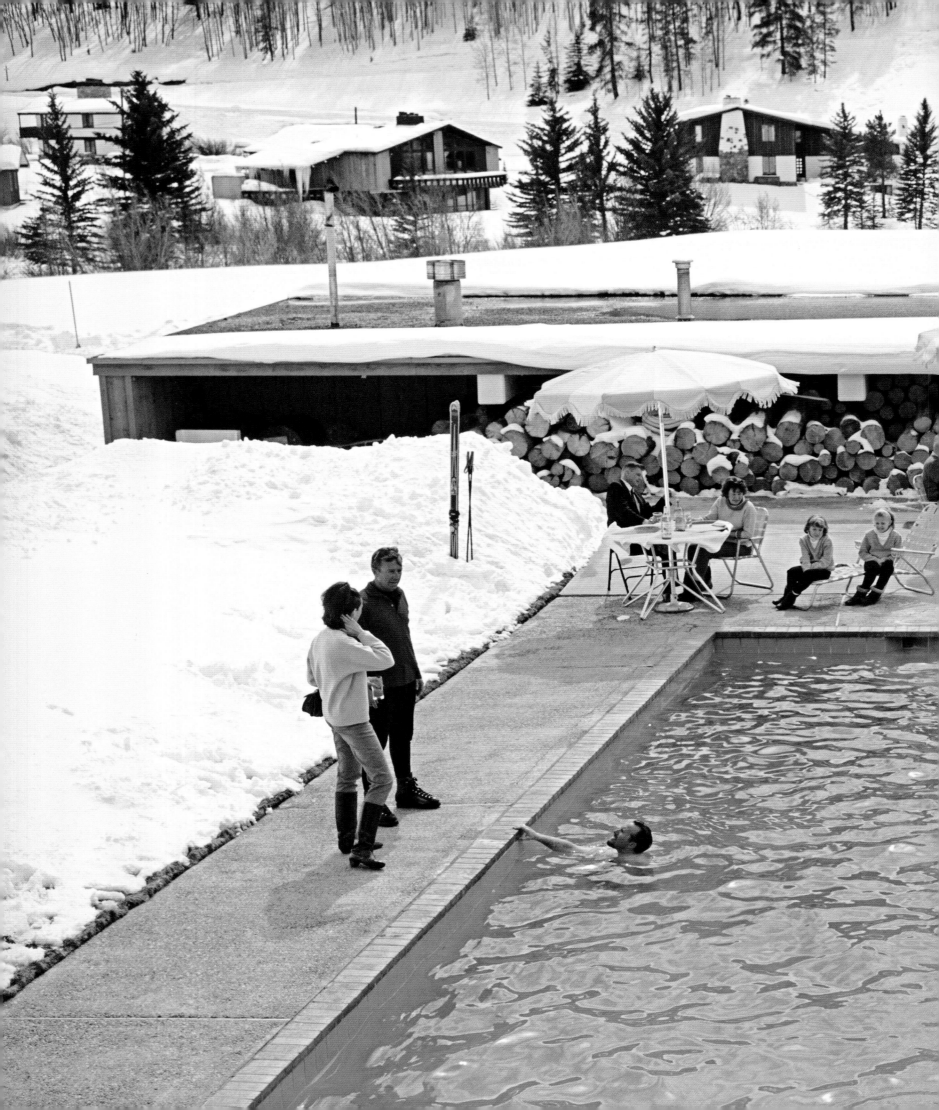

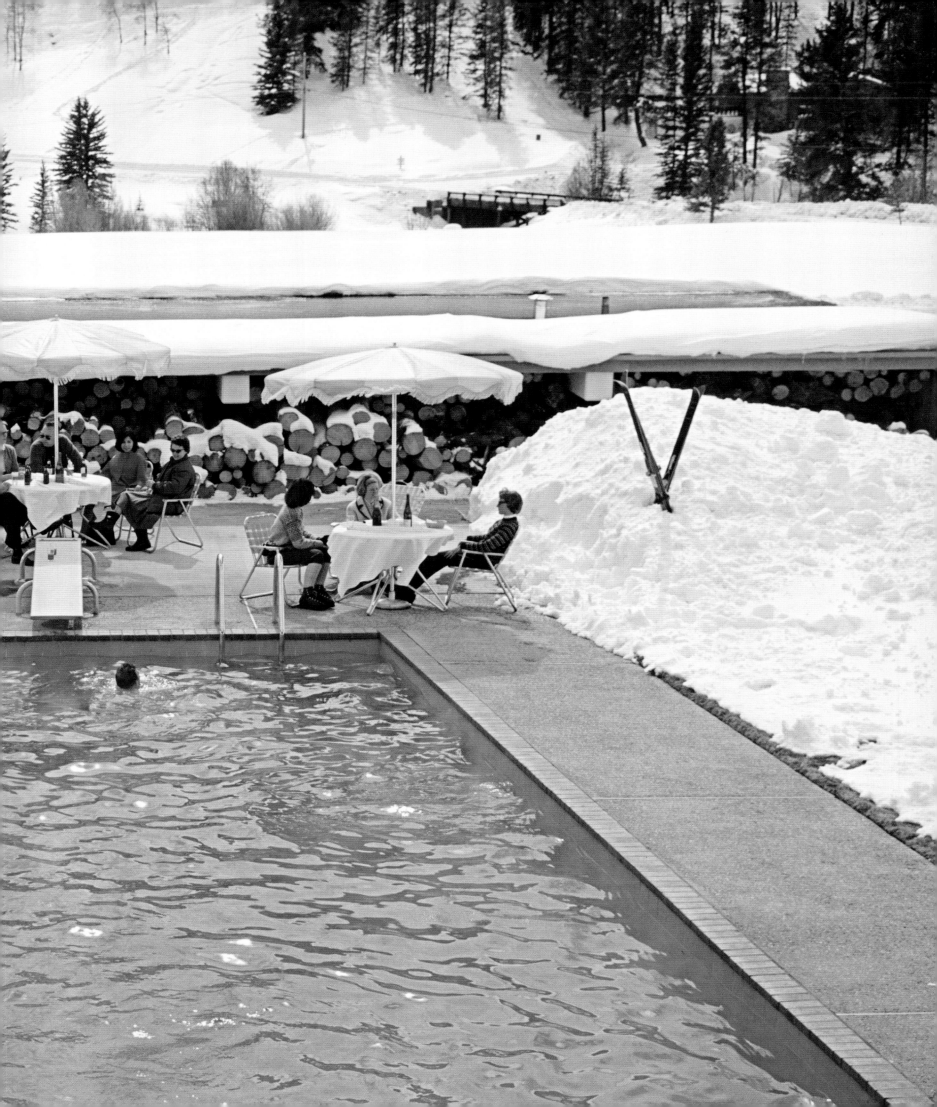

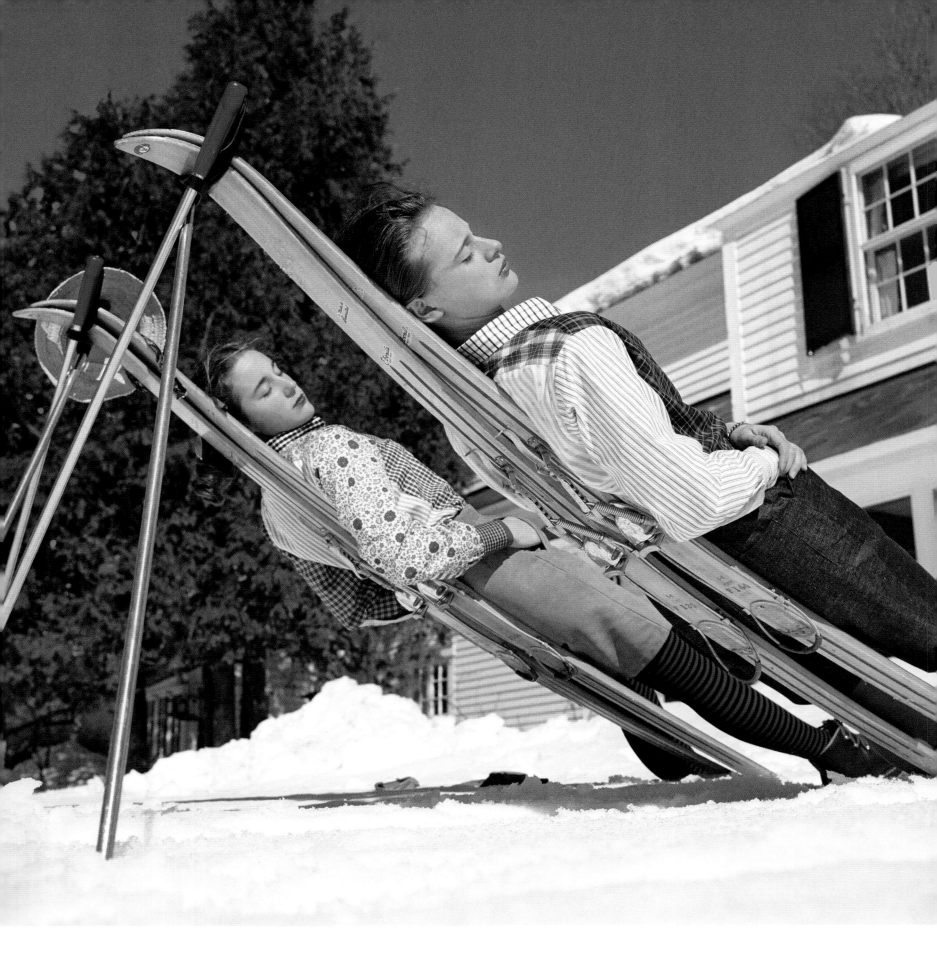

Improvised sunbeds in Cranmore
Mountain, New Hampshire, 1955.

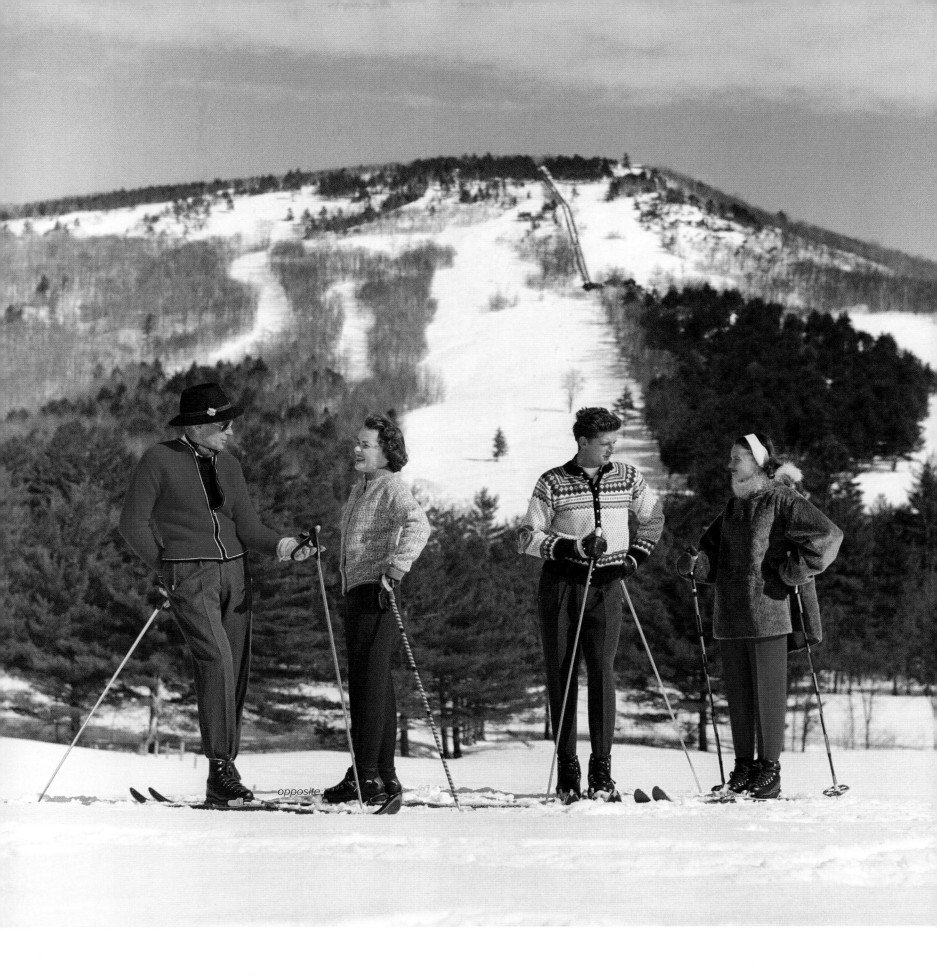

opposite

Skiers at the Cranmore Mountain Resort,
North Conway, New Hampshire, 1955.

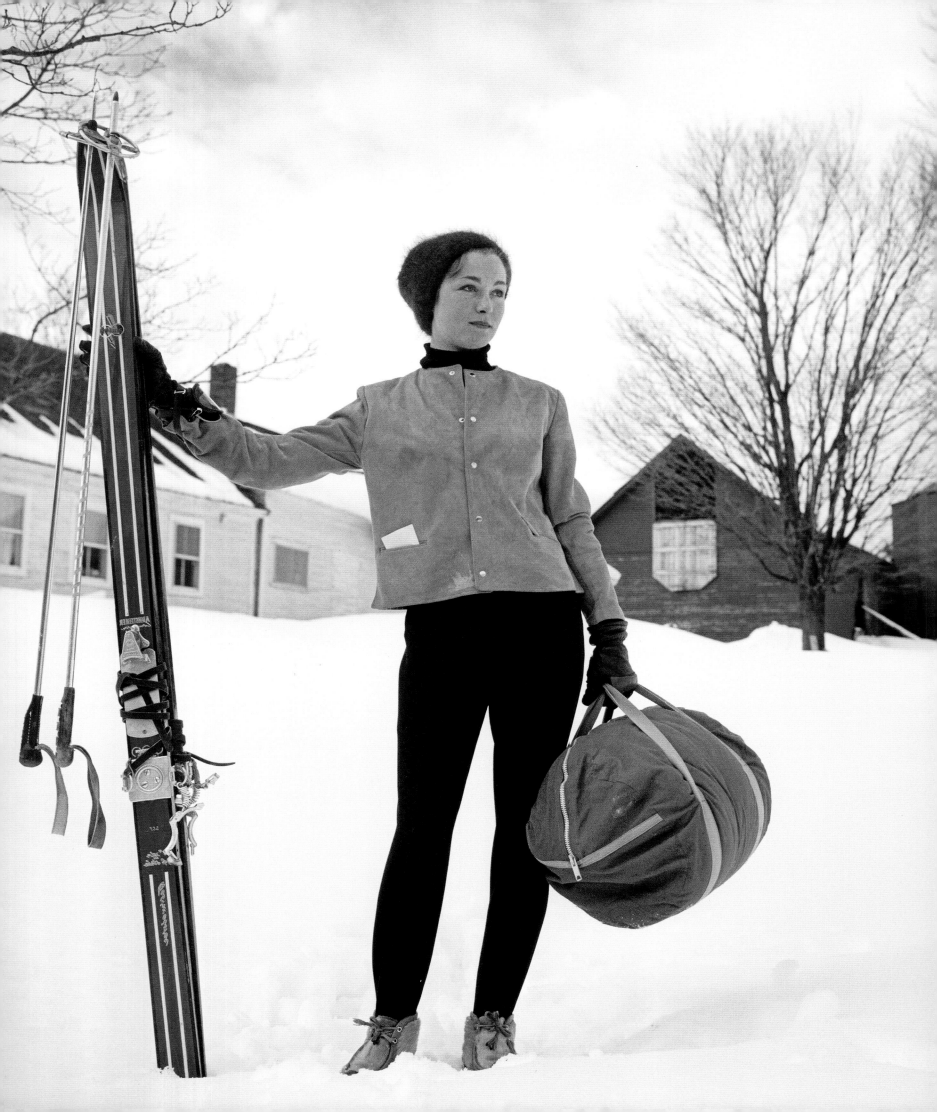

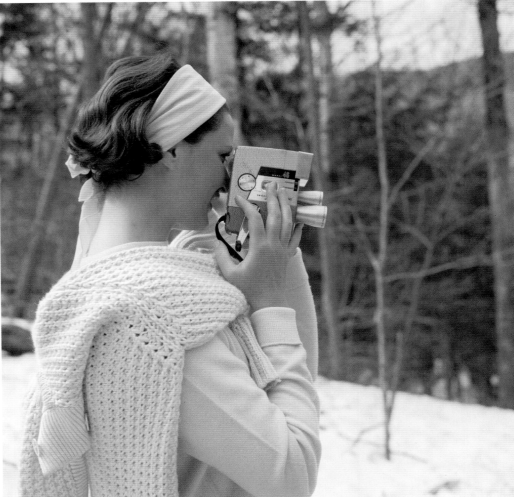

opposite Skiing simplicity in Stowe, Vermont, 1962.

above Slope-side access in New Hampshire, 1955.

right Buttery yellow on the slopes of Sugarbush, Vermont, c. 1960.

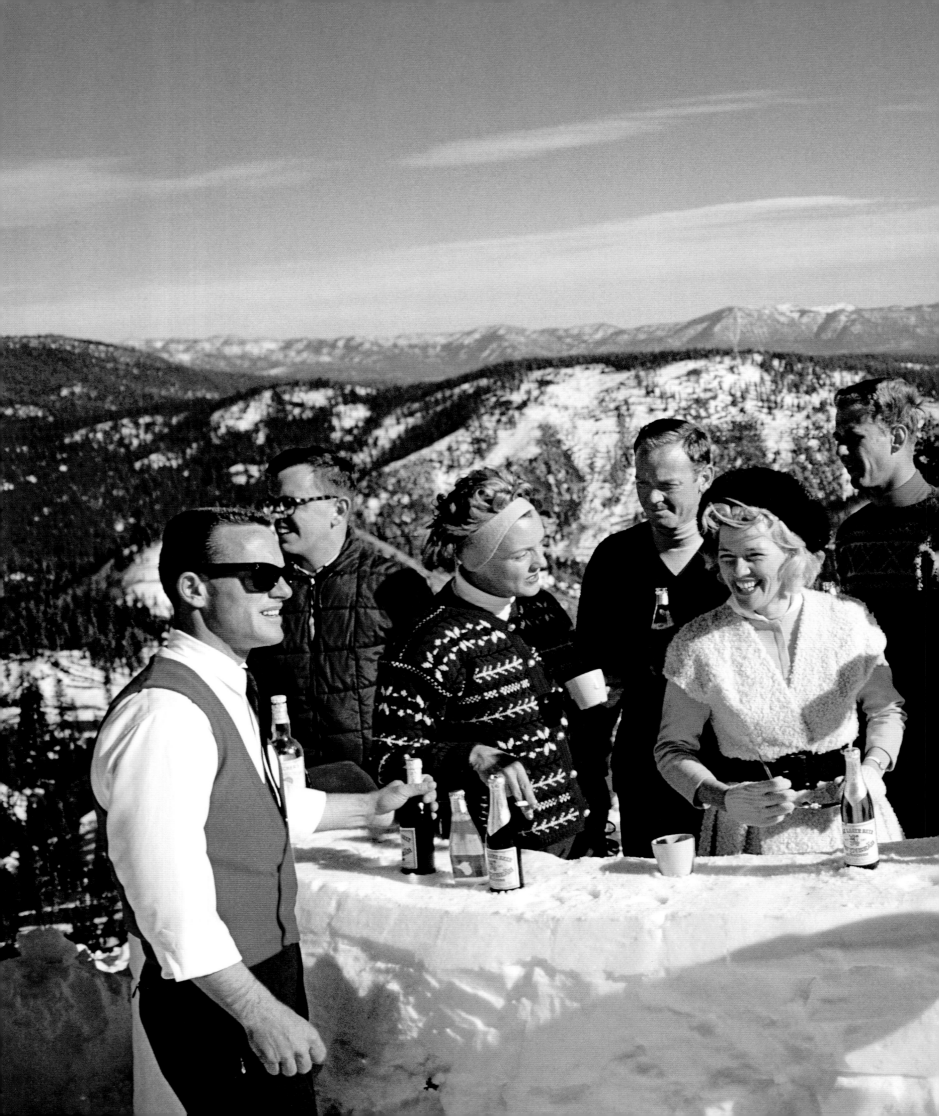

Cocktails atop peak KT-22, Squaw Valley, California, 1961. American lawyer and businessman Alexander Cochrane Cushing (in yellow) developed the resort.

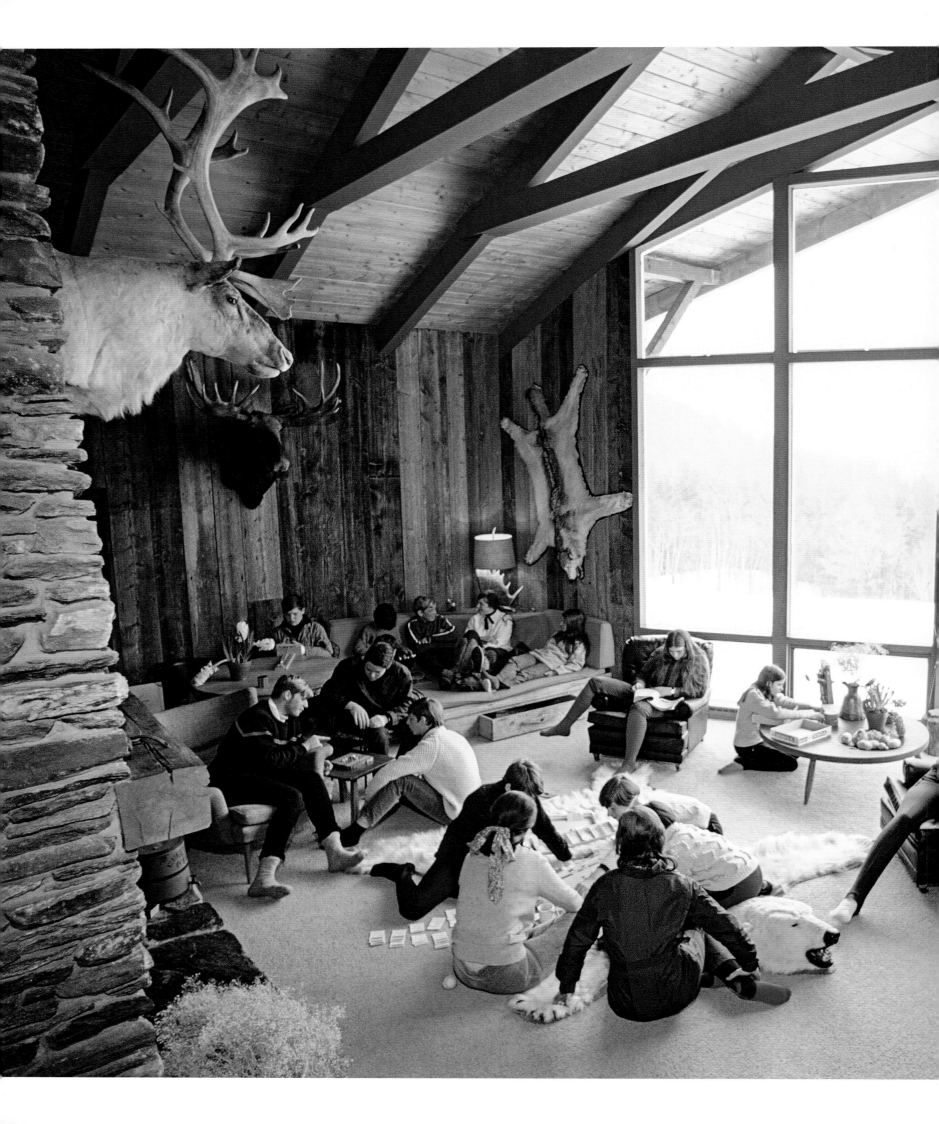

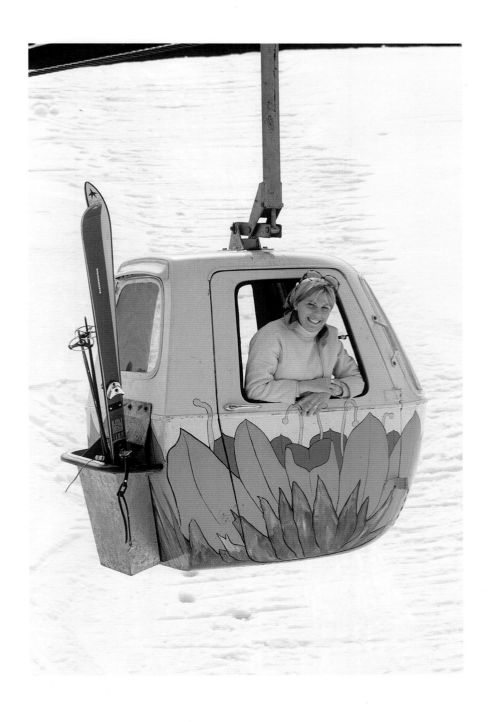

left Après-ski at Sugarbush Mountain
ski resort, Vermont, c. 1960.

above The cable car at Sugarbush,
Vermont, 1960.

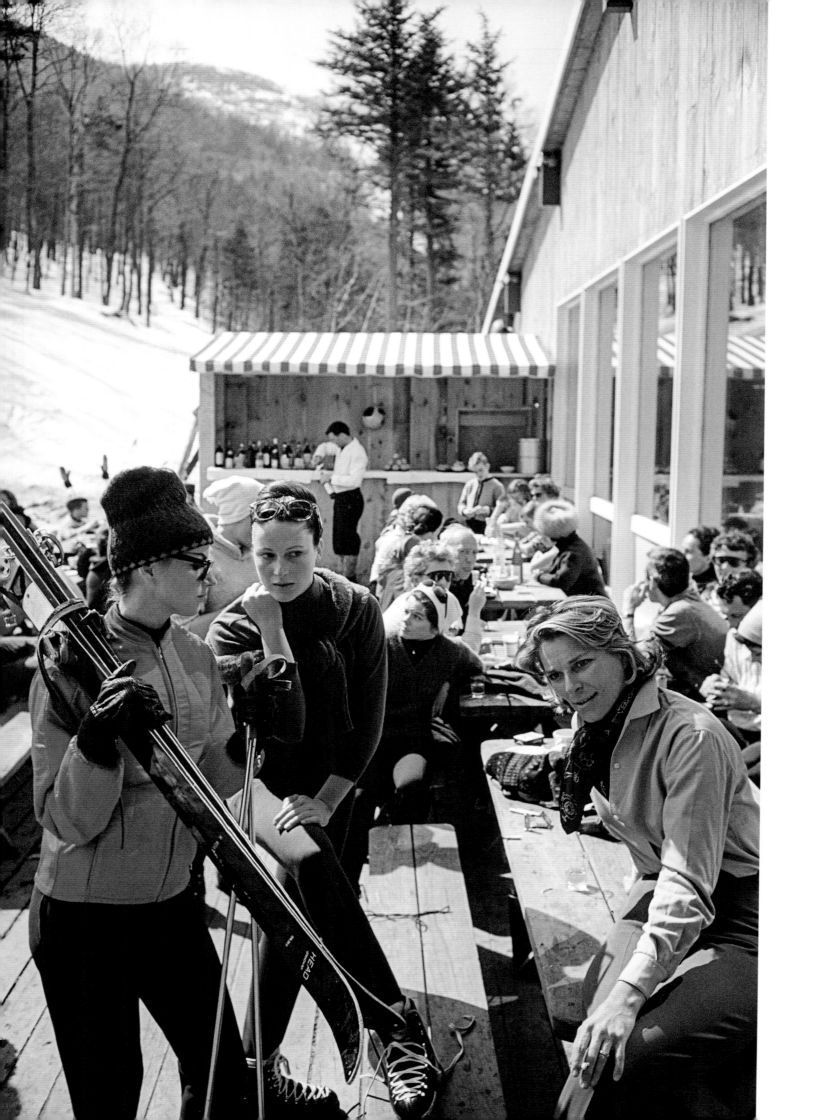

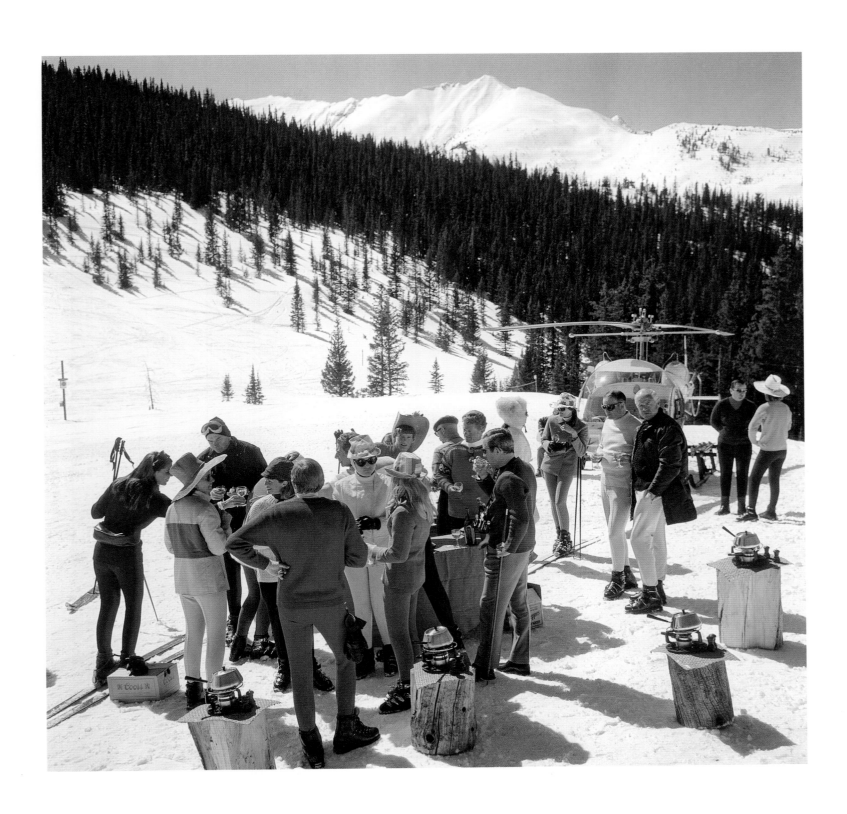

opposite American socialite and fashion writer Nan Kempner and other skiers having lunch in the lodge at Sugarbush Mountain ski resort, Vermont, 1960.

above Skiers enjoy fondue at Snowmass-at-Aspen, 1967. The mountaintop picnic was orchestrated by *Holiday*, who hired a helicopter to get the food up top in a hurry. Guests included Howard Head of the Head Ski Company, president of IBM Thomas Watson, Jr., and his wife, Olive, Norwegian Olympic skier Stein Eriksen, and American restaurateur Armando Orsini.

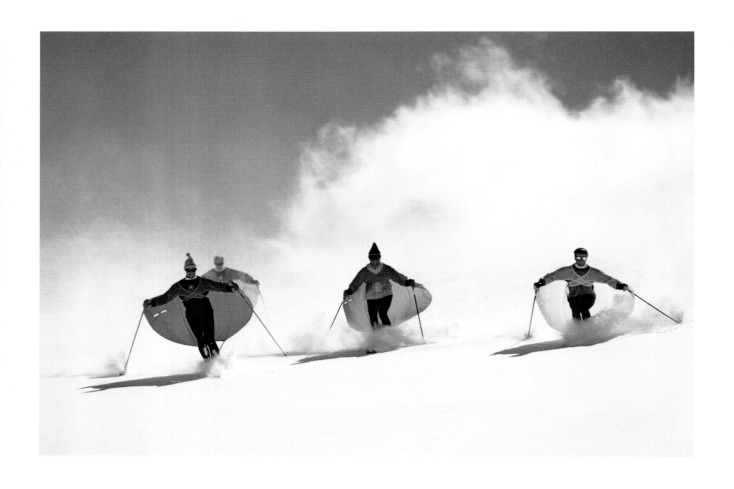

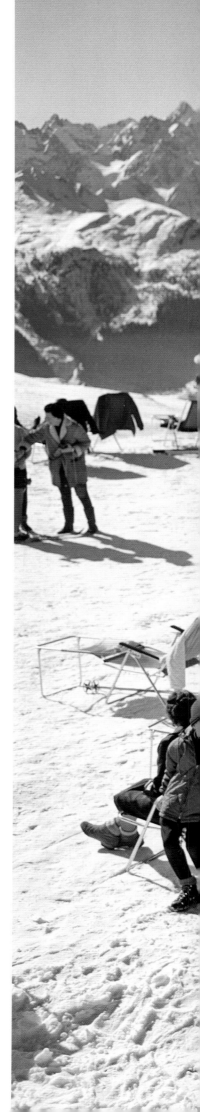

above Led by *skimeister* Stein Eriksen, skiers "sail" down a slope at Snowmass-at-Aspen, 1967.

right The view from the peak at Verbier, 1964.

following spread American opera singer Karen Davis arrives at the Palace Hotel, St. Moritz, 1978.

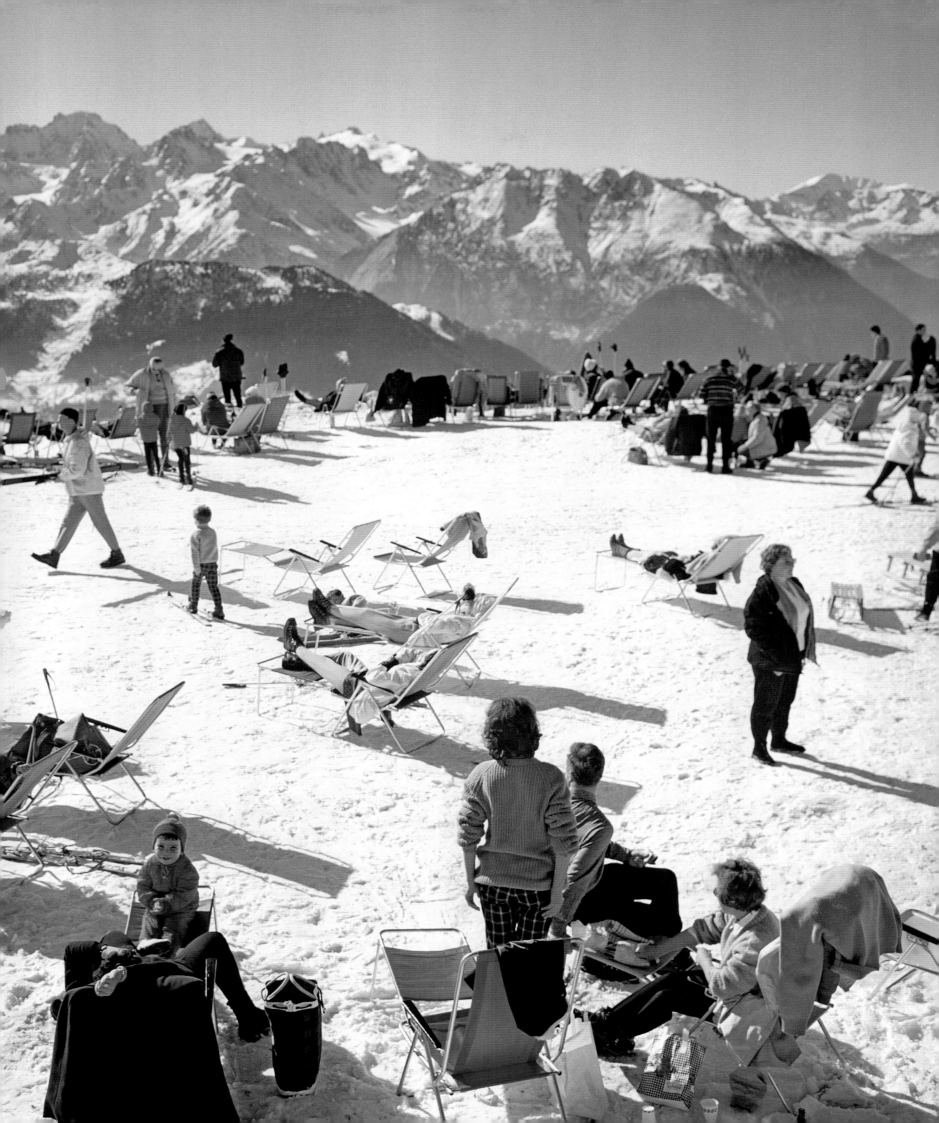

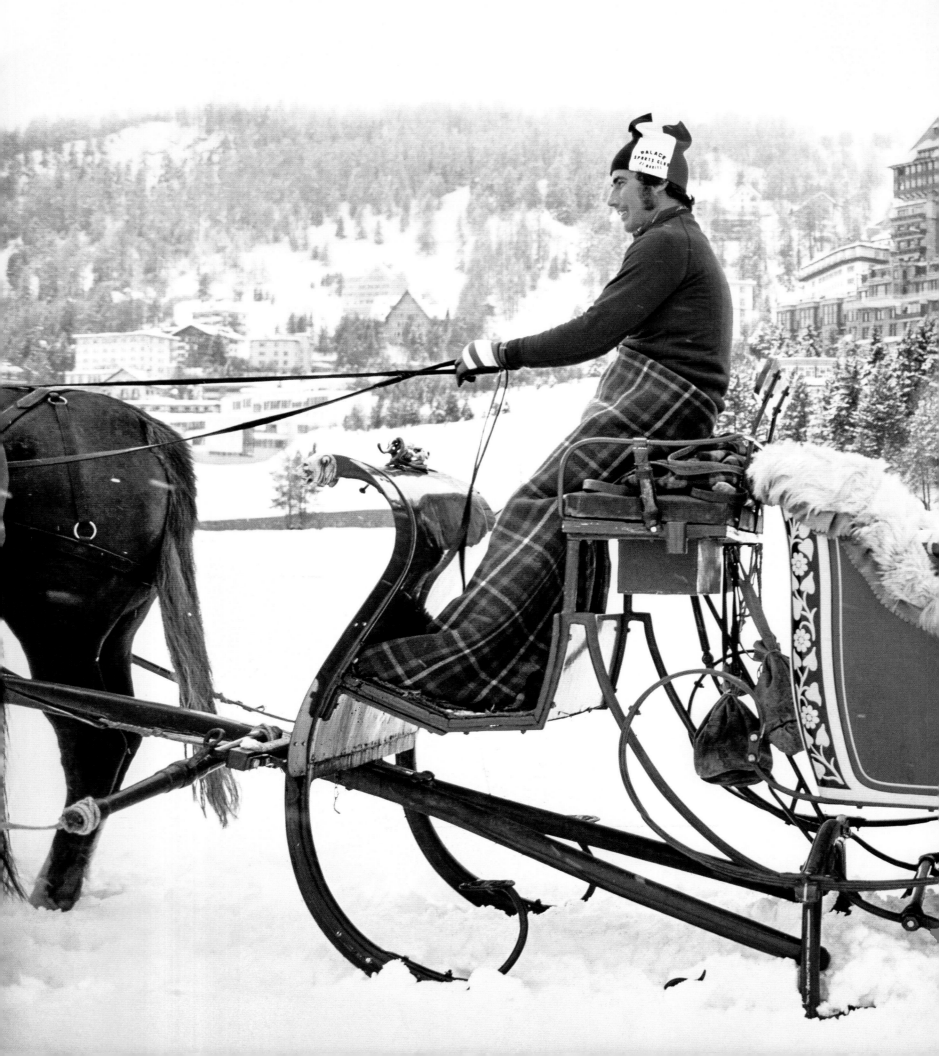

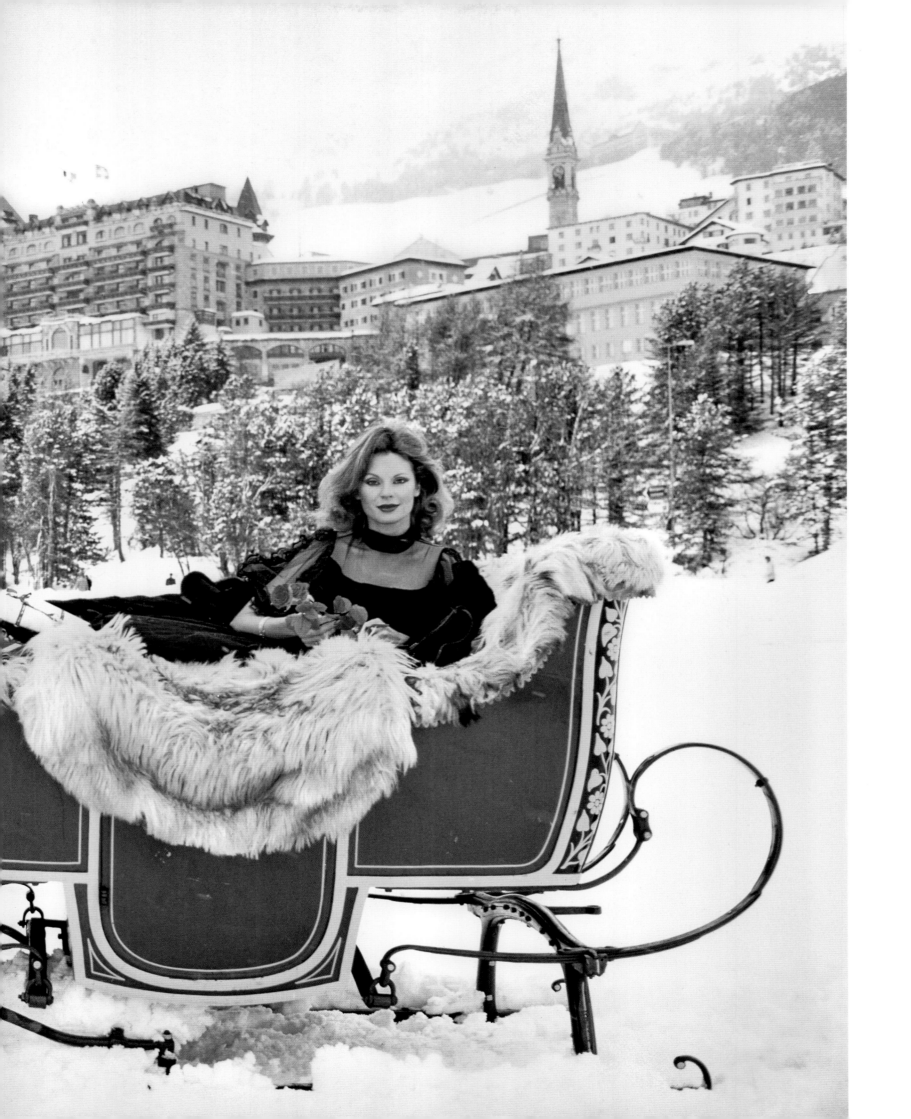

If It's Winter, This Must Be Gstaad

Skiing became a topic of much interest to readers of *Holiday* magazine in the late 1940s as ski resorts in New England were developed and became coveted destinations for the newly affluent. The Winter Olympics of 1932 had attracted the great skiers of the world to Lake Placid, and the resulting rise in interest in the sport inspired the writer Robert M. Coates to write about the way ski resorts in New York's Lake Placid, Vermont's Big Bromley, and New Hampshire's Mount Cranmore were developed and maintained. In those days a day-long lift ticket would set you back one dollar, and skiers wore leather Bass ski boots. Coates's article was illustrated with photographs by one George Aarons. It was one of the photographer's first stories for the magazine.

Later, in 1956, Aarons did another feature on New England ski resorts and discovered the brand-new ski-country attraction of racing cars on ice at the Sports Car Club of America's annual winter meet. He traveled to Franconia, New Hampshire, to shoot auto enthusiasts like Lee Wernicke and Derrick Stedman in their North Pole gear. Other popular "off piste" activities featured in the story included sleigh rides around North Conway, New Hampshire, and après ski cocktails of buttered rum around the fireplace at the nearby Oxen Yoke Inn.

But it wasn't until 1963 when Aarons ventured to Gstaad, Switzerland, and captured one of his most iconic photos, "Winter Sun," which features a lineup of female skiers sunbathing after lunch, wrapped up in fur coats, plaid wool blankets, and fur-trimmed parkas. Suddenly après-ski fashion was a winter style sensation, and Aarons was spending part of each winter documenting the scene on the slopes—and in the nightclubs—of Zermatt, Switzerland; Lech, Austria; and Cortina, Italy.

In 1967, Snowmass-at-Aspen opened in Colorado, and the Rocky Mountain town became a glamorous midwinter destination. To celebrate more than fifty miles of trails and snowfields, the mountain association invited *Holiday* magazine to organize a ski party. Helicopters were used to transport hot food, and guests enjoyed the stand-up picnic— another winter ski tradition.

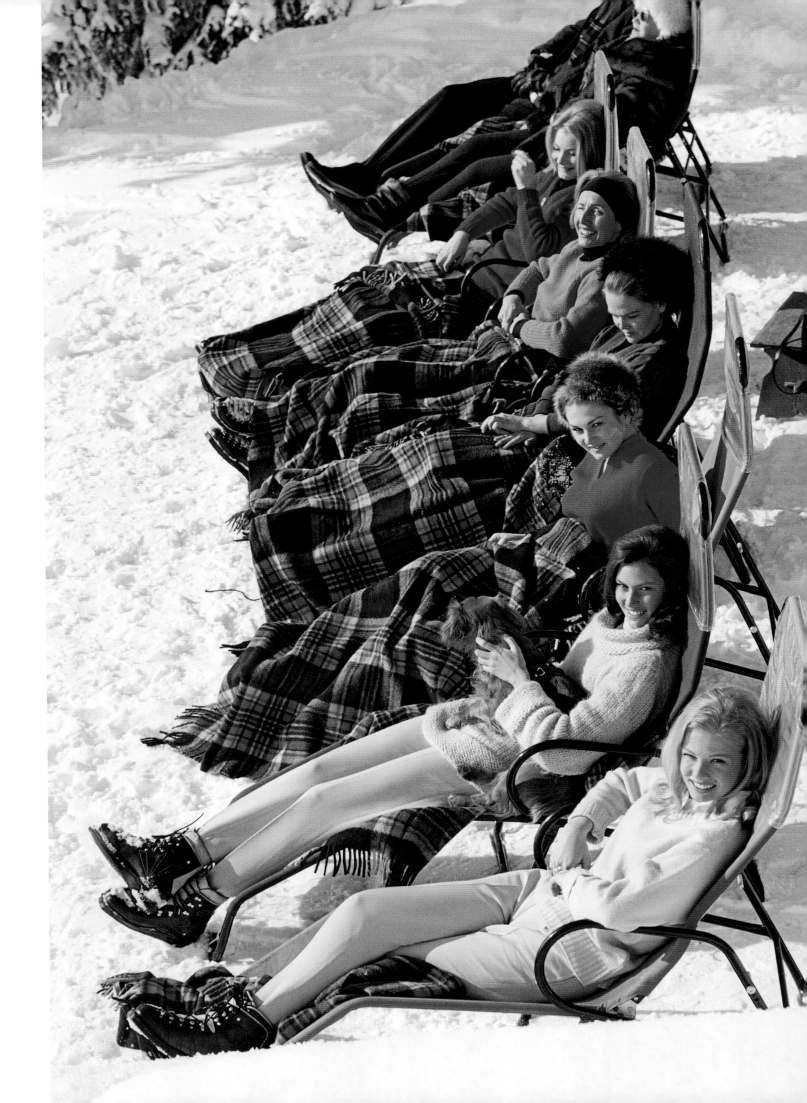

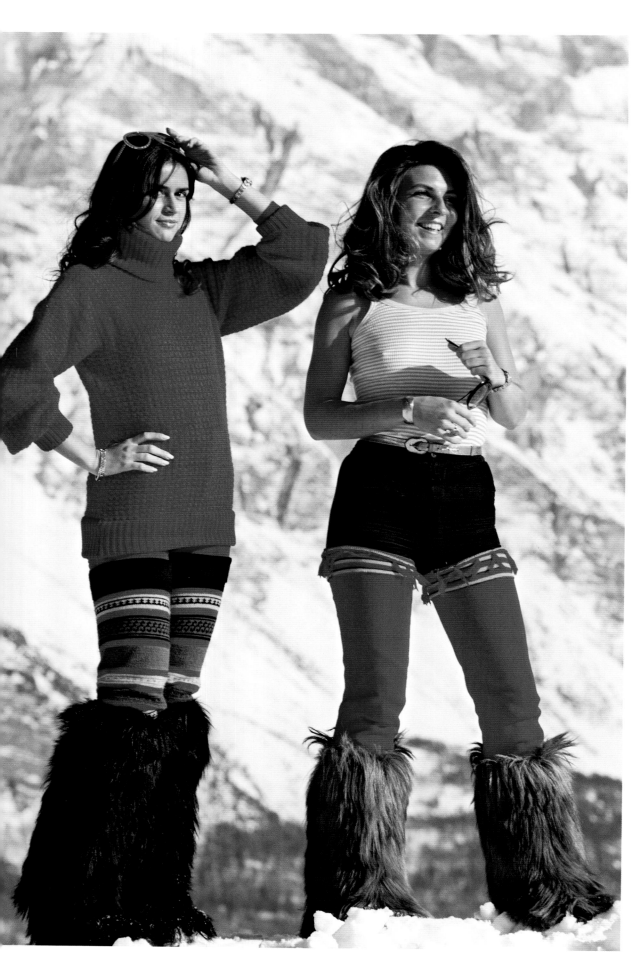

left Manuela Boraomanero (left) and Emanuela Beghelli taking advantage of the strong midday sun, Cortina d'Ampezzo, 1976. Their goat fur boots and ski gear are typical of the 1970s Cortina crowd, who valued the latest fashions as much as fresh powder.

opposite above left Italian actors Christian de Sica and Elsa Martinelli at the Eagle Ski Club, Gstaad, 1977.

opposite above right Princess Bianca Hanau-Schaumburg, one of Slim's favorite subjects, at her Gstaad chalet, 1985.

opposite below left Fashion designer Valentino relaxing with his flock of sheep chairs in his Gstaad chalet. Designed by the French artist François-Xavier Lalanne, the chairs debuted at the 1965 Salon de la Jeune Peinture in Paris and were popular with designers such as Yves St. Laurent and Peter Marino, who commissioned flocks of their own.

opposite below right Isa Genolini and Maria Antonia greet each other outside of Bredo, a luxury boutique in the village of Cortina d'Ampezzo, Italy, 1982. Dressing in Cortina is a two part equation: the practical need to stay warm plus the desire to turn heads. Hats and fur are musts; the bigger the better.

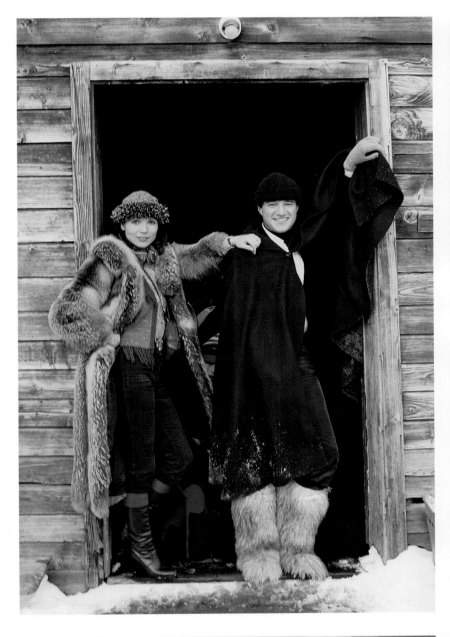

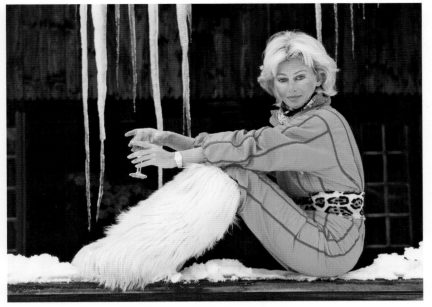

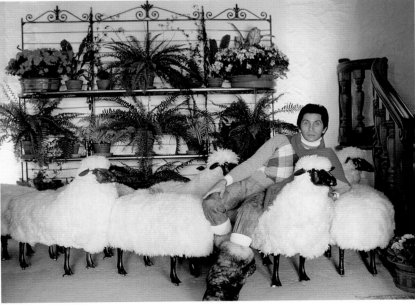

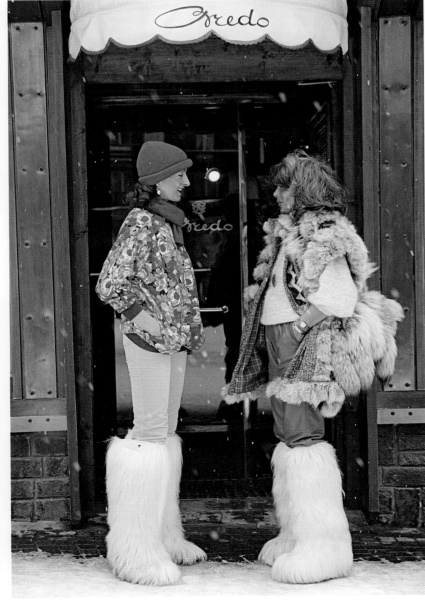

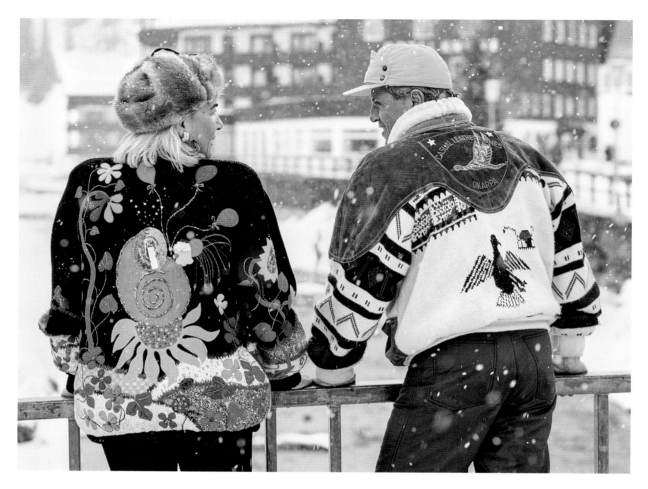

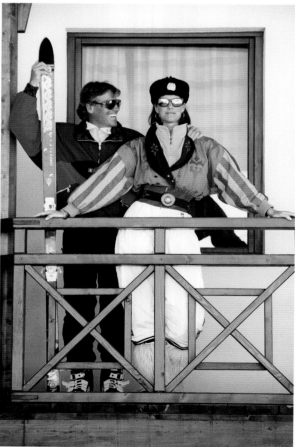

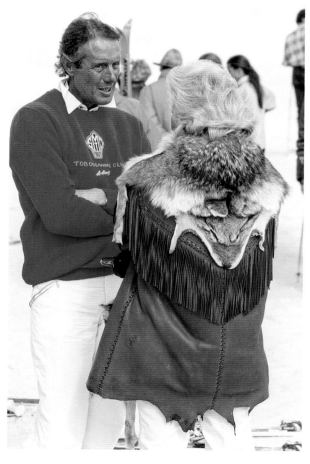

above Brioni heir Gigliola Savini Perrone and husband Ettore Perrone skiing in Lech, Austria, 1991. Savini's father, Gaetano Savini, and his partner, Nazareno Fonticoli, were the visionary founders of Brioni, the influential Italian menswear brand. Their original shop on Rome's via Barberini opened in 1945 and still occupies the storefront today. In 1952, Brioni changed the face of the fashion industry when they staged the first menswear presentation inside the Palazzo Pitti in Florence. In 1985 the company opened a tailoring school, Scuola di Alta Sartoria, to pass on the Brioni methods to the next generation of tailors.

below left Alpine ski champion Max Rieger and Meg O'Neil in the Caucasus Mountains of Georgia, 1990. Her suit is by Bogner.

below right Giulio Ricci and Countess Adriana Sterzi deep in conversation in Cortina d'Ampezzo, Italy, c. 1980. His sweater is from the St. Moritz Tobogganing Club, a private club founded in 1887 to oversee access to the Cresta Run in partnership with the people of St. Moritz.

opposite From left: Elena Pratolongo, Prince Edward Egon von Furstenberg, Contessa Geronaffo holding Bamba the Italian spaniel, Luca Stucchi, Silvia Ferrante, and Conte Adriano Geronaffo outside Villa Bella, the Furstenberg family villa, Cortina d'Ampezzo, Italy, 1976.

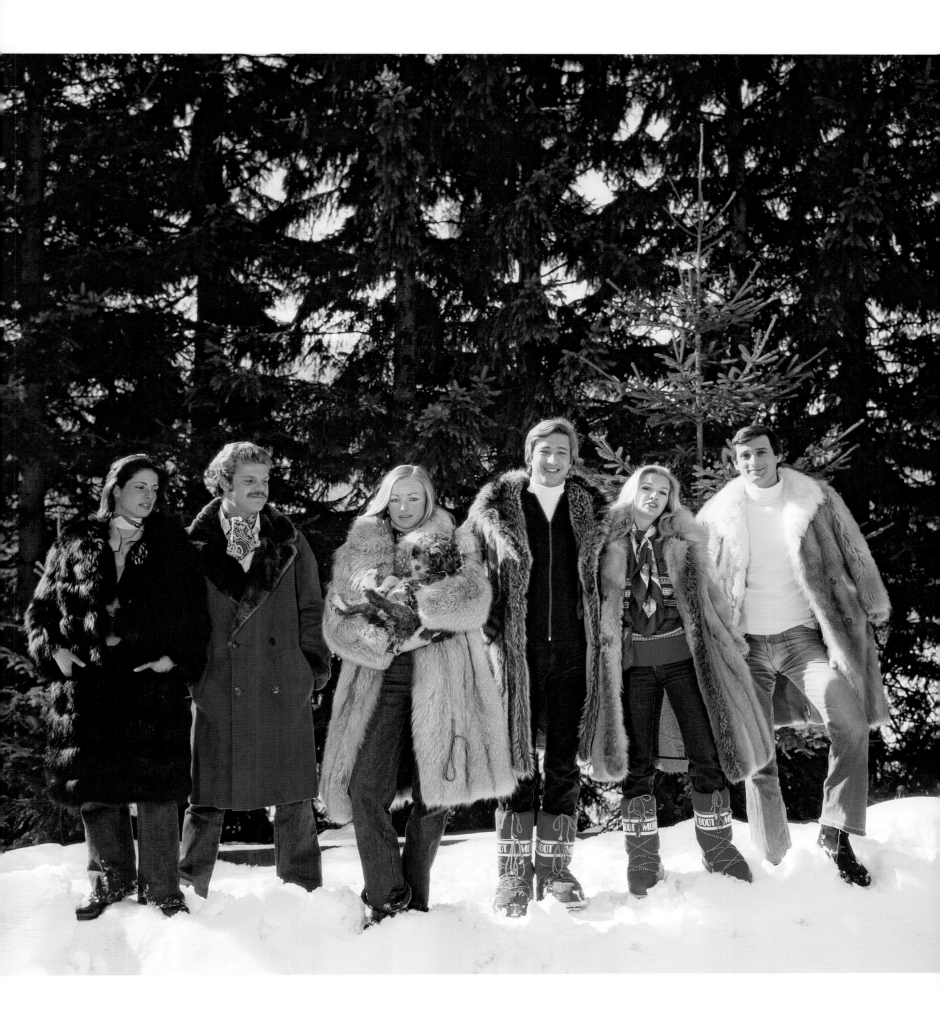

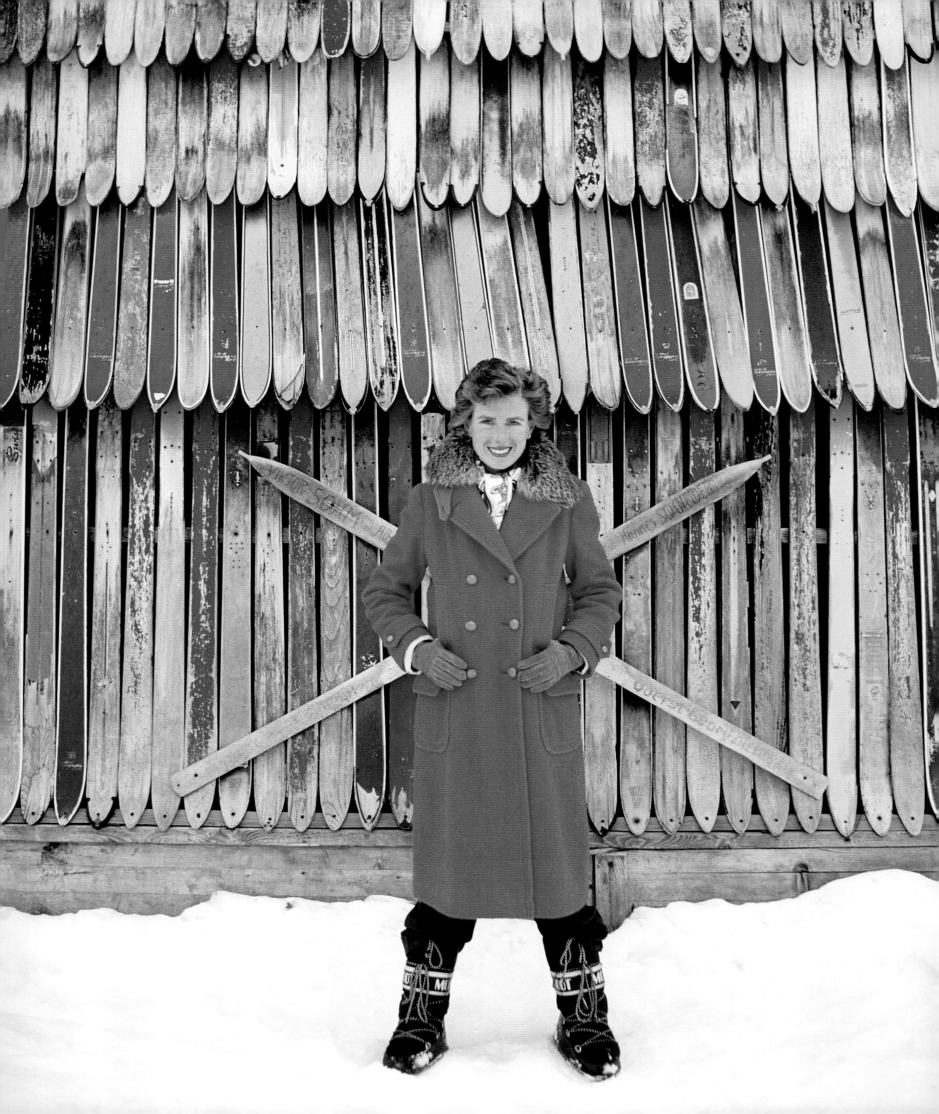

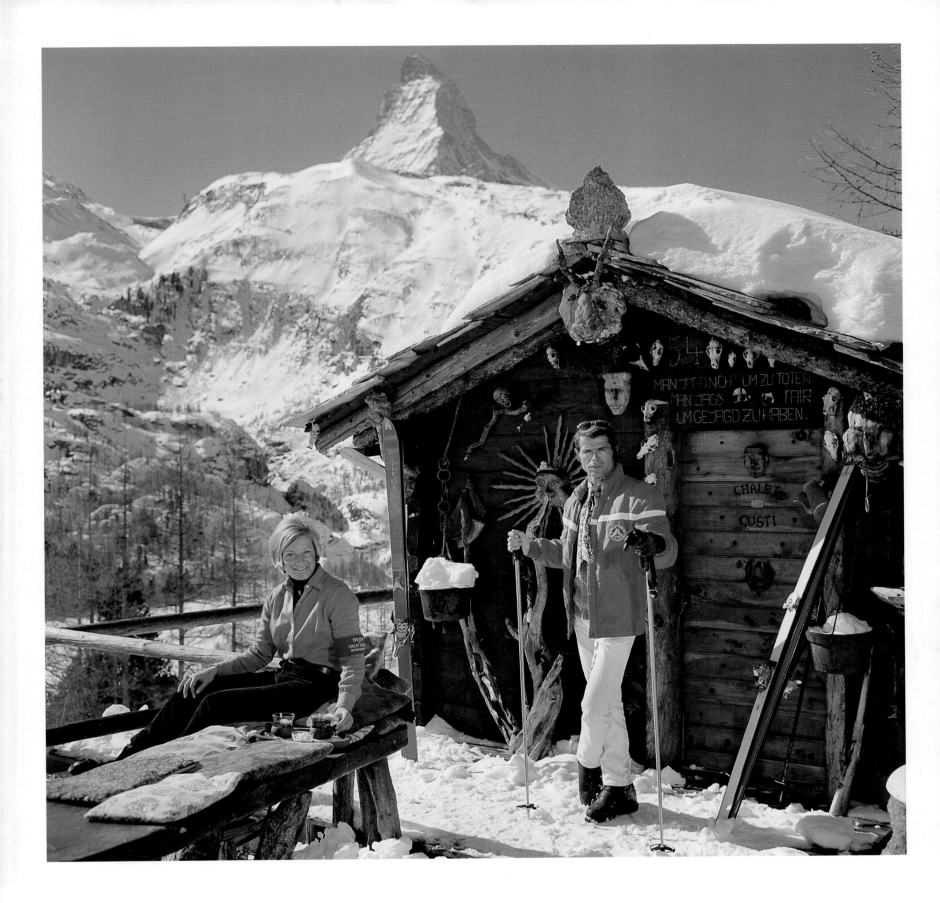

opposite Princess Lucy Ruspoli in Lech am Arlberg, Austria, 1979. She is wearing a pair of Moon Boots, an essential piece of the fashionable—and functional—1970s après-ski wardrobe. The boots were designed by Giancarlo Zanatta of Technica after watching the 1969 lunar landing on television.

above Skiers outside the Chalet Costi in Zermatt, Switzerland, 1968.

following spread Guests lounging by the indoor pool of the Gasthof Post, Lech, Austria, 1979. The resort was acquired by Erich and Irma Moosbrugger in 1937 and is still operated by the family today.

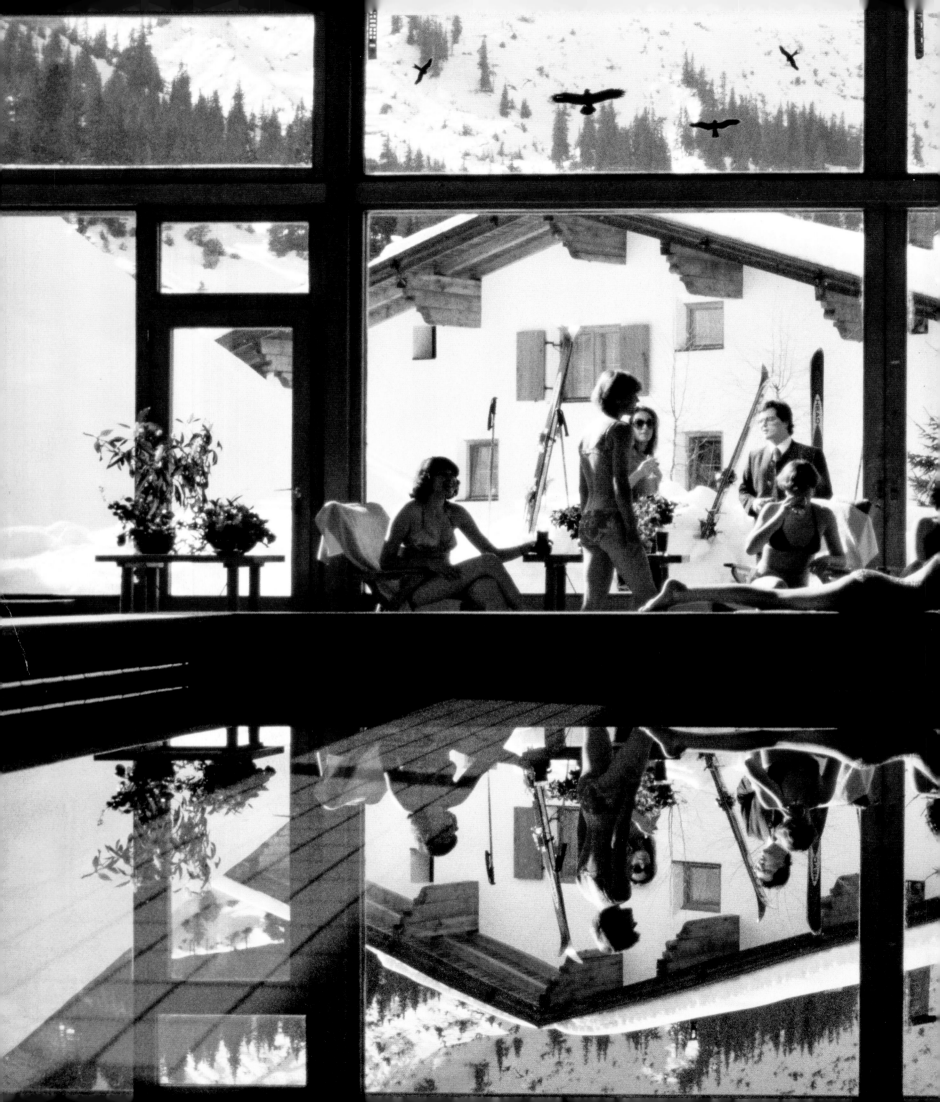

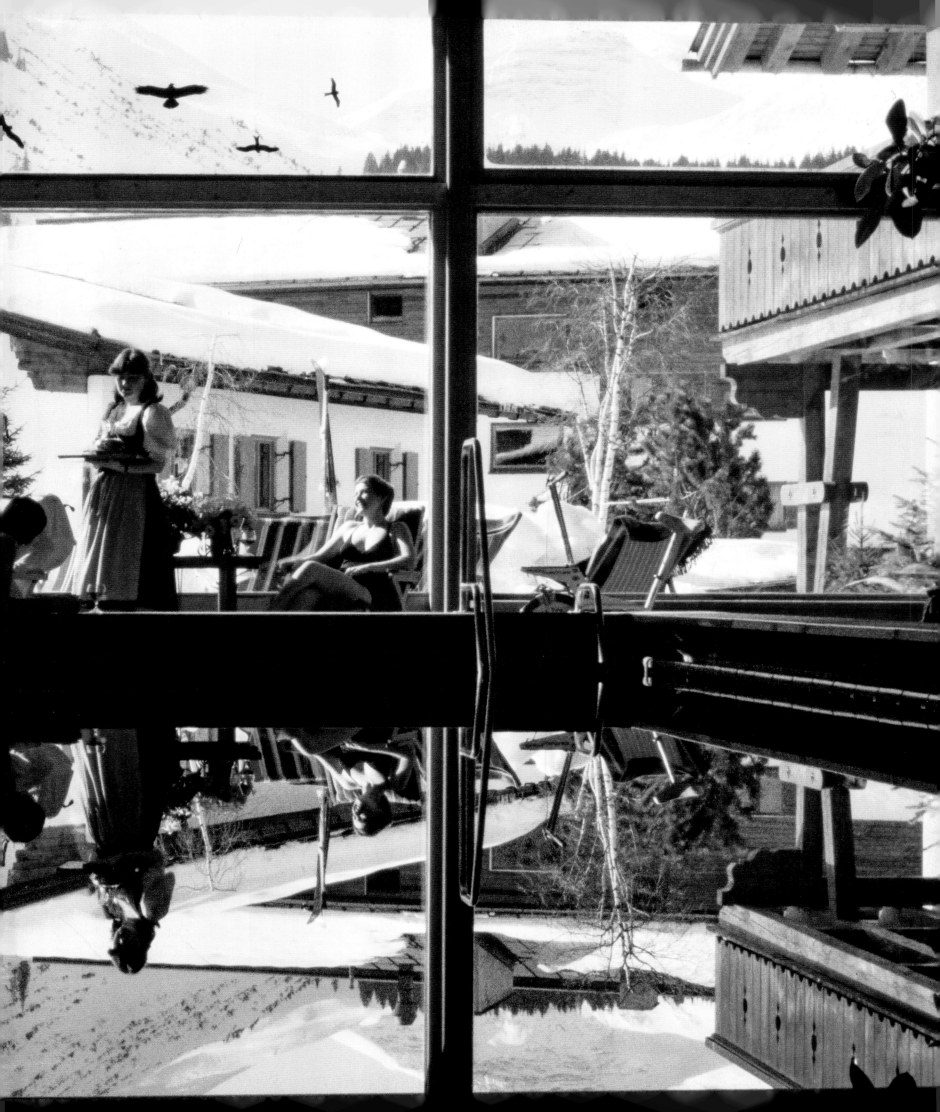

above A Venetian doggy bag, 1978.

page 1 Model Gretchen Van de Kamp Ward wearing a dinner dress by Gustave Tassell, Beverly Hills, 1960. The bodice is made of white silk faille and the skirt is apple green peau d'ange. Tassell began his fashion career in the advertising department at Hattie Carnegie before striking out on his own. He moved to Paris in 1952 and worked with Jacques Fath and James Galanos. In 1956, Tassell returned to the US and opened a studio in Los Angeles and quickly became a favorite among the Beverly Hills society set. Tassell won the prestigious Coty Award for best American designer in 1961; the following year he dressed First Lady Jackie Kennedy for her official tour of India.

page 2 Actress and model Renata Boeck at the New York Regency Hotel, 1964. Slim didn't know much about his subject other than the fact she was German, so he brought along the monocle as a prop.

pages 4–5 Sunbathers on the painted terrace of Il Canille on the island of Capri, 1980.

ACKNOWLEDGMENTS

At Getty Images—to Matt Butson, Bob Ahern, Melanie Llewellyn, Karen Leach, Bianca Marchetti, Jim Nye, James Bloomfield, and the entire Archive and Research teams for their knowledge, along with Peter Orlowsky, Katie Calhoun, and Craig Peters; to Mary Cirincione for the extra set of eyes; and to Brian Doherty and Antonia Hille for their darkroom skills and expertise.

To my colleagues at Getty Images Gallery—Amie Lewis, Lauren Katz, Sophie Shohani, Dana Angotta, and Grazia Colica—thank you for your patience and encouragement. Special thanks to Lorna Robertson for her detective work and former colleagues Lia De Feo and Alex Timms, who are sorely missed.

At Abrams—Laura Dozier for her diligence, determination, and stewardship; Danielle Youngsmith for making the layout shine; and Gabby Fisher for getting the word out.

Thank you to Kate Betts for her professionalism and expertise and Jonathan Adler for his words and humor; to Tory Burch, Jack Carlson, Michael Kors, and Sid Mashburn for lending their voices; and to Jonathan Baker, Ryan Dziadul, Katelyn Glass, Emily Morris, and Keaton McGinty for making it happen. I'm grateful to Penelope Rowlands, Robin Muir, and Gretchen Fenston, who all came through in a pinch.

Finally, to Mary and Rita Aarons for their support and, of course, to Slim, whom I did not have the honor of meeting but grow closer to every day. —S.W.

Editor: Laura Dozier
Designer: Danielle Youngsmith
Managing Editor: Lisa Silverman
Production Manager: Sarah Masterson Hally

Library of Congress Control Number: 2021932532

ISBN: 978-1-4197-4617-8
eISBN: 978-1-64700-474-3

Foreword text (page 6) © 2021 Jonathan Adler
Text © 2021 Getty Images
Photographs © 2021 Slim Aarons/Getty Images

Jacket © 2021 Abrams

Printed and bound in China
10 9 8 7 6 5 4 3 2 1

Abrams books are available at special discounts when purchased in quantity for premiums and promotions as well as fundraising or educational use. Special editions can also be created to specification. For details, contact specialsales@abramsbooks.com or the address below.

Abrams® is a registered trademark of Harry N. Abrams, Inc.

ABRAMS The Art of Books
195 Broadway, New York, NY 10007
abramsbooks.com